Back to Black

Critical Graphics

Series Editor: Frederick Luis Aldama, Arts and Humanities Distinguished Professor, The Ohio State University

Volumes in the Critical Graphics series bring scholarly insight to single authors and their creator-owned graphic fiction and nonfiction works. Books in the series provide context and critical insight into a given creator's work, with an especial interest in social and political issues. Each book is organized as a series of reader-friendly scholarly chapters that precede the reprinting of short graphic fiction or nonfictional works—or excerpts of longer works. The critical insight and commentary alongside the creative works provide a gateway for lay-readers, students, and specialists to understand a given creator's work and life within larger social and political contexts as well as within comics history. Authors of these books situate the work of their subject within the creator's larger body of work and within the history of comics; and bring an engaged perspective to their analysis, drawing on a variety of disciplines, including medical humanities, environmental studies, disability studies, critical race studies, and women's, gender, and sexuality studies.

Recent titles in the Critical Graphics series:
Fabrice Leroy, *Back to Black: Jules Feiffer's Noir Trilogy*
Maite Diaz-Basteris and Fernanda Urcaregui, eds., *Latinx Comics Studies*
Andrew J. Kunka, *The Life and Comics of Howard Cruse: Taking Risks in the Service of Truth*
Jan Baetens, *Rebuilding Story Worlds: "The Obscure Cities" by Schuiten and Peeters*

Back to Black

●●●●●●●●●●●●●●●●●●

Jules Feiffer's Noir Trilogy

FABRICE LEROY

Rutgers University Press
New Brunswick, Camden, and Newark, New Jersey
London and Oxford

Rutgers University Press is a department of Rutgers, The State University of New Jersey, one of the leading public research universities in the nation. By publishing worldwide, it furthers the University's mission of dedication to excellence in teaching, scholarship, research, and clinical care.

Library of Congress Cataloging-in-Publication Data

Names: Leroy, Fabrice, author.
Title: Back to black : Jules Feiffer's noir trilogy / Fabrice Leroy.
Description: New Brunswick, NJ : Rutgers University Press, 2025. | Series: Critical graphics | Includes bibliographical references and index.
Identifiers: LCCN 2024041363 | ISBN 9781978842915 (paperback) | ISBN 9781978842922 (hardcover) | ISBN 9781978842939 (epub)
Subjects: LCSH: Feiffer, Jules—Criticism and interpretation. | Noir comic books, strips, etc.—History and criticism. | Graphic novels—United States—History and criticism. | LCGFT: Comics criticism.
Classification: LCC PN6727.F4 Z74 2025 | DDC 741.5/973—dc23/eng/20240911
LC record available at https://lccn.loc.gov/2024041363

A British Cataloging-in-Publication record for this book is available from the British Library.

Copyright © 2025 by Fabrice Leroy
All rights reserved

No part of this book may be reproduced or utilized in any form or by any means, electronic or mechanical, or by any information storage and retrieval system, without written permission from the publisher. Please contact Rutgers University Press, 106 Somerset Street, New Brunswick, NJ 08901. The only exception to this prohibition is "fair use" as defined by U.S. copyright law.

References to internet websites (URLs) were accurate at the time of writing. Neither the author nor Rutgers University Press is responsible for URLs that may have expired or changed since the manuscript was prepared.

♾ The paper used in this publication meets the requirements of the American National Standard for Information Sciences—Permanence of Paper for Printed Library Materials, ANSI Z39.48-1992.

rutgersuniversitypress.org

To Irène and Shelly, the mothers in my life

Contents

	Introduction: Back to Black	1
1	*Kill My Mother*: From Oedipal Trauma to Hollywood Simulacrum	13
2	*Cousin Joseph*: A Noir Take on the American Dream	65
3	*The Ghost Script*: Revenge, Repetition, and Reflexivity	123
	Conclusion: Homage, Experimentation, and Irony in the Trilogy	175
	Acknowledgments	181
	Notes	183
	References	197
	Index	207

Back to Black

Introduction

• • • • • • • • • • • • •

Back to Black

Jules Feiffer's *Kill My Mother* trilogy (2014–2018) undoubtedly constitutes a singular object within the author's illustrious body of work and the history of American graphic comic art. An unexpected initiative for an octogenarian author who had long remained in the periphery of the graphic novel genre, it can be considered the crowning achievement of his long and diverse career as a cartoonist, playwright, screenwriter, and children's book writer and illustrator. Through a series of close readings and thematic discussions, this monograph aims to identify and examine the remarkable visual and narrative constructs that contribute not only to the uniqueness of these works but also to their innovative "expansion of the range of possibilities" that graphic storytelling can offer (Groensteen 2017, 4).

 The title *Back to Black* alludes both to a return to Feiffer's origins as a cartoonist and to his trilogy's intermedial reproduction of a particular mode of representation: film noir. To the extent that they are somewhat contradictory, these two aspects warrant introductory remarks before delving further into their expression on the page. With *Kill My Mother* (2014), the first volume of what would become a set of three graphic narratives, Feiffer indeed decided

to come back to the foundational moment of his career, when he served in the mid-1940s first as an apprentice and gofer to Will Eisner, then as his ghost scriptwriter for the action series *The Spirit* (Feiffer 2010, 48–69). As he explained to Françoise Mouly and Mina Kaneko in an interview for *The New Yorker Magazine*,

> As I aged into my eighties, I found that my interests in the long form, which over the preceding forty years had been largely taken up with theatre and film, shifted back to what I loved most as a kid: the classic adventure strips exemplified by Will Eisner's *The Spirit* and Milton Caniff's *Terry and the Pirates*.... Working in the noir form for the first time, I began fooling with a story line, not really knowing where I was going, leaving behind the sketchy line drawings I had become known for and the satiric political and social ideas that made up my subject matter for over forty years. Instead, I began to experiment with the sort of work I loved and read as a teen-ager: not only Eisner and Caniff but the private-eye guys Hammett and Chandler, along with such noir movies as *The Maltese Falcon*, *The Big Sleep*, *Double Indemnity*, and *Mildred Pierce*. I tried to write and draw in celebration of the works that meant so much to me as a young man, areas that I had steadfastly avoided up till now because I didn't think I was the right artist to draw the story I wanted to tell. (Mouly and Kaneko 2014)

Although Feiffer stated that "going full circle in your dotage is nothing but fun" (Kellogg 2014), by his own admission, drawing in the noir style presented its own series of challenges, however nostalgic this renewed immersion into his earliest work may have seemed. The hyperdistinctive Feifferian line—a loose, flowing, elegant, and sketchy style—remained as ill adapted to the visual codes and expectations of graphic noir as it was at the time of his collaboration with Eisner in 1946. With his usual honesty and self-criticism, Feiffer expands on his early and lasting artistic limitations in *Backing into Forward*, his autobiography:

> At seventeen and eighteen, I could not draw a convincing chair or table or desk (it's still hard). I was hopeless at vehicles of any kind: cars, trucks, trains, planes. And don't talk to me about guns, the very staple of adventure comics, without which there are no heroes, no villains, no reasons to beat up bad guys. I drew guns as if they were made of melting butter. Mushiness would describe the pure essence of my style at this time. Adventure comic art was programmed to look hard-edged, tough, combative. The best of this art was displayed by Eisner, Caniff, Frank Robbins in his strip *Scorchy Smith*, Jack Cole in his *Plastic Man*

comic book, Joe Simon and Jack Kirby in *Captain America* and *Boy Commandos*, Irv Novick in *The Shield*. There were others whom I admired and planned to grow up to be. But as I discovered in my first weeks at Eisner's shop, I lacked every one of the basic skills to fulfill my ambitions. My line was soft when it should be hard, my figures amoebic when they should have been overpowering.... My style was self-effacing, a pretend style trying to look like the cartoonists I admired—this one, that one, the other—and monumentally failing to pull it off. (Feiffer 2010, 59–60)

He also considered himself "hopeless" at drawing backgrounds: "When I tried backgrounds—city street scenes, lampposts, waterfront docks with tugboats, suspension bridges, automobiles—my ineptitude was pathetic" (64).[1] By contrast to Feiffer's "soft" line, the noir genre demanded expressionistic visuals and photorealistic aesthetics, for which Eisner had developed a graphic template that still influences today's illustrators: "Eisner, like me, was from the Bronx and had brought the Bronx with him to *The Spirit*. His art crawled with Depression-era urban imagery, his drawings dark and clotted and often ungainly. Grotesque and bulky figures fighting it out in heavyweight balletic violence, the action lifelike, despite its distortions. One felt force behind the punches, the physical damage absorbed by combatants. Elevated subway tracks over slimy, puddled, scrap-strewn streets. Filth and decay and sound effects, in graphic detail. You could hear and smell the city" (49).

Noir and neo-noir comics continue to employ this formula in the twenty-first century. "Murderers lurking in back alleys, seductresses bathed in the light of cigarette smoke, detectives covered in the barred windows of Venetian blinds, crooked cops" (Biesen 2005, 2): the recurrent themes and distinctive visuals of the overall noir mediascape (spreading over literature, film, television, comics, animation, advertising, and video games) are immediately recognizable among consumers of popular culture. The longevity of their appeal is remarkable in itself; with roots in late 1920s and 1930s hardboiled fiction, they are now approaching the century mark. While the stylistic traits and social relevance of noir may now appear dated to a certain extent—as black-and-white aesthetics, references to prohibition, or predatory femmes fatales belong to another cultural age—they have been intently recycled, reworked, and hybridized in an array of contemporary productions that testify to their lasting allure. In the area of comics and graphic novels, the label "noir" has become associated with a particular subgenre of detective narratives (and, by extension, to other subgenres such as superhero, horror, or cyberpunk comics) employing aesthetic devices and

storytelling patterns reminiscent of noir fiction and film, but through the stylistic and semiotic capabilities that are particular to the medium. To distinguish this category of products, various publishers have created thematic labels or collections that signal the adherence of the product to its readership's expectations. As further evidence of this recognition as a separate style, tutorials on how to draw in the style of noir comics are now available for the budding cartoonist (Hart 2006; Martinbrough 2007).

It is also worth noting that, as a subgenre of graphic storytelling, noir works played an important role in the development of the long-form graphic novel (Kunka 2018). From the outset, detective comics appealed to adult readers, to the extent that they often employed realistic aesthetics (as opposed to a more cartoonish style), relied upon a complete storytelling arc with complex suspense devices (as opposed to single-page gags), and drew on an intermedial dialogue with other narrative art forms (film and prose fiction, but also theater, radio, and television). Detective comics were also part of an important debate about the visual nature of the medium itself, in relation to the depiction of violence. Although comics—and especially contemporary graphic novels—have the unique ability or propensity to indulge in the most explicit displays of brutality (which has motivated various forms of censorship and vilification over the years), they can also rely on far subtler forms of implicit, allusive, or suggestive representation (indirect framing, metonymic frame-to-frame transitions, iconic symbolism, lighting effects, etc.). What comics show and what they do not show but imply through lateral means remain central questions of the noir iconography, dating back to its origins in German expressionism. Feiffer was well aware of this iconographic legacy: "All noir demands street scenes, cars at night with headlights, pouring down rain.... I knew that I had to do that, I just didn't know how I was going to craft it, how I was going to make it look convincing. Learning how to do that, figuring it out, was both scary and very exciting" (Kellogg 2014).

Feiffer's trilogy emerged in the wake of the so-called neo-noir comics revival of the late 1980s and 1990s, which paralleled a return of the noir genre in film. Highly reflexive in nature—insofar as its citation-based aesthetics are deeply aware of film and comic art history—this noir resurgence is epitomized by Frank Miller's Batman opus *The Dark Knight Returns* (1986) and his *Sin City* series (1991–2000), as well as their film adaptations. Miller's stylized black-and-white drawings combined lighting and perspective effects with abstract geometric forms to create "a purer experience of noir, a *hyper-real* noir that makes the old look new" (Wandtke 2015, 86). Other comics illustrators like Sean Phillips, Brian Michael Bendis, Darwyn Cooke, or Eduardo Risso

applied their personal touches to the noir codes, which they revitalized for a twenty-first-century readership.[2] In this regard, the particularity of Feiffer's graphic novels lies in their deviation from the codes established by these previous noir and neo-noir works. They approach the genre with a unique graphic vocabulary that is highly personal and uncommon for the accepted iconographic standards, reminding the reader of the old OuLiPo[3] principle according to which constraints (and sometimes deficiencies) can paradoxically heighten creativity. The visual inventiveness of the trilogy owes much to the singular graphic solutions that Feiffer devised to replicate, *in his own way*, the look and tone of film noir. In this productive encounter between his deeply idiosyncratic style and this hypercoded genre lies these graphic novels' originality, which some reviewers—who expected formulaic repetition of or mimetic adherence to the established recipes of noir—failed to properly acknowledge. Bethany Latham, for instance, wrote:

> A graphic novel invites scrutiny for both its writing and illustrations; in this case, the latter are distracted, hasty-looking black/white/shades-of-grey constructions. The color palette (or lack thereof) is appropriate, but *the style seems wrong*—it gives a sense of frenzied energy and slapdash execution, rather than the polish of noir cinematography. Faces are so indistinct and similar, especially for females, that it can cause confusion as to which character is actually in frame. The prose is likewise unrefined. Unlike the sardonic wit and biting dialogue of a Chandler or Cain work (both of whom are mentioned in the dedication), this novel's prose has little to recommend it. (Latham 2014, my emphasis)

Needless to say, my analysis of the three works profoundly disagrees with this unflattering assessment on all counts: Feiffer's complex page layouts are neither distracted nor hasty; the kinetic energy with which he infuses his illustrations constitutes a central component of his cine-mimetic aesthetics; the resemblance among three female characters who switch identities and are revealed to be sisters is an intentional component of the plot; and the dialogues are masterfully orchestrated by an experienced playwright.

In his attempt at emulating authors like Eisner and Caniff, Feiffer was deeply aware of the inherent cinematic qualities of their illustrations, remarking notably that "Caniff was a master of complex light and dark shading contrast, of movie-angle shots alternating long shots, medium shots, and close-ups" (Feiffer 2010, 10–11). However, replicating the visual appearance of film noir in his own style presented yet another challenge. Like in other paracinematic "graphic projects that are, in one way or another, permeated,

possessed, or obsessed by cinema" or "genuinely haunted by cinema as a device and a mode of representation" (Belloï 2022, 11), film is indeed a central component of these three fictions, to the extent that they not only feature actors, agents, and film producers involved in tangled mysteries and conflicts but also reflexively interrogate the simulacrum of filmic images themselves, dissecting the illusion mechanisms of the Hollywood industry and probing the ideological role of cinema in the era of the Great Depression, World War II, and the "Red Scare." Furthermore, Feiffer's intermedial dialogue with film has a pronounced effect on his spatio-topical configurations. This book will therefore focus on the intricate page layouts and the innovative graphic devices that Feiffer employs to translate film aesthetics and syntax to the comics page at the formal level.

By experimenting with narrative and visual continuity without resorting to the standard comics grid or multiframe, Feiffer systematically plays with ingenious forms of "iconic solidarity," to reuse Thierry Groensteen's term (Groensteen 2007, 20), that blend the filmic language with the braiding possibilities inherent in graphic art (145–158): effects of framing and perspective, creative uses of objects and décors, encroachment and reiteration of visual motifs, rhythmic patterns, multidirectional gazes, and textual polyphony, among others. Such stratified layouts, which can accommodate sequential progression within a single image as a composite rendition of the fluidity of film, are employed throughout the novel to explore unusual expressions of speech, time, or space, as well as interweave several diegetic strands. In my analysis on these graphic configurations, I rely on Groensteen's explanatory model for comics semiosis, which I consider the most complete template to this day for the study of the internal mechanics of comic art (Groensteen 2007; Groensteen 2013). Drawing on formalist approaches to film, literature, and comics, I examine this intermedial exchange through individual case studies of compositional techniques that rely on the transference of genre-specific codes or devices (Lefèvre 2011; Baetens, Frey, and Leroy 2022). As noir comics have often been permeable to the multiple influences of other modes of representation, particularly cinematic techniques of cutting, framing, lighting, and voice-over narration, this examination will necessarily bring attention to the transmedial nature of noir itself—its ability to transcend and traverse the confines of film, literature, television, animation, digital art, and comics by transposing its aesthetics and storytelling patterns to other forms of visual narrative.

In addition to cinema, the trilogy makes multiple references to the medium of radio from the 1930s to the 1950s, which helped shape Feiffer's storytelling imagination: "I was addicted to radio drama, so much suggested so minimally,

sound effects mingling with terse dialogue, movielike musical scores that heightened suspense" (Feiffer 2010, 2–3). A child of the "golden age of radio," he cites detective radio programs such as *I Love a Mystery* (NBC, 1939–1944), *Suspense* (CBS, 1940–1962), and *The Adventures of Sam Spade* (ABC, CBS, and NBC, 1946–1951) as having influenced his approach to comics narration from an early age. He recalls lifting settings of mood and atmosphere from *Suspense* and transposing them into the first script he ever wrote for *The Spirit* (Feiffer 2010, 67). His three graphic novels also invoke the medium of song in recurrent allusions to radio tunes, film scores, folk repertoire, and cabaret singing, all containing thematically appropriate lyrics.

How Feiffer approaches the composition of page layouts is particularly interesting in the wider context of his long career. Such are the paradoxes and complexities of his personal and creative arc that most of his graphic output did not require elaborate visual or sequential arrangements until that point, with the notable exception of *The Spirit*, for which he handed Eisner crude layouts of a storyline broken down into panels and dialogue, leaving to the more accomplished artist the final say in editing the narrative (which often involved removing his apprentice's left-wing slant, in Feiffer's amused recollection) and providing the artwork (Feiffer 2010, 69). His earliest personal works (*Clifford*, 1947–1951; *Kermit*, 1950; *Dopple*, 1953) followed the standard comic strip formula by juxtaposing framed panels, either in regular grid format (as in *Clifford*, which often used a three-by-three multiframe) or in a single strip of four or five panels (as in *Kermit*). A "continuity strip," *Kermit* told a linear narrative (as opposed to single-page gags), which was also the case for Feiffer's groundbreaking *Munro* (written in 1951–1953), a fifty-page "cartoon narrative" often considered an early step in the prehistory of the American graphic novel (Leroy 2023, 50–52). Despite its complete storytelling arc, its provocative subject matter, and the emergence of Feiffer's recognizable style, *Munro* did not involve sophisticated page compositions either, as each page only displayed a small number of unframed images positioned below a hand-lettered narrative, akin to the format of illustrated stories. Similarly, the 183-page *Tantrum* (1979), labeled "a novel-in-cartoons" by its publisher, mostly comprised a single image per page, precluding any effects of "iconic solidarity" among multiple motifs disposed on the same paginal space. Such works present formal and thematic similarities with the children's stories that Feiffer published between the 1990s and the early 2010s, before he embarked on writing his noir trilogy, such as *The Man in the Ceiling* (1993), although their format is far more text-dominant, with only a few interspersed illustrations. As for the illustrious *Feiffer Strips* by which the author gained national visibility as a satirical newspaper cartoonist

and sociopolitical commentator on American life since the 1950s and throughout subsequent decades, their format remained far more situational, based on dialogue (or monologue) rather than narrative. They often relied on simple iconic reiteration, staging multiple images of the same character(s) as a mere source of enunciation. In this context, Feiffer's previous lack of engagement with intricate and interlaced page designs makes his graphic experimentation in the trilogy even more compelling.

A specific compositional aspect will draw my attention throughout my analysis of these three graphic novels: the depiction of movement. An essential feature of the comics language, movement is often understood as created and intimated through sequential effects: a string of consecutive signifiers each capturing a "frozen" instant in a continuous chain of motion (Eisner 2005, 105–107). Other approaches focus on the stylistics of movement: notably, how bodily postures can translate the impression of momentum through angles, curves, distortions, and other appended markers such as action lines (McCloud 1994, 107–117). While Feiffer uses both of these motion-implying devices, his style develops singular kinetic features that offer new graphic solutions and consequently deserve particular scrutiny. While these unique configurations may often be employed to replicate the fluidity of cinematic movement, they are nevertheless rooted in Feiffer's fascination for corporeal dynamics, for instance in his earlier drawings of tap dancers and boxers (Fay 2015, 242–248): "Whenever I get a chance to dance on paper, I adore it," he told a journalist at the time of the publication of *Kill My Mother* (Kellogg 2014).

Despite its overt novelty, this trio of late graphic novels does not come entirely ex nihilo. Although writing in the noir style and about noir subject matters represents a sharp and unexpected thematic shift for Feiffer, the *Kill My Mother* trilogy continues to explore motifs that have been recurrent throughout the author's artistic output, and to express the same overall worldview. The focus on children and the family structure is at the core of many of his previous works, from the early strips (*Clifford* and *Kermit*) featuring children struggling with parental authority and seeking to preserve their imaginative independence from the adult world, to longer graphic narratives such as *Munro* and *Tantrum* (one featuring a little boy mistakenly drafted by the U.S. Army and the other a grown-up man reverting to infancy), in which juvenile characters serve as revealing agents of social conformism and hypocrisy, and throughout his later children's books, which celebrate youthful imagination, such as *The Man on the Ceiling* (the story of a little boy who dreams of becoming a cartoonist) and *Meanwhile* (about another boy who projects himself into his favorite comics, using the magic word

"meanwhile" to change his adventure settings). In other words, Feiffer repeatedly delighted in using the comics medium, often considered as infantile itself (Groensteen 2017, 4), to portray children upending the adult world. Furthermore, in *Kill My Mother* particularly, Feiffer's fiction presumably draws a connection with his personal life by depicting children of the Great Depression whose nuclear families are impacted by financial difficulties and changing social and professional mores. Feiffer grew up in the 1930s as the son of Bronx-dwelling Jewish immigrants whose livelihood was compromised by the difficult economic circumstances of the era. In the absence of his father's income (perhaps due more to his poor business disposition than to the Depression itself), his mother Rhoda—a fashion designer who sold her sketches to dress manufacturers in the Garment District for three dollars apiece—became the main family breadwinner, while raising three children who resented her unavailability, and contended with guilt (Feiffer 2010, 1–4, 32, 56). *Kill My Mother* undeniably resonates with Feiffer's long-standing habit of channeling his family trauma into comics, beginning with his early satirical cartoons about Jewish mothers in the 1950s. The three stories abound in Oedipal configurations, intertwined in a complex narrative web of overlapping destinies.

Another recurring theme in Feiffer's work that reappears in the trilogy is his probing into American masculinity and gender roles. One striking aspect that made *The Feiffer Strips* a groundbreaking form of social commentary at its time lay in the cartoonist's unremitting exploration of seduction rituals and relationships in the age of the sexual revolution. His characters Bernard and Huey represented opposite poles of male behavior, each deeply flawed and comical—one too "nebbish" and the other too aggressive—much like the polar opposites of Sandy and Jonathan, portrayed respectively by Art Garfunkel and Jack Nicholson in his screenplay for Mike Nichols's *Carnal Knowledge* (1971). In his three graphic novels, Feiffer reexamines and deconstructs the two main gender archetypes of film noir, the private investigator and the femme fatale, both linked to the cultural and sociopolitical context of the Great Depression. Indeed, it has often been noted that, following the effects of the stock market crash of October 1929, "readers . . . wanted images of strong men taking control of their world" (Sabin 1996, 54). Forced to work to earn a living wage, often disillusioned, nihilistic, or simply down on his luck, the private eye is a figure of self-reliance and a model of masculinity that coincides with the ethos of an era filled with instability and ambiguity. This independence makes hardboiled fiction a perfect vehicle for social criticism: alone against the establishment, without any official mandate, the lone PI

often discovers that the city's plague emanates from its social and political elite (cops, politicians, corporate bosses, and other town notables) working in alliance against the common man. Conversely, many critics see the archetype and "misogynistic construct" of the femme fatale—"a transgressive object of desire who asserts her own subjectivity and predatory craving as a pursuer of men" (Diffrient 2018, 6)—as the embodiment of a "male crisis" brought on by changing social and professional roles during the Depression and after World War II. Returning to his deep antimilitaristic stance in *Munro*, Feiffer also interrogates the shallow images of masculinity produced by Hollywood's representations in war movies. By presenting the performative nature of gender—most notably through surprising reversals—he offers a progressive, contemporary perspective on the iconic figures of another era. The same reexamination of past representations applies to signifiers of race as well, which he similarly deconstructs and imbues with ironic devices, here also returning to his earlier preoccupation in the *Feiffer Strips* with civil rights, right-wing racism, and the hypocrisies of the left (Fay 2015, 114).

Of course, Feiffer would not be Feiffer without broaching political subject matters. From an early age, he showed an interest in liberalism and radicalism and developed an anti-authority stance rooted in rebellion against his parents' immigrant conformism and the repressive culture of the 1950s in general. The trilogy continues his preoccupation with the traumas of American history that have always captured his empathy and imagination since his teenage years: the first Red Scare, labor unionization, and McCarthyism. He cites some of his political heroes in the prefaces of the novels in the trilogy and alludes to them in the stories. They include the journalist and political commentator Murray Kempton (1917–1997), who contributed to the birth of "new journalism" through his storytelling approach to reporting; the civil liberties attorney and left-wing activist Leonard Boudin (1912–1989), who defended witnesses subpoenaed by the House Un-American Activities Committee (HUAC) in the 1950s and the draft dodgers during the Vietnam War; and the investigative journalist Isidor Feinstein Stone (1907–1989), who denounced the Stalinist regime, fought antisemitism in the U.S. Army and government, opposed the Korean and Vietnam Wars, and was himself blacklisted and wrongfully accused of espionage. One could be tempted to read these graphic novels as romans à clef whose characters, either individually or as composites, and either physically or behaviorally, allude to real individuals: Archie Goldman looks a little like the blacklisted actor J. Edward Bromberg, Billy Doyle like Jimmy Hoffa, "Beanie" like the actor Spencer Williams, to name a few examples. Intertextuality is also often at play in such characters,

which have in all likelihood been inspired by novels, films, radio shows, and comics. Similar inferences and connections could be made regarding historical events, locations, film titles, and other elements of the fictional universe. Although it pays homage to left-leaning luminaries, the trilogy also balances its political discourse by considering insincerity and betrayal on the left as well, most notably in the context of the blacklist and its unsavory denunciations (including episodes that Feiffer witnessed personally and that imprinted a permanent mark on his political sensibility). While some of the overtly political episodes of the trilogy—such as Billy Doyle and Cissy Goldman's strike against the Knoxworks cannery—remain independent diegetic strands of the larger fiction (to the extent that any subplot can be considered independent in this complex web of intersecting stories), many of them are expressed through symbolic conflicts that took place within Hollywood cinema among external right-wing propaganda forces, liberal screenwriters and directors, and political censors.

Furthermore, the trilogy reiterates classic Feifferian themes through reflexivity. This set of graphic novels often references Feiffer's own love affair with comics, which began at a very young age as a form of escapism from a stifling family life in a confining social environment. Feiffer came into the world at the same time as some of the most seminal American comics—he was born in January 1929, "the same month as *Tarzan of the Apes*, *Buck Rogers in the 25th Century*, and *Popeye the Sailor*" (Fay 2015, 17). In his autobiography, he comprehensively describes his childhood as a graphic apprenticeship, through sheer imitation of models he admired: adventure cartoonists such as Milton Caniff, Will Eisner, Alex Raymond, Hal Foster, and Burne Hogarth, as well as artists working in the humor vein, such as Roy Crane, E. C. Segar, Raeburn Van Buren, Al Capp, Frank King, George Herriman, Cliff Sterrett, Walt Kelly, and many others (Feiffer 2010, 3–12). Later, he discovered the more conceptual drawing styles of cartoonists for *The New Yorker*—Abner Dean, Saul Steinberg, William Steig, André François, Peter Arno, Chas Addams, Whitney Darrow, George Price, Helen Hokinson, Gluyas Williams, Alan Dunn, Sam Cobean, Frank Modell (162–165)—and equally absorbed some of their influence. With his encyclopedic knowledge of comics history, Feiffer was among the first American intellectuals not only to articulate a defense of the medium as art (Feiffer 1965) but also to draw a direct connection between comics and his own Jewishness, arguing for instance that Joe Shuster and Jerry Siegel's *Superman* represented the "ultimate assimilationist fantasy" (162–165), a perspective also expressed in Michael Chabon's *The Amazing Adventures of Kavalier & Clay* (2000). It is therefore compelling

to note that, as the trilogy performs a return to the origins of Feiffer's career in comics and his undying love for the same early works, for instance by referencing Caniff's character Normandie Drake, his stories reflect on Jewishness and antisemitism in the America of the 1930s and the 1950s through the character of Archie Goldman, depicted as a reader of Will Eisner's (and Feiffer's) *The Spirit*. Full circle.

Finally, to the extent that graphic novels employ novelistic narrative devices, the complex diegetic structure of the trilogy requires careful examination. Each volume slowly builds an intricate plot by alternating short chapters focusing on different narrative strands. The initial effect is one of narrative profusion and disorientation, until the braided threads gradually intersect in a cohesive fashion. In its early stages, this structure of alternation bears a resemblance to multithematic story forms, such as the "choir film," with its system of thematic parallels and echoes. Throughout the three novels, however, clear references to the narrative modes of film noir (the PI's voice-over monologue and the characters' vernacular dialogue) continue to invoke the storytelling template of the source material. Additionally, these stories achieve a unique combination of historical verisimilitude, the teleological format of detective stories, unpredictable twists, and whimsical, if not implausible coincidences straight out of the melodramatic imagination (Brooks 1995). Clearly, Feiffer had fun with his project, and the playfulness of an eighty-five-year-old cartooning legend is endearing, provided that one suspends disbelief to engage with his metanarrative sense of humor, which defies the stern conventions of noir. In a phone conversation with the author, I asked him how he came up with the ending of the last volume (which features, quite unexpectedly, a flying saucer). His answer was the same as his advice to the students he taught at Stony Brook Southampton: "Improvisation!"[4]

Summarizing Feiffer's numerous reinventions (from comics author to sociopolitical satirist to screenwriter to children's book author to graphic novelist), the arts writer Judith Goldman noted that "what's interesting is how, when he undertakes to do something for which he might not have talent, he goes into it very confidently" (Fay 2015, 146). As a contributor to the history and evolution of the American graphic novel, Jules Feiffer was both early and late: a pioneer of early graphic narratives for adults since the 1950s, a time when few such works existed, and, against all odds, a belated yet innovative contributor to the form in his ninth decade (Leroy 2023, 49–55). If the graphic novel is in a constant forward evolution, it is paradoxically by looking back that Feiffer challenged its possibilities and created a deeply original project.

1

Kill My Mother

● ● ● ● ● ● ● ● ● ● ● ● ●

From Oedipal Trauma to Hollywood Simulacrum

As the first installment of a trilogy of noir graphic novels that also included the subsequent volumes *Cousin Joseph* (2016) and *The Ghost Script* (2018), *Kill My Mother* (2014) represented a major thematic and stylistic departure for Jules Feiffer, who began this challenging series in his mid-eighties, after a long and celebrated career as a satirical cartoonist, playwright, screenwriter, novelist, and children's book author. In various interviews,[1] Feiffer has stated that life circumstances motivated his unanticipated foray into the noir territory. As Feiffer describes it, the project initially grew out of new constraints imposed by aging: when, as a lifelong New Yorker, the octogenarian decided to remove himself from an urban environment that his body could no longer handle, he also began to redefine his work and reflect on the cultural referents of his childhood.[2] Having grown tired of political satire[3] after five decades of providing weekly strips for *The Village Voice*, then for *The New York Times*, and moving away from playwriting as the result of diminished hearing and his retreat from New York City theaters, he began to revisit the

staples of American popular culture that marked his youth, from the Great Depression through World War II to the early postwar years: the adventure comics of Milton Caniff, gangster movies, film noir and hard-boiled pulp novels, boxing, the star culture manufactured by Hollywood studios, dance movies, radio comedy shows, jazz and blues, cabaret singers, patriotic films and "camp shows" designed to boost soldiers' morale during the war, among others. His fondness for the glamorous and escapist entertainment of the Depression and wartime eras rekindled his adolescent desire to be an adventure cartoonist, when, as a sixteen-year-old apprentice, he worked as Will Eisner's assistant, most notably on one of the first noir series, *The Spirit*.

Born in the Bronx in 1929, Feiffer could certainly bring a testimonial authenticity to the depiction of this era, yet, despite his firsthand familiarity with the subject matter and his impressive credentials[4] as a writer and illustrator, he felt aesthetically ill equipped to conform to its usual stylistic requirements to the extent that, by his own admission, his graphic style was antithetical to the expected photorealistic codes of noir-ness. His early work with Eisner had led him to the conclusion that he did not possess the technical ability to draw the standard signifiers of noir—consequently, his personal style, while extraordinarily proficient in its own right, had evolved in the opposite direction: that of a sketchy, flowing, gestural, cartoony minimalism, more appropriate for social and political satire (*The Feiffer Strips*) as well as children's stories,[5] such as his wonderful illustrations for Beth Kobliner Shaw and Jacob Shaw's *Jacob's Eye Patch*, published only a year before *Kill My Mother*. Although he initially projected to have *Kill My Mother* illustrated by another artist more in tune with the norms of the genre, he challenged himself to seek a new adequation between his style and the demands of his subject matter. From this confrontation between an artist and a style emerged one of the most idiosyncratic masterpieces of comic art in the twenty-first century.

The dust jacket of the graphic novel is insistent upon inscribing Feiffer's graphic work in a literary and filmic tradition, as well as in the filiation of comic art pioneers. The book is presented as "a noir graphic novel and loving homage to the pulp-inspired films and comic strips of his youth," a work "channeling Eisner's *The Spirit*, along with the likes of Hammett, Chandler, Cain, John Huston, and Billy Wilder," "a trip to Hammett-Chandler-Cain land: a noir graphic novel like the movies they don't make anymore." Such paratextual validation of the graphic novel, which is certainly warranted by the quality of Feiffer's contribution to the noir genre, as well as its intentional faithfulness to its most salient codes and overall spirit, relies on a triple assertion: it provides artistic legitimation by correlating comic art with

literary and cinematic references and with its own history; it highlights the author's personal connection with the era in regards to existential circumstances ("his youth") and artistic intent (a "loving homage"); and it underlines the intertextual and metatextual dimensions of the project, not only as a graphic novel informed by iconographic citation but also as a reflexive revisiting of the past, *a noir about noir*. However, by emphasizing fidelity to the classic noir corpus, this paratext also tends to underplay the profound originality of Feiffer's work, particularly in aesthetic terms. Although statements such as "a drawing style derived from *Steve Canyon* and *The Spirit*" point to a continuity between Feiffer and his models, they ultimately fail to capture the genuine singularity of his graphic style and compositional approach. The same can be said about Laura Lippman's otherwise praiseful review in *The New York Times* (August 14, 2014), which argues that "the plot [of *Kill My Mother*] doesn't break new ground in the genre, but that's almost impossible to do. The more central question is whether a noir graphic novel has something to offer that traditional novels and films do not," without truly answering the latter question.[6] In this chapter, I aim to identify the distinctive constructs—both visual and textual—that contribute to the author's innovative take on the noir genre.

A Double Oedipal Play

In the concluding chapter of his essay on *Le roman policier ou la modernité* (The detective novel and modernity), Jacques Dubois proposes that the Oedipus myth permeates detective fiction as its symbolic blueprint (205–218). Although Dubois reminds us that it would be anachronistic to view *Oedipus Rex* as a founding detective novel, he asserts that Sophocles's play has seminal correlations with the thematic and structural constituents of modern crime fiction. Indeed, in search of the truth, Oedipus engages in a "hermeneutic exercise" involving the establishment and corroboration of facts about Laius's murder. His inquiry, which puts traditional investigative methods into practice (examination of clues, verification of evidence, comparison of witness testimonies, logical deduction, etc.), provides both the dilatory structure of the play and its pathos—it postpones the tragic revelation of his true identity and the full cognitive grasp of his life's trajectory. If Oedipus is a "solver of enigmas" (including the Sphinx's riddle), the most striking characteristic of his investigation lies in its paradoxical and reflexive nature: Oedipus finds out that his double crime (parricide and incest) is the very antithesis

of his intent. It was precisely in order to avoid such transgressions that, following the oracle's predictions, he had left Corinth for Thebes, and he was wholly unaware of his own misdeeds. In search of a murderer, the investigator eventually discovers himself to be both culprit and victim in a logical loop that coalesces the three major roles of detective fiction upon a single individual.[7] Therefore, in the Oedipus myth as in detective fiction, which tends to reshuffle its major components,[8] identity is at the core of the mystery to be solved and is often the object of various dramatic reversals.

These three dimensions of the Oedipal narrative—family dysfunction,[9] self-denial, and identity reversal—clearly pervade the complex plot of *Kill My Mother*, which merges multiple storylines that display parallel themes, often through the use of sophisticated devices of graphic braiding and synthesis, which I will discuss later in this chapter. In essence, Feiffer's narrative intersects the stories of two families, each afflicted by parental absence, affective deficiency, and violence, set against the backdrop of the Great Depression and World War II. The novel's rapidly alternating chapters paint a fragmentary portrait of five women whose destinies become intertwined through various contact points. On one side, the Hannigan family suffers from the disappearance of Sam, Elsie's husband and Annie's father, a cop who was killed under murky circumstances that are kept outside of the novel's timeframe and scope, although a short segment alludes to the fact that Sam's demise was prompted by his naïveté and trust in the police hierarchy during corrupt times (the full story will be recounted in *Cousin Joseph*, the second volume of the trilogy and a prequel to *Kill My Mother*). To make ends meet after her husband's death, Elsie Hannigan must work as the assistant of the intolerable and often intoxicated Neil Hammond, a private investigator and her husband's best friend (44), who appears too inept to gauge her true value and intellect. Because of the tough economic conditions of the Great Depression, combined with the era's gender imbalance in the workplace, Hammond is at liberty to exert undue pressure on Elsie, whom he attempts to seduce and occasionally threatens with unemployment (22). Left alone during Elsie's long working hours, the spirited and irascible Annie translates the trauma of her father's death and her mother's forced absence into deep acrimony toward Elsie. In one of their numerous confrontations, Annie conveys her hatred quite explicitly to her mother: "Do you know how many times I've wished you dead? A hundred times a day? A thousand? Do you have any idea about how many fantasies I have had about killing you?" (103). As a child, Annie also enters into sexual competition with her mother and projects her Electra complex onto Hammond as a substitute figure for her father: "I'm too young for him now,

Neil Hammond—a fifteen year old without tits—if she gets him to marry her, my mother, all of us living under the same roof—Two, three years from now—the way I'll look—I will take Neil Hammond away from my mother. You know what that's gonna do to her? It will kill her. Hooray" (6).

Later, as a grown woman, Annie creates a second Oedipal conflict by neglecting her own son (little Sammy, named after Annie's father) and rejecting the boy's father, Artie, whom she belittles for his weakness and resents for having earned Elsie's affection. Deprived of his mother's presence, little Sammy Hannigan repeats the family pattern of temper tantrums and transgenerational hatred. At the conclusion of the story, it is only through the sacrificial catharsis of Artie's death, as well as Elsie's near death—both of which Annie partially caused—that she will come to the realization that her unwarranted hatred for her mother originated in traumatic complications within the Oedipal triangle:

> It took a walk in the jungle, and you getting shot—for me to figure this out . . . I felt left out. And you and pop were so close. I hated you. And I hated you more after Pop got shot, and you went to work for that stupid private eye. I was sure you were sleeping with him. What I needed was a mother I didn't hate. Who would protect me. From you. So I invented one. Tough, hard-boiled, mean enough to keep me from getting shot like Pop. I called her Chelsea—the opposite of Elsie. Chelsea gave me a thumbs-up on everything rotten I wanted to do. Lie, steal, manipulate, turn Artie into my slave—Browbeat and humiliate you. Turn you into a full-time babysitter because I couldn't stand my baby. Because Artie was his father. Every dirty trick I pulled, Chelsea said "Atta girl!" Then Artie got shot—and you got shot. And Chelsea whispered, "Better them than you." So I strangled her, right there in the jungle where you were lying there bleeding. I killed my fake mother to save my real mother. Only then did I learn how much I loved you. (142)

Only by identifying the source of Annie's delusive anger and by undoing the substitutive defense mechanism of an imaginary mother with opposite characteristics can the frayed mother-daughter relationship be repaired in the end.

In the other main strand of the narrative, the title *Kill My Mother* also applies to another family equally affected by a founding trauma of a maternal nature. The three Hughes sisters—twins Patty and Dorothea and their younger sibling Mae—grew up with an abusive mother suffering from mental illness. The twins raised and protected Mae from their mother's violent outbursts and recreated a symbolic motherly bond with her. Patty intervened when their

mother was beating young Mae with a baseball bat, then Mae killed her assailant by shooting her twice with her own gun (136). Unable to process this matricidal ordeal, Mae slipped into psychosis and reversed the terms of the narrative of her mother's passing: convinced that her mother protected her from her twin sisters' bullying, and that Patty was the actual murderer, she sets on a revenge course to kill her own sister. Dispersed by this original trauma, the three sisters are estranged and assume new identities in accordance with the Oedipal model: Mae becomes the wife and agent of a boxer and Hollywood actor, Eddie Longo, whose career she seeks to boost through unscrupulous tactics while attempting to track and murder Patty; Dorothea, equally disoriented, becomes a homeless woman with a self-imposed vow of silence, then reinvents herself as a mournful cabaret singer under the stage name of Lady Veil; and Patty, in order to hide from Mae, acquires a new gender identity as Hugh Patton, a Hollywood leading man. In this last case, as I will discuss below, the Oedipal archetype takes on a new meaning, to the extent that its presumed gendering mechanism deviates from its standard pattern in this singular family configuration. The resolution of this web of delusion and denial mirrors that of the Hannigan family and comes from the same circumstances—when Mae, still unaware that Hugh Patton is actually her sister, attempts to kill the actor so that his part in an upcoming movie be given to Eddie Longo instead, the violence is returned upon her, which creates the necessary catharsis that resets her psyche. As she is wounded and lying in a hospital bed, Hugh/Patty reveals his/her true identity to Mae and triggers a liberating recollection of the actual events of their mother's death (136–137).

Feiffer's fast-paced storytelling alternates between fragments of these two main narrative strands and creates a variety of contact points between the Hannigans and the Hugheses, all of which involve intrafamilial violence. Their independent dramas converge first when Mae hires Elsie's boss, the private detective Neil Hammond, to find Patty, who has become an actress. Hammond involves Elsie in setting up a fake casting call to entice Patty to come out of hiding, and in staking out Mae, whom he suspects of concealing her true motives in typical femme fatale fashion. When the PI eventually locates Patty, thanks to his casting stratagem, he attempts to seduce her, albeit quite unsuccessfully, as she is too strong and too independent to fall for his gruff machismo. Motivated by income, unhampered by morality, and eager to avenge his rejection, Hammond accepts Mae's payment to murder her sister, but is killed by his intended victim instead. Patty throws the murder weapon onto a deserted street, where, unbeknownst to her, it lands near a sleeping vagrant, her sister Dorothea.

Meanwhile, Annie meets the mute and homeless Dorothea (still nameless at that stage) when the latter comes to her rescue after a shoplifting incident (17–21). As a violent security guard prepares to beat Annie's boyfriend Artie and possibly rape Annie[10] in a dark alley, Dorothea emerges from the shapeless periphery of the page to hit the aggressor with a baseball bat. Annie repays her savior's favor by inviting her to her apartment for food and a bath, after which she loses contact with Dorothea, only to find her again later in the story as she performs under the identity of Lady Veil (86–87). The unlikely bond between Annie and Dorothea, two individuals with symmetrically opposed daughter complexes—one who delusively contemplates the demise of her mother and one who actually witnessed her mother's murder at the hands of a sibling—creates a symbolic and substitutive parentage between two victims of family trauma.

Finally, after Hammond's death, Elsie Hannigan relocates to Hollywood to work for a film studio. There, she falls in love with a leading actor named Hugh Patton, a tall, handsome man with a pencil mustache, the ultimate signifier of suave masculinity in 1930s and 1940s American cinema (as worn by William Powell in *The Thin Man*, Clark Gable in *Manhattan Melodrama*, Errol Flynn in *The Dawn Patrol*, etc.). Patty Hughes hides her identity under this male disguise, which calls upon notions of gender performance worth examining in their own right, and provides the ultimate identity reversal at the conclusion of the narrative, when she reveals her true self not only to her lover Elsie but also to her sister Mae, who had homicidal intentions against both Patty (for having killed their mother, in her deluded perception) and Hugh (for undermining the film career of her husband, Eddie Longo). Although Feiffer's plot, with its multiple reversals and fortuitous encounters, stretches all realistic plausibility, it ultimately conforms to the norms of detective fiction, whereby the realm of action is restricted to a finite cast of characters (Dubois 1992, 87–91), among whom all combinatorial configurations are possible as predestined overlaps or entanglements. In its Oedipal dimension, it owes more to the psychological focus of Ross Macdonald's Lew Archer novels[11] (such as *The Galton Case*, 1959) than to the sociological themes of Hammett and Chandler (Lehman 2001, 173–174; Porter 2003, 110; Van Dover 2022, 65–89).

Narrative Fragmentation and the Shadows of Noir

Divided into two long sections set a decade apart (part 1, "Bay City Blues 1933," containing twenty-four chapters, and part 2, "Hooray for Hollywood

1943," consisting of thirty chapters), *Kill My Mother* maintains a swift cadence typical of the fast storytelling pace of detective pulps and film noir. Often short in length, and as brief at times as a single page—with the significant exception of part 2's chapter 22, "The Jungle Follies," central to the convergence and resolution of multiple narrative strands, which swells to a full twenty-six-page arc—the respective foci of these chapters alternate among the numerous characters' substories. Weaving a complex tapestry of characters, motives, and situations, this systematic alternance not only constructs a system of parallels and echoes among the actants, such as their shared Oedipal predicaments, but also provides a hermeneutic fragmentation that maintains suspense and defers the readers' eventual grasp of the tortuous plot. Feiffer's narrative structure recalls the manner in which postmodern detective fiction—for instance in novels such as Jerome Charyn's *Blue Eyes* (1975)—builds a story from an aggregate of fragments, through successive waves of centrifugal dispersion and centripetal conjunction, which Charyn called "the wild masonry of laying detail on detail to make a structure" (Charyn 1975).

Such a compositional approach is reminiscent of film as well. As Raymond Bellour has shown, methodical crosscutting (which has become synonymous with cinematic narration) not only focuses the viewer's attention on the story, as a puzzle to be reconstructed, but also delays its climax (Bellour 2000, 262–278). In its kaleidoscopic nature and reliance on the alternation of diverse storylines, each periodically interrupted by one another yet forming a coherent thematic whole, Feiffer's narrative blends some of the structural features of "choral" film—a genre of filmic narration with antecedents in early films which became a trend[12] in the 1990s and 2000s—with the teleological cohesiveness of crime fiction. Like choral film, *Kill My Mother* presents "a mosaic of characters intertwined along the path of the narration" (Labrecque 2011, 32, my translation) and, at least partially, gives equal importance to a variety of individuals, thereby attenuating the importance of a central hero figure. Also like choral film, it stages individual storylines that are, at least until their eventual merging into a unified whole, fairly autonomous and unaware of each other, although their protagonists may intersect. Finally, like choral film, its juxtaposition of fragments calls upon the reader to draw thematic parallels between the respective sections (in Feiffer's case, much of the thematic inference centers not only on the characters' shared Oedipal dysfunction but also on a rewriting of the gender roles of noir, as I will discuss below). However, the novel's explosive plot transgresses the frequent banality or uneventfulness[13] of the choral genre, and its unifying arc, evolving from mystery to resolution, is

too prevalent and too well established in comparison with the more dispersed structure of choral narratives. This is indeed, despite its apparently scattered exposition, a carefully designed architecture in which the parts form a single story and find a single resolution. All individual protagonists, although separated at first, are eventually connected in the unfolding of a single drama.

While Feiffer's clever arrangement of narrative segments is remarkable in itself, it is at the visual level that he accomplishes his most inventive braiding, while retaining the overall stylish look of noir. On the back cover, in an endorsement blurb for Feiffer's book, Chris Ware, himself a master at intertwining and synthesizing narrative content through elaborate structures of semiosis, notes that "*Kill My Mother* stretches the long-form graphic novel into *formidable textures of compact expression*, daring to try things that film noir could only dream of" (my emphasis). This textural singularity relies on specific types of graphic configurations that I would like to explore below.

At its core, film noir is a shadow play on darkness and light. Similarly, throughout the album, Feiffer skillfully maintains a balance between clarity (for expository purposes) and opacity (to heighten mystery and surprise, as well as for aesthetic effects). In various segments, he uses the full resources of the comics medium to create the types of *hors-champ* (off-screen) and *contre-champ* (countershot) effects prevalent in film noir. An early example of the use of such visual devices in *Kill My Mother* is chapter 9 of part 1, a three-page segment entitled "Gotcha!" (19–21). After shoplifting a few items from a department store, Annie and Artie are caught by a menacing security guard in a deserted alley, following an arduous foot chase. A series of three vertical panels, drawn from a high-angle perspective and juxtaposed in a single row, alludes to ominous violence, as the threatening figure penetrates deeper into the alley and approaches the reader's point of view, while the elongated, rectangular shape of the panels conveys the cornered youngsters' entrapment (19). The enraged guard is already clutching the defenseless Artie under one arm, while Annie's escape seems blocked by the bottom limit of the panel. On the right side of the last two panels, against the fence, are indistinct shapes, blurred and obscured by a black ink wash; among these, the reader hardly notices a larger object apparently collapsed onto itself, although a retroactive reading may reveal hints of two feet and a hat barely emerging from this amorphous mass. Through its chain of signifiers, the following double-page unit (20–21) relies on a shift from concealment to exposure, and a calculated form of "optical progressivity" (Groensteen 2013, 146).

Indeed, page 20 is itself organized into two "blind" sections (figure 1.1). On the left side of the page, still screened from the reader's view under a black

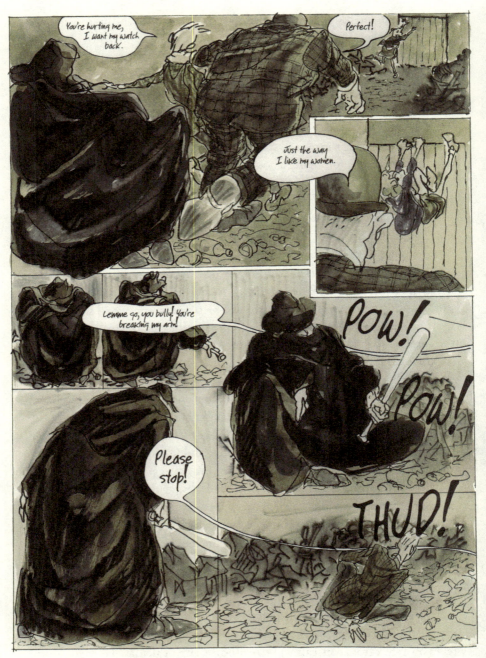

FIGURE 1.1 A mysterious figure comes to Annie and Artie's defense from the shadows. From *Kill My Mother: A Graphic Novel* by Jules Feiffer, p. 20. (Copyright © 2014 by B. Mergendeiler Corp. Used by permission of Liveright Publishing Corporation).

blanket and a hat, the same indeterminate figure gradually unfolds into a vaguely human shape over five consecutive panels displaying an increasing level of detail: a hand sticking out of the black garment and holding the handle of an object, then a full view of this object (a baseball bat) as well as bodily fragments (two hands and a small patch of face, still without any distinct feature). In the final panel of this series, the figure is shown from behind, erect and holding the bat, about to spring into action. This side of the page is characterized by a certain type of visual mediation akin to what narratology has labeled "external focalization"[14] (Genette 1988, 188–189, with various debates ensuing, including Bal 1997, 144): a form of visualization shown neither from the perceptual source of an omniscient narrator nor through the subjective access of a character's gaze but within a scopic restriction to the most outward features of the perceived object, which as a consequence is often shrouded in incompleteness and awaits further elucidation. Although the relevance of the concept of focalization may come into question in regard to the visual specificity of comic art, despite its acceptance by various theoreticians (Miller 2007, 110; Groensteen 2013, 84), it remains undeniable that the focal agency or "monstrating instance" in this segment of the graphic novel—"the instance responsible for the rendering into drawn form of the story" (Groensteen 2013, 86)—chooses to obscure the initial recognizability of the homeless woman with a baseball bat and to display her shape in a particular arrangement that shifts from illegibility to legibility.

The second "blind" device occupies the right side of the page. In panels 4 and 6, the two characters, both sitting on the ground, turn their gaze toward actions left unshown and implied as taking place outside of the right border of the frame, corresponding to the back of the alley. Speech balloons, whose tails emanate from this space cut off from the reader's view, allude to the violence taking place therein. Annie's cries of "Lemme go, you bully! You're breaking my arm!" and "Please stop!" as well as sound onomatopoeia implying brutality ("Pow! Pow!"), reach across the page and are juxtaposed with the figure of the homeless individual, who bears witness to the scene. The last panel, depicting Artie with his back turned away from the reader and toward the site of the assault, implies a more forceful blow through a sound effect ("Thud!"). This allusive depiction, which hints at violence instead of representing it more explicitly, translates in graphic terms another device of film noir, its pervasive use of "on-screen and off-screen dynamics" (Deyo 2020, 147)—not only the implied extension of space beyond the frame but also the indexical repercussions of out-of-frame actions inside the frame. Keeping violence out of view, which often conformed to

censorship constraints imposed by the Hays Code (1934–1968), contributed to an indirect system of representation, an aesthetic of paranoia by which the film spectator viewed the on-screen character as the observer of another spectacle whose effects were vicariously transferred back onto the film viewer, often amplified by the virtual menace of the unknown. In a recent essay, Eyal Peretz sees the "off" portion of any enframed image as a "haunting space," to the extent that "the dimension of the 'off' carries with it a disidentifying disturbance, for its decontextualizing power takes away any orientation and directionality, any meaning and identity that we might have" (Peretz 2017, 41–42). Although this reading may overstate the destabilizing and frightening power of the "off" in images that do not imply an enigmatic surrounding, it is certainly relevant to genres such as horror, the *fantastique*, or film noir, which rely on metonymic connections with a context that exceeds the periphery of the selective framing imposed by the monstrator. Of course, in the context of comics, as opposed to photography and film, what is outside the frame is actually inexistent; although the framed image may point toward a world beyond its limits, the prolongation of the image outside of its borders is pure mental extrapolation (Baetens and Lefèvre 1993; Groensteen 2020).

The second half of this two-page diptych (21) widens the reader's perspective, but only through a temporal ellipsis, following the visual ellipsis of the previous page (figure 1.2). It shows the aftermath of the unknown figure's intervention: the guard's body lying unconscious, with a bloody wound to the back of the head, situated between Annie and Artie still sitting on the ground and seen from a high-angle shot, looking up at the person holding the baseball bat, who occupies the forefront of the image and is shown only partially from behind, her face still hidden and facing the scene, not the reader. This tableau is structured along three parallel figures, set along the perspective axis of the reader, in increasing proportions relative to their proximity to this viewpoint: in the background, Annie, still lying on the ground, gazes at the horizontal body of her assailant, aligned with the angle of the baseball bat in the foreground. With its reciprocal system of gazes across the diagonal of the panel and its suspended motion, this symmetrical configuration conveys suspense and anticipation, to which the last three panels of the page only bring limited closure. In this instance again, Feiffer organizes a gradual chain of monstration: in the manner of a countershot, the first and largest of these panels provides a frontal view of the children's protector, revealed to be a very tall individual, yet devoid of any facial specificity in this image; the second panel closes in on the rescuer's head but still falls short of revealing any distinctive features emerging from the character's black

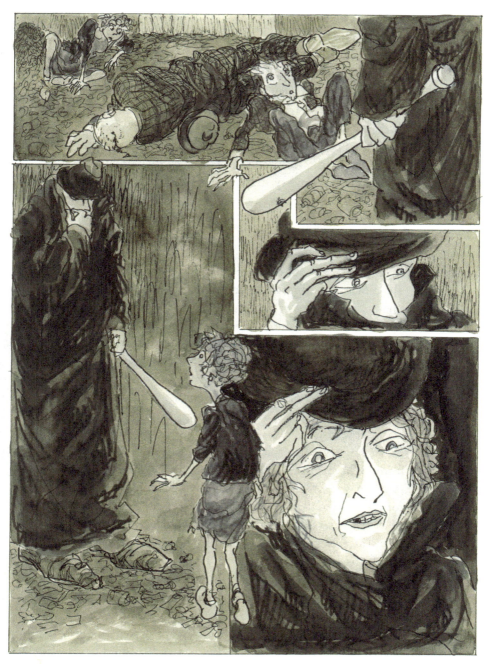

FIGURE 1.2 The aftermath of Dorothea's intervention. From *Kill My Mother: A Graphic Novel* by Jules Feiffer, p. 21. (Copyright © 2014 by B. Mergendeiler Corp. Used by permission of Liveright Publishing Corporation).

clothing; finally, the last panel offers a full view of a woman with a triangular face and blonde hair. While providing partial answers to its own set of enigmas, the end of this segment opens new questions for the reader, whose answers are delayed by the alternating focus of the following chapter, which is devoted to Hammond. The reader's conjecture is solicited in two directions: reexamining clues gathered from previous chapters, one can correlate the physique of the guardian angel with that of Neil Hammond's client, the "Big Blonde" (Mae Hughes) in search of her almost identical sister (Patty), as described in chapter 4 (7–10). Indeed, she is also tall, blonde, and strong, and has a similar facial geometry, despite obvious signs of having suffered a hard life on the streets. Projecting questions into the future, the reader may also anticipate potential plotlines connecting the two characters, but the opacity of the homeless guardian angel will continue to derail such predictive assumptions, to the extent that there are not two but three Hughes sisters. Despite the recurrence of the character at multiple junctions of the narrative, she remains an ultimate figure of mystery throughout the novel, devoid of a name, a backstory, or even the ability to speak. We remain a long way from learning that the woman, who later reappears as the singer Lady Veil, equally shrouded in secrecy, is Dorothea Hughes, and from finding out which traumatic events resulted in her becoming homeless and mute, as the pieces to Dorothea's puzzle are disseminated throughout the novel and interrupted by its constant change of focus, keeping her in a blind spot for most of the narrative.

In this regard, the physical resemblance of the three Hughes sisters—and the ensuing dynamic play between resemblance and dissemblance—functions as both a factor of hermeneutic confusion and a device of narrative linkage. The initial scene in which Mae hires Neil Hammond to find her missing sister, while conforming to a well-established trope of hard-boiled fiction and film noir, as well as to a standard actantial configuration, blurs and overlaps two traditionally distinct roles—that of the "sender" instigating the quest and that of the object of this quest (Greimas 1983, 211–213). By a strange, duplicative loop, it appears as if Mae, in the panel where she holds the picture of her sister near her face (8), is showing Hammond a picture of herself (figure 1.3). This image of a character holding her own effigy, which juxtaposes in close proximity two drawings of the same face yet of a different iconic status, insofar as one is presented as the story-world equivalent of an ontological being while the other is to be understood as a photographic replica, offers a reflexive depiction of the very principle of analogy at play in the novel. In this doppelgänger effect, Mae is indeed looking for herself when she sends Hammond on his

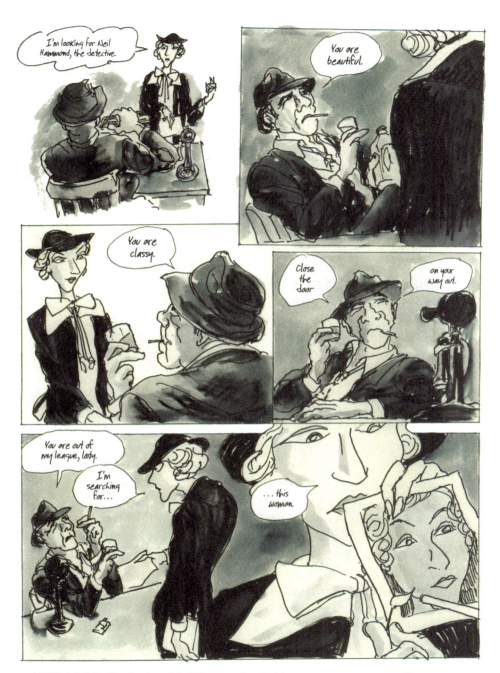

FIGURE 1.3 Mae Hughes hires Neil Hammond to find her missing sister. From *Kill My Mother: A Graphic Novel* by Jules Feiffer, p. 8. (Copyright © 2014 by B. Mergendeiler Corp. Used by permission of Liveright Publishing Corporation).

search, to the extent that finding Patty will liberate Mae from her own psychotic delusion. Conversely, in regard to graphic ambiguity, the final surprise of the novel (the revelation of Hugh Patton's true identity as Patricia Hughes) relies on maintaining the proper balance between similarity and difference: the reader must not suspect Patton's gender until the final revelation, which is accomplished by the temporal, geographical, and thematic disconnect between part 1 and part 2. Rereading the novel with the added knowledge of Patton's secret reactivates a trail of visual and verbal clues, as if Patton's disguise were simultaneously invisible and visible—often as thin as his pencil mustache yet convincingly opaque to the reader and to his own sister (although Mae surmises on multiple occasions that Patton reminds her of someone else).

Braiding and Thematic Echoes: The Art of Rhetorical Page Layouts

Feiffer's expository system builds on inventive layouts that often reconfigure the standard elements of the comics page in stunning displays of narrative efficiency and aesthetic synthesis. Although some pages of *Kill My Mother* at times employ what Thierry Groensteen has defined as the classic "spatio-topical" apparatus of comics—"multiframes[15] divided into strips and panels" (Groensteen 2013, 56)—the majority of its layouts falls under what Benoît Peeters (Peeters 2002, 62–67) and subsequently Groensteen have labeled a "rhetorical" approach to page composition, which "molds the shape or size of the panel to the action that it encloses" (Groensteen 2013, 46). Even when he uses a standard multiframe,[16] Feiffer never repeats a uniform or preset pattern from page to page, and tends to distort the geometrical regularity of the grid-like arrangement by varying his panel sizes and shapes, as well as the number of panels and strips per page, and by creating various encroachment, permeation, and layering effects between panels. Such pervasive stylistic variation results in a paradoxical reversal of the logic of *norm versus deviation*: as Groensteen pertinently noted, while a fixed and repetitive format tends to highlight any divergence from the recurring structure, what stands out when inconsistency and variability become the norm are "localized incidences of regularity" (Groensteen 2013, 148).

Let us consider Feiffer's rhetorical panel structure in one specific double-page unit, in order to examine the types of effects that it allows. In pages 24 and 25 (part 1, chapter 11), he stages a bar altercation between Hammond and

a much larger man who asked him to speak less loudly. Hammond proceeds to confront the man, offers him his gun, then pistol-whips his unsuspecting opponent. While this sequence is important, at the thematic level, to set up the PI's lack of hesitation for violence, his pragmatic ethos, and his quick sense of repartee, it carries its message across with a series of "rhetorical" devices. Although each page contains elements of traditional panels, framed as rectangles or squares by straight lines and separated by white gutters, their partition is attenuated by various forms of interpenetration. For instance, on the first page of this sequence, the speech balloon emanating from Hammond, as he tries to provoke his antagonist by speaking even louder, exceeds the limits of its panel and encroaches into the first panel of the page, containing the disputant's original complaint. By transgressing the panel separation, Hammond's reply gains in visibility (it is visibly "louder," matching its sound level through a figuration of excess) and in irreverence (it crosses the bounds of the frame as an expression of social disorder). On the next page, parts of the characters' bodies—such as Hammond's arm, as he holds a gun, and his challenger's foot, as he stands up from his barstool in defiance—trespass on adjoining frames, suggesting the imminence of violence. Both pages feature unusual panel shapes that create a diagonal axis in the center of the multiframe. On page 24, the second panel takes on a reverse L pattern, as if resulting from the collapse and synthesis of two panels forming a right angle. The rhetorical impetus of this configuration molds the panel around the ninety-degree angle of a bar counter and creates an intriguing depiction of perspective and temporality. Indeed, the two parts of the angled panel represent the same characters, seen from different viewpoints: the top right section shows them from a distance in three-quarter profile, while the bottom left area shows them from the opposite angle in closer view. The increased size of the figures in the second iteration indicates an escalation of the conflict. However, the juxtaposition of two successive snapshots in the same panel creates a minor cognitive dissonance for the reader as to the temporal delineation of the two scenes described therein. This obstacle to a progressive reading is further complicated by the presence of another panel below the opening frame and on the left of the L-shaped one, yet smaller in size and barely separated from the latter by a thin black line and with no gutter. This lateral image—showing Hammond retorting the man's complaint—poses its own set of problems, as its placement against the larger panel to its right juxtaposes two almost identical depictions of Hammond, while the bar counter prolongs its shape between the two images, creating the impression that the two Hammonds are sitting next to one another. This image forces

the reader to break the L-shaped panel in two and return to a more traditional reading progression, starting with the opening panel, the top part of the L pattern, the small panel of Hammond, and, finally, the bottom half of panel two. In negotiating such an interpretive path, the reader must also accept a new contractual agreement by which spatial arrangements are not entirely literal and can accommodate some symbolic play. A similar disruption cuts across the layout of page 25, this time in the shape of a zigzag. Panels 1 and 2 are disproportionately sized, and their respective bottom edges are consequently staggered. This allows Feiffer to insert a third panel below panel one, which increases this asymmetry and creates a bottom panel with a jagged top. While all panels infringe to some extent upon one another—notably when the characters' body parts protrude into adjacent frames—the most striking bleed-through effect in this singular layout is the open border between panels 2 and 3, which creates a zigzag pattern and a "door" in the center of the page, through which the pivotal object of this scene (Hammond's gun) can be passed from one character to another. In this double-page segment, quite rhetorical in nature, "the size (and sometimes the shape) of each frame is adapted to the content, the subject matter of the panel" (Groensteen 2013, 148). Indeed, such a configuration confers an energetic quality to the passage, where characters "zig and zag" in both speech and movement, while the page espouses the contours of their bodies and of the bar décor, infusing the graphic representation, necessarily static, with a certain dynamism akin to film.

Such a rhetorical approach also pervades full-page effects that remove or reconfigure the multiframe or the hyperframe.[17] In this regard, Feiffer can certainly be considered among the graphic artists who employ what Groensteen called a "neo-baroque"[18] conception of the page, meaning one that "exacerbates the rhetorical intention" by more or less abandoning or dismantling the canonical comics grid in favor of freer (and often more ornamental) compositions (Groensteen 2013, 47). As we have seen in the previous example of the bar fight, the manner in which Feiffer, as an established playwright, uses rhetorical layouts to set up dialogue is particularly salient. For instance, chapter 17 of part 2 (97–99) consists of three full-page units with no panel separation. Its overhanging perspective shows three black cars traveling on the same road, with speech balloons emanating from the vehicles. This extradiegetic layout allows the reader to have more information than each of the characters, to the extent that, in contrast with standard dialogue, the enunciators are isolated in their respective automobiles and cannot hear each other's speech, while the reader sees their combined

enunciation for a more complete grasp of the drama. This type of polyphonic simultaneity would be difficult to accomplish in other dialogue-based genres such as theater and film, as it would require characters to speak at the same time and not in direct response to each other (unless this concurrence is intended as a metaphor on incommunicability, as in Samuel Beckett's *Play*). In such instances, the narrative principle of this page is not sequential, as in most panel-based transitions, but concurrent. This type of braiding effects separation, but also convergence, as three distinct narrative lines intercross in this passage, which achieves the confluence of characters about to travel to the same destination. Annie and her publicist must travel to Tarawa, in the South Pacific, to settle a lawsuit with Artie (an officer in the U.S. Army who felt defamed by Annie's radio show), while her mother Elsie accompanies her lover Hugh Patton to a USO show for the troops, and Mae escorts her husband Eddie Longo to the same performance. The three sets of characters only have partial awareness of each other: Elsie and her daughter Annie do not know that they are about to travel together, while Hugh is unaware of Eddie's jealousy and the Longos' machinations to steal his role in an upcoming war movie by injuring him during the USO show. Feiffer's parallel display conveys a clear contrast between the two couples in individual sets of disconnected dialogue overlapping on central themes—the goodhearted Pat feels like a "phony" for receiving a red-carpet welcome from legitimate war heroes, while the envious Eddie bemoans the size of his vehicle as an insult to his status, in comparison with Pat's larger limousine. Similarly, the alongside configuration exhibits the different dynamics of each couple, as the benevolent Elsie offers reassurance to Pat's insecurity, while the scheming Mae assists Eddie by drawing nefarious plans. This passage also evokes two of the graphic novel's main thematic axes that I will examine below: the notions of simulacrum and gender, which are pervasive throughout the story. Pat remarks that his on-screen persona as an action hero is a pure construct unworthy of the "real" heroism of soldiers ("Real life . . . Contact with the real world . . . Kids who fight and die"). His ambiguous statement—"if they only knew the truth about this movie star"—can be understood as the expression of a lack of courage, but also hints at his hidden sexual identity. His conflicted views on stardom contrast with Eddie's drive to be successful at all costs. Meanwhile, Mae must reassure her unconfident husband about his physical size and masculinity by comparing him favorably with other Hollywood actors of equally diminutive stature who look "queer" (98) (figure 1.4). The third and final page of this chapter (99) employs the same device of concurring yet independent dialogue, but adds a visual element that Feiffer

FIGURE 1.4 Parallel conversations in cars. From *Kill My Mother: A Graphic Novel* by Jules Feiffer, p. 98. (Copyright © 2014 by B. Mergendeiler Corp. Used by permission of Liveright Publishing Corporation).

frequently adopts in structuring his full-page layouts: the use of the physical features of an object to create different zones on the page akin to a panel architecture. In this particular instance, the three cars, previously shown as following the linear path of the road, are separated by the wing and propeller of an airplane seen from above, as well as the black geometric lines of a road leading to the runway. The angle formed by the shapes of the propeller and the top side of the wing form a triangular panel of sorts around Annie's car, while the bottom side of the wing and the fuselage delineate another space for the other two vehicles, partially separated by the darker outline of the asphalt road.

Such iconic and narrative plays on fusing the multiframe with spatial features of the scenery abound in the novel and are not restricted to effects of polyphony or structures of parallel monstration. For instance, page 60 makes a creative use of the grid formed by the pavement lines under Elsie's feet as she hurries across a bad neighborhood at night to bring Hammond a bottle of bourbon. The page displays eleven images of Elsie, without panels or gutters, and stacked in four rows of increasing scale, as if the character were coming toward the reader's point of perception. The network of lines under Elsie reminds the reader of the "waffle-iron" pattern of comics and provides a structural symmetry to this juxtaposition—a general sense of the geometric organization of individual images on the comics page—yet without any specific dividing function. The principle of focal expansion that governs the positioning of the images itself is sufficient to carry their sequential momentum. The gradual enlargement of the images and their diminishing number in each row (four, three, two, and two, ending on a close-up of Elsie's face) form a trapezoidal shape on the page. Although the horizontal juxtaposition of different iterations of a forward-facing character is an unusual way of representing a walking motion (in contrast, for instance, with the more traditional display of successive panels showing the individual in profile view facing the right side of the page, in the direction of reading), the page constructs an effective, autonomous unit, with its own narrative arc shaped by Elsie's thought process, which recapitulates the events of the night as well as her predicament as a widow and the mother of an unloving child, while coming to the realization of her own strength and independence.

Feiffer frequently uses such forms of segmentation in hybrid layouts that blend a single, expansive image with a more traditional panel structure embedded therein or juxtaposed thereto and following the contours of a larger object. In such rhetorical devices, the panel's architecture conforms its shapes to a pattern determined by the mimetic form of a material or environmental design, as opposed to the abstract multiframe.[19] By inscribing panels

within a broader image, or in the spaces adjacent to it, these layouts break the rhythmic progression of the usual grid and may create unusual effects of optical, temporal, and sequential ambivalence. This is the case, for instance, on page 30, which shows two characters (Elsie and Hammond) waiting in line to enter a boxing arena (figure 1.5). The page is organized diagonally, along a left-to-right axis formed by the angle of the marquee[20] sign above the street, shown from up close in a high-angle perspective and dividing the page into two triangular sections. On the left of the large marquee sign, a series of six panels shows Hammond and Elsie standing in the rain under umbrellas and waiting to enter the venue. Feiffer uses the triangular shape of the panel structure to create a succession of frames of increasing size—following the expanding width of the triangle and gradually revealing a wider context around the characters—that can be read sequentially, from top to bottom, in the usual reading direction of comics. However, the very sequentiality of this series of panels is mitigated and brought into question by various countereffects or irregularities. First, the third panel, presenting Elsie and Hammond's interlocutor (the menacing bodyguard Gaffney), interrupts the series in two significant ways: not only is it detached from the other panels by a white gutter, as opposed to the thin black lines separating the other frames of this cluster, but it also reverses their perspective, offering, in the manner of an inset countershot, a frontal view of the character instead of the lateral view used in the other panels. This infringement on the pattern makes the intimidating Gaffney stand out and anticipates his rather violent involvement in later segments of the narrative, as a killer for hire. Second, the lines separating the last two panels from the rest of the page do not reach all the way across the triangular subsection, leaving areas where the two images merge and communicate with each other. This open configuration creates the impression that the three individuals occupy multiple positions in the same line of people waiting to step inside the boxing venue, as if they were progressing toward the entrance. It fuses two temporal occurrences and two spatial positions within the same image instead of isolating them in their own self-contained spaces. Likewise, it deviates from the practice of repeating the same background in two or more successive panels and offers instead a single contextual backdrop for successive moments or actions. Third and finally, this particular arrangement of panels requires some amount of optical negotiation from the reader, as it can be read in two directions. Although the standard cognitive path of Western comics—from top to bottom and from left to right—clearly applies here, notably in the textual unfolding of the dialogue, the proportions of the depicted objects also draw the reader's attention in the reverse trajectory.

FIGURE 1.5 Hammond, Elsie, and Gaffney stand by the entrance to the boxing venue. From *Kill My Mother: A Graphic Novel* by Jules Feiffer, p. 30. (Copyright © 2014 by B. Mergendeiler Corp. Used by permission of Liveright Publishing Corporation).

Because the most striking object on the page is the marquee sign, which minimizes the opposite half of the page and pushes the reader's gaze downward toward the larger frames of the left section, which are depicted from a closer perceptual viewpoint, and because those larger panels at the bottom are somewhat easier to read than the smaller ones at the top, there is a tendency to apprehend the page from another starting point. The effect is similar to a two-directional trolley shot in film: the same objects are either brought closer to the reader's eye (in the standard reading path, from top to bottom) or recede from his or her position (from bottom to top).

Such stratified layouts are employed throughout the novel to explore unusual renditions of speech, time, or space. They are particularly prevalent in full-page compositions featuring cars, a ubiquitous motif of film noir. As Andrew Dickos notes in his history of this cinematic genre, cars are a recurring theme connected to dangerous attraction (the unsettling power of seduction or eroticization), the enthrallment of freedom and escape (the "getaway" vehicle allowing the characters to leave the scene of the crime or the constraints of a dull life), and the assault on social order (often present in scenes of car theft or bank heists using cars). As a "symbol of the modern urban landscape," the car has a central place in the "texture and mood" of noir iconography (Dickos 2002, 174–176). Here again, Feiffer borrows a cinematic trope in homage to the genre but translates it into aesthetic and narrative compositions that capitalize on the medium-specific possibilities of comics. By stacking multiple images of the same vehicle in different layouts, he often creates a visual configuration similar to what Groensteen calls a "stanza" effect, "a group made up of several panels that stand out in relation to the page, the sequence, or the book as being particularly salient, because the panels in question produce a seriality effect through the repetition or alternation of content or formal features" (Groensteen 2013, 146). Such is the case for page 27, in which Feiffer creates a hybrid between a standard panel layout and a full-page tableau. The page features four images of the same car, which are placed on top of each other to form a vertical line on the page and are separated by black horizontal lines. Consecution is implied by a continuous dialogue unfolding from panel to panel, and by the figuration of movement, suggested by the increasing size of the vehicle as it approaches the reader's field of vision. However, in the visual economy of the page, various elements hint at a single composition and provide an underlying unity to the stanza display. The vertical pattern of the cars, which forms the straight line of a single road, and the continuity of the décor around it, whose abstract shapes transcend the panel separation, contribute to unifying the tableau as a single unit. The

patterns made by diluted ink wash, white watercolor, hatching, and rough-shading not only create an impressionistic rendition of the rainy weather (another atmospheric trope of noir) but intimate that, beyond the graphic facsimile of a filmstrip composed of successive photograms, this is also a cohesive paginal space. In this complex dynamic between the parts and the whole, the page can be read both as homogeneous and heterogeneous at the same time. In this interplay, the dividing function of the lines separating the cars is attenuated and constitutes a locus of ambivalence. Because of their very thinness, their lack of contrast with the overall darkness of the drawings, and their relative incompleteness (as they do not fully reach across the page and leave a liminal space on the side of the road), they appear less categorical in their compartmentalizing power than a full gutter with a blank void.

A few pages later, Feiffer reuses the same car in two stanza layouts (on pages 39 and 47) that echo the structure of page 27 and offer variations on its design. On page 39, he apparently removes the multiframe and offers five images of the same car stacked upon one another, all located in the same position in the center of the page and drawn with the same orientation, inclination, and proportions (figure 1.6). In contrast with the previous display of cars, this arrangement of images is intended to express immobility rather than motion; the fixed position of the vehicle on the page and the absence of kinetic lines, perspectival enlargement of the object, and panel-to-panel modulation of actions all suggest that the car does not "travel" in relation to its surroundings. To this extent, the rhythm conveyed by this grid-less depiction is as static as the parked vehicle. Here again, Feiffer plays with the multiframe in an inventive and rhetorical fashion motivated by the shape of his drawings. Although the panels are not preset as a grid, nor separated by gutters, the artist uses a physical feature of the décor to produce a framing effect: the repeated pattern of the edge of the sidewalk striates the page diagonally to form the equivalent of parallelogram-shaped panels, although their dividing function is more aesthetic than functional, as each iteration of the car straddles these makeshift boundaries. These lines do not partition the page as multiple spaces, since they repeat the same object in the same location, but they accentuate the demarcation of time; Feiffer uses the immobility of the vehicle to visualize a microsequence of actions, as small variations stand out from the repeated pattern. The first three depictions of the car are identical, but the fourth one introduces a slight alteration in the chain of drawings that makes up the stanza. The interior of the car lights up in the darkness and creates a small and brief spot of luminance on the page, which rather poetically highlights Elsie's body as she exits the car, before the

FIGURE 1.6 A stanza effect of stacked car images. From *Kill My Mother: A Graphic Novel* by Jules Feiffer, p. 39. (Copyright © 2014 by B. Mergendeiler Corp. Used by permission of Liveright Publishing Corporation).

final representation of the car returns to its original darkness—a minute event set up against the monotony of repetition. Elsie's gesture is not meaningless, however. It is the starting point of a lateral section of the narrative that demonstrates her strength, wit, and independence as she enters a bad neighborhood at night to procure alcohol for the hapless and manipulative Hammond, who stays in the car. From her tiny silhouette in the glow of the car's opened door, Elsie will reach heroic proportions in the ensuing episode, in which she single-handedly defeats a gang of young street delinquents (40–43).

Page 47 returns to the car motif in another graphic stanza configuration that also happens to evoke a literary one. This is another full page devoid of any panels, showing a street with six vertical rows of cars traveling in two sets of three lanes in each direction. The north-to-south axis corresponds both to the top-to-bottom reading path of the viewers and to their perceptual point, although there are in this instance no apparent effects of perspective through proportional enlargement of the vehicles as they approach the viewer's point of observation. The particularity of this design is that it accommodates sequential progression within a single image as a composite rendition of the fluidity of film. What appears at first glance to be an array of different vehicles on a busy road contains in fact multiple occurrences of the same vehicle, shown four times with accompanying speech balloons. While the norm of comics narration is that each framed image contains only a singular iteration of a given character or object, this particular image synthesizes multiple occurrences as one panoramic tableau without internal partitions, subsumed as a single unit within the borders of the hyperframe. In this instance, the textual inserts provide the stanza mechanics that are necessary to understand that the seriality effect actually involves consecutive moments in time, to the extent that each speech balloon carries on the discourse contained in the previous one, in a syntagmatic chain that implies continuity. Because the discursive content of these balloons forms a literal and highly recognizable stanza grafted on a visual one—which only confirms Groensteen's judicious choice of term—the reader can determine that the enunciation emanates from the same individual inside the same car. In this passage, Hammond attempts to recite Henry Wadsworth Longfellow's poem, "There Was a Little Girl," or one of its nursery rhyme versions, such as Mother Goose's:

There was a little girl
Who had a little curl
Right in the middle of her forehead.

> When she was good,
> She was very good indeed.
> But when she was bad she was horrid.

Increasingly inebriated by his continuous consumption of bourbon, Hammond's mind and speech become disconnected from the purpose of the car chase. In his intoxicated state, his delivery is hampered by slurring and confusion, and transforms the original text into a ramble—quite poetic in its own right—of garbled words, colloquialisms, and non sequiturs:

> There washa lil girl—
> hadda lil curl—
> right inna mil of her forehead—
> An' when she wash good—
> You made me f'get!
> Washa lil girl—hadda lil curl—
> In the mil of her forehead—
> primeval. An' when she was good—
> No, I dropped a line. Drop me a line
> shometime. Come and shee
> me shometime.
> Shtay in touch.
> An' when she wash good—
> She was—What? What wash she?
> You never, never help!
> Yer ushelesh!

In spite of its apparent pointlessness, the drunken detective's incoherent monologue is carefully woven into the narrative fabric of the novel and echoes its various themes in reflexive fashion. The nursery rhyme story of the little girl, with its reference to Victorian repression of "bad" girl behavior, brings to mind Annie Hannigan and her incessant tantrums, while its interrupted recitation mirrors the unfinished tale of Annie's story at this point of the narrative. The "middle of her forehead" reference also applies to Hammond's own demise, as he later projects to execute Patty but is gunned down by her instead in two parallel chapters entitled, quite pertinently, "Right in the Middle of Her Forehead" (57) and "Right in the Middle of His Forehead" (60), whereby Feiffer arranges an internal rhyme structure that ties together multiple threads of Hammond's life path, all associated with his ineptitude

and mistreatment of women. In this regard, Hammond's death at the hands of the woman he intended to kill performs a reversal of his abusive and misogynistic behavior in the nursery rhyme scene, where he calls Elsie useless and intersperses his own monologue with random womanizing rants ("Drop me a line shometime").

Motion Pictures

As Scott McCloud aptly points out, "From its earliest days, the modern comic has grappled with the problem of showing motion in a static medium. How do you show this aspect of time in an art where time stands still?" (McCloud 1994, 110). Theoretical discussions of motion in comics generally take into account two complementary approaches. On the one hand, borrowing from the principles of photochemical arts (namely photography and film, as well as other late nineteenth-century optical devices such as Etienne-Jules Marey's chronophotography), scholars consider movement in relation to ontological time, and tend to view the panel as a "frozen" capture of a longer and continuous action, "a single instant in time" (McCloud 1994, 96). Eisner calls this isolated instant a "posture": "a movement selected out of a sequence of related movements in a single action" by the cartoonist for a given narrative intent and stylistic expressiveness and "frozen into the panel in a block of time" (Eisner 2005, 105). On rare occasions, an individual panel itself may contain a chain of actions instead of a single "frozen" snapshot, such as in the "Marey effect," which decomposes the multiple phases of a movement in a series of juxtaposed or partially overlapping drawings, mimicking the results of Marey's chronophotography (Mikkonen 2017, 156–157), or offering the comics equivalent of Marcel Duchamp's famous painting *Nude Descending a Staircase, No. 2* (Potsch and Williams 2012, 20). On the other hand, other comics theoreticians (including Eisner himself, who blends both series of principles) tend to view the expression of motion in comics as a pure pictorial construct. Indeed, the conceptual analogy between the comics panel and the filmic photogram requires further nuance, to the extent that each motion panel is not excerpted from an actual series or continuum of frames capturing an ontological referent itself in motion and passing through time but only implies such a series virtually. The conceptual imprecision of McCloud's categories of "moment-to-moment" versus "action-to-action" transitions (McCloud 1994, 74–78) points to the difficulty of applying the principles of the photogrammatic or chronophotographic sequence to comics. The art

of the cartoonist is allusive in nature: it merely suggests that the still image has a before and an after. The very sequencing of drawn panels can of course reinforce the notion that the action contained in a single panel is inscribed within a process or a set of actions (each selected by the artist with equal discrimination), but the panel itself can contain various expressions of dynamism by resorting to "specific conventions in action comics for visually representing motion and force events: ribbon paths, motion lines, and impact flashes" (Potsch and Williams 2012, 19). To this extent, a comics panel does not *capture* movement but resorts to kinetic effects of a stylistic nature, which Eisner, asserting that "the human form and the language of its bodily movements [are] one of the essential ingredients of comic strip art," calls "a non-verbal vocabulary of gestures" (Eisner 2005, 100): "In the print medium, unlike film or theater, the practitioner has to distill a hundred intermediate movements of which the gesture is comprised into one posture. This selected posture must convey nuances, support the dialogue, carry the thrust of the story and deliver the message" (Eisner 2005, 103). As comics historians remind us, such semiotic efficiency is already at play in the earliest days of comic art, for instance in William Hogarth and Rodolphe Töpffer (Smolderen 2009; Groensteen 2014), who sought to bestow semantic legibility to physiognomies, bodily postures, facial expressions, and, particularly in Töpffer's case, movement. In addition to their focus on gesturality and "hyperbolic theatricality" (Groensteen 2014, 126, 149), Töpffer's stories developed a new kinetic vocabulary—comical falls and somersaults, absurd chains of accidents, frantic chases—that would become a dominant characteristic of the medium throughout its history.[21] For a large percentage of comics readers, action comics continue to represent one of the most defining expressions of graphic storytelling, only rivaled in preeminence by the humoristic tradition. In this regard, the emergence in the latter part of the twentieth century of non-action-centric comics, often autobiographical and privileging uneventful aspects of daily life, portrayed with "graphic immobility" (Schneider 2017, 22), constituted an important shift by which alternative productions could offer an innovative take on the medium (Hatfield 2005, 30–31).

If, according to Eisner's assertions, "the skill with which [the language of bodily movements is] employed is . . . a measure of the author's ability to convey his idea" (Eisner 2005, 100), then Feiffer can certainly be counted among comic art's most gifted creators, and his predilection for depicting dynamic scenes is evident throughout his graphic novel. Let us consider, as an initial example of Feiffer's kinetic style, the opening chapter of *Kill My Mother* (1–3). Two panels depicting a Philco "cathedral-style" radio from the early 1930s

playing the Ginger Rogers song "The Gold Diggers' Song (We're in the Money)" (from the film *Gold Diggers of 1933*) anchor the scene in the context of the Great Depression, both technologically (the "gothic" radio serving as a clear marker of an era) and thematically, as the song itself refers to the economic difficulties of the period.[22] However, while the song expresses enthusiasm in the waning of the Depression ("We're in the money! / The skies are sunny! / Ol' Man Depression, you are through, you done us wrong!"), Feiffer cleverly replaces the original lyrics with a more realistic statement about the perdurance of bad times: "We're out of money, No money honey, Grin at the bad news, Just laugh it away!" Below the two panels figuring the radio, Feiffer shows two teenagers, Annie and Artie, swing dancing to Rogers's song. In fluid, flowing, arcing lines, he translates the kinetic energy and elasticity of the dancers' jitterbug moves in a manner that contrasts with the realistic depiction of the radio and the verisimilitude of the Rogers reference. While the scene preserves some amount of mimetic and historical accuracy regarding the dance fads of the 1930s, it employs a far more expressionistic style.[23] The shapes of the dancers' bodies are elongated as if stretched outward by the centrifugal pull of their joined movement, translating its speed and energy, while their contorted bodies—with arms and legs swinging in various directions—create a series of parallel lines and geometric patterns that inject liveliness in this choreography. Interestingly, Feiffer renders motion purely through the plasticity of anatomy, without any of the standard accentuating markers of comics, such as action lines or blurring effects. He continues this scene in the following two pages, which display ten images of the dancing couple, whose bodies create symmetrical or discordant configurations, often encroaching into adjacent panels. His graphic ingenuity in the passage lies in his use of dance as a conversational and expository device. Not only does the reader learn about Annie's predicament (her hostility toward her mother, the violent death of her father, her mother's career as the assistant to a private detective) and psychology (her headstrong personality, her desire to compete with her mother, her bullying of Artie) in a far less static way than in a standard conversation, but the jitterbug choreography—with its alternance of to-and-fro and side-to-side movements, pushing bodies apart then pulling them together—offers the perfect visual match to their verbal exchange. The dynamic of Annie and Artie's relationship, summarized in the recurring lines of "Shut up, Artie!" and "But, Annie," is conveyed by the very momentum of the dance, in which of course Annie leads her partner in domineering fashion.

The same two characters are involved in another kinetic scene a few pages later (chapter 8, "On the Run," 17–18) when they are chased by a department

store's security guard after having shoplifted a few items at Annie's instigation. Here, Feiffer relies on perspective effects to intimate the imminence of the teenagers' capture, yet once again refrains from underlying the simple eloquence of the characters' anatomy and posture with unnecessary momentum or trajectory lines. The alternance of perspective creates visual empathy in that it invites the reader to experience the looming danger of the guard's pursuit. On page 17, the cartoonist presents two large parallel panels stacked vertically, depicting Annie and Artie running toward the viewer with their pursuer in tow. This perspective angle compresses the distance between the fugitives and their assailant and draws the reader into the scene, to the extent that the menacing figure is shown approaching the viewer across the diagonal of the page. The bodies of the runners are bent forward, with arms and legs outstretched as an expression of momentum. In the second image of this series, the angle of the character's path turns more sharply toward the reader, further reducing the gap between them. Annie's head exits the frame, which places Artie in the center of the panel and in harm's way. Between these horizontal panels, on the left side of the page, the author inserts a vertical series of two smaller inset panels showing the two protagonists in frontal view, directly advancing toward the reader's viewpoint. The top panel of the following page reverses the perspective angle and displays the foot chase from behind, with the pursuer in the forefront of the image as a large and threatening figure, whose right hand appears inches away from Artie. A middle row of two smaller panels returns to the same angle as the previous page; the second panel of this series contains two sequential drawings of the guard gaining ground on Artie, whose limbs are increasingly flailing as a sign of fatigue and fear. The absence of separation between these consecutive images further accentuates the imminence of Artie's arrest. Finally, the bottom panel of this page uses yet another perspective angle—a side-to-side view of the characters that allows us to gauge the diminishing distance between them as well as the contrast in size between the brutish guard and the frailer Artie, while the background of the panel is striated with black horizontal streaks that resemble the dramatic use of backdrops made entirely of motion lines in manga. Here again, a contrapuntal dialogue between Annie and Artie continues to unfold throughout the scene, which grafts character development onto an action sequence in the same manner as in the opening dance scene. Annie, who is responsible for placing her friend in this dangerous predicament, continues to dominate him by proffering advice on how to distract their pursuer, while Artie's candor adds levity to this grim chase.

Among the action scenes in which the depiction of motion constitutes a central component, the boxing match depicted in part 1, chapter 13, entitled "The Dancing Master" (30–35), offers one of the most interesting visual sequences of this graphic novel. Let us note that, in evoking the world of boxing, Feiffer revisits another recurring theme of noir. The subgenre of "boxing Noir"[24] (Spicer 2010, 24–26) includes classics such as Raoul Walsh's *Gentleman Jim* (1942), Robert Rossen's *Body and Soul* (1947), Robert Wise's *The Set-Up* (1948) and *Somebody Up There Likes Me* (1956), Stanley Kubrick's *Killer's Kiss* (1955), Mark Robson's *The Harder They Fall* (Bogart's last film, 1956), as well as later films such as John Huston's *Fat City* (1972). The drawn fight unfolds over three pages that, for the most part, feature images of the boxers without panel separations, which accentuates the fluidity of their undulating bodies. The sequence begins with the last panel of page 32, showing three iterations of the two fighters juxtaposed within the same frame, with their sinuous shapes bending in unison with choreographic grace. Tailless balloons inscribe the voice of the boxing commentator between the images and offer a reflexive description of the contestants' moves, which underlines Eddie Longo's uncanny agility, as he playfully floats and dances around his opponent, "like a matador with a bull" (33). Page 33 displays eight illustrations of the boxers' intertwined bodies without any multiframe or hyperframe, with the announcer's commentary wrapping itself around the images, untethered by balloons. The sheer flow and accumulation of postures and Longo's swirling ubiquity communicate his rhythmic mobility and allow the reader to experience the frustration of Elmo Stavisky, his overwhelmed opponent. While Feiffer's depiction of boxing as a dance sings an ode to the artful side of the sport, the conclusion of this narrative segment returns to its most brutish reality, as Longo, showboating in front of his wife at ringside, becomes a victim of his own playfulness and gets punched out by Stavisky (34) (figure 1.7). This conclusion is given preeminence on the page as the only drawing that is partially framed, although here, again, Feiffer uses an element of the physical décor to segment the page, with the rope of the ring forming the top line of the panel. Therefore, this sequence, which at first seemed disconnected from the narrative as it unfolded thus far, is not a gratuitous exercise in choreographics but implies its own moral significance. It suggests that for Eddie Longo, the allure of spectacle trumps the pragmatic necessities of reality—a recurrent theme in the graphic novel's exploration of simulacrum in times of great social upheaval. The boxing scene indeed echoes subsequent passages where Eddie Longo performs his dance for the movie camera (75) or onstage (120–121).

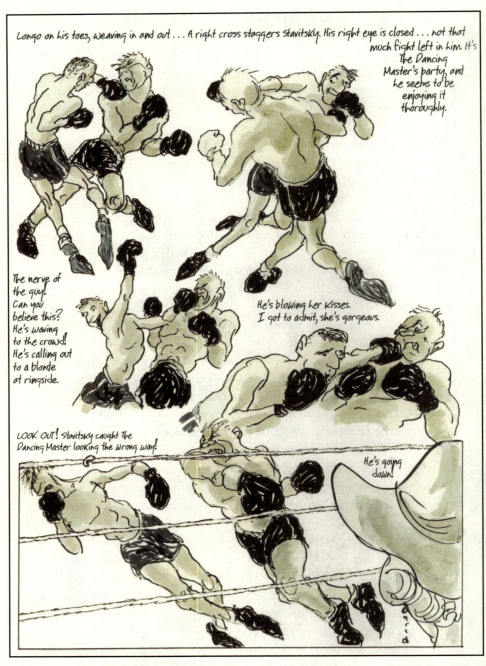

FIGURE 1.7 Eddie Longo as the Dancing Master. From *Kill My Mother: A Graphic Novel* by Jules Feiffer, p. 34. (Copyright © 2014 by B. Mergendeiler Corp. Used by permission of Liveright Publishing Corporation).

A Crisis of Masculinity

Kill My Mother, in its unflattering depiction of Neil Hammond, revisits the figure of the private investigator with critical distance and irony. In metatextual fashion, in the early sections of the novel, both Annie and Elsie project the fantasy inherent to this literary and filmic trope onto Hammond, imbued with the mythical aura of this era-defining hero. "I love it when you sound like a detective out of the pulps," utters Elsie (5), while, on the following page, her daughter equally professes her enthrallment for the detective's true-to-type masculinity, assertive and cynical: "Neil Hammond! You could eat him for breakfast, he's so sexy. His eyes don't blink. The way he smokes. The wisecracks. The way he drinks.... I have a crush on Neil Hammond" (6). Annie's monologue, while listing the appealing characteristics of the PI, sets up an immediate contrast with her timid boyfriend Artie, whom she bullies and browbeats throughout the novel. It is not without significance that she is shown enumerating Hammond's supposedly "virile" qualities while painting flowers on Artie's back, which highlights his meekness and docility as a passive canvas for Annie's headstrong disposition. The scene also implies to some extent, in reference to the cultural codes of the era, a symbolic feminization of Artie's body, which will play a part in the character's subsequent gender overcompensation, as I will discuss later. Despite their initial idolatry of the PI type, either programmed by literary models or societal norms, the reality of Hammond's systematic incompetence will soon shatter this image of confident machismo and reveal the gender insecurity that resides at its core.

In chapter 4 of part 1 (7–10), Feiffer reenacts the standard contractual interaction between the PI and a seductive female client who bears all the defining traits of another trope, that of the archetypal femme fatale. This episode indeed recalls the four main components of the interplay between those two heavily gendered figures of hard-boiled fiction, as they are displayed in the opening scene of *The Maltese Falcon*, for instance: seduction, deception, transaction, and distrust. The scene is imbued with sexual attraction, as Hammond immediately remarks that the tall lady is "out of [his] league" and proffers various innuendos ("I bet you are used to men indulging you"), while she engages in return in flirtatious gestures, such as letting him light her cigarette. The interaction also implies hidden motives and a false narrative: the client seeks the detective's assistance under misleading premises, attempting to use him in the pursuit of a crime (in this instance, Mae's lie about trying to find her sister is similar to Ruth Wonderly's deceit of Sam Spade in *The Maltese Falcon*). The contractual arrangement between the PI

and his client hinges on class difference, to the extent that the client has financial means while the detective does not have the security of a stable income and must rely on the odd case to make ends meet, particularly in the dire economic conditions of the Great Depression. This transaction is not only entrepreneurial in nature but also psychological—beyond its monetary and sexual dimensions, the game of repartees hinges on evasive dialogue, where each party keeps its motives secret and does not trust the other's façade ("I don't believe your story," bluntly declares Hammond to the "Big Blonde" seeking his assistance).

Such models of masculinity and femininity are of course constructs of a particular era. Contrasting with the earlier British model of detection novels, which often portrayed genteel dilettantes and dandies as investigators, the tough private eye character correlates with the context of the Great Depression, in which the individual must become self-reliant and remains distrustful of institutions in the face of job instability, social inequity, and widespread corruption. Preoccupied by the necessity of making a living as a free agent at the margins of society, between crooked policemen, upper-class profiteers, organized crime, and those wrecked by the system (prostitutes, gamblers, drug addicts, etc.), the PI occupies a morally gray zone where self-determination separates the winners from the losers (Évrard 1996, 53; Porter 2003, 106). In this dog-eat-dog world, "[the] new detective created by Hammett and Chandler, rather than seeking some collaborative social order in a chaotic world, became a law unto himself and administered his own brand of justice as he saw fit" (Baker and Nietzel 1985, 20). As Hammond puts it in the novel, in his inebriated speech, "mansh gotta do his job" (60).

Conversely, the figure of the femme fatale corresponds to male anxiety and bitterness in the wake of several social changes such as the establishment of women's suffrage in the United States (1920) and the aftermath of World War II, where "many of the men returning home from the war were faced with the new social and professional roles taken by women in their absence" (Diffrient 2018, 6). Feiffer recalls the pervasive male resentment of women's right to vote that still lingered in the mid-1930s in an episode where Patty orders a drink at a hotel bar, only to hear the bartender launch into a sarcastic and reactionary tirade: "We don't get many unescorted single gals. A few years ago I wouldn't be serving a single gal unescorted, but now—since they up and gave you gals the vote, anything goes. You're so big, maybe they gave you two, three votes. No stoppin' you gals these days, am I right?" (58). In this regard, the compensatory trope of the predatory femme fatale[25] and the depiction of "strong, manipulative, sexually assertive women" have often been seen as

"a reassertion of masculinity in the sphere of cultural production" (Diffrient 2018, 6).

While the initial meeting between Hammond and Mae Hughes evokes multiple film noir scenes of the same type, they also bring up references to comics of the same era. In the conclusion of this passage, Mae tells Hammond that her name is "Normandie Drake," to which he cynically replies: "Doozy of a name. I sure hope it's yours." "One can only hope," she retorts (10). By referring explicitly to Normandie Drake, a character from Milton Caniff's *Terry and the Pirates*, which he has credited with introducing sexuality in the American newspaper strip of the 1930s,[26] Feiffer also borrows from the series' gender and class dynamics. As one of the love interests of the adventurer Pat Ryan (among other highly sexualized figures[27] such as the sensual singer Burma and the Dragon Lady, the ultimate cunning femme fatale), Normandie Drake embodies various attributes of the 1940s masculinity-femininity struggle as it was depicted in American popular culture of the 1930s and 1940s. A "spoiled and headstrong" heiress (Harvey 2007, 220), rather aloof and conniving at first, she falls in love with the heroic and hypermasculine Ryan in melodramatic fashion, only to be rejected by the roaming hero, whose lifestyle is incompatible with conventional married life. The impossible love affair between Normandie and Pat evokes class difference—and, ultimately, the renunciation of class envy—but also notions of male pride. Assertive and independent, Normandie initially dismisses Pat and his friends as lower-class specimens. Impressed by his heroic demeanor (he saves her life when they are threatened by dangerous men on a desert island), she falls in love with him and finds a pretext to meet him again by having him wrongly arrested for check forgery, deeply insulting his ego. By referring to Normandie Drake, Feiffer suggests that the conflicted interaction between Hammond and Mae equally reflects the class- and gender-based tension between a working man and a wealthy and attractive female patron.

Feiffer's portrayal of Hammond reconsiders and reshapes the PI trope by amplifying its most problematic characteristics and showcasing the dysfunctional nature of his professional competence, his ethics, and his gender demeanor. Such a denouncement of the detective's questionable heroism implies a retrospective reassessment of the social and cultural codes of a bygone era but was already encoded in the moral ambivalence of noir itself, to a large extent. On the professional level, Hammond clearly appears inefficient, as Annie remarks: "The whole year my mother's worked for him, I don't think he solved a single case" (6). His alcoholism hampers his work; as Elsie notes: "If Neil's not drunk, he's on his way to getting drunk. Half his

clients have left him" (44). His clouded judgment interferes with the most basic requirements of his work: he does not remember his own cases (4), repeatedly falls asleep at critical junctures of his investigations (45, 48, 53, 59), and allows his libido to betray his own stratagems, for instance when he poses as a film producer to coax Patty out of hiding, only to forget his own plan by offering her a secretary job (55).

In this last instance, the attempt to control women through subservient roles echoes the workplace politics of the era, which are particularly visible in Hammond's continual abuse of Elsie, who is far more competent than her boss yet always criticized by him and subjected to his sexual advances. Forced to compensate for her boss's ineptitude, Elsie makes sense of his cases, refocuses his attention when he becomes distracted, and even puts her own life at risk to assist him, often left alone to confront violent men, against their gender expectations of her. In a stakeout episode (38–44), Elsie must protect herself from three threatening "goons" who taunt her with sexual innuendos ("We got something t'show ya!") and follow her as she walks through the city at night to supply Hammond with more alcohol. Undaunted, she grabs and uses the liquor store owner's revolver to scare off her aggressors, who are surprised by the fortitude of the "little lady." Later, yet again left to her own devices by a passed-out Hammond, she is punched unconscious by Eddie Longo's brutal bodyguard, Gaffney (50). Against the backdrop of the Great Depression, to which Feiffer alludes in numerous panels,[28] Elsie strikes a figure of determination and self-reliance far more compelling than the private eye.[29] As a widow and a single mother, she is even more vulnerable to economic pressure, and Hammond never hesitates to threaten her with unemployment to coerce her into working long hours and neglecting her daughter: "Kiddo, only broads who don't work for me turn down my invites" (22).

Similarly, Hammond's ethics are typical of the PI's pragmatism. Flexible and opportunistic in his outlook, he abides by a moral code of his own, neither predetermined by laws nor anchored in essential values. Sometimes chivalrous, sometimes ruthless, he applies his own judgment on a case-by-case basis, always weighing his own interests against the attainment of a greater good. Such ethical pliability usually confers to the PI figure the autonomy necessary to survive in the gray areas of society and in the margins of institutions. In chapter 11, "The Risk Factor," the cynical[30] Hammond contrasts his ethics with that of Sam Hannigan, redefining the concept of honesty as a relative term: "For a cop, there are two kinds of honest: smart-honest and idiot-honest. Putting your nose where you shouldn't and telling your superiors about it, that's idiot-honest.... Me, I'm smart-honest. I navigate around the

risk factors. But not your Sam. Which is why I drink this bourbon with you and he don't" (23). As shown in the bar fight scene described above, he is also prone to gratuitous violence. However, when Hammond accepts Mae's offer to kill her sister Patty for a fee of $3,000, stating that he has "no moral objection" to committing a murder for hire (57), Feiffer takes the detective's moral adaptability to a new extreme and departs from Raymond Chandler's principle, according to which the PI must remain a "man of honor" who rights wrongs while abiding by "a secular humanistic ethic . . . that embodies an idea of duty and of a professional code of conduct" (Porter 2003, 97). The singular nature of this ethical transgression is that it stems from the very gender insecurity that is implicit to the private eye figure.

Indeed, it is the social and sexual unattainability of Patty that drives Hammond's desire for revenge. Having located the missing woman thanks to a fake casting call, he feels immediately threatened by her good looks and superior height, shown in a vertical panel where Patty's imposing physical stature dominates her interlocutor (54). Although she is actually six feet, two inches, she is accustomed to understating her size in order to protect men's egos: "Men aren't comfortable with women over six feet. I'm five-ten" (a reflexive statement that calls into question men's power to define women's bodies by presenting it as a conscious concession from women themselves, which is a clever way to regain power while expressing deference). Still hung over from the previous day's excesses, Hammond forgets his scheme of posing as a film producer and reverts to his default strategy for putting women back in their proverbial places: he offers to hire her as his secretary and invites her to have drinks with him. She refuses and walks away in frustration. This blunder leads her to realize that Hammond is a private eye who was hired by Mae to find her (55). In the aftermath of this rejection, Hammond is left to brood over his failure to seduce Patty in a long internal monologue laying bare his resentment and insecurity. This reflective pause in the action is rendered by a single drawing of the moping detective, occupying the space of the entire page[31] (56) and devoid of the standard elements of the comics layout: no multiframe segmenting the page in successive panels, no hyperframe demarcating the image, and no speech balloons. In lieu of such expected devices, Feiffer communicates his character's state of mind through his own aesthetic means, notably his skillful depiction of the human body. In this image, Hammond—sketchily drafted, with the cartoonist's distinctive use of loose, flowing, expressive lines in faded gray tones, with a pale green wash providing a slight relief effect—appears dejected, slumping on a chair with a cigarette in his mouth and a glass of alcohol in his hand. His

monologue, written in the cartoonist's own stylized script, is not separated from the character's body but overlaps with it, in two long columns of text placed on each side of the character but encroaching upon it.[32] The monologue therefore appears introspective on visual terms as well: it permeates the corporeal space of the figure as if emanating from its core, efficiently conveying mood and mimicking the enunciative device of the detective's internal monologue prevalent in hard-boiled literature and the voice-over narration in film noir.

Offering unique access to the PI's psychology, this soliloquy captures the multiple stages of Hammond's thought process, in contrast with the stillness of the image. It begins with delusive attempts at self-reassurance of his virility: "Something was goin' on between us. I felt it. On the surface, you could miss it . . . that she sees I'm not like the others. I'm different, dangerous. She makes fools of the others. But not me. She's big, but I'm plenty enough man for her" (56). It progresses into self-righteousness and pronouncements of indignation over Patty's transgression of gender expectations: "Looking down on me. Who does she think she is? Where does she get the nerve? I come up with a decent offer, cards on the table. And what's the first thing she says? 'I can't type.' Who can't type these days? Every broad, she wants a job, types. Trust me, she types. Mocking me that way. She was mocking me. When I'm trying to give her a break" (56).

At this point, Hammond's resentment morphs into fantasies of reversing his deficit of power through professional and familial subjugation: "I start her out typing—The time come, I promote her—To my assistant. After that, what's to stop her? Nothing! We get married! A kid or two. My mother had five of us. What's the matter with five? Five kids, that should cut her down to size." Finally, he devises a passive-aggressive plan for symbolic revenge, before realizing its futility and reaching a stage of pure hostility: "Looking down her nose at me that way. She thinks she can play me? No broad plays me! Here's how it goes down, OK? I don't show up for that drink at the Flora. That'll put a crimp in her style! Who'm I kidding? She won't show either. She won't show. She was never gonna show. Whore!" (56).

This rare insight into Hammond's psychology deconstructs the heroic attributes of the supposedly "tough" PI figure and uncovers the multiple layers of rationalization by which he ultimately accepts to kill the woman who offended his manhood: "I'm a P.I. I never pulled a finale before. Huh! But wouldn't that get her attention! She thought she had me all figured out" (57). Revisiting the cultural and psychological underpinnings of the trope, Feiffer transforms the typical PI monologue (with its cynical, detached, blasé tone)

into an expression of powerlessness, misogyny, fragility, and, ultimately, gender violence.

The reversal reaches its climax in a surprising and humorous conclusion to the conflict between the PI and the femme fatale. As Hammond breaks into Patty's hotel room and awaits her return, gun in hand, he is once again victim of his ineptitude and alcoholism. By the time she returns to her room, he is lying asleep on her bed, wearing her panties over his trousers, to her complete stupefaction: "You come here to kill me... but first you try on my panties?!" (59). The detective's autogynephilia suggest that behind his conflicted attraction to women and simultaneous rejection of the feminine, under the façade of his rugged masculinity, lies a desire to be feminine himself. To protect herself against further homicidal attempts from her sister, Patty drives the inebriated investigator into the woods and guns him down, thus becoming a literal femme "fatale" (60).

Feiffer's showcasing of the crisis of masculinity and the "gender distress" (Biesen 2005, 3) at play in 1930s and 1940s American culture is pervasive throughout the graphic novel. It takes on a particular form and significance in his commentary on the entertainment industry of that era, as I will discuss below, but ultimately affects most male protagonists, down to somewhat minor figures such as Gaffney and Artie, the colossal bodyguard and the meek boy turned tough soldier. A former bootlegger now providing private security services, "Tiny Tim" Gaffney strikes a figure quite similar to Hammond's—that of an opportunistic man prone to violence and with a conscience for hire. In his first appearance (30), he boasts to Elsie about the size of his penis ("I'm the opposite of tiny in every way. Get my drift?"), then punches her unconscious later that night (50) without hesitation or remorse ("I know I'm gonna hate myself in the morning. But I'll get over it," he says ironically). His capacity for violence toward women mirrors a filmic trope of gangster movies, from precode productions—for instance when James Cagney smashes half a grapefruit in Mae Clarke's face in *The Public Enemy* or slaps Evalyn Knapp in *Smart Money* (both movies from 1931)—to late films noirs such as Fritz Lang's *The Big Heat* (1953), in which a sadistic Lee Marvin throws boiling coffee in Gloria Grahame's face (Belloï 2022, 33–34). Gaffney's enormous body exceeds the proportions of the hyperframe on page 91, where he is shown coming out of Mae Longo's pool, naked and menacing, exposing his frontal nudity to her gaze. A professional hitman, he agrees to disable or kill Hugh Patton so that Eddie Longo can be cast in his place in a war movie. However, when Gaffney finally holds Patton at gunpoint at the denouement of the story, which takes place in the

aftermath of the battle of Tarawa in the South Pacific, he is utterly confused by his victim's double reversal, first as Patton chivalrously saves him from the attack of a Japanese soldier, then as he discloses his true gender identity as Patty Hughes. Being rescued by a man whom he considers effeminate, revealed to be an actual woman, offends his pride and virility: "Bad enough a pansy should save my life, but a bimbo with a mustache? You make me a laughing stock!" (119). Wounded by further Japanese fire, Gaffney refuses Patton/Patty's help to spare himself more humiliation, and is eventually killed by Mae, who wants to erase any trace of her crimes.

Similarly, Artie struggles throughout the novel with his own adherence to the period's cultural standards of virility. Constantly bullied and taunted by Annie, both in real life and on the latter's radio show, called a "fairy" and a "girlie" at various points (14, 19), he constructs a new persona as a hypermasculine soldier, intent on avenging his degradation. By his heroic actions—he saves Annie and Mae at the cost of his own life—he finds redemption in Annie's eyes and re-earns his status as the father of her child, but Annie seems to imply that his gender overcompensation was unnecessary. Although Artie's genuine heroism provides a contrast with the fakeness of Hollywood's war pictures and their actors, it calls into question a society that promotes militaristic behavior as a model for masculinity (a recurrent theme of Feiffer's work since his army satire *Munro*, written between 1951 and 1953).

"Isn't That Hollywood for You?": Gender and Simulacrum

In detective fiction in general, and in the hard-boiled tradition in particular, the narrative revolves around a series of surprises, the most central of which being the identity of the culprit, often revealed at the conclusion of the story. Thereby, detective fiction gives preeminence to what Roland Barthes (1970) called the "hermeneutic code," to the extent that it poses various enigmas to be eventually solved in the course of an interpretive process that delays its final resolution and constitutes the bulk of the narrative matter (Dove 1997, 62–70). This quest for closure often implies unexpected identity reversals: to put it simply, "people turn out to be more or less than they at first appear" (Porter 2003, 108). Feiffer's story probes this duality between appearance and reality in performative terms by reflecting on the image-building process of the film industry. In this regard, *Kill My Mother* not only takes on a metanarrative dimension as a story about story-making

but reflects upon gender performance in the context of social and cultural expectations. Indeed, the novel's ultimate surprise—Hugh Patton's transformation into Patty Hughes—primarily deviates from narrative norms (Dubois 1992, 105–118) and confounds the reader's assumptions because it transgresses binary postulates relative to identity.

References to the gendering mold of Hollywood begin in part 1 of the novel, when Hammond, in an attempt to lure Patty out of hiding, sets up a casting call for a tall blonde actress, "six feet tall or over," and in her late twenties (15). Hammond's mock film company, "Starstruck Productions, George E. Goldwyn, President," refers to the MGM composer George E. Stoll and the producer Samuel Goldwyn (whose 1938 movie *The Goldwyn Follies* is an early satire of Hollywood). Responding to Hammond's ad, a long line of tall actresses shows up in his office—alluding to their interchangeability as objects of spectacle, according to the cinematic canon of femininity—but the detective's ruse backfires when, drunk and intimidated by Patty's physical stature, he fails to remember his own scheme (54–55).

Annie Hannigan is also involved in the fiction industry. At the beginning of part 2, ten years after the Bay City shoplifting episode, she has become a writer-producer for a "new comedy sensation" radio show, broadcast from Hollywood on the Armed Forces Radio Network (67–69). Echoing the opening page of the novel, this scene (once again showing a disembodied voice emanating from a radio) reverses part 1's incipit, in that Annie has evolved from receiver to creator of staged productions. Her sketches feature the character of a weak and stupid boy named Artie who is recurrently asked to "Shut up," a catchphrase guaranteed to provoke the audience's amusement.[33] The premise of Annie's show reminds us that radio was the dominant mode of home entertainment in the 1930s and 1940s, with a frequent focus on vaudeville plays and formulaic family comedies[34] often focusing on blundering boys, such as *Meet Corliss Archer* (1943–1956) and *The Aldrich Family* (1939–1953), both relying on the device of catchphrases.[35] In addition to co-opting her real-life relationship with Artie for career purposes, at the cost of ridiculing a man who has become a war hero, Annie's make-believe has more serious consequences in the real world, as Artie uses her broadcast to lure and kill Japanese soldiers who are attracted by the mysterious sound from the audience's laughter in the jungle and investigate its source at their peril (68–69).[36]

In his analysis of Ed Brubaker and Sean Phillips's *The Fade Out*, a noir graphic novel set in the world of 1940s Hollywood studios that exposes the general corruption of the film industry and the appalling exploitation of

its workers—victimized actresses, underpaid scriptwriters, blacklisted directors—David Scott Diffrient reflects on the "inherent emptiness of Hollywood" and "the moral and spiritual void... that was at the heart of an industry built upon the appeal of comforting lies and false images" (Diffrient 2018, 4). Feiffer raises the same questions by contrasting two actors, Eddie Longo and Hugh Patton, as well as their respective wives and managers, Mae Hughes and Elsie Hannigan, who take an active role in supporting their husbands' careers. Following his failed boxing career, Longo has become a tap dancer[37] and a "B-star of low-budget musicals" (78). Dissatisfied with his film roles and low celebrity status, he is prone to suicidal threats and self-pity, clinging to his past athletic fame and often blaming his wife for having engineered his conversion from boxing to acting. Despite his spouse's undying support and sacrifice,[38] he remains insecure and ungrateful and craves "real stardom" at all costs, which implies being cast in a "big-budget" film and earning a nomination for an Oscar. Longo's thirst for fame knows no moral bounds—he proposes to Mae that they hire a hitman (Gaffney) to injure and incapacitate his acting rival Hugh Patton, so he may take his place in an upcoming major studio production[39] entitled *Terminal Triumph* (79). His envious, malignant, and scheming personality stands in complete contrast not only to Hugh Patton's scrupulous attitude but also to the heroic roles and public adulation that he seeks. In their relationship, the strongheaded Mae, far from a subservient figure, takes a leading role as her infantile husband's enforcer, often dominating him physically and psychologically.[40]

The conflict between Longo and Patton also takes on a gender dimension, insofar as both men compete in regard to their perceived masculinity and must contend with innuendos about their sexuality. "The rumor is [Patton]'s a pansy," suggests Mae (93). Elsie believes that Hugh's participation in a USO tour of the South Pacific presents an opportunity for him to prove his virility: "There are all sorts of rumors about why a big, strapping guy like you isn't in the service. A U.S.O. tour will shut up the loud mouths" (96). Elsie's job as "Executive Vice President for Image Security and Maintenance" (or "cleaning lady," in more candid terms) for Pinnacle Studios is to handle letters and blackmail threats against its actors, including Eddie Longo (76). This recalls the various strategies of Hollywood studios to market their actors' sex appeal and, when required, construct a heterosexual façade for LGBT performers, including "lavender marriages" and fake tabloid liaisons to hide their true sexuality from the public—a practice reflected in *Something to Sing About* (1937), a meta-movie on the film industry that portrays a studio publicist creating fake news stories about the actors' love interests to promote their

movies. Similarly, Eddie depends on Mae's complicity to reassure himself about his physical size and masculinity, and compares himself with other stars of diminutive stature: "I could name a dozen, a half-dozen, half-pints in movies, bigger stars than Hugh Patton . . . Cagney's my size, almost exactly—Alan Ladd's almost a midget—Eddie Robinson—Astaire's a half-pint"—to which Mae replies: "I seen him in a picture once. He looked queer. One thing about you tap-dancing, Eddie: you don't look queer" (98). Indeed, tap dancing challenged established notions of masculinity, and male tap dancers,[41] consequently, were under particular suspicion of nonconformity[42] to 1940s gender norms, which considered the form "effeminate business" (Valis Hill 2014, 158). Mae is quick to exploit Longo's gender insecurity to motivate him to contend with Patton and refrain from his natural cowardice: "You see that big lug? He's better looking and more manly than you are!" (107).[43] In this context, Feiffer's portrayal of Eddie's ultimate success as an actor is an ironic indictment of the Hollywood simulacrum. Coerced at gunpoint by his wife to overcome his panic and dance on the USO stage under enemy fire, he acquires the undeserved reputation of a war hero and earns the role of his dreams in *Terminal Triumph*, while the real heroes who enabled his performance are wounded or killed. Artie succumbs to Japanese fire and Mae is shot twice, first by Gaffney in self-defense, then mistakenly by Eddie himself as she seeks his assistance. In his usual selfishness, Longo shows no gratitude for his wife's sacrifice. He quickly hires a new agent and divorces Mae, only pretending to care for her for publicity. Faithful to his use of poetic parallels and humor, Feiffer reuses the phrase "Terminal Triumph" in an ironic manner in the title of one of the novel's concluding chapters (146–147) which shows Longo's eventual demise. On the night of winning his Oscar for best actor in the movie of the same title, he thanks his "former wife" and "best friend" Mae, and stages a publicity reunion with her that evening in the presence of press photographers. However, his ultimate attempt at manipulating fame backfires—as he arrives at Mae's home, still wearing his Oscar tuxedo and triumphantly raising his statuette, she is waiting for him in a wheelchair, holding a gun (147). Her final revenge over her husband is left unrepresented.

Feiffer's depiction of the USO show also juxtaposes spectacle and reality and creates a metanarrative disjunction between the two modalities. The performances unfolding onstage and the events taking place in the adjacent war zone are interconnected through a complex system of braiding and correspondence. At the very moment when Patton fights in the jungle with a Japanese soldier, Annie greets the audience from the stage and asserts the "untrue" nature of Hollywood: "Now the story I just told you is my answer

to the question: is 'Shut Up, Artie!' true-to-life? I'll explain: I write a radio comedy show. *Nothing* I write is true-to-life. If it was, I wouldn't be working in Hollywood. We, in Hollywood, have nothing to do with the real world. That's *your* job. *Our* job is to show our thanks and our gratitude by singing and dancing for you. And tell jokes, and give you boys a true-blue American old-fashioned good time!" (112).

To further highlight this contrast, Annie's speech to the troops is inscribed in speech balloons that do not show the enunciator but are grafted on scenes of war violence (Patton hitting an enemy soldier with a branch, then stabbing him with his own bayonet). On the following page (113), this disconnect is accentuated by the contrast between the performers' lighthearted humor and the brutality of the offstage battle, as Feiffer continues to alternate between the two realms. The two comedians onstage, Harris and Homberg, perform a "straight man" routine—inspired by the comedy duos of the 1930s and 1940s, such as Lum and Abner, Stoopnagle and Budd, and Abbott and Costello—delivering deadpan jokes and remarking that the war movies they saw did not accurately portray the abundance of jungle mosquitoes, again setting filmic representation in opposition with reality. The fragments of their dialogue are embedded into the panels representing Gaffney's attempt to murder Patton, as if the amplified sound emanating from the show carried over to the nearby jungle, merging two simultaneous scenes and emphasizing the divergence between grim wartime reality and its embellished depiction in movies.

Mae Longo's assertion that Hugh Patton is "more manly" than her husband sets up another surprising reversal in the novel. From his early flirtation with Elsie, Hugh has been hinting at an inner secret. When Elsie, as a studio publicist, asks him why he creates fake tabloid rumors about himself, he responds in a cryptic yet reflexive manner: "Isn't that Hollywood for you?" (80). During their first date, Elsie, drunk and naked at Hugh's poolside, confesses that she usually does not fall for the fake persona and the "nice act" of movie stars but feels strangely comfortable in his presence (85). There lies Hugh's contradiction: his "fakeness" does not correspond to the character inauthenticity of actors but has another source. In reality, Hugh's personality stands in perfect contrast to Longo's: he is confident, unambitious, respectful of women, and quite self-conscious about Hollywood's misrepresentation of heroism and the inherent dishonesty of performing in front of soldiers: "If they knew the truth about this movie star—It's crazy! Insane! They'd run for the hills!" (98), a statement with polysemic implications, alluding to his modesty, his implied lack of courage, and his true gender identity at the same

time. On Tarawa, while Longo behaves like a coward, Patton acts like a genuine hero in the face of danger. Although partially announced by the aforementioned hints, which are validated only in hindsight, the revelation of Hugh's femininity constitutes the pivotal surprise of this graphic novel and is staged by explicit graphic means. The disclosure of his actual gender takes the form of a single drawing occupying an entire page (117), which frontally shows Patton's topless figure and reveals a woman's breasts (figure 1.8). In the forefront of this image, the left side of the page shows Gaffney's astounded reaction, which mirrors and underscores that of the reader, along the same line of perspective. This revelatory image carries meaning without words; neither Hugh's anatomy nor Gaffney's stupefaction requires verbal explanation—in fact, the latter's speechlessness is accentuated by his posture (eyes bulging out and mouth wide open, about to be covered by his left hand: a perfect "vocabulary of gesture," to reuse Eisner's term). Gaffney's shape is backed up against the corner of the page, which forms a partial hyperframe, while Patton's side of the page is left unframed and open. The puzzling figure of Patton's body draws attention to the fragility and reversibility of bodily signifiers of gender to the extent that, although explicit and unmistakable, his only anatomical feature associated with femininity remains proportionally discreet and creates a momentary gender ambivalence. Lippman's review of the graphic novel points to this partial hesitancy: "Feiffer delivers his biggest twist wordlessly, forcing the eye to linger: Am I seeing what I think I'm seeing?" (Lippman 2014). Conversely, Hugh's breasts resignify the former indicators of his masculinity, particularly his era-appropriate pencil mustache (worn by many Hollywood leading men such as Clark Gable, Errol Flynn, William Powell, and Robert Donat), whose function as a marker of virility is suddenly brought into question as a thin disguise. Hugh's exposed bust reactivates other physical details that remind the reader of his sisters Mae and Dorothea, notably his height and facial features.[44]

Having questioned the essentialist constructs of masculinity and femininity of the 1930s and 1940s throughout his graphic novel, Feiffer concludes his story with a contemporary take on gender theory and gender relations. When Hugh finally reveals the secret of his "natural" sex to Elsie, while the latter is temporarily blind and recovering on a hospital bed, he describes his former masculinity as a mere external construct, an acting performance, or "performative accomplishment"[45] in Judith Butler's understanding of gender identity as "the stylized repetition of acts through time," "constituting that identity as a compelling illusion, an object of belief" (Butler 1988, 519–520): "I'm a woman, Elsie. Hugh Patton is an invention. I was on the run. Mae had

FIGURE 1.8 Hugh Patton exposes his true identity as Patty Hughes. From *Kill My Mother: A Graphic Novel* by Jules Feiffer, p. 117. (Copyright © 2014 by B. Mergendeiler Corp. Used by permission of Liveright Publishing Corporation).

been hiring people to kill me. . . . I had to go into hiding. I became a man. I'm big. Bigger than most men. *I can act. I can sound and move like a man*. Patty Hughes became Hugh Patton" (143–144, my emphasis).

As Butler notes, "The acts by which gender is constituted bear similarities to performative acts within theatrical contexts" and imply the construction of a "corporeal style" (Butler 1988, 521). Elsie's unforeseen reaction to Patty's reacquired femininity provides a final twist to the period's hegemonic expectations of binary genders and heterosexual attraction. Although Patty assumes that Elsie will now reject her as her lover, Elsie surprises her by remaining committed to their relationship:

Patty: I'm sorry. I'll leave now.
. . .
Elsie: You will not leave!
Patty: Elsie, I am so sorry.
Elsie: Sorry isn't the half of it! He's sorry!
Patty: She's sorry. Patty is sorry.
Elsie: Are you still six foot two? Or is that also a lie?
Patty: I am still six foot two.
Elsie: No mustache?
Patty: Nope.
Elsie: I'll miss that mustache. You have tits, I suppose.
Patty: Yes.
Elsie: That's why you never undressed, or let me touch you intimately. I assumed it was some movie star I-don't-like-to-be-touched affectation, and it might take years for me to wear you down. Big tits or little tits?
Patty: In-between.
Elsie: Oh, dear!
Patty: What?
Elsie: I like small tits.
Patty: Elsie . . .
Elsie: We'll work it out. (144–145)

Elsie's momentary blindness is an important factor in this scene, as she neglects the surface signifiers of Hugh's masculinity in favor of more permanent, nonperformative aspects of his being, such as his height. The novel ends on a happily-ever-after moment featuring Patty and Elsie's reconstituted family, with Annie and her son Sammy, watching Lady Veil singing onstage.

Lady Sings the Blues

In contrast with the falsehood of Hollywood culture and the trappings of patriotism, Feiffer presents Lady Veil's performance, and jazz or blues in general, as an authentic artistic expression. His inclusion of singing performances by a female entertainer conforms to a recurring theme of film noir, which often resorts to such scenes to express "erotic undercurrents" (Ness 2008, 52) but also "dystopian elements" and violence (Kalinak 1992, 167). With Lady Veil, one is reminded of classic scenes of noir: Rita Hayworth's nightclub performances in Charles Vidor's *Gilda* or her crooning "Please Don't Kiss Me" in Orson Welles's *The Lady from Shanghai*, Lauren Bacall's club singing in Howard Hawks's *The Big Sleep* and *To Have and Have Not*, or Ida Lupino's role as a lounge jazz singer in Raoul Walsh's *The Man I Love*. The subgenre of noir musical films, "[blending] musical production numbers into [a] classical noir framework," cultivated an atmosphere that "was characterized by smoke, shadows, and moody strains of jazz and blues.... Storylines involved antiheroes—tormented performers and musicians—battling obsession and dysfunctional personal relationships.... Thus, these dark 1940s and 1950s noir musical films strayed from the norm of more typical musicals. Their plots uncovered what was happening backstage, contradicting the glamour onstage" (Biesen 2014, 1–2).

The story of Dorothea Hughes, Patty's twin sister, is marked by tragic violence. Her other sister Mae killed their mother in self-defense, and Dorothea became unable to speak as the result of the ensuing trauma. Yet she is able to channel her emotions through singing: "Shut up. It didn't happen. I refuse to remember. Can't make me tell if I refuse to remember. I was always the responsible one in the family. Can't make them trick me, make me talk. Somebody you love shoots someone else you love. Every word I speak causes damage. Can't be tricked if I never say another word. If I never speak again, I can't tell them anything. Never speak. Silence. But I can sing. Singing is my life. What harm if I sing?" (62).

Such a difficult life and family circumstances—which recall those of many jazz and blues performers such as Bessie Smith and Billie Holiday—find their adequate expression through the blues idiom, for instance when she sings "Bay City Blues," the soundtrack of the graphic novel as well as that of her own existence. Through the figure of Lady Veil, Feiffer implicitly comments on the silencing of women through violence and the emotive power of the blues as an artistic reclaiming of voice for socially disempowered individuals.

Dorothea also fills an emotional void in Annie's existence and in her broken family. In this regard, she effects a double symbolic replacement, as the object of Annie's motherly attention and as a parental substitute; tellingly, Annie gives her father's clothes to Dorothea (29). Annie is equally drawn to Dorothea's singing alter ego as a figure of truthfulness and authenticity that contrasts with the make-believe glamour of Hollywood, to which she contributes herself as a producer. Presented onstage as "the Shadowy Songstress," "the Divine Diva of Melodious Magic," or "Her Royal Shyness" (71), Lady Veil sings honestly about heartache and the travails of a woman unlucky in life and in love. Her songs about lost lovers and missed encounters have a particular resonance for Annie, who experienced the loss of her father and feels estranged from her mother, but also for all the other characters in the novel, who suffer similar forms of alienation. As any blues listener, Annie projects her own suffering into the generic narrative of loss that the blues provides:

> You never told me what went wrong,
> We never parted, not one "so long"
> How could you vanish without a trace,
> Leaving an emptiness I can't face. (72)

By weaving musical lyrics into his graphic novel, Feiffer draws metaphorical echoes and metonymic connections between the songs and his own narrative and incorporates a fitting soundtrack to a noir story, despite the auditory deficiency of his medium.

The dual identity of Dorothea and Lady Veil provides another hermeneutic quest that occupies Annie's attention for most of the story. Noticing the singer's resemblance to the homeless lady who once saved her life when she intervened to stop her aggressor a decade before, she is intrigued by the mysterious, veiled figure. Her tall stature suggests that both women are a single individual, but her face covering prevents her definite identification, although the reader is afforded more information than Annie's character in this regard, for instance on page 73, which opposes Annie's gaze and the reader's. This single-drawing page shows Annie and her boyfriend leaving the concert venue and looking for the singer, their eyes pointed in the wrong direction, while the reader enjoys a full view of the unveiled Dorothea, hiding from Annie's sight around the corner of the building. The two characters are finally reunited when Annie pleads with Lady Veil to come live with her and, as a result, she becomes a member of her family. The scene in which Dorothea, still mute, comforts Annie's son Sammy by improvising a beautiful song and dance,

twirling the little boy above her head, is another one of Feiffer's kinetic and emotional tours de force and testifies to the power of music and bodily expression in the context of trauma.

Fittingly, it is Lady Veil who utters the closing words in the story, providing a metanarrative epilogue in the form of a song:

> Remember my story? I had a story.
> A beginning, a middle, and an end.
> I told my story, I sang it, I meant it,
> It was my only story,
> And now I repent it.
> All that I knew, I thought it was true,
> I don't know any more what I think,
> And do you?
> What is your story? Is it truer than mine?
> Will you speak plainly,
> Or will you give it a shine?
> Invent your own story,
> I'm done telling mine. (148)

2

Cousin Joseph

• • • • • • • • • • • • •

A Noir Take on the
American Dream

The second tome of Feiffer's trilogy, *Cousin Joseph* (2016), maintains a thematic connection with the same characters and the same historical context as the inaugural work, but performs a compelling chronological twist. Set in 1931, two years before Neil Hammond and Elsie Hannigan's encounter with the Hughes sisters, it constitutes a prequel to the events featured in *Kill My Mother* (2014) and provides an explanation for Sam Hannigan's death, the consequences of which—on the lives of his wife Elsie, his daughter Annie, and his partner Neil—were explored in depth in the first volume. In a long complementary analepsis, the story retraces the facts and circumstances of Sam's demise, presented as an enigmatic fait accompli in the earlier graphic novel, where Hammond merely remarked that "Sam's problem was that he was the wrong kind of honest. For a cop there are two kinds of honest: smart-honest and idiot-honest. Putting your nose where you shouldn't and telling your superiors about it, that's idiot-honest" (Feiffer 2014, 23).

While *Kill My Mother* unfolded a political subtext whose meaning and ramifications I examined in the previous chapter, *Cousin Joseph* deals even more explicitly with Depression-era politics and reactivates some of the critical stances that have always been present in Feiffer's cartooning and playwriting. In the foreword of *The Ghost Script*, Feiffer notes that this shift toward political content was not intended from the onset of the project:

> The *Kill My Mother* trilogy . . . was never meant to be political. It was dreamed up as an old man's homage to the noir fiction and films of my boyhood, drawn in a style based on the works of the two cartoonists who were my adventure strips deities, Milton Caniff and Will Eisner. Nonetheless, by the middle of book two, *Cousin Joseph*, it became clear that I had tricked myself into writing about that time, nearly seventy years ago, when my Bronx-boy, left-wing leanings fixed on the Hollywood blacklist, and I found myself shaped as a political being, from that time to this. (Feiffer 2018, foreword)

Indeed, the transgressions that cost Sam his life—the places where he "put his nose," in Hammond's words—impeded the collusion of certain hegemonic forces in American society of the 1930s: industrial leadership, the police corps, private reactionary militia, agents of the Red Scare, and influential backers of antisemitism. *Cousin Joseph* introduces the readers to the titular character, a mysterious propagandist intent on preventing Hollywood filmmakers from making movies that depict or confront America's socioeconomic problems for fear that they will instill a leftist conscience among the masses. A virulent antisemite, Cousin Joseph views Hollywood as a nest of subversive Jewish artists who must be stopped at all costs, either through bribe or violence. To this effect he employs a series of enforcers, one of which is Sam Hannigan, whose romantic nationalism and propensity for violence he stokes and exploits with various ideological fallacies. The arc of Hannigan's relationship with Cousin Joseph eventually shifts from illusion to disillusion when the duped policeman realizes that his mentor preyed upon his uncritical patriotism, and that Joseph's true allegiance lies not with America but with Germany. However, such newfound critical thinking will have dramatic consequences for Hannigan, to the extent that his disengagement with these covert political machinations will lead to his murder.

The other powerful mogul in Feiffer's second volume is Old Man Knox, also known as Hardy Knox, the wealthy owner of a California cannery,

Knoxworks. In contrast with Cousin Joseph, who operates in the symbolic sphere of media representation, the industrialist's alignment with right-wing politics appears more economic than ideological in nature: Knox aims to protect his profit margin against union demands for better salaries, shorter workdays, safer working conditions, and employment security in an era when diminished purchasing power and low market demand resulted in falling wages and unemployment for the working class. Knox opposes all union negotiations and organizes the brutal repression of a workers' strike with the assistance of the police and strikebreakers. The story's subplot that centers on labor action against Knoxworks involves multiple characters, including Elliot, Knox's right-hand man and private investigator;[1] Sam Hannigan and Neil Hammond, who lead the union-busting activities of the Red Squad with the full blessing of the police authorities; and two strikers with contrasting profiles: Billy Doyle, a charismatic organizer, and Cissy Goldman, a Jewish worker and single mother. Here again, Hannigan's participation in anti-union clashes stems from the character's misguided views on entrepreneurial capitalism and organized labor, which also erode over the course of the novel as he becomes increasingly aware of systemic injustice and corruption, following the same disenchantment trajectory as his faith in Cousin Joseph, and equally leading to his demise. Hannigan is therefore positioned at the center of a political web, the intersection of multiple narrative lines that mirror the structural underpinnings of power in this troubled decade.

Finally, *Cousin Joseph*, like *Kill My Mother*, also features child characters who not only echo Feiffer's long-standing preoccupation with depicting childhood in comics but also reflect the broken family of the Great Depression and its fictions, including hard-boiled literature and film noir. These include Elsie Hannigan and her boyfriend Artie, the core protagonists of *Kill My Mother*, who make a brief appearance in this second installment, as well as two new characters: Valerie Knox, Old Man Knox's troubled daughter, whose death becomes the pretext for Billy Doyle's arrest, and Archie Goldman, Cissy's son, a young Jewish boy bullied at school but intent on becoming a detective. The family backgrounds of Archie and Valerie set up a reversed symmetry between the boy without a father, who idolizes Sam Hannigan as a paternal figure and role model, and the girl without a mother, raised by a monstrous father. Although Archie Goldman mostly remains a lateral figure in *Cousin Joseph*, he will become a central protagonist in the concluding volume of the trilogy, *The Ghost Script*, which follows his private investigations.

Graphic Braiding and Intermediality: A Cine-Mimetic Opening

Structurally, *Cousin Joseph* mirrors the fragmented diegetic organization of *Kill My Mother*, with a succession of short chapters whose alternating contents weave a complex narrative tapestry of intertwined or parallel motifs, using a rich graphic syntax and vocabulary in the author's inimitable style. Among this second volume's many topics, Feiffer continues to focus on cinema in two distinct manners: thematically, by reflecting on the Hollywood industry and its products in the 1930s, and aesthetically, through visual compositions that mimic the appearance and language of film. On numerous occasions, this filmic style itself is employed as an effective device to merge multiple narrative strands on the page.

An early passage of the graphic novel provides a striking example of such forms of narrative and visual braiding, effectuated through cine-mimetic configurations. Pages 10–13 unfold a continuous sequence akin to a cinematic tracking or "following" shot where the spectator's gaze follows the path of an object in motion, revealing a wider setting in its periphery. In this chapter, Feiffer draws the progression of a car through a cityscape as a continuous, winding motion—a process that requires the cartoonist to seek creative solutions to compensate for his medium's inherent stillness. In contrast with the apparent fluidity of film, graphic sequences intended to impart the impression of motion must usually rely either on stylistic dynamism (action lines, distorted shapes, metonymical effects such as dust clouds, sweat drops, or impact markers) or sequential juxtaposition (generally, a succession of panels detailing the successive stages of a movement or gesture). In this section of the novel, however, as in other pages of the previous volume, Feiffer represents the car's advance through multiple iterations of the same vehicle within a single, full-page tableau, a bird's-eye view of a curved road punctuated by several renditions of the same traveling object at different locations, yet without standard panel dividers. Such a composite image, like a drawn version of time-lapsed chronophotography but redistributed over diverse points of a scenery, imparts a visual flow that effectively translates the optical continuum of film with graphic means. Let us also note that this large image involves another type of visual synthesis in terms of perspective, to the extent that its top and bottom halves, although connected by a seamless landscape, offer two incompatible viewpoints of the same car traveling in opposite directions, like an M. C. Escher "trick" composition.

The car motif unfolds its own narrative content, insofar as its occupants (Hannigan and Cousin Joseph's hired gun and driver, Gaffney) are shown conducting a conversation on their way to delivering a bribe to a filmmaker in exchange for the withdrawal of his script (see the section below on Cousin Joseph and Hollywood). The car's path therefore provides a series of anchoring points for the multiple speech balloons that accompany the moving object not only through space but also through time, contributing to the overall effect of linear continuity. Hannigan and Gaffney's dialogue establishes a linkage with the plot of *Kill My Mother*, in which Gaffney is prominently featured as a ruthless enforcer capable of extreme violence, particularly against women (in this passage, Hannigan remembers that he once arrested him for illegal activities and asks if he carries a weapon). However, in this complex visual construct, this strand of the narrative featuring the actions of Hannigan and Gaffney is augmented by lateral plot elements. Feiffer accomplishes such a polyphonic amalgam by grafting onto this large tableau other scenes that take place concurrently in the vicinity of the passing vehicle. Page 10 contains, in the top right and bottom left corners, three appended panels of a more traditional shape, which visualize a simultaneous interaction between two other characters of the novel, Valerie Knox and a young man. The top panel repeats and magnifies a fragment of the main image, a small house on the roadside situated along the path of the traveling car. Such forms of iconic repetition, whereby a cityscape is anatomized in enlarged fragments allowing visual access to domestic interiors and unfolding past or simultaneous narrative content, are reminiscent of Chris Ware's masterful layouts in works such as *Building Stories* (Leroy 2014, 231–232). Seen from the same overhanging perspective but depicted on a larger scale, and therefore appearing closer to the reader's viewpoint, this house constitutes at first—like the car—a "talking" object, the physical envelope from which undepicted characters engage in dialogue, shown in speech balloons whose tails point toward the windows. The middle panel zooms onto a frontal view of the same house with a close-up on its windows which reveals the protagonists inside. In this scene, as in variants thereof dispersed throughout the story, Valerie Knox proposes a sexual transaction to an unnamed boy (a peek at his penis in exchange for a dollar) while expressing confusion and ambivalence about her own request ("I can't remember. Did I promise you a dollar? . . . Do you think you made a mistake? Am I the wrong person?"). Finally, in the third and bottom panel, Valerie turns toward the window in the direction of the road below, not only facing the reader but seemingly contemplating the same passing car below.

Although this section of the narrative only alludes to Valerie's psychological imbalance fragmentarily and in passing, the story will later return to this subject on multiple occasions. Seemingly unrelated to the main narrative, Valerie's brief episode nevertheless provides a thematic analogy with Hannigan and Gaffney's mission, in the sense that both involve a financial transaction, a bribe of sorts.

Regarding this elaborate page design, two additional elements are worth noting. First, Feiffer's creative composition appears to be more than an intermedial homage to the aesthetics of film or a transmedial reworking of filmic devices. Indeed, while these interpictural references are unmistakable—and, by the author's own admission, intentional—what he accomplishes here through graphic braiding would be impossible to achieve in film. Neither the juxtaposition of simultaneous plotlines (which only split screen effects could render, at the cost of clarity, particularly in this instance of double dialogue) nor the combination of opposite gazes (the tracking shot following the vehicle on a horizontal plane and the zoom onto the house on the axis of depth) could be resolved within a single visual frame, as they are here. Second, we should also note that, although they are conceivable in the comics medium, such devices still challenge the reader's deciphering habits, to the extent that they deviate from the standard left-to-right, top-to-bottom reading path and therefore require some amount of cognitive adjustment. It is certainly a testament to Feiffer's visual genius that such sequences, while admittedly demanding, remain legible through the sheer expressivity of his style. Third and finally, such braided layouts can also cultivate a reflexive, metaliterary dimension; indeed, in this section Feiffer literally drives his reader through sections of his own plot, presented as spectacles upon which his protagonists themselves can gaze from the window of a passing car.

The car sequence extends on the following page (11) but shifts the focus of the secondary narrative. The single background image continues to show the path of the vehicle on a road surrounded by buildings, with the concomitant unfolding of Hannigan and Gaffney's conversation about the necessity of being armed to perform their mission. In this instance, however, the paginal space devoted to this scene has shrunk in relation to the previous page, occupying only a small portion of the top left corner. This is due to the encroachment of a parallel diegetic segment superimposed onto the street panorama. Although it repeats the pattern of three lateral panels used in the preceding layout, it takes on larger dimensions and is configured slightly differently, with rectangular panels aligned on the right edge but gradually expanding on the left side of the page, covering most of the road scenery. Simultaneity of the

two sets of actions is also implied here: while Hannigan and Gaffney debate the mechanics of armed bribery, two other people are having a conversation in a diner. Addie, the diner's manager and waitress, and Sam's partner Neil Hammond are discussing the latter's career move, the prospect of leaving his police job and opening his own detective agency (figure 2.1). Addie asks if she could become Neil's assistant, arguing that she can "outshoot most of you cops," but he turns down her request. This foreshadowing scene will find its counterpart at the conclusion of the story when Addie, making true on the assessment of her gun-handling abilities, will shoot and kill Hannigan for profit, despite her genuine affection for him. Feiffer's plot constructs many echoes and loops of this kind. Indeed, one could also see in this dialogue a premonition of Hammond's relapsed alcoholism—when he dismisses Addie's request by telling her, "Sounds like you've been drinking your own after-hours hooch," he unknowingly anticipates his own intoxicated breakdown in the same diner at the end of the novel (108–109).

Furthermore, Feiffer cleverly creates an overlapping point between the parallel diegetic lines converging on this page (the car and the diner). At the very center of the page, as Hannigan and Gaffney drive in front of the diner, their vehicle can be seen through the restaurant's window, between Addie and Hammond. A speech balloon emanating from the vehicle confirms that it belongs to the primary narrative sequence. This line of vision is made possible by the reversed angle of perspective, which faces from inside the diner onto the nearby street. This window device fashions a zone of interaction between the two parallel narratives, whereby they are not simply juxtaposed or overlaid but communicate through an inlaid motif. Here again, as in many other layouts of his trilogy, Feiffer derives structural and semantic effects from the physical shapes and characteristics of objects, the window's rectangular outline and transparency serving as a makeshift frame inside the frame and embedding a diegetic fragment from an adjacent scene.

On the following page (12), the car once again allows brief access to yet another subplot when it passes in front of a school as students are leaving. Reversed symmetrically, with the depiction of the car and the urban scenery on the right and the annexed panels on the left below the larger image, this layout performs a variation on the previous pages while keeping its main structural elements. The characters involved in the adjoined scene include two of the child protagonists of *Kill My Mother*, the brazen Annie Hannigan and her meek boyfriend Artie—in their brief interaction, Annie utters her emasculating catchphrase: "Shut up, Artie!"—as well as Archie Goldman, a Jewish student at the same school whom Annie proceeds to browbeat with

FIGURE 2.1 Multiple storylines along the path of a moving car. From *Cousin Joseph: A Graphic Novel* by Jules Feiffer, p. 11. (Copyright © 2016 by B. Mergendeiler Corp. Used by permission of Liveright Publishing Corporation).

antisemitic discourse and outright discrimination. Given Sam Hannigan's reactionary politics in the first half of *Cousin Joseph*, it can be posited that Annie's prejudice was acquired at home. Although Annie and Artie have a minimal presence in this volume, their inclusion ensures the continuity of the three graphic novels, and Annie's antisemitism alludes to a central theme of *Cousin Joseph*, to the extent that her verbal assault on Archie manifests some of the insidious and implicit rhetoric[2] that the titular character systematically employs. On this page again, the two scenes taking place in visual proximity to each other are not simply juxtaposed but integrated in two panels that show, in the background of Annie and Archie's heated conversation, the black car passing near the congregated students.

The car sequence continues at the start of the following chapter, featuring a large depiction of Old Man Knox standing at the upstairs window of his cannery (13), gazing on workers entering the factory while a protest folk singer performs a pro-union song (see below in this chapter for a more extensive analysis of this page). Following the same pattern, the black car makes an appearance at the bottom right edge of the frame, with Hannigan visible in the back seat, his head turned toward the same spectacle as the one presented to the reader. The vehicle finally reaches its destination at the lavish home of Mr. Ackerman, a movie producer to whom Hannigan delivers Cousin Joseph's bribe (15); the car is then shown on its return journey, in a single-image page once again featuring multiple iterations of the same vehicle traveling through a wooded area (18) while Hannigan and Gaffney reflect on the violence they just inflicted.

Unwinding over several pages and chapters, this early sequence of the graphic novel appears both thematically dispersed (with a fragmented diegesis and sudden shifts of focus) and visually continuous, despite its assemblage of apparently disconnected segments. Its chronological linearity, following the car's trajectory, constructs a complex system of opposing gazes and accommodates a multiplicity of peripheral elements, all of which communicate metonymically and reflexively with larger subplots and recurring motifs. The polysemic layouts that Feiffer invents employ a graphic vocabulary and syntax that combine comics-specific devices (multiframes, panels, speech balloons) with designs borrowed from other media, such as illustrated narratives (for its page-size tableaux) and especially film. These singular spatio-topical configurations create intermedial hybrids between comics' own braiding mechanics, based on the syntagmatic "copresence" of multiple images in "dialogue" with each other on the page or double page (Groensteen 2007, 57), and visual experiments replicating the fluid continuity of cinematic action and its assortment of gazes.

Cousin Joseph, Antisemitism, and the Hollywood Dream Factory

From his entrance in the graphic novel, a full-page depiction (2), Cousin Joseph displays the appearance of a man of power, a mover and shaker. Elegantly dressed and operating from a mansion, bestowed with an elegant physique (sporting white hair and round spectacles), and adopting a posture that exudes influence (sitting cross-legged in an armchair, a long cigarette in hand), he is shown giving detailed instructions to his driver and assistant, Baxter. The framing of this conversation, which leaves Baxter unrepresented and outside of the paginal space, with only speech balloons protruding from the cut-off margins, implies subordination and deference. The graphic disposition of this enunciative exchange indeed carries indications of dominance: not only does Baxter reiterate his boss's name and his compliance to the latter's demands no less than five times ("Yes, Cousin Joseph") but his fragmented responses are positioned below and to the right of Joseph's lines of dialogue, which form a continuous entity through connecting channels as a single monologue only interrupted by his interlocutor's periodic expressions of acquiescence. At Cousin Joseph's request, Baxter hands stacks of dollar bills placed inside music boxes to Sam Hannigan so that, in turn, the latter may deliver bribes to filmmakers and movie producers (3). From the onset, Baxter's mission is associated with era-defining filmic and musical references. As he turns on his car radio, he hears KYC Music Hall bringing "the soothing sounds of Mr. Russ Columbo," the New Jersey–born actor and singer of Italian descent who starred in musicals, Westerns, and romance films before his accidental death by gunshot in 1934.[3] Feiffer's soundtrack not only anchors his story in a specific time period (the early 1930s) by recalling the entertainment culture of this day (music boxes, car radios, popular film genres, and the crooning style of vocalists like Columbo) but also alludes to the harsh reality of the Depression (with a song stating, "Does it matter to you that I don't have a dime?").

Baxter communicates the details of their assignment to Hannigan: they are charged with making three deliveries in Beverly Hills. "Each one, heads of a production studio. One is new. *A Jew, like the others*. . . . He likes the money. They all do. It just takes a little encouragement" (8, my emphasis). Although euphemistic, Baxter's statement suggests that intimidation and violence might be used should financial incentive prove insufficient. The stated objectives of such buyouts are to prevent the making of what Baxter labels "problem movies," some of which have already been withdrawn from production by the

studios under similar pressure: "One about a father who can't find work and tries to jump off the Brooklyn Bridge. Another about homeless boys on the road. A third about a working girl whose boss makes her pregnant and then fires her" (9). Evidently, these examples indicate that Cousin Joseph's censorship is specifically aimed at suppressing media representations of America's economic problems during the Depression, notably its effects on the family (a suicidal father and homeless children), workers, and women. This battle for image control seeks to replace such depictions with wholesome or escapist spectacles more aligned with conservative values and tropes, for instance "a small-town family series featuring a high school teenager." Baxter concludes that, by accepting payment[4] as impetus for artistic censorship, "*these foreigners are starting to understand our values*" (9, my emphasis).

In conveying Cousin Joseph's strategy to Hannigan, Baxter makes a double association worth examining—between Hollywood and Jews, and between Jewish filmmakers and social topics. The movie industry of the 1930s can indeed be considered "an area of spectacular Jewish success" (Desser and Friedman 2003, 25), with a high number of prominent producers and heads of studios, directors, screenwriters, actors, and animators:

> The names of Louis B. Mayer, Irving Thalberg, Marcus Loew, Carl Laemmle, Adolph Zukor, Jesse Lasky, Joseph and Nicholas Schenck, Dore Schary, Harry, Jack, Albert, and Sam Warner, Samuel Goldfish, Harry Cohn, and William Fox may be known to a relative few, but the companies they formed and ran—M-G-M, Universal, Paramount, Columbia, 20th Century-Fox, and Warner Brothers—invigorated the hopes and dreams of an entire nation. These Jewish film producers, known not entirely affectionately as movie moguls, employed a veritable army of talent both in front and behind the camera, and many of those soldiers were Jewish. The number of Jewish writers and actors in particular is amazing, as are the number of émigré directors who started in the 1920s. (Desser and Friedman 2003, 25)

However, in regard to the portrayal of social issues, it is commonly established that the so-called moguls of the 1930s were driven by financial motives and therefore "sensitive to the effect of controversial film content on box-office products" (Morgan 2016, 2). To this extent, they were also not keen on depicting Jewish subject matters or Jewish life on-screen, opting instead for a strategy of cultural assimilation that removed markers of Jewishness in favor of representations of generic Americanness, effectively "de-Semiticizing... the action that took place in front of the lenses" (Desser and Friedman 2003, 1–2).[5]

The British film critic Raymond Durgnat offered a similar, albeit blunter and somewhat oversimplified assessment of the movie industry's reluctance to delve in social criticism during the Great Depression: "The financial and industry-labour battles of the '30s are poorly represented in Hollywood, for the obvious reason that the heads of studios tend to be Republican, and anyway depend on the banks" (Durgnat 2006, 39).[6] Indeed, seeking social acceptance, many, like Louis B. Mayer, fought antisemitic prejudice through political affiliation with conservatives, although others like Jack Warner promoted the Democratic policy of FDR's New Deal (Wheeler 2016, 29–32). Any injection of progressive political meaning would often take on implicit (disguised or metaphorical) rather than explicit forms and would likely emanate from the directors and screenwriters[7]—many of whom came from East Coast intellectual circles and Jewish cultural backgrounds (Gabler 1988, 327; Wheeler 2016, 39)—rather than the heads of studios. By contrast, "much of American Jewish literature of the depression . . . takes note of the economic circumstances or its protagonists" and focuses on class struggle to a large extent (Desser and Friedman 2003, 15).

Iwan Morgan (2016) confirms that concerns for the profitability of films during the Depression were justified and had an impact on the types of movies produced and favored in that decade. As movie ticket sales collapsed during the financial meltdown of 1931–1932, creating significant budget issues for the studios, the industry responded to these challenges not only with technological adjustments and new marketing strategies but also with escapist spectacles that distracted viewers from their harsh economic reality. Preferred genres included musicals, "song-and-dance" productions, tap dancing, and "operetta movies" (*Footlight Parade, Gold Diggers of 1933*, RKO films featuring Fred Astaire and Ginger Rogers); vaudeville (the Marx Brothers, Eddie Cantor, W. C. Fields), sentimental comedies (Shirley Temple), or screwball comedies (Frank Capra's *It Happened One Night*); horror movies (such as *Dracula, Frankenstein*, and *King Kong*); and Westerns (mostly B movies from the low-budget "Poverty Row" studios) (Morgan 2016, 9–14).

While many film historians conclude that, for the most part, "Hollywood churned out celluloid Lethe to lull the miserable Americans into forgetfulness" (Schwartz 2001, 5), some movies still offered partial reflections or more overt critiques of the socioeconomic changes brought by the Depression: "The Hollywood studios of the 1930s turned out a cycle of distinctive political movies, characterized by a richness of writing that produced settings, characters and narratives capable of resonating with a shell-shocked public" (Scott 2016, 51). Although "the 'social problem' genre had limited significance in

the production strategies of the majors" (Morgan 2016, 11), it included indirect depictions of societal issues in gangster (*Little Caesar*, *The Public Enemy*, *Scarface*), prison (*I Am a Fugitive from a Chain Gang*), and law-enforcement movies (*G-Men*, *Bullets or Ballots*), as well as more frontal representations of America's economic gloom in a handful of films.[8] Interestingly, Baxter's list of withdrawn scripts includes references to some of these movies. For instance, the story about "homeless boys on the road" presumably alludes to William Wellman's *Wild Boys of the Road* (1933), in which desperate teens are forced to leave their poverty-stricken families and enter into a life of vagrancy, riding freight trains through the Midwest, living in "hobo" encampments such as Sewer Pipe City near Cleveland and the New York municipal dump, facing unsympathetic and inefficient authorities, and eventually resorting to petty crime. Other films of this era that confronted its socioeconomic problems include Frank Borzage's *Man's Castle* (1933) and King Vidor's *Our Daily Bread* (1934), both of which were box-office failures, an indication of audiences' preference for escapist entertainment over mimetic drama. Lewis Milestone's adaptation of John Steinbeck's *Of Mice and Men* and John Ford's adaptation of *The Grapes of Wrath* would only come in 1939 and 1940, as the Depression began to recede. Feiffer's counter-example, "a small-town family series featuring a high school teenager," likely echoes the sixteen-film *Andy Hardy* series produced by MGM between 1937 and 1946, with the teenage actor Mickey Rooney (facing another teenage star, Judy Garland, in three movies). Representative of a media denial of the Depression, the *Andy Hardy* movies offered a glossy, reassuring image of a fantasy America where the nuclear family remained intact and conservative small-town values were upheld, including patriotism and a conspicuous respect for figures of authority.

Feiffer's plot attributes the relative absence of realistic social content in Depression-era cinema not to the marketing choices of film producers and the tastes of movie audiences but to active counterforces exercised upon the industry by external political agents. At the conclusion of the story, as Hannigan realizes that Cousin Joseph has misled him with a false patriotic narrative, Hannigan suspects that his mysterious patron does not work on behalf of America but a foreign power: "He talks slow. Like maybe he's covering up an accent. He says he loves his country. Which country?" (98). Earlier, Elsie Hannigan also remarked that Joseph has "a slight foreign accent" and asks her husband if he has any German relatives (37). With these two clues, as well as the character's ideology (most notably his recurrent antisemitic diatribes), the reader can infer that Hannigan's mentor is a covert operative of Nazi

Germany specializing in media disinformation. The realization that film narratives and images were a "political means of power" that could be employed to shape political understanding and instill or reinforce mental representations was central to Nazi iconography: "Adolf Hitler and his vociferous party ideologue Joseph Goebbels had recognized the propagandistic potential of the new medium of sound film long before the Nationalist Socialist rise to power" (Stargardt 1998, 1).[9] As the Nazi propagandist Hans Traub remarked as early as 1933, "There is no doubt that film as language is an excellent means of propaganda. Influencing others has always demanded such types of language that create a memorable and moving plot in a simple story.... However, from the wide field of languages brought directly to the receiver through technical and economic processes, the most effective is the motion picture. It demands constant attention; it is full of surprises in the alternation of plot, time, and space; it has an unimaginable richness of rhythm for increasing and repressing feelings" (Traub 1933, 29, my translation). On home soil, pretexting that Jews dominated the German film industry and promoted a negative image of the nation, Hitler and Goebbels set up a vicious policy of *Entjudung* (dejudification) that removed all Jewish participation from the medium and targeted movie imports, with a ban on "all foreign films involving [German] émigrés" whose Americanized views deviated from Nazi ideology (Stargardt 1998, 2). The Berlin showings of certain Hollywood films[10] made by Jewish directors and presenting what was deemed as a pejorative image of Germany were the object of calculated assaults, such as the American film adaptation of Erich Maria Remarque's 1929 novel *All Quiet on the Western Front* (1930); the film's director (Lewis Milestone[11]), producer (Carl Laemmle Jr.), and actors (Louis Wolheim in particular) were of Jewish descent. Conversely, the Nazis commissioned a type of cinema that conformed to Nazi narrative and iconography. Siegfried Kracauer's classic analysis of Nazi film propaganda in *From Caligari to Hitler: A Psychological History of the German Film* (originally published in 1947) observes that it sought to "supplant reality with a pseudo-reality of its own manufacture," channeled through "a medium whose very essence is the creation of pseudo-realities"[12] (Stargardt 1998, 6–7).

However, Hitler and Goebbels not only took control of German media but also attempted to bend Hollywood representations in their favor. As Steven J. Ross (2017) notes:

> For Nazi propaganda minister Joseph Goebbels, no American city was more important to the cause than Los Angeles, home to what he deemed the world's

greatest propaganda machine, Hollywood. Although many people in the United States and around the world viewed New York as the capital of Jewish America, Goebbels saw Hollywood as a far more dangerous place where Jews ruled over the motion picture industry and transmitted their ideas throughout the world. Goebbels and Hitler had one thing in common with Soviet dictator Joseph Stalin: they saw Hollywood as central to their efforts to win over the American public and the world to their cause. The power of the cinematic image, Hitler wrote in *Mein Kampf*, had far "greater possibilities" for propaganda than the written word, for people "will more readily accept a pictorial representation than read an article of any length." ... While Reds tried to control Hollywood through infiltration, Nazis planned to do it through intimidation and murder. (3)

Physical intimidation is indeed present in the early scenes of Feiffer's graphic novel, which depict Hannigan's transaction with film producers in their impressive Beverly Hills mansions (15–17). While the first one, Mr. Ackerman, accepts the music box filled with cash with a dose of pragmatism, arguing that the film business has become financially unstable in the face of the Great Depression ("Next month I could be in a tailor shop in Pasadena pressing pants!"), the second, Mr. Kornblum, collects his payment but refuses Hannigan's request that he sign a receipt. Escorted out of the filmmaker's estate by an imposing bodyguard, Hannigan proceeds to knock out the larger man with a blackjack, a demonstration of brutality that convinces a terrified Kornblum to comply and sign the document (17). The graphic rendering of violence in this fight scene returns to the same visual devices used in *Kill My Mother*, most notably in the boxing scenes (Feiffer 2014, 33–34) and in Hammond's bar altercation with a bigger opponent (Feiffer 2014, 26). The impact of the blow projects the bodyguard's body backward, and Feiffer's supple touch fashions highly expressive kinetic lines uninterrupted by panel dividers, imparting a dynamic flow through sketchy, interwoven, curvilinear shapes—a choreography of anatomical malleability highlighted by the transparency of a light ink wash. The bodies of the fighters are shown from a rotating angle that also conveys movement: the three images juxtaposed in this sequence show Hannigan frontally, then dorsally, and conclude with a view of the defeated guard seen from above.

While Hannigan states that a producer's ethnicity is of less concern to him than the filmmaker's alignment with his vision of America—"None of my business who he prays to, as long as he's with us" (8)—Cousin Joseph's politics express overt antisemitism. In a sequence of two pages, Feiffer stages a

long monologue from the propagandist that constructs a cunning narrative of doom and blame, aimed at convincing Hannigan to further intimidate Kornblum, who persists with his intent to make an "un-American" film:

> Kornblum's hubris puts at risk all our good work, Sam. Why should Europe buy films about an America that is down and out? Or worse, shows racial and religious intolerance? Europe and the rest of the world don't want to import our problems. They have plenty of their own. They want our love stories, our comedies. It's these immigrants! Their fault! First, nobody wanted them in their own countries, so we let them in here. This crowd, who no one could stand in the first place: their looks, their religion, their manners—what were we going to do with them? Aggressive. Pushy. We looked for some place out of the way. We gave them Hollywood. Nobody wanted it, no water, a desert. Far away from anyone or anything that counted. But clever, that tribe, full of surprises. For over a thousand years they became practiced at being unwanted, and making the best of it. So what do they do out there, in exile? They invent the film business—[in] which before them, no one was interested. And what did they choose to make films about? Their problems? No! If our America didn't accept them, they would invent another, dream America—their own version: romantic, optimistic, glamorous! And when the America that couldn't stand them saw the America they were making films about, that's the America they wanted too! And soon—the whole wide world wanted to share the America invented by these people no one could stand. So what happens, Sam? As the night follows the day, what always happens when things are going well. Some of these immigrants—or their children—living the high life in Beverly Hills, they decide they don't like being mere entertainers. They want to be Artists! Tackle serious subjects. That rub our noses in our sins and our hypocrisies. The fools! The more these works of Art are shown overseas, the more everybody stays away. This is not the America they go to the movies for. The market dries up! And so, Sam, we come to your mission with the music boxes. What you do, Sam, is like a patriot on the front lines, convincing these phonies to be entertainers again. And it's working, Sam! But always, always there is the danger of slipping back. This is no time to delay your mission. Kornblum must be made an example of! (50–51)

In contrast to the dynamic or braided page layouts that constitute the defining aesthetics of this volume and of the trilogy as a whole, this double page appears both unusually static and word dominated.[13] Hannigan is merely portrayed as the motionless and speechless receiver of a long harangue

emanating from an invisible interlocutor across a telephone line and spreading over the left sides of the pages in no fewer than twelve speech balloons (figure 2.2). Hannigan's passivity and uncritical receptivity are clearly implied by the absence of action in this sequence of two images showing two identical bodily postures and facial expressions, albeit from different angles. As for the rhetorical construct of Cousin Joseph's speech itself, it accumulates the typical fallacies and inconsistencies of far-right argumentation.[14] A double dissonance permeates its overall reasoning. First, Hollywood "entertainment films"—as opposed to their more artistic counterparts—are presented both as "phony" products made by illegitimate outsiders *and* as desirable commodities that embody the nation's collective aspirations and identity; in essence, Jews are simultaneously blamed and hailed for "glamorizing" the American Dream. Second, the Jewish immigrants who specialize in the niche business of film are characterized on one hand as despondent and unwanted foreigners relying on America's generosity and permissiveness, and on the other as entrepreneurial geniuses capable of identifying a new market and thriving from it ("clever, that tribe"); in essence again, they are intrinsically unlikeable and admirable at the same time. Paradoxically, according to this logic, the values of social promotion through individual resourcefulness and business ingenuity integral to the American Dream do not extend to Jewish Americans.[15] These contradictions are resolved by a racialized understanding of the Jewish "essence" that fully aligns with Nazi ideology, whereby Jews are inherently different, inferior, and devious. Cousin Joseph's scapegoating logic relies equally on such binary markers of non-normativity ("their looks, their religion, their manners," seen as "aggressive" and "pushy"), on the falsehoods of atavism ("for over a thousand years they became practiced at being unwanted, and making the best of it"), and on a presupposed consensus about universal antipathy toward Jews, in their home countries as in the United States ("these people no one could stand"). By referring to individuals as a "tribe," this argumentation not only places generic blame on an entire collective but also presents its actions as intentionally coordinated, a standard feature of conspiracy-fixated, far-right charges against minority groups. References to wealth and luxury ("living the high life in Beverly Hills") have the clear intention of triggering Hannigan's working-class envy and resentment. Finally, ridiculing the artistic ambitions of Jewish filmmakers and the status of cinema as an art correlates with the deep anti-intellectualism at the core of Nazism and its culture wars, which prompted book burnings, exhibitions against modern art, and a profound reform of the German educational system[16] (Bendersky 2007, 121–122). In addition to its unequivocal antisemitic

FIGURE 2.2 Cousin Joseph's antisemitic speech about Hollywood. From *Cousin Joseph: A Graphic Novel* by Jules Feiffer, p. 51. (Copyright © 2016 by B. Mergendeiler Corp. Used by permission of Liveright Publishing Corporation).

bias, Cousin Joseph's speech seeks to bend cinematic representations of America to his (and his nation's) political interest. As a propagandist, his understanding of Jewish filmmakers' ability for seduction is deeply ambivalent, insofar as it faults image makers for their very efficacy. To stop the new trend of "social films" focusing on America's economic difficulties and societal flaws such as "racial and religious intolerance," which could lead to the development of a leftist social conscience among spectators, he demands the return of glossy, seductive, escapist, but ultimately superficial spectacles that shield viewers from critical perspective.

In depicting German agents operating on U.S. soil in the early 1930s, specifically in the Los Angeles area, Feiffer's fictional plot does not stray too far from actual events. Ross's historical essay on the activities of the Friends of New Germany (FNG) and the German American Bund cells against Hollywood and Jewish filmmakers documents a series of similar activities for media control, which included pressuring movie studios to promote a favorable image of Germany and hatching plots to murder moguls (Samuel Goldwyn and Louis B. Mayer) and directors (most notably Charlie Chaplin) (Ross 2017, 198–213).[17] In addition to the film industry, the Nazis saw other potentials to exploit in Southern California, such as a very active Ku Klux Klan (Ross 2017, 11); a long history and a rising tide of antisemitism and right-wing extremism (3, 11); a financial oligarchy with "pronounced fascist leanings" (198); an array of evangelists, demagogues, and propagandists spewing far-right rhetoric to the masses; and a large population of World War I veterans whose anti-government resentment and precarious status during the Depression could be stirred to foment trouble, as they were in Germany (15–16). Ross also notes that members of the Los Angeles law enforcement system had connections or sympathies with Nazism and its American branches, which leads us to examine the emblematic case of Sam Hannigan.

Sam Hannigan and the Immigrant Parable

"What you do, Sam, is like a patriot on the front lines." Cousin Joseph's appeal to Hannigan evidently targets and manipulates the latter's nationalistic predisposition. Although he is unaware of his mentor's true political agenda and has no ideological ties with Nazism, Hannigan is particularly receptive to such reactionary rhetoric because it confirms his own understanding that America is in decline during the Depression. His first words in the novel are fragmented thoughts about the disappearance of his father's America: "Where

did America go?" (4). This is precisely the type of homegrown disenchantment on which pro-Nazi agents attempted to capitalize. Throughout the novel, Hannigan's misguided patriotism is reiterated. In his ethos, restoring the nation justifies violence against agents of social decay, either in the media (filmmakers) or in the workforce (labor unions): "My life, for what it's worth, . . . is doing what I can for my country" (7). He does not accept Cousin Joseph's payment for his services but works pro bono out of duty to his country, only seeking to do "some good" as a "good American" (8). Patriotism also trumps religion in his personal ethos, as he remarks to Gaffney when discussing their common Irish Catholicism: "First, I'm an American. After that, it's nobody's business" (18).

Hannigan's idealized notion of America is steeped in his romantic understanding of his father's immigration as the epitome of the "American Dream," a term first coined formally in 1931—the very year of Feiffer's story—by the historian James Truslow Adams, himself the son of immigrants, in *The Epic of America*: "The American dream, that dream of a land in which life should be better and richer and fuller for everyman with opportunity for each according to his ability or achievement . . . it is not a dream of motor cars and high wages merely, but a dream of a social order in which each man and each woman shall be able to attain the fullest stature of which they are innately capable, and be recognized by others for what they are, regardless of the fortuitous circumstances of birth or position" (Adams 2001, 404).

The double-page sequence in which Hannigan idealizes his father's immigration story is rich in elements that exemplify such aspirations, both thematically and visually:

> My father, Dennis Colt Hannigan, came to this country dirt poor. A failure at farming, and anything else a man could fail at back in the old country. The one thing he had going for him was his voice. His beautiful tenor voice. On the ship coming over, his golden voice belted out songs he learned off the radio. Not Irish ditties, mind you, but American songs, meant to bring him luck in the new land! And his listeners were done for! Overcome! They threw coins at him. More coins in an hour than he'd seen for a year in County Mayo. And as my father crossed this country on foot and mule and boxcar, the breadth and grandeur of this new land—America! gave him a lover's passion. And the shower of coins went on. He taught himself more up-to-date songs. *Toot-Toot-Tootsie Goodbye* . . . Luck and more luck! And then, one day, it was over. Stopped cold. And then a month or so later, began again. And then, stop again! And that's how it went with my dad. A married man, by now, five mouths to

feed. Stops and starts, rich or on the skid, no complaints. Never joining a union. Always good for a laugh. Till the day he died, on his fortieth birthday, my old man taught us we were the best family in the world living in the best country in the world. And here I am today, carrying his legacy. Can't sing a note, but with the wit, and muscle, the good lord gave me, fighting in my father's name to beat back the weak sisters, and the un-Americans who'd sell us down the river for a plugged nickel. (60–61)

This teleological narrative gathers all the chief components of the American Dream, namely an individual's transformation—through merit, gumption, and ingenuity—from abject poverty in the old world to economic and personal success in America, and the resulting sentimental attachment ("a lover's passion") to this land of opportunity, associated with its natural beauty (its "breadth and grandeur"). Such unconditional devotion becomes so deeply ingrained that it overlooks any contradiction thereto, notably the capricious and intermittent nature of wealth and success in America—an implicit criticism of those who lost belief in the country during the Depression ("the weak sisters and the un-Americans"), perceived to be weak and ungrateful. Other notions of resiliency permeate this complacent family mythology, such as the view that American immigrants of past generations, regardless of their financial needs ("five mouths to feed"), valued self-reliance above all and never complained ("always good for a laugh") nor asked for government assistance. Such glorification of individualism, understood in contrast to any form of wealth redistribution, remains an ideological staple of the American right to this day. The resulting impact of such idealized beliefs leads to uncritical assertions ("we were the best family in the world living in the best country in the world") and deprives Hannigan of the proper conceptual tools necessary for political nuance and relativity. Feiffer presents Hannigan as a test subject for the fallacies of the American Dream, who embodies the virtuous American citizen with good intentions yet is deceived, manipulated, and betrayed by those who exploit his mythical understanding of his country.

This hyperbolic memory of the American Dream recalls Judge Jerome Stern's long monologue in Feiffer's play *Little Murders* (skillfully delivered by Lou Jacobi in Alan Arkin's 1971 film version), when the character presides over Alfred Chamberlain and Patsy Newquist's civil wedding and chastises the groom's apparent nihilism. Much like Hannigan, his immigration family narrative mythologizes turn-of-the-century immigrants and captures the essence of conservative creed by praising his parents' hard work ("My father

worked fourteen hours a day in a sweat shop on lower Broadway"), sacrifice ("[My parents] had in common the sacrifices each of them had to make to get where they were"), gratitude ("[My mother] kissed the sidewalk the minute she got off the boat, she was so happy to be out of Russia alive"), freedom from persecution ("What they had in common was persecution"), faith ("So, they weren't so glib about God. God was in my mother's every conversation about how she got her family out of Russia, thank God, in one piece"), resiliency, and self-dependency ("There weren't any handouts in those days") (Feiffer 1968, 42–43). Similarly to Hannigan's, the judge's righteous and passionate discourse also implies generational decline as, by contrast to their elders, subsequent generations appear "pampered" and lazy.

Sam Hannigan's nostalgia for his father's America is inseparable from an embellishment of its virtues, which is conveyed not only by the stereotypical content of Hannigan's discourse but also by the irony that permeates Feiffer's illustrations thereof. Indeed, the graphic counterparts to this speech call attention to its subjectivity through an exaggeration of their own. The ancestor's mid-journey metamorphosis from indigent Irish immigrant to impassioned American performer is summarized in three contrasting images. The first two set up this duality through the juxtaposition of the despondent immigrant, slumped and carrying his meager possessions in a bundle, and a close-up on his face and hand gestures captured mid-song, exuding fervor and confidence. The third and bottom image—a full-body depiction of the singer's expressive posture during his melodramatic performance—overstates even more Hannigan's sentimental perception of his father. The top of the following page continues this series of drawings but on a horizontal axis, apposing four panel-less portrayals of the singer in similarly dramatic poses (clutching his heart, raising his hat, and holding a cane), but interrupted in the third iteration by an apparently dejected avatar of the same character with hands in pockets, eyes and mouth closed, and shoulders slumping, a figuration of his periodic failure in show business. The final two images of this illustrated sequence feature the immigrant proudly standing in front of his family and singing while raising a top hat, and a close-up on his smiling face, which concludes Hannigan's rosy narrative. This silent choreography of exaggerated postures not only recalls Feiffer's earlier cartooning but some of the founding aesthetics of comic art, most notably Rodolphe Töpffer's reliance on caricature, pantomime, and theatrical body language, often with ironic intent (Groensteen 2014, 46; 126–129) (figure 2.3).

There is additional irony from Feiffer in the repertoire he attributes to Sam Hannigan Sr. While all songs return to an era of American insouciance and

FIGURE 2.3 Sam Hannigan remembers his Irish father's immigration to America. From *Cousin Joseph: A Graphic Novel* by Jules Feiffer, p. 60. (Copyright © 2016 by B. Mergendeiler Corp. Used by permission of Liveright Publishing Corporation).

upbeat musical forms such as ragtime, vaudeville, and jazz of the 1910s and the "roaring" 1920s, they are also associated with Jewish creators and African American culture—a definite paradox given Sam Hannigan's reactionary beliefs. Irving Berlin's "Alexander's Ragtime Band" (1911), George Gershwin and Irving Caesar's "Swanee" (1919), and Gus Khan and Ernie Erdman's "Toot, Toot, Tootsie (Goo'Bye!)" (1922) not only epitomize the contributions of Jewish composers to early twentieth-century American music but are also associated with Jewish performers such as Al Jolson. Such is the paradox of Hannigan's nativism that, as the son of an Irish immigrant, he feels more "American" than those who arrived later and denies them the very opportunities that he cherishes in theory. In truth, his father's career as an entertainer is not all that dissimilar from that of the Jewish immigrants who sought fortune in the film industry. How an immigrant group that experienced discrimination, such as the Irish in America, can turn against another immigrant group under the false logic of nativism constitutes another contradiction in Hannigan's worldview. However, Hannigan is "not a stupid man" (83) by his own admission; interestingly, the events that lead him to reassess his actions are also linked to the power of cinema, as I discuss below.

Kornblum's Script: "Love America! We Are All One!"

Having reluctantly accepted Hannigan's bribe, albeit only under physical threat, Kornblum nevertheless persists with his project and prepares to announce the making of a new film—one that, in Cousin Joseph's assessment, will "make a mockery of the America that [he and Hannigan] are fighting for" (49). In retaliation for the scriptwriter's obstinacy and creative independence, and as a deterrent to other filmmakers who may follow suit by disregarding Cousin Joseph's directives, "Kornblum must be made an example of" (51). With the complicity of police authorities, the power broker arranges for Hannigan to be pulled away from his duties as a member of the Red Squad so that he may focus on delivering Kornblum's comeuppance (his "lumps," as Hannigan puts it), with Gaffney's assistance (54). On their way to the filmmaker's mansion, the two enforcers remain convinced of their patriotic mission: "For the love of country," they are off to "punish Kornblum and his kind" (another antisemitic allusion) for "crapping on the American flag," a form of desecration that Hannigan, using the same rhetoric, also associates with the union strikers and considers a justification for violence (59). The parallel between anti-union repression and the victimization of Kornblum is

visually displayed in a clever double-page layout (64–65) depicting, on the left side and partially across the page fold, the strikebreakers' chaotic assault of protesters and, in a thin vertical panel on the right, the conversation in which Hannigan and Gaffney draft their attack on the well-defended Kornblum mansion. While thematically justified, this juxtaposition nonetheless appears visually striking due to the heterogeneous nature of the two panels, which are different in size (one very wide and the other very narrow), geometric shape (one a horizontal rectangle and the other a vertical one), perspective (one a close shot and the other a bird's-eye view), text (one wordless except for protesters' signs and the other staging a dialogue in nine speech balloons), movement (one multidirectional and the other linear), time (one implying simultaneity and the other progression), positioning on the page (one central and the other marginal), iconic iteration (one a single tableau and the other a composite of multiple occurrences of the same figure), and number of protagonists (one painting a large crowd and the other only two people inside a car). Another irregular or unusual element is the vertical insertion of a chapter title (chapter 24, "Diversion") between the two images. Showing a vehicle in motion and an unfolding dialogue over a single page or panel space, without formal grid or sequential dividers, constitutes a visual device that mimics the continuity of film through an innovative reconfiguration of graphic syntax (see the introduction to this chapter and the discussion of similar layouts in chapter 1).

Hammond and Gaffney set fire to Kornblum's swimming pool to draw away his bodyguards, then kidnap the filmmaker at gunpoint (67–68) and drive him to the edge of a cliff, where they proceed to beat him savagely and suspend him by his ankles over the precipice (71–72). Accused of betraying Cousin Joseph's generosity and making an "unpatriotic" movie, Kornblum must convince the two brutes that "Cousin Joseph has it all wrong" and that his story in truth "loves America." In one of the book's longest and richest chapters (chapter 26, "The Pitch"), he narrates the content of his script in a desperate attempt to convince the two men that its true message does not disparage their values: "Give me five minutes—ten minutes! Is that too much to ask? You'll love it!" The singularity of this chapter lies in its inherent intermediality as a graphic translation of a (nonexistent) movie. Feiffer visualizes Kornblum's plot summary with corresponding illustrations, drawn in garnet ink, colored in sepia tones with pink and tan hues, and framed in panels with squiggly contours. These graphic choices constitute exceptions to the overall aesthetic codes of the novel as a whole and make this section stand out visually, by contrast, as a story within the story. The precarious context of

Kornblum's pitch also highlights the seductive nature of the filmic interplay itself—its communicative force and capacity to beguile even the most unsympathetic viewers. In this regard, Feiffer's visualization of a narrated plot is multifold, to the extent that the plot itself, as verbally enunciated, is all at once an invitation for the two listeners to picture filmic images, an optical rendition of the accompanying text for the readers, and the citational reiteration of a familiar, cinematic iconography (figure 2.4).

Kornblum's script tells the story of Jerry Margulies, a young Jewish immigrant from the slums of the Lower East Side who dreams of becoming a doctor and turns to professional boxing to finance his studies.[18] He changes his identity to Jerry Maloney to attract a bigger crowd, then wins the championship fight against an Italian prizefighter, Buddy Di Franco, and falls in love with a "shiksa" girl named Sally Savoy. Kornblum initially struggles to capture his listeners' enthusiasm, as Hannigan expresses disagreement with many elements of the plot's premise: he does not like the story's focus on Jews and slums, the notion of a Jew passing as Irish, nor the interethnic romance between Jerry and Sally: "A Jew with a white woman! I've heard enough!" (74). However, Kornblum adds that Sally's father objects to her dating an Irish boy, and that Jerry's new Irish name, although advantageous in the ring, becomes an obstacle to his admission to medical school, so he changes his name again to Jerry Montgomery. Such mentions of anti-Irish discrimination result in making the story more relatable for Hannigan and Gaffney, both of Irish descent, and on the basis of this newfound empathy, Kornblum begins to reshape his audience's understanding of immigration and patriotism. Having become a brain surgeon, Jerry befriends his old boxing opponent Buddy Di Franco, who also changed his name to Dr. Defoe[19] to hide his Italian origins and get into medical school. One day, Sally Savoy comes to the hospital with her father, who needs a brain operation. Sally does not recognize Jerry but falls in love with Defoe, while Jerry sacrifices his own romantic feelings for the couple's sake. Both men successfully perform brain surgery on Sally's father, then immediately enlist in the army upon hearing of America's entrance into World War I. This sequence of plot events unfolds over nine sepia panels representing its key stages as isolated film stills, or a "drawn film novel" (Baetens 2019, 11–17), although they do not employ the standard photorealistic aesthetics of the genre: Jerry as a young immigrant against a backdrop of urban poverty; Jerry's multiple roles as a boxer, as Sally's suitor, as a doctor, and as Defoe's friend; Sally with her father, then with Defoe; and the two surgeons lifting their gaze from the operating table to see the front pages of newspapers announcing the start of World War I.

FIGURE 2.4 Feiffer visualizes the plot of Kornblum's screenplay. From *Cousin Joseph: A Graphic Novel* by Jules Feiffer, p. 74. (Copyright © 2016 by B. Mergendeiler Corp. Used by permission of Liveright Publishing Corporation).

The conclusion of Kornblum's script formulates an allegorical aggrandizement of its characters' fates. As the two doctors prepare to leave for war in Europe, they take part in a parade on Fifth Avenue. Sally, tending to her recovering father and about to head to war herself as a nurse, sees the soldiers from her balcony and recognizes the two men she loves among them. From her overhanging perspective on the parade, she realizes that all the soldiers, regardless of their national or ethnic origins, are *Americans*: "Every last one of us! Protestant, Italian, Jew! All of us are Americans!" Individual distinctions—including her own conflicted attachment to two men—matter less than the common purpose and identity of the soldiers below, "men of every race and religion, [on a mission] to make the world a better place. A place like America! 'America!' Sally shouts. And the multitudes below shout back as one: 'AMERICA!' Fade out. The end. What do you think?" (75).

Kornblum's movie appeals to Hannigan and Gaffney's love of nation and belief in patriotic duty by resorting to classic melodramatic and didactic devices that draw on the intersection between the personal and the collective. The parade scene and its accompanying full-page illustration are exemplary in this regard. While borrowing from film and newsreel iconography, it sets—within a single moment and a single image—a contrast between the verticality and stillness of Sally's viewpoint and the horizontality and forward motion of the mass of soldiers on the street below, as well as between her individual desires and the communal progress of history. Similarly, other melodramatic elements of the film merge the main character's individual path with the usual pathos and relatable archetypes of the immigrant's social promotion, athletic ambition, impossible love, professional development, conflicted friendship, self-sacrifice for noble motives, and departure for war—all of which not only pull at the audience's heartstrings but also facilitate the concrete embodiment of abstract ideals, made more convincing through empathy. Feiffer's made-up film plot also echoes the history of 1930s American cinema, with multiple interpictural references to boxing films, medical drama, and war pictures. Indeed, boxing films made during the Depression, such as *Winner Take All* (Roy Del Ruth, 1932, with James Cagney in the leading role), often presented the sport as a metaphor for social struggle and economic desperation. Early medical dramas mixing romance with a hospital setting included the series of films featuring Dr. Kildare,[20] transposed from Max Brand's magazine stories to the screen by Paramount Pictures and MGM (1937–1942). Numerous war films of the 1930s also relied heavily on romance as a dramatic device, for instance *War Nurse* (Edgar Selwyn, 1930), depicting a group of American nurses in France during World War I, *A Farewell to*

Arms (Frank Borzage's 1932 adaptation of Hemingway's novel), and *Today We Live* (Howard Hawks, 1933, with a script by William Faulkner).

The question that Sally ultimately asks herself, as she watches the parade of men bound for war, conjoins her own identity with that of the nation: "Who am I?" correlates with a Pan-American identity that subsumes and sublimates tribal differences under a common sense of belonging, leading proponents of romantic nationalism like Hannigan and Gaffney to rethink their ethnocentric vision of America, no longer a fixed essence but a collective process of becoming. Surprised and seduced by the movie's unexpected message, Hannigan asks for Kornblum's confirmation: "I'll be damned! ... Tell me if I got this right. They all come from different places and have different faiths. But they all want the same thing. Even though they maybe don't start out as Americans, they wanna be American like us!" (76). Even the unenlightened Gaffney, who professes to dislike cinema because "all the actors look queer," admits that this is a movie he would like to see and draws a connection with his own family narrative: "Yeah! Like I'm from Ireland. But nobody is more American than me!"

Kornblum's script activates Sam's critical thinking, and he begins to see the flaws and contradictions of his patron's rhetoric: "Huh! I gotta think this over. It's possible Cousin Joseph was misinformed. I don't think you could get more American than this movie. I'll explain it to Cousin Joseph." This passage of the graphic novel where a left-leaning Jewish filmmaker manages to convince two violent and uneducated men to rethink their prejudice and ideology through the sheer power of images (mental ones at that, as Kornblum's narrative is only conveyed through speech) ironically confirms Cousin Joseph's fears about the persuasive force of media imagery. What Kornblum achieves with his fiction is no less than a complete reversal of his listeners' prejudice. Indeed, this script provides a discursive combination that uses staples of American mythology and cultural consensus against their reactionary appropriation: a collective belief in militarism (the army, war, and parades) and an uncritical adherence to models of masculinity that the two policemen can appreciate (boxing as a social ladder, the prevailing code of male friendship, and other forms of heroism such as brain surgery). The pulp tone of the movie also wraps its political message with a sheen of humor and romance, making it more palatable to a popular audience: "Kind of like a comedy, but it's really serious?" as Hannigan remarks. To combat antisemitism, it also reinscribes Jewish immigration and marginality within the wider context of other immigrant groups that also struggled to integrate into the American mainstream, the Irish and the Italian. In a whimsical plot twist, Feiffer stages

with obvious amusement an episode where an artist wins a battle against physical force with words and images—a meta-artistic statement about the political potential of art. The last image of this sequence, which depicts Kornblum's contentment, could be read not only as an expression of relief from peril but also creative satisfaction, as his two aggressors leave him with an apology.

In a follow-up telephone conversation, Sam summarizes his newfound clarity of perspective to his mysterious, "sorely disappointed" backer: "Cousin Joseph, you're wrong! Whatever you heard, Kornblum's movie is *not* anti-American. It couldn't be more American. It—It's what America is about! Every one of us coming from all over, different nationalities, religions, races— every Tom, Dick, and Harry wanting the same thing. To be just as American as the other guy in this, the greatest country in the world! That's the movie Kornblum is out to make" (83). In response, Cousin Joseph attempts to return to his antisemitic narrative. He contends that Hannigan was fooled and generalizes his assessment to all Jewish filmmakers, whom he presents as intrinsically manipulative and deceitful: "Men such as Kornblum— sophisticated, cosmopolitan, they are masters at this game. They've had centuries of practice.... Kornblum has tricked you, Sam. That's the genius of these people." Here, as in previous passages, Feiffer captures the obfuscations and circumlocutions of antisemitic rhetoric: "Men such as Kornblum," the pronoun "they," and the phrases "these people" and "this tribe of tricksters" express oblique, coded, yet unambiguous references to Jewishness; and stereotypes of class or intellectualism ("sophisticated"), statelessness ("cosmopolitan"), and history ("centuries of practice") rely on the same implicitness of language. Once again, Cousin Joseph's rationale also relies on fallacies of consequence, often using the same logical connectors (notably the Shakespearean "as the night follows the day") to construct false causalities or correlations anchored in what he frames as the inherent treachery of the Jewish people, whom he blames for instigating an array of global catastrophes such as America's involvement in World War I, the Russian Revolution and the creation of the Soviet Union, and the Great Depression. These charges of fostering conflict lead to another falsehood, the accusation that "these tricksters [may] succeed in luring us into another world war"—a particularly odious contention given the impending genocide of European Jewry during World War II. Lastly, the usual notions of conspiracy deeply embedded in antisemitic discourse—such as the "secret financing" of anti-American initiatives and covert intentions of "weakening" America for a takeover—likewise pervade this narrative.[21]

Although Cousin Joseph argues that Kornblum's film is a mere "diversionary tactic" and a "pretense" that is only "patriotic on the surface," and exhorts Sam to resume violent action against the filmmaker and to "stand up for [his] country," the once duped police officer no longer responds to such orders. Feiffer shows Sam's progressive disagreement and distrust in a sequence of nine iterations of his character receiving Cousin Joseph's monologue over the phone without uttering a single word of his own. The first eight images, arranged as two rows of four unframed figures each, render a process of increased detachment through bodily postures, viewing angles, and facial appearances. Sam's full-length body is shown from different angles (dorsal, frontal, and lateral) and in varied postures (sitting, standing) as he progressively moves the phone away from his face in an expression of skepticism and annoyance (84). His irritation and doubt, compounded by his silence, culminate in the last image at the bottom of the page, a larger rendition of Sam's face, presented frontally in an extreme close-up but truncated by the bottom edge of the page. This excision of his mouth and chin symbolically figures his refusal to further engage in acquiescence or debate with his interlocutor, left dangling on the other side of the line, repeating phatic calls for contact in multiple speech balloons emanating from the receiver: "Sam? Sam? Are you there, Sam? Sam?"

"I'm Sticking with the Union" (Woody Guthrie)

In his life narrative *Backing into Forward*, Feiffer recalls that he became interested in American politics and more specifically in union movements quite early in his creative life while working in Will Eisner's studio in the late 1940s and conversing with other artists and writers in that circle. There, he discovered American "left-wing heroes," and in particular novelists (John Steinbeck, Theodore Dreiser, John Dos Passos, Jack London, Dashiell Hammett), labor organizers (Bill Haywood, Eugene Debs, the Wobblies), civil liberties activists (Clarence Darrow), and politicians involved in labor reforms (the Illinois governor John Peter Altgeld) (Feiffer 2010, 76). In the same section of his autobiography, he also remarks that famous events in labor history had a deep and lasting impact on his political sensibility: the 1886 Haymarket Riot, the 1894 Pullman Strike by the American Railroad Union, and the 1910 *Los Angeles Times* bombing. In subsequent chapters, he also mentions the 1919–1920 Palmer Raids targeting suspected leftists and labor agitators (98). To that extent, the inclusion of a union strike in the fictional plot of

Cousin Joseph fits within Feiffer's larger worldview, as well as American literary and filmic history.

Indeed, using the narrative vehicle of noir to reflect on the struggles of the labor movement in the 1930s and 1940s goes back to one of the founding texts of American hard-boiled literature (Porter 2003, 98–101). In Dashiell Hammett's *Red Harvest* (published in the pulp magazine *Black Mask* in 1928–1929, then as a novel in 1929), the first-person narrator—a nameless agent of the Continental Detective Agency simply identified as the Continental Op—is a San Francisco private investigator who investigates the murder of a journalist in the Montana mining town of Personville, often called "Poisonville" by its inhabitants. He finds out that the victim's father, the industrialist Elihu Willsson, owned Personville "heart, soul, skin, and guts" and controlled the city's economic engine (the mine), its bank and newspaper, as well as local and state representatives. To maintain his economic empire, he ensured the brutal repression of a labor dispute organized by the Industrial Workers of the World (the IWW or the "Wobblies" as they were known), which Hammett's narrator summarizes with his usual ironic detachment: "The strike lasted eight months. Both sides bled plenty. The wobblies had to do their own bleeding. Old Elihu hired gunmen, strikebreakers, national guardsmen and even parts of the regular army, to do his. When the last skull had been cracked, the last rib kicked in, organized labor was a used firecracker" (Hammett 1992, 9).

Corporate exploitation of desperate workers during the Great Depression, labor struggles for living wages, safer working conditions, and shorter workdays, and violent responses thereto constitute recurring themes in American literary realism of the 1930s, most notably in John Dos Passos's *U.S.A.* trilogy (1930–1936) and John Steinbeck's *The Grapes of Wrath* (1939). The same subject matter is also depicted in American cinema of the 1940s and 1950s, for instance in *The Valley of Decision* (Tay Garnett, 1945), relating a strike at a Pittsburgh steel mill, or, more militantly, in *Salt of the Earth* (Herbert J. Biberman, 1954), a movie written by blacklisted writers and producers, reenacting a strike at a zinc mine in New Mexico. Such fictional representations clearly sought to refer—explicitly or in a more allegorical manner—to true historical events. The list of actual strikes around the period of Feiffer's graphic novel is of course too long to itemize here.[22] The 1929 Loray Mill Strike of North Carolina textile workers, the UAW auto workers' strikes of the 1930s, the 1931 Tampa cigar makers' strike, and the 1937 Little Steel strikes of industrial steel workers in Ohio and Illinois all share similarities in the nature of workers' legitimate demands, in the politicization of their action in the

context of the Red Scare (whose rhetoric heavily influenced the justification for harsh countermeasures), and in the concerted obliteration of their protests by the police and vigilante squads[23] (for a complete list of U.S. labor strikes, see Arnesen 2007). During the auto workers' strike at the Ford plant in Dearborn, Michigan, in March 1932 (often referred to as the "Ford Massacre"), the police fired machine guns at protesters, killing six and injuring many more. In the infamous 1937 Memorial Day Massacre, the Chicago police ended the Little Steel strike by clubbing unarmed citizens and firing at demonstrators, killing ten people and wounding many others.[24]

The subplot of *Cousin Joseph* that revolves around a union strike at a fictional California cannery called Knoxworks undoubtedly echoes the Santa Clara cannery strike that took place in the summer of 1931, the same year as Feiffer's story, and in the same general location (Feiffer's fictional Bay City standing in for Santa Monica as an intertextual allusion to Raymond Chandler's novels). Historians tend to view this event as an emblematic case study of the economic and political realities of California under the Great Depression (Daniel 1981). With a long practice of vegetable and fruit farming followed by the industrialization and corporatization of canneries, California suffered a major setback during the Depression when demand for its products plummeted along with consumers' purchasing power, threatening the profit of industrialists and creating deeper instability in working-class communities, where fluctuations in employment and wages were already the norm due to the seasonal nature of fruit and vegetable growing. Working conditions were also known to be especially harsh in canneries, where employees were often victims of occupational injuries. During the Santa Clara cannery strike, workers staged a walkout and protested in demand of better wages and working hours. Their collective action, supported by unions (the American Labor Union and the Cannery and Agricultural Workers Industrial Union), was met with violence unleashed by the police and vigilante squads of strikebreakers (Daniel 1981, 170; Devinatz 2007, 207).

In various parts of his story, Feiffer includes other citational elements referring to this era, such as allusions to Woody Guthrie. One of the chapters, entitled "Union Maid" and describing the profile of a female striker and single mother, alludes to Guthrie's song by the same title, extolling the resilient virtues of women unionists:

There once was a union maid
Who never was afraid
Of the goons and the ginks and the company finks

> And the deputy sheriffs who made the raid
> She went to the union hall
> When a meeting, it was called
> And when those company goons came round
> She always held her ground
> (Woody Guthrie, "Union Maid")

In the same vein, Feiffer depicts a Guthrie-like, guitar-slinging folk singer performing near the entrance of the Knoxworks cannery, singing anti-capitalist lyrics about unfair wages and the avarice of the factory owner:

> Union's comin' Hardy Knox
> Union's comin' to unlock your locks
> Unlock your heart, unlock your vaults
> Workers marchin' to end your assault (13)

Captured mid-performance, his head is tilted to the right, as in many iconic pictures of Guthrie.[25] The same singer, whom Feiffer playfully named Hootie Pines, is savagely assaulted by Sam Hannigan in a later passage in retaliation for his politics, even though the song he sings in this instance appears to have no overt political content whatsoever (24).

Feiffer's fictional—yet deliberately citational—depiction of a cannery strike centers on the intersecting actions of three archetypal characters in addition to Hannigan, the cop blinded by a deeply flawed sense of patriotism: the industrialist (Old Man Knox), a female striker (Cissy Goldman), and a union organizer (Billy Doyle). Old Man Knox makes his first appearance on the same page depicting Hootie Pines's protest song, whose lyrics rhythmically and visually unfold over the page in four sets of four-line stanzas, rising from the street level to reach the top of the page featuring Knox angrily observing the scene from his high-perched office window (figure 2.5). The vertical stratification of this page, organized around the shape of the gray factory, creates a symbolic separation between the top of the image (the factory's boss, observing the scene alone and from a panoptical position) and the bottom (the horizontal line of workers entering the factory as an indistinct mass with no discernible facial features nor individuality, all dressed in similar hats and coats). This stacking effect aptly visualizes the factory's hegemonic structure. However, within the blurred crowd, in contrast with the barely sketched figures of the workers, two characters emerge with a higher degree of focus and verisimilitude: the singer himself and Cissy Goldman, shown

FIGURE 2.5 Old Man Knox and the Knoxworks cannery. From *Cousin Joseph: A Graphic Novel* by Jules Feiffer, p. 13. (Copyright © 2016 by B. Mergendeiler Corp. Used by permission of Liveright Publishing Corporation).

facing the reader and walking in the opposite direction of the other employees, as if turning her back on factory exploitation and its negation of individualism. On the following page, Knox cuts an equally imposing figure of uncompromising capitalism as he makes a demonstration of his strength and immunity to intimidation by asking his right-hand man and fixer, Elliot, to punch him in the gut as hard as he can—intimating his invulnerability to union strikes (14). Yet a few pages later, in a carnivalesque reversal of this scene (chapter 10, "Not So Hard Knox"), the same experiment yields opposite results. In this corollary scene, Knox asks once again to be punched in the gut as hard as possible, this time by a much larger man, Monty Dobbs, chosen from among the strikers and charged with delivering a message of intransigence to his union leader, Billy Doyle (25). He assures his employee that there will be no repercussions for his actions: he will not be fired nor sent to jail for assaulting his boss. In fact, countering Dobbs's objections, he assures him that he will be fired should he refuse to act as ordered. However, when Dobbs obliges him with a punch so strong that it folds the old man's body in half, he becomes the victim of Elliot's retaliation: "Get that son of a b-tch! Kill that son of a b-tch! I want him dead!" As a token of labor negotiation with corporate ownership, this episode points to the latter's intrinsic lack of fairness; its posture of strength and inflexibility is a pure simulacrum, and its promises are neither honest nor binding.

Indeed, Old Man Knox appears highly skilled at constructing self-interested narratives and enlisting the assistance of repressive agents to quash any opposition to his enterprise. A recurrent rhetorical device consists of accusing strike leaders of being communists, with the implicit understanding that this label alone—whether accurate or not—legitimizes a violent repression of any organized labor demonstration, with the full consent of authorities, in the political context of the Red Scare. Although Elliot argues that Billy Doyle is "not a Red" (an assessment shared by Sam Hannigan himself, as I will discuss later), Knox advances that "the minute his men walk off the job, they're all Reds! What they call a strike, I call subversion" (38). Feiffer identifies the extent to which words, labels, and characterizations played a central role in the politics of the 1930s, as they did during McCarthyism, and have continued to do until today. Such a focalization on the rhetorical devices of politics and close attention to language—manifesting his apparent distaste for the inauthentic discourse of politicians—was a trademark of Feiffer's political cartooning in the *Village Voice* for six decades (1956–2002). He particularly excelled at capturing the tone and mechanics of political obfuscation (Fay 2015, 114) in caricatures of American presidents, from

Eisenhower to George H. W. Bush[26] (his anti-Nixon cartoons alone are masterful studies of political hypocrisy).

The pages depicting the strike itself employ remarkable aesthetic configurations to convey the intensity of the conflict. Chapter 21, entitled "Strike," consists of two juxtaposed, full-page sceneries (56–57), in the periphery of which Feiffer inserts more traditional panels outlining Knox's strategy for stamping out the workers' rebellion. The left side of this diptych offers a high-angled view of the workers marching toward the reader across the left-to-right diagonal axis of the page. From this distant and dynamic perspective, the strikers form an expressionistic mass of sketchily drawn faces shouting slogans and hands holding signs. Feiffer's bold hand-lettering of rallying cries ("Strike!" "Fair pay or no work today!" "Union pay must start now!" "Raise our pay or no fish today!" "Raise our pay for a shorter day!") spreads over the human silhouettes and adds to the liveliness of the spectacle. The demonstrators' signs reiterate the same collective demands ("Union now!" "Knox must pay!" "Fair pay!" "Workers have rights!" "Cut hours, raise pay!"). On top and in the right margin of this larger tableau, four individual and disjoined panels show Knox and Elliot, once again observing the scene from above, then two policemen (Sam and Neil) preparing to attack the strikers. The respective sizes of the lateral panels gradually decrease to conform to the triangular shape of the larger scene upon which they are grafted. The right side of this double page sequence presents, quite literally, the "opposite" side of the strikers' action through a composition of reversed symmetry. In this mirror layout, the full-page scene represents strikebreakers armed with baseball bats, lined up in front of police cars along the right-to-left diagonal axis of the street, with the cars facing the reader like the strikers on the adjoining page and the strikebreakers facing left in the direction of their intended victims. The parallel framing of the two contiguous scenes and the tension between the two sides of the folded diptych, as well as the content of the affixed panels, highlight the premeditated collusion of hegemonic agents of economic wealth and law enforcement. Manipulation and malevolence are explicitly stated in their speech balloons: Knox and Elliot formulate a pretext for violence ("Can't let it look like [the strikebreakers] start the trouble. It's the union that always starts the trouble.... They start it, our boys finish it") and the policemen rejoice at the opportunity to inflict pain ("Remember, let the goons do some real damage before you move in.... Lotsa busted heads").

Chapter 23, "Riot!" (62–65) provides an expanded counterpart to this sequence and utilizes similar visual constructs. This four-page chapter returns to the scene of the union strike and once again begins with a full-page

drawing of a horde of protesters turned toward the reader. In this entangled throng of overlapping lines and energetically traced human outlines, one recognizes Cissy Goldman, the largest figure at the forefront of the image, mouth wide open and protest sign in hand—a discreet but efficient marker of continuity and intersection among Feiffer's multiple storylines (62). Here as well, this large illustration is complemented by three lateral panels on the right, respectively showing Knox, Neil Hammond (both counting down the start of their goons' assault), and a group of strikebreakers menacingly holding baseball bats. The facing page fuses large drawings of Knox and Hammond with a scene of the riot below. Sending their troops into battle with similar verbal orders and gestures, the characters' index fingers point from each side of the page down to the group of strikers shown underneath. Devoid of any grid pattern, this convergence of two visual scales not only devotes equal paginal space to the close-up renditions of the two men and the panoramic view of the strike but also symbolically merges the two representations as an indictment of repression, to the extent that both images permeate into each other, with Knox's and Hammond's index fingers protruding into the riot scene (63). The following double page (64–65) comprises a single image across the fold, which intimates the chaos and violence of the assault through deconstructed signifiers; from a distance, the human figures form a series of tumultuous, intertwined lines and shapes that render movement and disorder with expressionistic means yet border on the abstract, although a few elements of this large tableau emerge as more recognizable: raised baseball bats (highlighted by the absence of color against the gray ink wash that covers the entire image), hands, fists, and hats. Among the few discernible faces, distorted by panic, only Cissy Goldman's is clearly delineated, facing the reader at the bottom of the frame. The right side of this large image devolves in increasingly less figurative lines, in mimetic correspondence with the agitation of the event.

Among the indistinct mass of strikers, Cissy Goldman cuts a more defined figure throughout Feiffer's graphic novel. In addition to discreet or marginal appearances in the strike scenes, she is a key protagonist of two chapters with important ramifications to the overall story. Chapter 17 (46–48), entitled "The Union Maid" (a reference to a Woody Guthrie song in support of female unionists, as I noted above), portrays Cissy in her domestic and familial space, attempting to balance the clashing demands of motherhood and organized labor. Here, Feiffer returns to one of the main themes of *Kill My Mother*, what Ellen Wiley Todd calls the "ambiguous and problematic relationship between femininity and labor in the Depression" (Todd 1993, 272). Sylvia Harvey also

noted that the "absence or disfigurement of the family" constitutes a recurrent theme of film noir (Harvey 1998, 45). Like Elsie Hannigan in *Kill My Mother*, Cissy's multitasking reflects "the era's conflict between traditional expectations and the realities of feminine economic desperation, between the still-potent ideology of woman's separate sphere and her new roles as self-supporting or family breadwinner, whether by inclination or default" (Hapke 1995, xx). As a child of the Great Depression, Feiffer experienced the effects of such social changes and understood the predicament of his own working mother,[27] Rhoda Feiffer, who "performed dutifully the roles of breadwinner, wife, and mother, unsought obligations inflicted upon her by a bad choice in husbands and the Great Depression" (Feiffer 2010, 2). In addition to her long working hours as a cannery employee, Cissy's commitment to the union compounds her absence from home. All while preparing, serving, and eating dinner, Cissy explains to her son Archie the mechanics of a counterstrike as an experienced marcher. Strikers undoubtedly face a variety of obstacles, both real and rhetorical. Through his advertising support, Old Man Knox controls the press and therefore the false narrative presented to the public. In addition to misrepresenting the facts in the media, the industrialist will inevitably "bring in scabs to replace us and goons to back 'em up" (47), the standard tactic for breaking up protest marches. Ready to face the inevitable consequences of her political actions with utmost determination, she reassures her son in a pragmatic tone about her own safety in case of a riot ("don't worry, I can take care of myself") and provides him with clear instructions on how to survive alone, should she be arrested. She assures him that the union fund and the workers' community will provide for him in her absence.

Cissy's confident activism—which recalls that of many historical figures among women labor organizers, especially from the Jewish immigrant community[28]—nevertheless implies a traumatic upbringing for her son Archie, who remains entirely silent during his mother's speech, with eyes closed and face turned downward in an expression of quiet resignation as he listens to her practical advice while playing with his food. Cissy's priorities indeed rationalize her child's abandonment in favor of a political cause by invoking a higher purpose that justifies such sacrifice: "I know you're mad at me, Archie. But you'll see, I'm gonna make you proud!" (48). She concludes this interaction with an ambivalent expression of guilt and affection: "Now give your momma a hug! They don't give ya hugs in jail." The concluding page of this chapter shows a full-page illustration of Cissy hugging her son, her larger figure dominating and engulfing his, while no fewer than seven speech balloons, all emanating from Cissy alone, overstate her justification and

silence Archie. The boy's body is lifted off the ground by this embrace, and his facial expression alludes to sadness, confusion, and perhaps—as in Feiffer's own life narrative—resentment (figure 2.6).

However, the conclusion of the graphic novel further hints at Cissy's own ambivalence through the medium of song, an intermedial device often employed by Feiffer in this trilogy, most notably through the character of Lady Veil in *Kill My Mother*. In this passage, Cissy meets Sam Hannigan on a "dumpy side street" (93) to lend her assistance to Billy Doyle, the wrongfully accused labor organizer framed by Knox and the police for Valerie Knox's death. Although Cissy believes that Sam is on the "other side" of the political spectrum, he assures her of his newfound realization that he has been "played" by his former allies, and both find common ground in discussing their children.[29] After Sam reenacts one of his father's favorite Irish songs, revealing the fracture of his own immigration mythology (see above in this chapter), Cissy launches into a song of her own. In staunch contrast with Sam's, hers is not about an Irish "lass" with comical physical features, whom the narrator nevertheless plans to marry for her good heart, but about a worried Jewish mother wondering where her son is: "Izzy, mine Izzy, please someone find Izzy, is he here? Is he there? Is he where he shouldn't go? I'm frightened for mine Izzy, I worry so, is he in school? No, Izzy's not, is he in shul? Ha! That's hot! If you run into mine Izzy, smack him for me, tell him I hate him, tell him come home, tell him I love him, I'm lost alone, Izzy, where is he? I'm lost alone" (95). The divergence between the two songs underlines the cultural differences articulated in the respective folklores of American ethnic groups. An Irish bar song filled with puns about a grotesquely shaped woman with a kind character conveys a self-deprecative sense of humor and a romantic preoccupation with love, marriage, and domestic life, which pertains to a large corpus of traditional Irish songs about women, some satirical, others containing a deeper metaphorical expression of nostalgia for the homeland.[30] Cissy's song, in addition to including several markers of cultural Jewishness ("Izzy" is a common nickname for Isaac, Israel, or Isaiah, and the Yiddish word "shul" refers to a synagogue), relates the anguish and contradictions of a stereotypical Jewish mother, a theme of predilection for Feiffer. Maternal concerns about a child's well-being also entail a desire for control of the child's independence, fueled by projective apprehension ("Is he where he shouldn't go?"), codependency ("I'm lost alone"), and antithetical sentiments ("tell him I hate him, ... tell him I love him"). Both Cissy and Archie will reappear in the concluding volume of the trilogy, *The Ghost Script*, which takes place two decades later, in 1953.

FIGURE 2.6 Cissy Goldman hugs her son Archie before the union strike. From *Cousin Joseph: A Graphic Novel* by Jules Feiffer, p. 48. (Copyright © 2016 by B. Mergendeiler Corp. Used by permission of Liveright Publishing Corporation).

Finally, Billy Doyle completes this trio of labor-related characters. He makes his first visual appearance in the graphic novel in a scene at Addie's diner (chapter 15, "High School Reunion"), where he engages in political debate and physical confrontation with his former classmate and football teammate, Sam Hannigan. Even before this entrance in the story, he is presented as "an effective organizer, tough, smart.... Smart in his way. He has no education" (38). A fictional composite of activists of labor unionism and social reformers such as Eugene V. Debs and Bill Haywood, Billy however maintains his independence and critical distance from political indoctrination and especially communism when confronted by Hannigan: "No Reds or anarchists here, Sam. Just honest, hard-working stiffs out to make a living wage, a forty-hour week" (41). Whether or not 1930s unions were indeed infiltrated by Moscow-abiding agents remains of course a more complex historical issue, but Feiffer's graphic construct establishes a clear distinction between a progressive labor worldview and the adherence to dogmas and ideologies. This passage resonates with Feiffer's autobiography, where he differentiates his own political stance—his "indigenous, romantic radicalism," inspired by figures such as Murray Kempton, Leonard Boudin, and I. F. Stone, to whom *The Ghost Script* is dedicated (see chapter 3 of this book)—from his sister's obedience to the Communist Party (Feiffer 2010, 20, 41). Nevertheless, Hannigan reiterates the prototypical rhetoric of the Red Scare and levels its customary accusations at Doyle, referring to him as a "freeloader," unions as a "racket," and strikers as "good-for-nothings." Conversely, he views Knox through the embellishing lens of the American Dream, a man who came up "the hard way" and owes his entrepreneurial success to hard work and ingenuity (his "moxie," as he puts it). Hannigan's discourse embodies a reactionary conception of class difference, whereby financial success stems from effort and merit alone and any opposition thereto is merely grounded in envy. It also relies on the fallacy of the industrialist's goodwill and receptivity to labor reforms, and his openness to meeting "man-to-man with anybody working for him, [as] long as they don't gang up on him like a mob of Reds and anarchists" (41), a romantic notion of individualism that negates the need for collective bargaining. Knox's previous one-on-one encounter with Monty Dobbs (also present in this scene) sharply contradicts this egalitarian principle. In the same stereotypical fashion, Hannigan's beliefs are also tainted by nationalist rhetoric, claiming a monopoly on American-ness: "Billy, I can see you kind of forget *what it's like to be an American*. Free and equal men sitting down to work out their differences. No mob rule like—call a spade a spade—Russia?" (41, my emphasis). Yet his own violence immediately belies such a grand posture of civic compromise: instead of "sitting down to work out [his] differences"

with Dobbs, he dishonestly knocks the larger man out with a blackjack, confirming the hypocrisy of his own discourse.

In this diner scene, as a gifted and experienced dramaturgist, Feiffer stages this interaction between four men divided by ideology (Hannigan and Hammond on the right, Doyle and Dobbs on the left) with a high degree of verbal realism. The conversational and colloquial tone of the passage not only captures the characters' individual stances and values, as well as their general worldviews and borrowed rhetoric, but also adds an element of ambivalence that provides a counterpoint to their dissent. To the extent that Hannigan and Doyle share personal ties outside of politics, having attended the same school and relied on each other as members of the same football team, their disagreement also involves an undercurrent of friendship and mutual respect. Their roles on the football field were as complementary as their respective physiques—the smaller, smarter Doyle as quarterback and the larger, brutish Hannigan as tackle. In this regard, the depiction of their dispute is imbued with contrapuntal irony, both in their facial or bodily expressions and in their banter. Doyle refers to Hannigan as a "needler," a man prone to provocative, sardonic statements. In Hannigan's presence, Doyle responds to his old friend's taunt with an equal quip, asking a guarded Hammond to investigate who assaulted the singer Hooty Pines (presumably knowing it was Sam), all while "[offering] his hand in friendship" to Hannigan (40). He responds to the latter's speech describing Knox's meritorious prosperity with laconic sarcasm, simply replying "yeah, yeah" with a grin on his face, as if he has heard this false narrative countless times but disputes its accuracy (figure 2.7). When the battle of words becomes more heated, and Hannigan resorts to violence against Dobbs, the two former teammates turned political opponents reiterate their statements of friendship and agree to settle their dispute in a physical challenge. Doyle then performs an unexpected reversal by hitting Hannigan from behind: "Only opening I was gonna get, Sam. I hadda go for it. Now go ahead and beat the crap out of me, if that's gonna make you feel better" (42). Paradoxically, Hannigan interprets this gesture as proof of Doyle's political honesty: "You still can call the plays, Billy. You ain't no Red. You're the same nut I played ball with in high school!" In this instance, the phrase "You ain't no Red" becomes less an abstract statement of political ideology than a practical recognition of social bonding across intellectual differences, through the common code of sport. Yet the episode concludes with another violent reversal. Their conflict apparently resolved, Hannigan allows Doyle to leave with the injured Dobbs, but Hammond steps in to pistol-whip the two union men, stating that Doyle is not *his* friend (43). In this complex

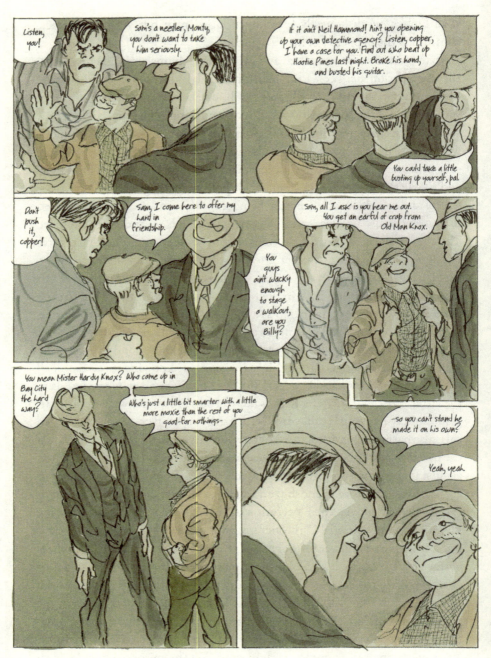

FIGURE 2.7 Billy Doyle and Sam Hannigan talk politics. From *Cousin Joseph: A Graphic Novel* by Jules Feiffer, p. 40. (Copyright © 2016 by B. Mergendeiler Corp. Used by permission of Liveright Publishing Corporation).

and quirky episode, in addition to depicting the sheer violence of male working-class culture in the Great Depression era, Feiffer threads subtle lines of social, political, and psychological motivations for his characters' behaviors, blending a faithfulness to historical conditions with a whimsical, humorous touch that is clearly his.

The character of Billy Doyle is also an opportunity for Feiffer to return to long-standing ethical preoccupations about the American justice system and its mistreatment of union leaders and civil rights activists, and more generally his profound distaste for injustice, which he relates to the corruption of his own political idealism at the time of the Un-American Activities Committee hearings in the 1950s (Feiffer 2010, 206–210). Framing union leaders and progressive activists and arresting them on concocted charges were indeed common repressive practices in early twentieth-century America. Among many similar cases, the multiple trials of the labor organizer Bill Haywood stand as examples of such tactics. Most notably, Haywood was implicated in the 1905 murder of the former Idaho governor Frank Steunenberg, when the actual murderer, Harry Orchard, falsely testified that his crime was connected to union retaliation against Steunenberg for his anti-labor policies and named Haywood among the conspirators. Such allegations were fabricated under pressure from a Pinkerton detective, James McParland, hired by an anti-union mine owners' association. Although Haywood was eventually acquitted, he was arrested again in 1917 under federal charges of espionage and conspiracy to overthrow the government, and subsequently fled to the Soviet Union to avoid a twenty-year prison sentence (Carlson 1983).

In similar fashion, the authorities exploit Valerie Knox's unexplained death to implicate Doyle in her murder. In the aftermath of the bloody assault on protesters, as the police arrest large groups of union members, Valerie's lifeless body is discovered under the crowd's feet. The quickness with which Knox transitions from mourning to self-absolution, then to vindication and machination is conveyed by a fluid, mostly panel-less double-page sequence (chapter 28, "Post-Mortem," 80–81). The grieving father begins by expressing doubts about his own parenting failure as a widower, but rapidly shifts from guilt to blame: "Valerie was not an easy child. I did my best." Facing the reader in the only framed panel at the bottom of page 80, Elliot and Knox assert commonplace gender principles: "Girls can be a handful!" and "It would have been easier with a boy." From the positioning of this panel and the negative portrayal of its enunciators in the novel, and from the author's personal life—as the father of three talented daughters—one can certainly discern Feiffer's irony and objection to this misogynistic proposition. After further

ambivalent consideration of Valerie's flaws and "abnormality," Knox sets his sights on revenge against the union and Doyle himself, vowing that "he will pay." This page layout again stages an emotional process through reiteration and juxtaposition of parallel figures without panel boundaries. On the top half of page 81, the stricken father is shown from behind, engaged in painful thought, in two symmetrical rows of three images each. By contrast, the bottom half of the page breaches this symmetry by reconfiguring the succession of three images over two rows and adding an enlarged figure in the concluding spot—that of Knox turning his head sideways in the reader's direction to pronounce his promise of retaliation. The triple deviation—of position, size, and angle—of this image in the overall equilibrium of the page layout effectively translates Knox's commitment to retribution.

Elliot and Neil Hammond play key roles in the scapegoating of Billy Doyle, the first by forging new passages in Valerie's recovered diary (82) and the second by coercing a false testimony from Monty Dobbs (85–88). Arrested for his participation in the union strike, Dobbs is unaware of Valerie's passing. Hammond exploits partial truths from Valerie's diary to construct an incriminating, albeit false narrative against Dobbs, according to which he murdered the young woman over "salacious" accounts of their sexual relationship and in fear of her mental instability. Hammond adroitly corners Dobbs into wrongfully identifying Doyle as the culprit to save himself from prosecution. Indeed, the corrupt policeman argues that only another adult would have had the strength to murder Valerie and, conveniently, the forged additions to the victim's diary mention another "grown male" left nameless but identified as "Mr. Brute." Hammond hints heavily at this suspect's possible identity: "a man too well known for Valerie Knox to write his name in her diary," who would be an "acquaintance," "friend," or "union comrade" of Dobbs's, somebody "who was in the news lately, . . . provoking a civil disturbance." Although Dobbs initially refuses to take Hammond's bait, he must ultimately face an inextricable choice under the policeman's mounting pressure: either implicating his innocent friend or taking the fall himself. Feiffer's layout depicts Hammond's coercion of a false testimony in densely packed clusters of small panels (a relative exception to the overall aesthetics of this volume) alternating between the two interlocutors shown in close-up. Hammond's impassible, controlling demeanor and his command over the guilt narrative are juxtaposed with Dobbs's horrified reactions, his eyes and mouth wide open in surprise and indignation (86–87). The final page of this interrogation sequence deviates from this alternation pattern to focus solely on Dobbs's reception of Hammond's off-screen threats; a series of nine panels of increasing proportions

offers a gradually closer and larger focus on Dobbs's face, which changes from resistance to acceptance as Hammond counts down the ultimatum for his confession (88). In the deeply flawed character of Neil Hammond, Feiffer synthesizes the many bad cops of hard-boiled literature and film noir who embody the public's awareness of systemic injustice and growing distrust in institutions in the 1930s and 1940s context of socioeconomic attrition. The genre's long inventory of corrupt policemen[31] (Knolle 2020) framing or beating innocent suspects, or being themselves guilty of crimes and other immoral schemes (theft, kidnapping, fraud, gambling, murder, etc.), reflects the era's sense of alienation from an unjust world and realization that power structures protect the wealthy and the notables over their victims.

Hammond's spurious indictment of Dobbs and Doyle constitutes a second breaking point for Hannigan, who already disengaged from Cousin Joseph's influence after realizing that he had been misled by false principles: "All his palaver! This invisible voice on the telephone whose love for America reminded me of my old man. He made sense! He made so much sense! His words meant as much to me as the 'Star-Spangled Banner.' And I went for it hook, line, and sinker, like some mark at a carnival" (91). Refusing to believe in the union men's culpability, and further angered by Hammond's assurances, he proceeds to hit his partner in anger, while dissecting the quadruple collusion of agents responsible for this simulacrum. Old Man Knox had incentive to use his daughter's unrelated death to get rid of Billy and destroy his union; the police authorities ("the boys upstairs") did not assign Hannigan to the strike for fear it would interfere with the framing of his friend; Cousin Joseph sent him to confront Kornblum in Los Angeles instead, as a diversion; and Hammond either stood to benefit financially from a payoff that would allow him to retire from the police force and open his own detective agency or chose to frame a Red simply "for the fun of it" (92). Appalled by this scam, Hannigan voices his independence from these multiple factions: "I don't know whose side I'm on, but it ain't yours. Or the boys upstairs. Or Cousin Joseph." As he walks away from Hammond to communicate his discontent to his superiors, Hammond urges him to refrain from endangering himself and his family, invoking "the risk factor."

Duel and Dialogue: A Cine-Mimetic Denouement

After speaking his mind to the police authorities who sidelined him as they were framing an innocent man (his friend Billy Doyle) and burning bridges

with his former éminence grise (Cousin Joseph) upon realizing the latter's dishonesty, Sam must now face the consequence of his uncompromising righteousness alone as the marginalized noir hero, confronting the connivance and amorality of those in power. Tragically, he is ultimately betrayed by his last ally, the diner waitress Addie, upon whom he relied to procure a boat that could ferry Doyle out of town at night (96–97). The sequence depicting their transaction already hints at Addie's unreliability and hidden financial motivation—as she agrees to help Sam and even offers to accompany him on his mission as an armed protector, she expresses her ambivalence about providing unpaid assistance to her friend. Addie's duplicity is cleverly framed in the juxtaposition of two contrasting panels (bottom of page 97): one in which she faces Sam and the reader, professing her disinterested loyalty and her empathy with Sam's predicament when he tells her that he is unable to pay for her services in these challenging circumstances ("I know all about it. How many years I been trying to raise the cash to buy this joint?"); and one in which she utters a much less altruistic statement to herself, turning sideways toward the reader as Sam exits the frame: "And how many years I pretend to be a good sport about it?"

The next night, when Sam meets Billy Doyle at the pier, puts him on the boat, and waves goodbye, his feelings of closure are short-lived. Addie makes a surprising appearance and reveals her betrayal to Sam ("You've been screwed all around, Sam. The cops are waiting to pick up Billy on the other side"), then shoots him at point-blank range, thrusting his body into the bay, where it floats horizontally before drowning. Addie delivers a final speech above Sam's corpse, which summarizes the respective values of friendship and money in the Depression-era ethos: "You were the only cop I would call a friend. But this way I score enough to open my own restaurant." Whereas, in Sam's case, his friendship and loyalty toward Billy had trumped ideological indoctrination, Addie's selfish economic impetus triumphed over her fondness for Sam—therein lie the destiny and demise of the noble 1930s hero, who lacked the pragmatic sense of self-survival, and whose death results from a far less idealistic morality, the prototypical ambitions of the small business owner. In this regard, Addie is reminiscent of Cora's character in James M. Cain's *The Postman Always Rings Twice* (written in 1934; the film noir adaptation dates from 1946)—a woman employed in a diner who resorts to murder to gain ownership of the establishment and economic independence.

It is worth noting that Feiffer pictures this dramatic denouement with cinematographic aesthetics and with cine-mimetic graphic devices staging

multiple perspective and reverse perspective effects. In the first frame of page 102, set vertically and occupying the entire left side of the page, Sam is shown from behind, awaiting Billy's arrival in the distance. The image is framed downward as an extreme wide shot with a high-angle tilt, revealing the atmospheric scenery of nighttime docks covered in fog and suggesting depth perspective along the vertical axis of the page, with bodies drawn according to a gradual distance scale. Facing Billy's arrival, the reader's point of view duplicates Sam's, thereby creating visual empathy for and investment in the character. Although subdued, the color palette is undeniably noirish: bodies are bathed in a dark ink wash set against the lighter gray of the fog. The larger vertical panel to the right pivots to a symmetrical countershot in which Sam is presented from behind, waving goodbye to Billy's departing boat, seen receding in the opposite distance. The long-shot framing brings the figures closer, at a reduced high angle, creating continuity and progression between the reversed viewpoints of the two panels. However, the second panel also accommodates a visual surprise: a third character (Addie, Sam's eventual killer) is shown behind the two men, outside their field of vision but in the forefront of the reader's, whose gaze is once again doubled by a character observing the same scene, inserting a menace between the reader and Sam.

The panels on the following page (103) similarly play with high-angle shots that increase the physical and symbolic distance between Addie and Sam. The first vertical panel places them in the opposite angles of a right-to-left diagonal axis, with Sam shown frontally, turning his head toward Addie appearing behind him. From this position that still deprives him of visual access, the unsuspecting Sam has not yet realized his friend's betrayal, made explicit in the following panel juxtaposed to the right, in which Addie, still dwarfed by the high-angled perspective, pronounces him "screwed all around." The bottom panel underneath shifts from the ominous aesthetics of surprise to that of conflict. Addie and Sam are situated at the opposite ends of a horizontal axis, where the double-crossed Sam openly expresses his anger and disappointment ("Damn you, Addie!"). The conclusion of this sequence (104–105) similarly employs dramatic, film-inspired visuals, drawn in Feiffer's idiosyncratic fluid and supple style, first contrasting motion (Addie's pistol shot, propelling Sam's body backward) and stillness (Sam's body, floating lifeless in the water), then vertical and horizontal perspectives (Addie overlooking Sam's drifting corpse from the edge of the pier, and Addie walking away from the scene of the crime toward the reader) (figure 2.8). The compositional and aesthetic components of this scene adhere

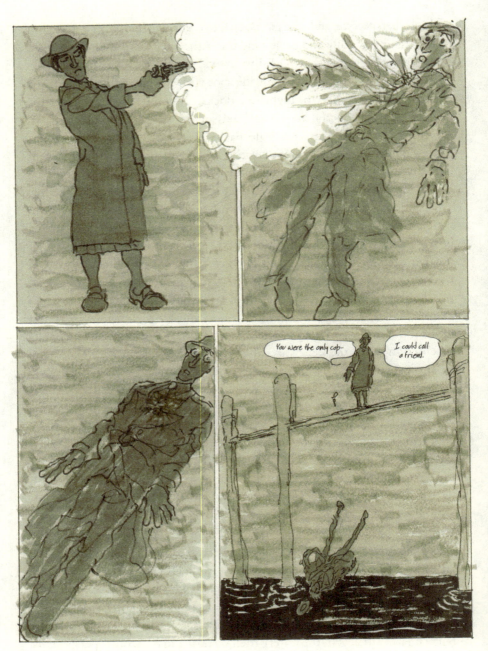

FIGURE 2.8 Addie Perl shoots Sam Hannigan by the Bay City docks. From *Cousin Joseph: A Graphic Novel* by Jules Feiffer, p. 104. (Copyright © 2016 by B. Mergendeiler Corp. Used by permission of Liveright Publishing Corporation).

to the main stylistic predilections of film noir, as Paul Schrader defined them in a classic essay originally published in 1972: dark shading and nighttime scenes; an obliqueness of perspective that tends to "splinter a screen, making it restless and unstable"; a "compositional tension" that "[moves] the scene cinematographically around the actor"; and "an almost Freudian attachment to water" displayed in ubiquitous rainfall and a preference for sites such as docks and piers (Schrader 2006, 57).

The final dialogue between Addie and Neil Hammond that serves as an epilogue to Sam's demise provides another lesson in Depression-era pragmatism, as the two protagonists negotiate the complex equation between their respective guilt and gain. Hammond reverts to his philosophy about the "risk factor," which he conveyed to Sam in an earlier sequence (92) and to Sam's widow Elsie in *Kill My Mother* (23): "You figure out the odds. When they stack up against you, you slow down, maybe you back off.... Upstairs, they don't like it when you shoot your mouth off. Upstairs, you don't tell 'em what you think, unless it's the same as what they think" (107). In *Backing into Forward*, Feiffer recognizes the same unassertiveness and self-censorship in his parents' generation, driven to social obedience and compromise by "a lifetime of humiliations" as Jews (Feiffer 2010, 20), and in the "blanding out" of the 1950s, when citizens and artists suppressed their subversive thoughts in the pursuit of conformity (217, 242). In such a repressive context, idealistic or heroic stances in response to one's personal moral compass are ill advised: "Sam took too many chances.... Sam didn't listen to anybody but Sam.... Sam the White Knight. You wanna know who killed Sam? Sam killed Sam" (107). For the reader, the tension and paradox that suffuse this dialogue stem from Hammond's ignorance of Addie's betrayal; conversely, she seems relieved that, in constructing the narrative of Sam's self-imposed punishment, Hammond does not identify her as the real criminal.

However, Hammond's bad-faith rationalization fails to assuage his guilt, which will eventually shape his character as an inept, violent, and misogynistic[32] boozer in *Kill My Mother*. Not only does Sam's death trigger the resumption of his alcoholism, after many years of sobriety, but it sends Hammond onto a career path for which both the economic context and his professional skills appear ill suited, as he confesses to Addie in a moment of self-doubt: "I ain't much of a cop, Addie. Or that much of a businessman. We're in the middle of a depression. You think I made a mistake? Opening my own agency?" Given his brutal downfall in the first volume of the

trilogy, one could conclude that Hammond's opportunistic ethos did not serve him any better than Sam's frankness and idealism in the end. The conclusion of *Cousin Joseph* also sets up another continuity strand with *Kill My Mother* in the person of Dorothea Hughes, the mute character–cum–blues singer whose mystery is a central element of the first volume's plot. Identified simply as "Jumbo" at this stage due to her oversized stature, and believed to have "a couple of screws missing" (96), she works in the kitchen of Addie's diner and intervenes when Hammond, under the influence of alcohol and slurring his words in the same fashion as in *Kill My Mother*, becomes increasingly self-deprecative, then belligerent toward Addie when she refuses to serve him another drink. Jumbo must knock him out with a baseball bat—her weapon of choice—to protect her friend from the ex-policeman's assault (109) before fleeing the scene, presumably to resume the life of homelessness that is hers at the beginning of the first volume.

In his verbal and physical confrontation with Addie, Hammond voices deeper insecurities than his professional and economic anxieties, comparing himself unfavorably with Sam in a garbled expression of self-pity and jealousy: "I'm not good enough for a drink? Ish zat it? Sham was, but not me? Neil'sh not good enough! Neil'sh never been good enough!" (109). Recovering from her attack, a disheveled Addie confirms Hammond's qualitative assessment as she stands over his unconscious body: "You're not half the man that Sam was. Why didn't they hire me to kill *you*?" But in the context of noir, the characters' fate is not predicated on their inherent "goodness" but on the mechanics of power and opportunism, in cynical contrast with the notions of meritocracy promoted by the American Dream. To answer the moral paradox posed by Hammond ("How come I'm alive, and Sam's dead?"), Addie's laconic, offhand answer is a fatalistic statement of dark humor about an unjust world: "Chalk it up to a mistake," which provokes their joint laughter (110). By concluding this second volume of the trilogy on an absurdist and nihilistic dialogue between two morally compromised characters struggling with the consequences of their self-preservation on others, Feiffer reaffirms the existentialist tonality of film noir and hard-boiled fiction that early French critics already noted when coining the term "film noir" (Porpiro 2006; Faison 2008), reflecting the genre's fondness for plotlines filled with deception, despair, violence, contradiction, and the general unkindness of fate in a social universe devoid of stable moral foundations and justice. If film noir tends to emphasize "the uniqueness and isolation of the individual experience in a hostile or indifferent universe" (Faison 2008, 16), Addie's and Hammond's characters embody the ethical malaise of their era.

The Damaged Daughter and the Boy Detective

As a corollary to *Kill My Mother*, which focused more directly on children and family dysfunctions, *Cousin Joseph* also depicts child characters embroiled in its intersecting plotlines. Sam Hannigan's daughter Annie makes a brief appearance that foretells her behavior in the opening volume of the trilogy. Already opinionated and contentious, she forbids her docile boyfriend Artie[33] from playing sports with their classmate Archie Goldman, which reveals her antisemitic prejudice, as Archie is quick to understand. This short episode already sets up Annie's domineering and antagonistic personality, as well as the dynamics of her relationship with Artie, whereby she repeatedly subjugates and silences her companion (12). Another short scene returns to Annie and Artie a few pages later, when Sam picks up his daughter from school (21). This passage reaffirms the Oedipal subtext of *Kill My Mother* by making Annie's adoration of her father explicit and anticipating the consequences of his looming disappearance from her life; she worries and is unable to sleep when he works at night. She also appears possessive of her father's attention and refuses to share it with Artie—when the latter expresses his admiration ("I gotta tell you, you're my father's hero. And you're mine, too!"), she replies with scorn: "Shut up, Artie! Stop embarrassing my father!" Annie's mother (Elsie Hannigan) voices to her husband her worries about Annie's escalating anger and its relationship with paternal absence: "I wish I knew what to do with Annie. I think about her all the time. The more you're away from home, the more she thinks I'm the worst mother in the world. And you're the best father" (36). As the reader of the full trilogy can assess, Sam's generic attempt at reassurance underestimates the gravity of the problem: "She'll grow up.... She'll be fine.... Girls are like that, Elsie."

In addition to Annie and Artie, whose presence strengthens the thematic bridge between the volumes, Feiffer introduces two new child characters in *Cousin Joseph*: Valerie Knox and Archie Goldman. From her first appearance in the graphic novel, the nineteen-year-old Valerie shows signs of psychological trouble. She repeatedly pays young men to display their penises yet seems confused by these transactions and unsure of her own intent: "I can't remember. Did I promise you a dollar? Do you think I made a mistake? Am I the wrong person? Before I pay you, could you describe it for me?" (10). While Valerie's sexual curiosity is not "deviant" in itself, "Am I the wrong person" suggests a dissociative psyche, a form of self-absence. In her first interaction with Archie, Valerie offers a similar, unsolicited remark: "Lots of times I don't know if what I say is wrong until it comes out of my mouth, and I hear it,

and *I can't believe it was me* who said it. But it is. And I'm so embarrassed I want to die. I think I spend too much time wanting to die. Do you?" (19, my emphasis). Another sign of Valerie's alienation and social impairment is that she seems unaware of the deep class and income disparity between her wealthy father and Archie's mother, of her father's ownership of a cannery, or even of the nature of his enterprise (she asks: "What's a cannery?"). An unwitting embodiment of the ruling class's social insensitivity, she remains indifferent to Archie's description of his family's economic condition under her father's management: "My mother works 55 hours a week at the cannery. You want to know her salary? Eighteen dollars a week!" The promiscuous, mentally unstable, or sociopathic daughter of a prominent man recalls the film noir theme of the "troubled" daughter, such as Carmen Sternwood in Howard Hawks's *The Big Sleep* (1946, based on a 1939 novel by Raymond Chandler), Veda Pierce in Michael Curtiz's *Mildred Pierce* (1945), or the young Martha Ivers in Lewis Milestone's *The Strange Love of Martha Ivers* (1946), all cases of family absenteeism or dysfunction (Harvey 1998, 35–46). After Valerie's passing, it is indeed revealed that her industrialist father struggled to bring up his daughter as a single parent (80).

Valerie's obsession with penises—which may or may not be exclusively sexual in nature, given her mental state—becomes the locus of her fascination with Jewishness, as a physical and symbolic marker of ethnic difference, a separate specimen aligned with racial stereotyping: "I just want to see what one looks like. A Jewish penis" (20). On seeing Archie's, she reacts with amazement and anatomical curiosity: "That's unbelievable! Jesus, do I love that little thing! Are all Jews born like this?" (22). Seizing this opportunity to reverse his interlocutor's stereotyping, Archie plays off her ignorance with wit and irony, renegotiating his othering with wordplay: "No, we're all born with green horns. A rabbi takes them off at birth, the same time he takes a piece of our schlong. It's call *circumgreenhorncism*" (22, my emphasis). This fantastical reformulation of the religious ritual that separates Jews from non-Jews (bris) invents new, absurd biological attributes—bestowed with animal or demonic connotations—that reinforce yet invalidate, through grotesque exaggeration, Valerie's naïve notion of a binary differentiation between Jews and non-Jews, the real target of Archie's self-deprecative humor. His wit reverses humiliation into intellectual superiority, as shown by Valerie's admiration: "What I like about Jews is you're smaller than other kids, but you know a lot more words."

The matter of Archie's Jewishness—a theme mostly absent from *Kill My Mother*—provides Feiffer with another opportunity to delve into his own

childhood as "a New York Jewish boy growing up during the Depression" (Feiffer 2010, 206). As I noted above, one could certainly draw parallels between Archie's relationship with his working mother and Feiffer's, as he describes it in various sections of *Backing into Forward* (1–2, 32–34, 56–58, 79–82); although Cissy Goldman's political radicalism greatly differs from Rhoda Feiffer's desire for conformity and assimilation, both mothers' commitments and obligations outside the home prevent them from devoting their full attention to their children.

Archie's Jewishness is associated with experiences of intimidation and humiliation. At school, where his short stature constitutes a disadvantage, he is bullied by a taller classmate who blackmails him by threatening to reveal the embarrassing content of Valerie's diary, notably her reference to his circumcision (44–45, 55). At home, he is assaulted by Elliot, Knox's personal detective, who falsely accuses him of having killed Valerie with his mother's assistance over the revelations contained in the victim's diary—an intentionally twisted allegation designed to scapegoat the innocent boy and his family (77–78). His attempts at denial and logic are met with more physical and symbolic violence from Elliot, who repeatedly throws the boy to the floor, slaps him, and threatens him, while referring implicitly to his perceived ethnic inferiority: "Why do *you people* make it so hard?" (79, my emphasis). Feiffer's illustrations accentuate the contrast between Elliot's and Archie's opposite statures and express the brutality of this interaction by depicting the boy's contorted body bowing under the force of a much larger adult. Perspective effects and framing devices further emphasize physical domination, with downward angles showing the detective towering over the boy and close-ups on the protagonists' faces expressing menace and terror, respectively. The largest panel of page 79 is unevenly framed by surrounding vignettes that affect the main panel's height and shape, both on the left side (showing Archie on his knees, stuttering the name of "Mr. Elliot") and on the right, with a higher "ceiling" that accommodates Elliot's taller physique as he is shown leaning over the boy with his fist clenched. In Feiffer's expressionistic, malleable style, Elliot's body menacingly curls around the kneeling child with downward pressure, and the entire scene takes on a kinetic dynamism akin to some of the dance or boxing segments in the trilogy, albeit with the graver tone of child mistreatment. Elliot's verbal violence seeks to impart a lifelong humiliation: "Burn that into your feeble little brain. Twenty-five years from now that name will be the first thing you think of when you wake up in the morning" (79). This passage clearly implies that such experiences of brutality and degradation are intended to create a lasting trauma in a young Jewish

subject and instill social obedience through fear. In a corollary segment of *The Ghost Script* (70), taking place twenty years later, Archie will meet his tormentor in a bar and recall the enduring impact of his violence, which still haunts him. Elliot's accusations against Archie are nevertheless revealed to be a pure fabrication only a few pages later, when he is shown forging Valerie's diary to frame Billy Doyle (82).

Finally, Archie's fantasy of becoming a detective undoubtedly constitutes a symbolic compensation for his loneliness and victimization through gameplay and its construction of an imaginary world. At the conclusion of his graphic novel, Feiffer inserts two consecutive chapters (36 and 37), respectively entitled "Archie Goldman, the Boy Detective" (99–100) and "Oh, My God . . ." (101). The first alludes to *The Boy Detective* (2013), Roger Rosenblatt's poetic musings about exploring the streets of Manhattan in the 1950s as a Jewish boy who dreams of being a detective patterned after his favorite characters—a composite of individual qualities from Sherlock Holmes, Hercule Poirot, Sam Spade, Miss Marple, and Philip Marlowe (Rosenblatt 2013, 10). *Cousin Joseph* is indeed dedicated to "Roger Rosenblatt,[34] Private Eye." In this chapter, Archie uses his deductive logic and investigative skills to search for Valerie's missing diary in her abandoned clubhouse, surmising that the bully who stole it left it behind to avoid incriminating himself. Fittingly, this is one of the only sections of the graphic novel drawn in the standard comics grid, whereby Archie's adventure is rendered through the visual style associated with childhood readings. As his exploration takes place at night, a complete darkness surrounds the boy's silhouette in each panel while he fumbles in search of the missing object and berates himself in typical self-deprecatory manner, calling himself a "moron" and a "schmuck" for not having brought a flashlight (100). However, he eventually locates the diary and praises himself: "Archie Goldman, you're a credit to the force." In direct contrast with this sequence, the following chapter not only displays a light gray background for full visibility (here again matching the chapter's thematic content: the revelation of the truth) but simply juxtaposes multiple iterations of Archie reading Valerie's journal, without panel dividers. Perusing her entries, he discovers that Valerie slept with many of his classmates (even Annie's boyfriend, Artie), as well as several adults, including their science teacher, Monty Dobbs, and . . . Billy Doyle! From her description of the latter's violent sexual behavior, Archie concludes that Doyle, while having been framed by the police for political reasons, actually killed Valerie for entirely unconnected motives. However, his discovery must remain a secret, to the extent that Valerie's diary also contains revelatory passages about

Archie himself. Thus, the boy detective, although the only holder of the truth, must paradoxically refrain from sharing it—a closing twist in a plot that accumulates reversals of all kinds.

Archie's discovery ultimately implies a political dimension. His realization that his mother's hero, whom she views as "the greatest guy in the world," is in fact an abuser and a killer not only indicates that her confidence was misplaced but also that her ideological investment in Doyle's probity has been betrayed. The final turnabout in this unforeseen, bewildering conclusion rebalances the critical outlook of the novel, whose denunciation of the far right is eventually offset by an indictment of deception and hypocrisy on the far left as well. In *The Ghost Script*, the last volume of his trilogy, Feiffer will indeed reexamine his own disillusion with romantic radicalism in the 1950s and return to some of its defining moments, which he related in other works such as his play *A Bad Friend*, as I discuss in the next chapter.

3

The Ghost Script

• • • • • • • • • • • • •

Revenge, Repetition, and Reflexivity

In the third and concluding volume of the trilogy, *The Ghost Script*, Jules Feiffer performs a temporal shift in the opposite direction of *Cousin Joseph*'s analepsis: instead of delving into his characters' pasts, he projects them two decades into the future, in 1953. Returning to the same protagonists, the story weaves together previous diegetic lines and brings them toward a relative closure, despite leaving several subplots open-ended by design.

As a continuation of stories begun in the previous two volumes, this graphic novel's narrative features a triple attempt at revenge and redemption against villainous antagonists with hidden identities, in melodramatic fashion. The couple of Elsie Hannigan and Patty Hughes seeks retaliation against the man responsible for Sam Hannigan's murder, Cousin Joseph, now living under an assumed name and persona as the philanthropist Lyman Murchison. In parallel, Archie Goldman, now a forty-two-year-old private detective, remains on the trail of Valerie Knox's killer, Billy Doyle, who also reappears under a different façade as Sox McManus, a nefarious

union leader who, unbeknownst to him, is also his mother's secret lover. Finally, the redemption plot also involves Addie Perl, who pulled the trigger on Sam Hannigan and used the "blood money" to improve her station by purchasing a nightclub while remaining indebted to Cousin Joseph.

Never at a loss for imagination, Feiffer also introduces a multitude of new characters in *The Ghost Script*, including a down-and-out, blacklisted starlet (Lola Burns), government agents of the House Un-American Activities Committee (Kline and Shoen), leftist screenwriters at work on a script denouncing the blacklist and its creators (Oz McCay, Faye Bloom, and Anthony Rose), an investigative reporter (Orville Daniels), and a cheeky janitor and former actor ("Beanie"). Two film producers already mentioned in *Cousin Joseph*, Sey Ackerman and Everett Kornblum, reprise their roles, albeit with significant changes to their previous incarnations.

In addition to the braided alternance of short chapters with contrasting themes, which is the dominant storytelling mode of the trilogy, Feiffer relies on other devices also used in the previous two installments: loops, parallels, and repetitions on multiple narrative levels—intratextual, intertextual, and metatextual. Within the diegetic universe of the trilogy itself, he repeats earlier passages or chapters and reinserts them verbatim in juxtaposition with their correlates, thereby creating an internal dialogue between past and present episodes. On six such occasions (8–9, 24, 62, 68–69, 91–94, 115–116), dispersed throughout the novel at regular intervals, these reiterated segments not only serve as reminders of a long and convoluted plot but also as a mirror of the characters' evolution and a statement on the cyclical nature of history, expressed through deliberate parallels. Feiffer also creates multiple points of thematic intersections through recurrent "Bedroom Scenes" (four in total, bearing the same title) in which protagonists from different narrative layers communicate their intentions and create unlikely alliances. At the intertextual level, multiple allusions to other works (Raymond Chandler's *The Big Sleep* and Will Eisner's *The Spirit*, as well as various films, radio shows, and TV series) continue to draw connections with cultural products of the same era, making this trio of graphic novels a highly referential and citational work.

Yet the most ingenious of these loops is performed at the metatextual level, through the reflexive depiction of screenwriters at work on a script about the very subject of the graphic novel itself. In this playful metadiegesis, Feiffer continues the preoccupation with Hollywood that was already at the core of *Kill My Mother* and *Cousin Joseph*, and faithfully refers to the politics of the era, most notably McCarthyism and the blacklist. As such, he

identifies film as the locus of an internal struggle in America. As Glen Frankel reminds us,

> In truth, Hollywood was a mere sideshow in the larger struggle [against communism].... But the symbolic power of Hollywood, its extraordinarily high profile, and its abiding role in our national culture and fantasies made it an irresistible battleground. These very features that drew the leaders of the American Communist Party to set up shop in Hollywood in the 1930s attracted its antagonists a decade later to come hunt them down. The House Committee on Un-American activities was at the vanguard of this crusade. Created a decade earlier, HUAC first held public hearings into alleged communist infiltration in the motion picture industry in 1947. The sessions had ended in a stalemate: eleven current or former Communist Party members had been called to the stand, ten of whom cited the First Amendment in refusing to answer questions about their political affiliation and were charged with contempt of Congress. Civil libertarians condemned the committee's methods and actions; even Hollywood's studio heads briefly resisted congressional repression, but ultimately purged the Hollywood Ten from their ranks. Four years later, when the committee returned for a second set of hearings, it faced no meaningful opposition as it issued salmon-pink subpoenas to dozens of actors, screenwriters, and other film workers. (Frankel 2017, xi–xii)

In this context of betrayals and hypocrisies, Feiffer reflects on the motivations, compromises, and contradictions of Americans in the troubled decade of the 1950s, which also coincides with his coming of age as a young adult and a professional cartoonist. His examination of the Hollywood world runs the gamut of all participants in the film industry: he considers what blacklisted actors must do to survive (Lola Burns); how external political forces apply undue pressure on the industry (Lyman Murchison, Silas Moffat); how leftist screenwriters nevertheless attempt to bypass censorship through a carnivalesque game of "fronts" (Bloom and McCay); how successful Broadway playwrights fail to transition to Hollywood (Rose); how opportunistic liberal producers eschew political confrontation by diluting the political content of their movies (Kornblum); and how blacklistees are reduced to bitter unemployment (Ackerman) or led to self-destruction (McCay). Other references to 1950s American politics are present in Feiffer's ode to investigative journalism and the revered figure of I. F. Stone, which serves as an inspiration for his Orville Daniels character. In this regard, this aspect of the story can also be seen as a revenge narrative, to the extent that it enacts a

whimsical reversal fantasy of the American cultural mainstream. Many of the diagnoses and indictments that Feiffer draws in this novel unfortunately remain applicable to today's America.

While Feiffer's narrative inventiveness continues to shine in this third volume, his aesthetics appear slightly more subdued than in the first two, particularly compared with the visual fireworks of *Kill My Mother*. Here, the cartoonist makes a more frequent use of the classic grid layout, which he seldom employed in the first novel, where each page is a masterpiece of graphic imagination. This is not to say, of course, that *The Ghost Script* lacks visual proficiency or inspiration, but it appears to be calibrated more for narrative efficiency than aesthetic sophistication. One could certainly posit that the difficult task of concluding such a multifarious story required a linear, sequential discipline and the legibility that the grid layout aptly provided. There remain many clever layouts throughout the volume, which will call for close formal readings.

Finally, this last installment of a film noir–inspired project continues to be influenced by the codes and tropes of its source model. If Feiffer's illustrations in this volume tend to be more traditionally graphic in nature and involve fewer attempts at replicating film stylistics or framing devices, the author still stands acutely aware of the norms that he replicates or from which he intentionally deviates. The most striking of such reinventions concerns the figure of the private detective himself. While Archie Goldman performs the investigative and narrative functions expected of the prototypical, Chandleresque PI, Feiffer problematizes his central hero as guilt-ridden, indecisive, and self-loathing—characteristics that relate both to the 1950s social malaise and to the author's playful depiction of his own Jewish sensibility.

Naming Names: Lola Burns and the HUAC Spooks

In his foreword to *The Ghost Script*, Feiffer recalls two life-shaping events that took place in 1953, the year in which his graphic novel is set, both pertaining to the House Un-American Activities Committee hearings. He also recounts the same anecdotes in a chapter of his autobiography, *Backing into Forward*, noting likewise their impact on his political education (Feiffer 2010, 206–210). As presented in the graphic novel's foreword, the first episode points to the proceedings' manifest anti-intellectualism, performed as a populist rhetorical strategy, and to the investigators' conflation of New York artists with Jewishness:

> A week or so after my discharge from the army in 1953, I went down to Foley Square in downtown Manhattan to hear Jerome Robbins testify before the House Un-American Activities Committee. From his *Fancy Free* ballet to his Broadway musicals *On the Town* and *West Side Story*, Robbins had revitalized theater and dance. The Committee chair swore him in and asked him what he did for a living. Robbins answered that he was a director and a choreographer. That last term had not yet entered common parlance, and Robbins was asked to explain what in the world it meant. But first, every Committee member took his turn mispronouncing it for the folks listening on TV or radio back home in Real America—"You're a choreogawhagawhut?" "You're a cory-corywhatzis?" "You're a corwaggawufer?"—thus indicating to the voters who counted that they were uncontaminated by this fairy-Jew York City word. (Feiffer 2018, foreword)

In *Backing into Forward*, Feiffer adds, "It was heartbreaking to watch Robbins go into his HUAC dance," and that, despite his visible discomfort, the witness eventually complied with the committee's request by "[spilling] all the names that had been agreed upon in order for him to go to Hollywood someday and make movies" (Feiffer 2010, 207). Indeed, such prearranged testimonies were clearly transactional in nature. Although "one could stand up to the committee, and many did," the actors, screenwriters, and directors making a living off their talent and trade in Broadway and Hollywood knew that their blacklisting would result in immediate unemployability, and often capitulated to the investigators' demands in order to salvage their livelihoods and careers (206).

Feiffer's second recollection and corollary disappointment are perhaps more profound and striking. More than the sad spectacle of a much-admired man forced to compromise his integrity, it identifies a fracture between political posturing and pragmatic cowardice:

> Not long after, I attended a memorial service in Brooklyn for the blacklisted actor J. Edward Bromberg, one of the founders of the Group Theatre. Midway through, another founding member, playwright Clifford Odets, made an unscheduled appearance. Odets gave a speech that had the audience on its feet, cheering. It was as if, lost in Hollywood hackdom for years, he was reclaiming his title as our most important left-wing voice. With the poetic-oratorical sway of his *Waiting for Lefty*, he denounced the Committee for killing his old friend Joe. But Joe's death would not go unavenged. Joe would be redeemed, the Committee would be vanquished, American idealism would be restored.

"Odets is back! Odets is back!" we in the audience cried, as we wept.

A week later, Odets appeared before the Committee. As a friendly witness! He named names. And when Odets was asked who recruited him into the Communist Party, he came up with his first name: "J. Edward Bromberg."

"Where am I? Am I going crazy? What kind of country am I living in?"

All these thoughts stuttered through my mind at that moment—and for seventy years after.

With the conclusion of this trilogy, I offer my last words on the subject.

(Feiffer 2018, foreword)

The corresponding passage in *Backing into Forward* further describes how Feiffer was "affected and changed" by this blatant turnabout, which became the inspiration for his play *A Bad Friend*, in which the character of Uncle Morty, a communist screenwriter, recalls Odets's soaring speech in full detail, with its "stirring and poetic defiance" (Feiffer 2010, 209). Feiffer drew a lifelong lesson in political cynicism from this pivotal disillusion: "Odets educated me. He taught me that there were no heroes, there was no one to trust. Betrayal was the watchword. Idealism was a joke that I could find nothing funny about, nothing to make cartoons of" (210). "Naming names" in front of the HUAC, as Odets and many others did (including the highly damaging testimonies of directors such as Edward Dmytryk and Elia Kazan), or standing in defiance of the committee with courage and integrity were the opposite poles of a moral spectrum that had a lasting impact on Feiffer's worldview.

Given the reiterated importance of the 1953 House Un-American Activities Committee hearings in Feiffer's personal narrative, *The Ghost Script*'s episode featuring Lola Burns's misadventures with the same committee and eventual revenge against its blackmail schemes takes on a deeper, symbolic value. Beyond the playful revenge fantasy by which the character turns the tables against her oppressors, it also entails symbolic reparation for the cartoonist himself.

Lola Burns's first appearance[1] in the graphic novel alludes to a trajectory of decline. Blacklisted and unable to find acting jobs in Hollywood, she has been forced into prostitution to "feed herself": she dates men for money and feeds the gossip she learns from them to Archie Goldman (5–6). Her agent, Ricky Pastor (Annie Hannigan's boyfriend in *Kill My Mother*), feels sorry for her ailing career and suggests that she seek protection from an older, influential man in order to "clear her name" and be allowed to work again (7). As in the previous volumes of the trilogy, Feiffer's depiction of this exchange captures the economy of female bodies in Hollywood: not only does her agent conflate his role with that of a pimp but, in two panels of page 5, Lola's buxom

physique is also the object of two male diners' insistent gazes from opposing viewing angles, back to front and front to back—the latter displaying Lola's figure in a medium shot, sandwiching the character between the reader's gaze and that of the two voyeurs in the background and rendering the reader aware, if not partially complicit, of the diners' ogling. This ironic device is less intended to oversexualize Lola's body than to reflect critically on its commerce. This is certainly not the first time that Feiffer offers a critical commentary on the predictability of American men's desires (see his corrosive screenplay for Mike Nichols's *Carnal Knowledge* on this matter).

To restore her film career, Lola must grant sexual favors of a performative nature to Lyman Murchison, the powerful head of an organization ("Our Forefathers for Freedom") known for its support of the blacklist. Here, Feiffer pokes fun at the old man's anti-communism through a whimsical role reversal: to please her client's sexual preferences, Lola is asked to dress in a red dominatrix outfit complete with red fur hat, mask, cape, and whip, and to memorize lines of dialogue in which she verbally debases him in stereotypical fashion, to his visible delight: "On your knees, capitalist swine! I am your brute Bolshevik, Lolichka! Lover of Lenin, Mistress of Stalin! I came from Moscow as your Soviet enslaver, you sniveling running-dog of capitalism! Prepare to obey my every command! Crawl to me, pig!" (31). These two pages (chapter 13, "The Blacklisted Dominatrix") highlight the ironic device of the abused abuser's paradoxical fetish with a rare use of color—the bright red of Lola's outfit—that stands as a conspicuous exception to the black-and-white aesthetics of these graphic novels. Similarly, Murchison's transformation from dignified magnate to submissive infatuate comically reverses his dominance and correlates his political obsession with a sexual one, for Feiffer's obvious amusement.

Despite her compliance with this role-playing scenario, the blacklisted starlet is still required to testify in the Los Angeles HUAC hearings under pressure from two menacing government agents, Kline and Shoen, otherwise referred to in the story as "the Spooks." The two investigators, using the rhetoric of the day, argue that her testimony would be "an act of patriotism that will aid in ferreting out communists, fellow travelers, left-wing unionists, pro-peace progressives, the whole subversive culture" (78). Not only did Murchison fail to honor his side of the deal by withdrawing his protection, but the agents now threaten to inform Lola's violent ex-husband of her whereabouts, which could endanger her. Once again, in accordance with standard HUAC practices, Lola's testimony would not be a genuine exercise but a prearranged sham in which targets are foisted upon the witness in

advance: the investigators are particularly interested in constructing charges against the liberal producer Everett Kornblum and tell Lola that they will provide her with a list of other names (80). This agreement relies on the same transactional principle as Lola's movie acting or self-prostitution: she is asked to "contribute her services to the Committee" and negotiates a fee per divulged name.

The duo of spooks is itself the butt of Feiffer's humor. Not only do their names, Kline and Shoen, allude to political cleansing ("clean" and "shine"), their contrasted physiques (one big with a large nose and a square jaw, the other smaller with a thin nose and a pointy chin) yet identical clothing provide a dose of comic relief anchored in the visual traditions of vaudeville, stand-up comedy, and slapstick cinema (from Bud Abbott and Lou Costello, Stan Laurel and Oliver Hardy, Dean Martin and Jerry Lewis, all the way to Simon Pegg and Nick Frost, to name only a few examples). In comics, more specifically, such duos of physically dissimilar characters have been used since the beginning of the medium, for instance in Wilhelm Busch's *Max und Moritz* (1865) and Rudolph Dirks's *The Katzenjammer Kids* (1897), with its sibling duo of Hans and Fritz. Harvey Kurtzman's early series *Hey Look!* (featuring a pair of protagonists, the "big guy" and the "little guy") makes a minimalistic but efficient use of this basic device (Kitchen and Buhle 2009, 22). Duos are also prevalent in the rich Franco-Belgian comics corpus (such as Alain Saint-Ogan's *Zig et Puce*, Goscinny and Uderzo's *Astérix et Obélix*, and Fernand Dineur's *Tif et Tondu*). The spooks' uniformity of clothing recalls the double play on twinhood in Hergé's *The Calculus Affair*, in which, according to Jan Baetens's perceptive interpretation, the Bordurian spies who keep Tintin and Haddock under surveillance have differing anatomies but dress alike in gray hats and trench coats and bear similar names derived from linguistic puns ("Kronik" and "Himmerseck" being Flemish references to constant sickness) (Baetens 1989, 76–79). In Hergé's novel, these characters mirror another set of "twins," Dupont and Dupond (Thomson and Thompson in the English translation), a parallel configuration by which *gémellité* is to be understood as a symbol of state conformity, blind obedience to authority, reproduction of the norm, and absence of individual, critical thinking. Another comical aspect of the "spooks" lies in their constant bickering and professional ineptitude. Shoen talks too much and produces long, neurotic monologues overflowing with thoughts that he cannot remember, and which require his partner's constant attention (45). He is also prone to blaming and criticizing his partner for his own mistakes, creating more squabbles between the pair. Feiffer's attention

to dialogue in these passages recalls his humorous, observational touch in earlier cartoons such as the *Feiffer Strips*, filled with self-justifications and arguments, and his work as a playwright and screenwriter.

When Lola is finally called to testify before the HUAC, armed with a list of names concocted by the authorities, she confides her troubles to her boyfriend and business partner Archie Goldman. Although Archie, raised by a Trotskyite mother, states that he is no fan of communists, he opposes the witch hunt on moral grounds: "Whatever I think of them, I don't believe that anyone has the right to prevent people from making a living at their trade" (125). Encouraging Lola to fight back, he suggests a playful approach to the committee hearings: "OK, if you have to name names, why not make it fun? Be unpredictable! Name Louis B. Mayer... Name Jack Warner!" (126). Lola objects that no one would believe such outlandish claims, so Archie counters: "Good point! Name someone not well known—but he's one of the biggest witch hunters of them all!... Lyman Murchison." Still in jest, Lola begins to rehearse her testimony gleefully: "It was Murchison who recruited me in the Communist Party, Congressman! He liked to dress up like Stalin! He liked to make me dress up and pretend I was Stalin's mistress!" (126). Reversing her own victimization through the same role-playing by which Murchison exploited and betrayed her, Lola concocts the ultimate revenge on her abuser.

The conclusion of the novel returns to Lola's retribution in two consecutive sequences employing contrasted modes of representation. The first one is direct and frontal—a page with two superimposed TV screens shows both sides of the hearings: the speaker introducing Lola as a witness with a dour facial expression, then Lola in front of the microphone, looking equally serious and determined (138). The contents of her testimony are not shown, however. Instead, they are related indirectly, without the matching visuals, in a subsequent radio broadcast by Miss Know-It-All (Elsie Hannigan), which serves as an epilogue to this strand of the narrative (140). The gossip columnist indeed reports that Lola's sensational deposition revealed that the "philanthropist and dedicated anti-communist, Lyman Murchison was, in truth, a Soviet agent," and that the actress, who had been unemployed for five years, received many movie offers in the wake of her testimony—a gratifying reparation for the injustice she suffered. Feiffer sets up an ultimate loop of representation in the penultimate chapter of the graphic novel, where Archie remarks that Lola's new roles cast her as a "femme fatale—Joan Crawford parts" (143). Returning to the well-known female film archetype he so cleverly deconstructed in *Kill My Mother*, the cartoonist not only references the cinematic sources that he transmediated into this graphic

project but also highlights the mimetic correspondence between Lola Burns in the story-world and the roles she performs on-screen, which often imply revenge against powerful men and double-crossing. The allusion to Joan Crawford, in particular, reminds the reader of such plot configurations.[2] In *Flamingo Road* (Michael Curtiz, 1949), for instance, where Crawford plays a carnival dancer framed and prevented from working by politicians who run a small Southern town, her character shoots and kills her corrupt abuser. To quote another title from Joan Crawford's filmography, *This Woman Is Dangerous*.

The Screenwriters and the "Ghost Script"

Hollywood cinema and its actors constitute omnipresent themes in Feiffer's trilogy, which not only engages with the visual language of film on graphic terms but also reflects on the tropes of American culture and its mechanics of cinematic representation. *Kill My Mother* features a conflict between two actors (Hugh Patton and Eddie Longo) and exposes the codes of war movies as patriotic simulacra. In *Cousin Joseph*, the author presents cinema as a contested battleground for image control and the reinforcement of mass ideologies under the influence of external propaganda forces seeking to shape the very manner in which Americans conceive of their nation. Continuing this thematic line of preoccupation with film, *The Ghost Script* relies on a reflexive premise: it portrays screenwriters at work on a script whose metadiegetic content—as a story being produced and told by secondary narrators within the story—duplicates and infiltrates the main diegetic level of the narrative.

Chapter 7, "The Kornblum Metaphor," depicts an interaction between Anthony Rose, a Broadway playwright who just completed his first Hollywood script, and Everett Kornblum, an established film producer with liberal tendencies. Rose's screenplay deals openly with the political issue of the day: the blacklist. Kornblum, with slick diplomacy, first praises the writer, whose previous theatrical work he claims to admire ("I'm your biggest fan!"), and the film script he submitted ("Great writing! God, I love it!") (16). However, he takes issue with the film's political explicitness ("It's too on the nose") and suggests a toned-down, metaphorical approach to make the film more palatable to an average family audience. His alternative proposal softens and dilutes the movie's original message into a generic statement on "civil consciousness" and "responsibility" devoid of any reference to the blacklist, a "Greek tragedy" of sorts: "A well-meaning but misguided hero who, while wanting to do some

good, does harm. Say, a farmer, in his zeal to feed his family, and help out his less well-to-do neighbors, adds a chemical to his crop that's poisonous. You see, there's your blacklist!" (17). Feiffer's visuals capture Kornblum's efforts at persuasion and seduction as a "dance" performed by the producer around the seated and motionless screenwriter—multiple iterations of smiling and gesturing Kornblums surrounded by six speech balloons unfolding his counter-narrative, to the writer's apparent dismay. Kornblum's reluctance to make films with overt political content undoubtedly matches his cautious approach in *Cousin Joseph*, where, as a younger screenwriter in the early 1930s, he had to cloak any progressive inference under allegorical cover for fear of violent reprisals from reactionary forces. By the 1950s, seeking the least offensive common denominator has indeed become a successful formula and a second-nature survival reflex for a generation of filmmakers accustomed to compromising or attenuating their political vision while maintaining commercial prosperity. Feiffer experienced in the same era a similar reticence to taking risks on controversial topics from book publishers when he submitted the manuscript for *Munro*: "From 1953 to 1959, *Munro* faced one rejection after another. My cartoon about a boy who didn't fit in the army didn't fit into conventional publishing" (Feiffer 2010, 132). Furthermore, as a screenwriter himself, Feiffer had firsthand experience with the type of extensive script modifications that directors, producers, and studios can impose on a film narrative—his screenplay for *Popeye* (1980), for instance, was largely rewritten by the director Robert Altman and the producer Robert Evans, resulting in an ambivalent critical response and a commercial flop (Feiffer 2010, 406–411).

A subsequent passage of the novel provides more nuance on Kornblum's equivocation. When Annie Hannigan, in a bedroom conversation, calls him "a sellout pretending to be a liberal," he responds pragmatically that "playing the game is the only way a liberal can survive in this climate. And I protect the careers of brilliant progressive artists, other than the small cadre of left-wing hacks you foist on me" (47). He maintains a careful balance by firing cast members who are too ostensibly active in left-wing politics but retaining more discreet ones—"That's how it works, little girl," he tells Annie with a mix of seasoned wisdom and paternalism (47). While Annie complains that his intrusive editing transformed her movie about civil rights into "another piece of sci-fi schlock," he brushes off her criticism with confident grandstanding: "I pray that someday it dawns on you that this poor fellow you so libel stands as the last of the little hope that remains in Hollywood."

Frustrated by Kornblum's avoidance,[3] Rose slams the producer's door and joins forces with a couple of accomplished but currently blacklisted

Hollywood screenwriters, Oz McCay and Faye Bloom, with whom he plans to collaborate on a screenplay about the witch hunt. In Rose's mind, the veteran writers offer a study in contradiction, as ostracized communists living in a Beverly Hills mansion and driving a Rolls Royce, luxuries that they find entirely compatible with their ideology: "Just because I'm a Communist, I can't drive a Rolls Royce?" Oz argues (39). To explain their maintaining a somewhat opulent lifestyle, they explain to Rose the common stratagem by which blacklisted writers can still earn a portion of their former income through the use of "fronts"—"kind, guilt-ridden liberals [who] deliver our crap to the producers" in exchange for a fee and a screen credit, with the full awareness of complicit producers, who find the arrangement lucrative insofar as it reduces their costs: "[The studios] love the witch hunt! They get 'A' list writers for half-price or less!" (40). Through this hypocritical though convenient arrangement, the screenwriters can continue to be nominated for awards, albeit under false names, and support their way of life without having to relocate to Mexico like other members of their profession who do not play this game. Feiffer's description closely matches the actual reality of blacklisted filmmakers throughout the 1950s (McGilligan and Buhle 1999, 595–596). Among the famous "Hollywood Ten" who refused to testify before the House Committee on Un-American Activities in 1947, and who were consequently fined, jailed, and banned from working in the film industry unless they renounced their convictions under oath, several became expatriates in Mexico or France (John Howard Lawson, Dalton Trumbo, Jules Dassin), adopted pseudonyms (Lester Cole, Ring Lardner Jr., Adrian Scott), provided uncredited material for television, or indeed used the subterfuge of fronts, "writing scripts under assumed names, at rates well below their usual standards" in what amounted to a "black market" (Ceplair and Englund 1983, 404). When Oz and Faye cheerfully remark to Rose that they have been nominated multiple times for Best Screenplay of the Year under different names,[4] their paradoxical triumph recalls famous movies that were similarly lauded by the Hollywood establishment despite the involvement of blacklistees, such as *Broken Arrow* (Delmer Daves, 1950), with a script by the Hollywood Ten member Albert Maltz under the front of Michael Blankfort (Buhle and Wagner 2005, 190), or *Roman Holiday* (William Wyler, 1953) and *The Brave One* (Irving Rapper, 1956), both written by Dalton Trumbo under the fronts of Ian McLellan Hunter and Robert Rich, respectively (Buhle and Wagner 2005, 89, 141; Ceplair and Englund 1983, 405, 419).

In Feiffer's playful plot, the artifice of fronts itself becomes a fertile ground for the writers' imagination and an opportunity for carnivalesque reversal.

Faye Bloom proposes that if the system is rigged from the onset, it can also be gamed to the point of circular absurdity by a writer who poses as her own front in disguise (41). A façade of a façade, such a theatrical play on mistaken identity (the classic Shakespearean or Molièresque *quiproquo*,[5] with its comical coincidences and paradoxes) serves as both a revelatory device and a reflexive twist: by peddling her own screenplays incognito, Faye Bloom not only flips the hypocrisy of the film industry onto its head but also performs an imposture in the very world of Hollywood dupery and simulacrum. With the help of a makeup artist, Faye dons a rubber prosthetic nose, a mustache, a goatee, a wig, fake sideburns, heavy eyebrows, gloves, and thick-lensed glasses, all of which give her a masculine appearance: "You should have no trouble passing as a man. Years of drinking and smoking have deepened your voice. The studios will never recognize Faye Bloom" (44). Faye's mischievous cross-gender transformation recalls that of Patty Hughes as Hugh Patton in *Kill My Mother*, to the extent that it negotiates masculinity as a performance against a male-dominated system of authority. Faye initially chooses as her front's identity a stereotypically masculine name that projects empowerment, Winston Howard, but eventually presents herself to the studios as Mr. Bostwick, a screenwriter returning to Hollywood after a three-year exile in Switzerland (85). A studio executive entrusts her with revising two scripts from "out of business" writers, a romantic comedy by Annie Hannigan (not blacklisted yet but soon to be called as an "unfriendly witness" by the HUAC) and a screenplay by—Faye Bloom. True to its comedic function, the mistaken identity scheme allows for double meanings in dialogues for the reader who is aware of the substitution. Bostwick comments ironically that Faye Bloom "had her ups and downs," and the executive criticizes her as "too opinionated. See where it got her?" Enacting the opposite of Bloom, Bostwick takes the inverse stance in a pragmatic, resigned statement: "Writers who ask questions get in trouble in this town," a witty line to which her interlocutor replies with a laugh: "That's worthy of Faye Bloom!" (a doubly true proposition, unbeknownst to the speaker). Through role-playing as well as a reflexive, polysemic dialogue, Faye's paradoxical impersonation of her own front—which places her on both the producing and the receiving ends of the writing process—creates a metatextual loop that subverts the duplicitous arrangement of the studios for comical effect.

Similarly, the screenplay that the trio of Rose, Bloom, and McCay concoct plays with paradox, metatextuality, and subversion. The original idea for the "ghost script" lies in a prank—a mere rumor about a script exposing the agents of the Hollywood purge and devised to "scare the bejesus out of the witch

hunters as much as they scare us," as Faye puts it (42). Rose suggests collaborating with the veteran screenwriters in composing this script for real, thereby creating a double metafictional loop by transforming a hoax into reality—making a forgery of another scam, in essence—and involving blacklistees in the crafting of a story about the blacklist itself. By this duplicative, metadiegetic mechanism, the making of the ghost script becomes a storyline within Feiffer's volume of the same title. Thus, passages of the graphic novel where the trio workshops ideas and shapes the plot of its film narrative also take on metatextual significance for Feiffer's novel. For instance, when they choose to make the story a thriller with "a hard-boiled private eye who's seen it all and believes in nothing . . . with a gorgeous sexpot as a client" (58), they reflexively identify the very tropes at play in Feiffer's adopted genre of storytelling and his own literary practice in this trilogy. Another metatextual element lies in the profile they assign to the detective's client, an attractive scriptwriter active in the left-wing writers' union whose life is threatened by opposing political forces—all story components that echo various parts of Feiffer's main diegesis. The screenwriters' imagination also intersects with other parts of Feiffer's body of work, for instance when they propose to make the leader of the right-wing union that endangers the PI's client "a Ronald Reagan type—a handsome, charming knucklehead!" (58), which correlates with the many anti-Reagan[6] cartoons that were a Feiffer trademark in the 1980s. Layers of reflexivity proliferate when the writers come up with the idea that the "Reagan character" keeps an incriminating diary (a twice-framed narrative):

> It's the inside story of the witch hunt. Dreamed up by the New York banks. And put in place by the studios. The scenario goes: First, fire the writers for being communists. Then tell them they can write again by working under false names for a quarter of the price they were paid under contract. Next, the studios start up a clandestine "clearing house" that processes blacklistees back into the business under their own names . . . once they fink on other writers. Thus, writers regain their legitimacy by naming names. And before you know it, you have a booming assembly line of besieged schmucks turning on each other. (59)

Furthermore, Feiffer cleverly pokes fun at his own framed narrative when he shows his characters debating and critiquing the very devices used in their own plot as lacking verisimilitude of credibility: "My goodness! All of this she finds in that one diary?" (59) (figure 3.1). By playfully creating such exchanges between the diegetic and the metadiegetic levels whereby the

FIGURE 3.1 The blacklisted screenwriters discuss their plot. From *The Ghost Script: A Graphic Novel* by Jules Feiffer, p. 59. (Copyright © 2018 by B. Mergendeiler Corp. Used by permission of Liveright Publishing Corporation).

embedded narrative does not merely mirror but contaminates and is contaminated by the primary level of representation, Feiffer flirts with the line between metadiegesis and metalepsis, a "deliberate transgression of the threshold of embedding" that "[disturbs], to say the least, the distinction between levels," often for humorous effect (Genette 1988, 88).

In addition to exposing the main operatives of the blacklist, the screenwriters' ghost script targets one individual in particular: "The man who runs the clearinghouse for the studios, Lyman Murchison" (60), who is "responsible for the loss of jobs and the dissemination of paranoia" (81), although neither he nor his organization ("Our Forefathers for Freedom") can be named explicitly. Beyond identifying Murchison as a behind-the-scenes puppet master, their plot also aims to reflect on the wider objectives of the blacklist which, according to their Marxist understanding of political dynamics, are not simply a repression of progressive intellectuals and communism itself but ultimately a tool against left-wing unions. In their structural interpretation of economics, "Union busting is what the witch hunt is about. The blacklist exists as its negotiating tool" (60). In regard to the screenwriters' radical ideology, a rift begins to appear between the liberal Rose and his more entrenched communist counterparts as to the tone and overtness of their message. Seeking to "humanize" the Murchison character in order to temper what he views as his colleagues' melodramatic Manicheanism, Rose proposes "a more nuanced approach" to "balance him off" with more positive aspects—a misguided rather than purely evil individual whose zeal to protect America leads to its very destruction (81). Bloom and McCay remain uncompromising on this point: "Our aim is not to write an even-handed script that finds fault with both sides: the persecuted and the persecutors. . . . We're telling the truth here, Mr. Rose! Not one more compromised piece of Broadway or Hollywood claptrap" (81–82). Angered by this comparison between Broadway and Hollywood, Rose leaves their mansion in frustration, while Faye calls him a "weak-kneed liberal assh-le." On the subject of conformity to communist doctrine, party censorship is also evoked in the novel when Archie Goldman receives a visit from Silas Moffat, a former screenwriter turned chairman of "The People's Peace and Progressive Coalition" (identified by the PI as a communist front), who offers him money for a peek at the script so that the association's "cultural committee" can verify its accuracy. Archie takes his usual distance from the party by notifying his client that the PI firm's senior partner (Archie's mother) is a Trotskyite who will likely not approve this request (76–77).

This spectrum of positions and sensibilities on the left turns into another comedy of errors in Feiffer's story, "a circular firing squad on the left," as Annie

Hannigan puts it when hearing Rose complain about his writing partners' intransigence (83–84). He argues that, as a Broadway playwright, he is more accustomed to working alone rather than "by committee" and expresses his desire to complete the script on his own, claiming that it was his idea "in the first place." Annie rightly replies that the ghost script was in fact *her* initiative, and that it was originally conceived as a mere gag to worry the architects of the blacklist, a red herring of sorts. Feiffer's illustrations for this scene depict Rose and Annie dancing as a contrapuntal expression of verbal debate and a return to the choreography motif interspersed throughout the trilogy, including in the opening scene of *Kill My Mother*, also featuring Annie. Through a tragic turn of events, Rose gets his wish of single ownership when Faye, returning from having fooled the studio executive disguised as her own front, finds Oz dead at his typewriter from an apparent suicide by gun. His touching suicide note testifies to the damage caused by the blacklist: "Sorry, Toots, I ain't so tough" (87). We learn in the conclusion of the novel that Faye suffered a stroke after her companion's passing and never returned to Hollywood in a writing capacity (140). With this somber turn of events, which cuts against the reflexive playfulness of the plot, Feiffer's fictional characters bring a tragic reference to the death by suicide of several blacklistees unable to cope with the undoing of their careers, including the actor Philip Loeb and the lawyer Bartley Crum. Here again, the figure of J. Edward Bromberg, who suffered a heart attack in 1951 in the wake of his defiant HUAC testimony, and whose funeral deeply impacted Feiffer's political consciousness, looms large over his graphic novel. Although Faye Bloom and Oz McCay are invented, composite characters, their duo alludes to the many screenwriting couples whose lives were turned upside down under McCarthyism, such as Ruth McKenney and Richard Bransten (who died by suicide), Jean Rouverol and Hugo Butler, Garson Kanin and Ruth Gordon, Norma and Ben Barzman, and Marguerite Roberts and John Sanford, to name a few. In the acknowledgments section of *The Ghost Script*, Feiffer also refers to "old and valued friends" whose profiles likewise informed the novel's fictional characters, such as the screenwriter Lillian Hellman, who took a principled, courageous stand against the HUAC; Walter Bernstein, who was sidelined from Hollywood into television work and wrote the script for Martin Ritt's *The Front* (1976, featuring Woody Allen and Zero Mostel); and the actress Lee Grant, whose film career was severely harmed by the blacklist—all countermodels to the disappointment caused by Odets and the other HUAC "finks."

Henceforth, Rose completes the screenplay on his own and submits it to Everett Kornblum, who calls it "brilliant" but declares that "it is so

undeniably true that it can never see the light of day" (127). The producer states the rules of the game quite plainly—in the current repressive climate, Hollywood can only afford the most inconspicuous of transgressions: "Baby steps. An inch here, an inch there. Acceptable truths—framed as entertainment! That is our goal, and that is our limit. But in this script you force feed the audience truths that are not yet acceptable." Kornblum, in his usual mitigating approach, determines that "a few fixes" would improve the script, likely by softening its oppositional stance, and informs Rose that clearing his reputation by acknowledging past associations with "known radicals, proven communists" in front of the HUAC will be required before the movie is approved. Countering Rose's protest that he has no such affiliations to hide nor report, Kornblum insists that the hearings are a mere performative formality, a necessary concession with no bearing on reality, an opportunistic simulacrum with preestablished rules: "Names will be supplied to you. Not that many. And all previously blacklisted, so you won't be hurting anyone. It's a ritual. A rite of passage. Think of the greater good. Once you've done penance, we can go forward! We can make your film that exposes the witch hunters" (128). He also adds that only actors who have been cleared by the committee and who have themselves named names can be cast, which provokes Rose's ironic remark: "Are you telling me that in a film that exposes the blacklist, we can't cast anyone blacklisted?" Dismayed and defeated, Rose decides to return to Broadway to "put this on as a play" (129). Kornblum offers perfunctory regrets and insincere praise for the writer's integrity, then dumps the script in a trash can upon Rose's departure, which indicates that his passive resistance intentionally sought to prevent the making of this movie.

This final paradox concludes the reflexive loop of the ghost script, a denunciation of censorship that is itself censored by the very system it condemns—the hollow center of a multilayered system of representation: a nonentity from its beginning as a hoax to its ending as an unmade film, and a red herring on both diegetic and metadiegetic levels.

Archie Goldman, the Wishy-Washy Detective

In defining the standard features of the private eye, Dennis Porter identifies two key elements of complementary yet distinct natures. The first one implies the psychology of the character as a tough, independent problem solver with a strong moral compass, evolving amid an unstable world. He recalls

Raymond Chandler's essay on Dashiell Hammett's fiction, which states that the PI character "must be, to use a rather weathered phrase, a man of honor": "In brief, the private eye is held up to be the stubbornly democratic hero of a post-heroic age, righting wrongs in a fallen world in which the traditional institutions and guardians of the law, whether out of incompetence, cynicism or corruption, are no longer up to the task" (Porter 2003, 97). This description befits Archie Goldman, a man who keeps his critical distance from politics in the complex and troubled context of the 1950s yet attempts to find an individual path through a labyrinth of conspiracies while struggling with his own morality.

The second main characteristic of the PI, both in literature and in film, lies in an enunciative configuration found in some of the earliest hard-boiled novels such as Dashiell Hammett's *Red Harvest* (1929): "One of the most widely imitated features of *Red Harvest* is Hammett's use of the first person as narrative voice and as point of view, since together they embody a whole way of observing and representing the world" (Porter 2003, 99). The PI's tone—his "corrosive, wise guy-wit" (101)—indeed conveys a perception of social and political realities that implies cynical self-reliance. The toughness and self-confidence of the private detective, conceived in the age of the Great Depression, have become inseparable from the construct of American masculinity in the twentieth century. By both standards, however, Archie Goldman's penchant for self-doubt and self-analysis deviates from the established norms of the PI character and narrator. The manner in which his "nebbishness"—to use a quintessential Feifferian term—adds psychological and cultural complexity to the figure is ground for critical investigation.

The opening chapter of *The Ghost Script*, a first-person monologue by Archie, echoes the typical narrative voice of hard-boiled literature and the voice-over technique of film noir, by which contrapuntal images run parallel to a spoken account. Archie is shown walking past a street demonstration with people holding signs exposing an array of 1950s political issues such as world peace, nuclear testing, segregation, male chauvinism, and workers' salaries (3). As a graphic equivalent to a voice-over, Archie's commentary does not emanate from a speech balloon but is inscribed in the space of the panel, either in shadow script superimposed over the images or in plain black ink in the upper portion of the panels. Archie's descriptive considerations conform to the usual detached tone of the stereotypical PI, expressing boredom with the habitual predictability of his surroundings: "Another day in Hollywood. Another strike, or demonstration or confrontation or riot. Depending on what the players planned for that day. The signs cover all bases. The

usual going-nowhere demands of left-wing unions. Plus the regular line-up of police standing by, just in case there's trouble they won't do anything to stop. And here they come! Right-wing goons with clubs and epithets. And here am I, Archie Goldman, who will never learn that it is my lot to be an innocent bystander. One look at me and every right-wing union goon can smell my mother's a socialist" (3). Although Archie's narrative begins in standard caustic fashion, it concludes with a comical admission of weakness when his mere appearance incites the suspicion and violence of the counterdemonstrators armed with baseball bats and screaming invectives at the protestors ("Commie bastards! Go back to Russia, you queers!"). The last panel of the page, which corresponds to the delayed sentence fragment "can smell my mother's a socialist" and shows the PI fearfully running away from an angry mob toward the reader's gaze, introduces an unexpected comedic shift that undermines Archie's attempt at verbal toughness. The following page continues the same narrative and visual configuration, with a sustained monologue over a sequence of images depicting Archie's flight, progressing toward the reader in increasingly closer focus until he disappears from the last frame under the blows of his assailants, leaving only his hat suspended in midair. Matching this kinetic chain of panels, drawn in the unmistakably supple Feiffer line, the first-person confession shifts from assuredness to complaint and reveals an unusually vulnerable detective:

> And do they give me a chance to explain that I don't share her politics? And anyhow, she's an anti-communist? No! Or do the cops raise a finger to help? No! Not even when the cops who know me because I'm a private eye, and I'm in and out of headquarters. Does anyone say, "Let's save Archie's ass, he don't deserve to get pounded?" No! So two, three times a week, because I can't help myself, I stop to watch one of these demonstrations, and time after time, it's the same goons and the same cops following the same script, me included. Half the time I get away. Half the time I don't. (4)

Archie's gripe takes on a particular tone antithetical to the expected PI's self-assurance and closer to the famous "kvetching" that Feiffer introduced in his 1950s cartoons for *The Village Voice*, where his characters were "so busy explaining themselves that they never shut up" (Feiffer 2010, 241). In addition, it unfolds according to a specific format and rhythm in which repetition constitutes a central comedic device. Not only does the out-of-luck detective voice his protest in a string of rhetorical questions that all end with the same response ("No!"), which establishes a pattern of passive-aggressive

introspection and repeated disappointment, but his behavior also implies obsessive tendencies that lead to self-destruction despite himself ("because I can't help myself"). The verbal and visual rhythms of this chase sequence—where the chasers remain invisible, placing the focus on Archie alone—are perfectly synchronized and conclude with the panel in which Archie's fall matches the final sentence ("Half the time I don't [get away]").

The introductory chapters of *The Ghost Script* continue to mirror the conventions of hard-boiled fiction when Archie encounters another frequent protagonist within this literary form, the powerful magnate who exercises economic and political influence over the city. In this instance, the notable in question is the millionaire philanthropist Lyman Murchison, "a mystery man, who appeared out of nowhere" after World War II to fight Reds in Hollywood (10–11). Here again, the detective's monologue remains true to type, offering the customary blend of subjective description, ironic detachment, and offbeat commentary. In his usual derisive tone, he remarks on a series of contradictions: he takes notice of the unusual location of Murchison's mansion, a seedy part of San Pedro normally home to "dopesters and petty thieves," and jokes that his residence resembles an unassailable medieval castle, despite its owner's reputation for integrity. Still in his wisecracking tone, he also compares the hyperpatriotic Murchison to Captain America[7] for his opposition to communism and extends this comics reference to current politics by observing that, after the war, "faster than a speeding bullet, Red went out of style. That is, if you wanted to keep your movie job." Despite Archie's verbal bravado, however, his short and pudgy physique—which bears a slight resemblance to that of J. Edward Bromberg,[8] whose ghostly presence pervades this graphic novel—constitutes another source of insecurity, as evidenced by the sharp contrast between the diminutive detective and Baxter, Murchison's burly bodyguard (11).

Further reinforcing such conformity with the tropes and style of hard-boiled literature and film noir, Archie's meeting with Murchison—the classic confrontation between the PI and a wealthy mogul—calls on an intertextual reference when the latter declares: "You have read Raymond Chandler? Since you are a private detective, I take it that you are familiar with 'The Big Sleep.' Here you see my duplication of General Sternwood's greenhouse as seen in the Howard Hawks film. The very spot where he assigns Philip Marlowe his most famous case" (13–14). However, in this interaction, where the reader finds early clues that Murchison is in fact the alter ego of Cousin Joseph (see the next section of this chapter), Archie performs a significant reversal of the hard-boiled formula: rather than accepting a mission

from an affluent sponsor (as Marlowe does from Sternwood), Archie has other motives beyond financial retribution. In this instance, he actively manipulates his interlocutor into believing a made-up story with impending consequences for Murchison: he informs the old man of the existence of a "ghost script"—"which may or may not exist"—that "tells the inside story behind the blacklist [and] reveals how a secret order of powerful individuals," whose real names are disclosed, conspired to ban leftist actors, directors, and screenwriters (18). In essence, the ghost script proposes an alternative conspiracy that "names names" in return, including Murchison's. Angry and fearful, the millionaire hires Archie to bring him a copy of the ghost script, offering a very large sum of money. The PI accepts with a quip, "I'll see what I can Jew—I mean do" (20), then reports to Annie, Elsie, and Patty, the instigators of this scheme, that their target is "hooked."

Archie's relationships with three women also contribute to his neuroses. In one of the novel's numerous "bedroom scenes" (37–38), we learn that he has been in a relationship with Annie Hannigan for the past seven years and surmise that her usual hypercritical attitude has taken its toll on his self-confidence. Notoriously hard to please, as shown in *Kill My Mother*, Annie withdraws her romantic affection and pesters her lover with suspicions of infidelity (calling him a "deceitful little twerp") and insinuations of professional incompetence, making sarcastic, passive-aggressive comments about his abilities ("You're not very observant, are you?"; "Not that you're very good at [finding people]. But aren't you a detective?"). In addition, Archie works for his mother, whom he describes as "the brain of the operation," leaving him the lesser tasks of doing the "leg work" (34). Finally, through another "bedroom scene," we are privy to Archie's relationship with Lola Burns, the blacklisted starlet turned prostitute whom he uses as a gossip informant. Here again, Archie appears dominated and infantilized by a more powerful female figure who reigns over their sexual and financial exchanges. In one episode where a badly bruised Archie visits Lola after a beatdown inflicted by the anti-union goons who constantly victimize him, the statuesque actress carries the undersized PI over her shoulder and treats him like a child, to his visible dislike (56–57).

Archie's chronic hesitancy and insecurity can be traced back to his childhood encounter with Knox's enforcer, Mr. Elliot, whose violence left a lasting trauma in the grown-up detective. As a reminder of this daunting past, Feiffer embeds the chapter of *Cousin Joseph* depicting this earlier episode within a passage staging another interaction between the same two characters, in the present of the narrative. On this occasion, when the adult Archie meets Elliot by chance in a bar, his nemesis has become an impaired alcoholic

who cannot recall his mistreatment of the child twenty years before. The man who viciously insisted on Archie's remembrance ("Burn that into your feeble little brain") denies any knowledge of the very psychic wounds he inflicted and rebuffs him with homophobic slurs, leaving Archie to struggle with a moral paradox: "Omigod! This thing still haunts me, and this broken-down old drunk doesn't remember any of it! Is that fair?" (70). Furthermore, Elliot's unreliability denies Archie the recognition of his professional competence, to the extent that the debilitated bully can no longer corroborate the evidence that led Archie to solve Valerie Knox's murder, the impetus for his becoming a detective.

Such repeated affronts alter the tone of Archie's PI monologues, where detached toughness turns into self-loathing. Driving away from his frustrating encounter with Elliot—one of the many uses of the automobile motif as an enunciative device throughout the trilogy—Archie berates himself ("Jerk! Idiot! Moron!") and takes inventory of his failures and shortcomings: "getting into an argument with a broken-down old drunk who still scares you"; serving merely as "a gofer and an errand boy" for his mother's agency, at the age of forty-two; and failing to measure up to his role model, the rugged Sam Hannigan ("Me? I'm a joke! Sam beat up the bad guys. *You* get beat up by the bad guys... Sam acted. *You* analyze" (71). This unfavorable comparison with Hannigan leads to more ambivalence about the latter's politics. Reconsidering Hannigan's actions and values, Archie admires his initiative and decisiveness (qualities that he personally lacks, in his own assessment) yet concedes that his views oversimplified the complexity of American history, particularly about immigration, assimilation, and freedom. In his meandering, conflicted thoughts, Archie remarks that Hannigan's immigration narrative did not take into account Black citizens, who did not come to America "to be free" (72). Sam's violence creates yet another quandary for Archie, who examines his own masculinity by this token: "And you? You don't have a speck of violence in you. Does that make you less of a man than Sam?" In an age when popular culture favors hypermasculine, hard-boiled heroic figures, the indecisive detective acknowledges that his propensity for self-doubt amounts to inadequacy: "I tie myself up in knots.... Anyone who wants to write my story, I've got the perfect headline for them: 'The Wishy-Washy Detective'" (72). In essence, Archie's overabundance of critical thinking leads him to envy a man who lacked perspective and nuance but acted with unconditional conviction.

Archie's self-hatred recalls an earlier attempt by Feiffer at writing a parody of a private detective afflicted by an inferiority complex in his 1977 novel

Ackroyd: A Mystery of Identity. Like Archie, Ackroyd repeatedly confesses his personal and professional insecurities through a self-castigating inner voice: "Why did I humiliate myself by telling that awful story? . . . Why can't I conduct a professional surveillance? I am a flop. A f-ckup. I am everything my father said I was. He may call me his enemy, but, in truth, I am his ally. I have done my best to prove that he is right about me" (Feiffer 1977, 34–35). A reader of Chandler and Hammett, he bemoans—in contrast to the eventfulness of their stories—his tedious life and lack of clients, as well as the mundane nature of his few investigations. Like *Kill My Mother*, *Ackroyd* continually plays with identity reversals among the protagonists, including the detective himself.

Feiffer's tendency toward extended character monologues in *The Ghost Script* also bears a striking resemblance to his playwriting style, which was itself an extension of his newspaper comics. In this regard, one may find numerous parallels between the *Kill My Mother* trilogy and his 1967 play *Little Murders* (adapted from his 1963 novel and remediated as a film by Alan Arkin in 1971), a dark existential comedy on the unraveling of authority and civility in post–JFK assassination America.[9] Indeed, both *Little Murders* and the three noir graphic novels stage the misadventures of inept detectives overwhelmed by violence and prone to nervous breakdowns and long, self-centered complaints (Lieutenant Practice and Archie). Archie also resembles *Little Murders*' main character, Alfred Chamberlain, to the extent that both are resigned to being the victims of recurrent and unprovoked aggressions, which they have come to accept as unavoidable realities in their lives. As Alfred puts it, "There's no way of talking someone out of beating you up if that's what they want to do" (Feiffer 1968, 20). The peculiar rhythm of *Little Murders* stems from its unusual reliance on lengthy monologues, often stretching over several pages in the published script, in which the characters deliver uninterrupted harangues or grievances. In addition to the aforementioned soliloquy by Lieutenant Practice (Feiffer 1968, 73–77), which devolves into delusions of conspiracy, and Judge Stern's reactionary sermon about his parents' immigration to America (see chapter 2), one may also recall Reverend Henry Dupas's absurdist lecture on the institution of marriage (performed by Donald Sutherland in the film version) (50–51), Patsy's numerous reflections on men and relationships, Alfred's story about driving an FBI agent to paranoia (60–61), and Carol Newquist's final call for a repressive surveillance state (77–78).

Furthermore, Archie's monologue also provides a commentary on another cultural aspect of the 1950s, "the onslaught of doubt, insecurity, neurosis" (Feiffer 2010, 217) that began to pervade the zeitgeist and was reflected in

various forms of introspective expression. In this instance, Archie's first-person complaints echo the singular voice of the "self-pitying cartoons" that Feiffer created for *The Village Voice* in the 1950s, and in which he channeled his own feelings of frustration and exclusion:[10] "Yak, yak, yak. That's what my characters did—turn their pain and humiliation into talking points.... What if I introduced the 'I' voice to my readers in the form of eight- or ten-panel monologues—unwinding, self-serving kvetches in which my 'I' character gives away more than he means to, exposes what he'd rather keep hidden. It would be comic strip psychotherapy, laugh while you wince, wince as you laugh" (Feiffer 2010, 211–212).

In this regard, Archie's Jewishness appears pertinent not only to Feiffer's inside joke on his own cultural predisposition toward guilt and rationalization but also to the author's statement about the contributions of Jewish humorists[11] to the reassessment of the American tradition of positive thinking and self-confidence in the 1950s: "Confused and on the defensive, WASP America, having begun to lose faith in its mythic identity, looked around and found a few funny Jews who mirrored their anxiety. They welcomed and embraced the victimized Jewish sensibility of displacement. WASP America was now feeling displaced. It chose the chosen funny people to explain them to themselves. Jews were far more comfortable with the language of anxiety and alienation" (Feiffer 2010, 217).

In a later segment of *The Ghost Script*, the private investigator, finally having won a fight, reflects once again on his overcautious, overanalytical flaws, using a different benchmark than Sam Hannigan: Will Eisner's crime-fighting hero the Spirit: "I used to read the Sunday comics ... about this masked crime-fighter, 'The Spirit' ... who, almost every week, got into fights where he got the crap pounded out of him. Terrible beatings. Until ... at the very last minute, with his last shred of strength, he'd win the fight" (121). Feiffer's clever intertextual allusion not only draws a thematic parallel with Archie's victory, acquired in similar fashion after a nearly lost struggle with Billy Doyle (see later in this chapter), but also draws a direct connection with Feiffer's cartooning origins, where he served as Eisner's assistant and "ghost" scriptwriter for *The Spirit* for a period of three and a half years (Feiffer 2010, 67–69). This reference also takes on a metatextual dimension, insofar as Feiffer not only creates a parallel with his earlier noir work but also distinguishes his character from the formulaic template of the source material and identifies the distinctive tone of his meta-noir series. Here again, victorious for once, albeit by chance only—his opponent died of a heart attack while beating him—Archie is unable to draw from the lessons of his success and continues to be

plagued with questions: "Did I win that one? Do I know the difference between losing and winning? Can you live your life without knowing the difference? Is that something important to know?" (121). The corresponding illustration shows the PI slumped on a chair, holding a bottle and a glass, and looking disheveled (figure 3.2).

Finally, the conclusion of the story still does not offer any closure on Archie's indecision, even after the positive outcomes of his double investigation into Murchison's and Doyle's hidden pasts. The penultimate chapter 62, "Swimming Upward" (141–147), returns to the car motif and depicts the detective driving around in circles in the desert, unable to decide on a place to bury Murchison's *kompromat* files. Archie's directionless state is expressed through the panel-less juxtaposition of multiple images of the same vehicle with various orientations, forming circular or zigzag patterns over five consecutive pages, with anxious speech bubbles emanating from the driver's window. He states his awareness of his quixotic complex in clear terms: "I do know what I'm doing! I'm battling windmills in the desert. And the windmills are winning" (141). While the epilogue that Archie enunciates in this one-sided conversation with the windmill takes stock of the changes that have been accomplished, it leaves many strands of the story open-ended. On the positive side, his assistant Orville has recovered from his injuries and has surpassed him in investigative prowess. On the negative side, his mother has stopped talking to him because he killed her lover, Billy Doyle. In the less-defined space between those two poles, many questions remain unanswered for Archie. Should he switch careers and become Lola's manager, now that she has become a successful actress? Or should he work for Annie's new "civil-liberties-do-good foundation" and stand by his lover, who is about to be blacklisted by HUAC? In both cases, he struggles morally with career opportunities that result from his lies (Lola's false statement against Murchison, which he suggested) and murders (Doyle's and Murchison's, which he caused and covered up, respectively). The culmination of his guilt takes on the same circular trajectory as the vehicle—a reflexive guilt, in search of itself: "Shouldn't I feel guilt? Is that why I'm driving around in circles? I'm searching for my Jewish guilt?" (143).

Feiffer finally brings Archie's self-questioning to an ironic ending. "Screw the guilt! Screw the doubt! I'm an American! Americans are the children of destiny!" Archie finally concludes (144), finding confidence—like Sam Hannigan before him—in the moral certainties of the American Dream, according to which America is on a perpetual path of righteousness, betterment, and triumph over other nations. As he finds a metaphorical expression

FIGURE 3.2 Archie compares himself to the Spirit. From *The Ghost Script: A Graphic Novel* by Jules Feiffer, p. 121. (Copyright © 2018 by B. Mergendeiler Corp. Used by permission of Liveright Publishing Corporation).

of America's invincibility in alien invasion movies,[12] where "America always wins in the end," his car is lifted off the ground by the beam of a flying saucer above (figure 3.3). Archie's final thoughts, after wondering why his vehicle stopped and bemoaning that he does not know much about cars, leave his impending demise unrepresented: "I better get out and take a look" (147). From Sam Hannigan in the 1930s to Archie Goldman in the 1950s, the loop of America's infatuation with its own myth ends in similar disenchantment.

Orville and Beanie: Race and the "Ally" Posture

Until *The Ghost Script*, Feiffer's trilogy only examined American diversity though the lens of immigrant, non-WASP, white minorities who were long denied full status as Americans, and whose hyphenated identities were deliberately kept outside the selective sphere of American "whiteness": the Jews and the Irish. *Cousin Joseph*, in its chapter presenting Everett Kornblum's egalitarian script about American integration, briefly mentioned Italian Americans as another group who suffered similar assimilation difficulties due to WASP rejection. In his third volume, Feiffer introduces two Black characters—Orville Daniels and Beanie—whose narrative profile and graphic treatment warrant discussion. As *Kill My Mother* and *Cousin Joseph* revisit the gender portrayals of film noir, these protagonists propose multilayered constructs that interrogate the mechanics of racial representation.

It is important to note that, by replicating film noir in drawn form, Feiffer also mirrors its rather progressive agenda for ethnic and racial equality, as well as social justice[13] (Flory 2013, 387). Even though they "only occasionally confronted anti-black racism directly, ... noir films still advanced modestly, and on occasion startingly, progressive perspectives on race, particularly concerning anti-black racism" (396–397). Of course, film noir, like most cultural representations of its era, was hardly free of deeply problematic and painful stereotypes. Because of the pressure of the Film Code Authority and the disposition of certain producers, Black characters were often confined to stock roles as "maids, waiters, Pullman porters, shoeshine men, faithful retainers, and the like" (Flory 2013, 396). However, even in these limited and invariably demeaning roles, and within the constraints of their conventions on otherness, film critics often argued that some Black protagonists were imbued with more visibility and agency than in other films of the same period. Often-quoted examples are *The Reckless Moment* (Max Ophüls, 1949), where Frances E. Williams plays a housekeeper whose actions gain a central importance to the plot, or *The Set-Up*

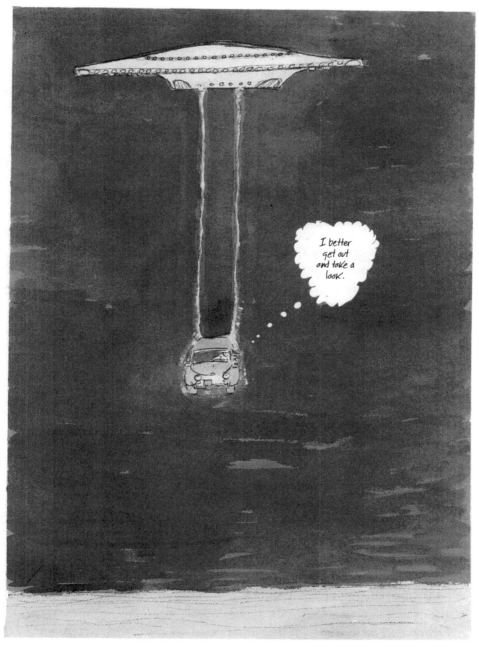

FIGURE 3.3 Archie is abducted by a flying saucer. From *The Ghost Script: A Graphic Novel* by Jules Feiffer, p. 147. (Copyright © 2018 by B. Mergendeiler Corp. Used by permission of Liveright Publishing Corporation).

(Robert Wise, 1949), in which James Edwards plays the boxer Luther Hawkins, a man who expresses his hopes of improving his condition.[14] Other films noirs challenged the prevalent Hollywood stereotypes more openly and were far more explicit in their anti-racist message. For instance, *No Way Out* (Joseph L. Mankiewicz, 1950) featured a Black doctor (Luther Brooks, played by Sidney Poitier) who encounters the bigotry of his white patients—in a shocking scene, a white woman spits in his face when he attempts to treat her son—and whose noble actions are unjustly met with violence against his entire community. The scenes depicting the viciousness and absurdity of a race riot are among the most unequivocal indictments of prejudice in the cinema of this period. *The Breaking Point* (Michael Curtiz, 1950) promoted the agenda for equality through its portrayal of a friendship that crossed racial divides. At the end of the 1950s, as American society underwent the beginnings of a transformative shift toward desegregation, Hollywood produced what Eric Lott calls "a real civil-rights noir" (Lott 1997, 561), *Odds Against Tomorrow* (Robert Wise, 1959, written by the blacklisted screenwriter Abraham Polonsky and starring Harry Belafonte) (Flory 2013, 397–398).

A "white liberal" by his own definition, Feiffer has had a sustained interest in the Civil Rights Movement and was an early admirer of the activist Bayard Rustin, one of the organizers of the 1963 March on Washington, whose lecture on "the future of civil rights in America" he attended at the Quaker Meeting Hall in 1953, the very year in which the events of *The Ghost Script* are set. He credits Rustin[15] for changing how he perceived the urgency and importance of race in America, allowing him to realize, in Rustin's terms, that "the issues raised by the end of the Civil War were as unresolved in 1953 as they were in 1865. The inability of white America, North and South, to come to terms with its Negro citizens, a tenth of the population, was the single most important issue Americans faced.... America's future, white and black, depended on whether in the next decade we began to seriously address segregation and racism in our society" (Feiffer 2010, 284–285). Convinced by Rustin's "reconciliation" rationale, Feiffer took to heart the notion that the nation's cohesion and survival depended on fostering unprejudiced interactions across communities and erasing divisions by living together in schools, workplaces, and neighborhoods. In this regard, the *Feiffer* strips from the *Village Voice* are reflective of the author's internal and external questioning about achieving racial equality, often from sarcastic and self-critical perspectives. It is quite significant that Feiffer's first true political cartoon (September 18, 1957) pokes fun at Eisenhower's hands-off, noncommittal response to school desegregation (Fay 2015, 114). The strips featured observations about

the problematic and sometimes hypocritical "ally" position of white liberals like himself. One cartoon published on May 6, 1965, shows a group of white "liberal reformers" assuaging their guilt by paying a Black activist to ridicule them on a weekly basis (Fay 2015, 120). Another from the same period shows a Black man reflecting on being a "token" guest at white liberal parties, concluding on the speed of integration with this acerbic punch line: "At their next party they had *two* negroes—just in case the first one didn't work out" (Fay 2015, 121). Some of these provocative cartoons were republished under separate covers in 1966 by the Anti-Defamation League of B'nai B'rith in a volume entitled *Feiffer on Civil Rights*, prefaced by Rustin himself, who remarked that "Feiffer was one of the very first to understand that there were complexities—and even hypocrisies—in some of the attitudes of white liberalism" (Fay 2015, 115).

Even with the best of values and intentions, depicting Black characters and racial diversity in general in cartoons, comics, or graphic novels constitutes a challenging enterprise in a medium dominated by "a white comics imaginary that has persistently represented Black embodiment as monstrous and grotesque by way of racist caricature," promoting an iconography of inferiority[16] (Davis-McElligatt 2023, 194). Creating visual signifiers that function as legible markers of racial identity—to the extent that they intend to make a point about race—without resorting to a heavily codified graphic vocabulary that is itself complicit with racism requires discernment and adroitness. In his *Village Voice* strips, Feiffer formulated solutions that, in retrospect, may have lacked some nuance. In some cartoons, he opted for a simple binary code that indicated skin color through hachure—shading with fine parallel lines—which served as the only indicator of dissimilarity, all other facial and bodily features remaining more or less the same between white and Black figures. Other drawings, however, ventured in the area of verisimilitude, albeit in a discreet, noncaricatural manner aligned with Feiffer's flexible line and nonmimetic style; in such cases, the cartoonist made an apparent attempt at capturing other generic components (hair, noses, lips), although each character presents a different physique. These past graphic choices inform our present discussion of the manner in which Feiffer reflects on his own depiction of Black protagonists in *The Ghost Script*.

The first Black character introduced in this third and final installment of the trilogy is Orville Daniels, whom Archie encounters during a foot chase, while both are running away from the same mob of union "goons" (32–33). This scene establishes a visual and narrative parallel between the two men—a Jewish detective and a Black reporter—through visual juxtaposition. On

page 32, four narrow vertical panels imply a similitude between two people who are prey to the same victimization. They depict Archie and Orville moving in the same direction, toward the reader and away from the same threat of physical harm (figure 3.4). In addition to the comedic nature of this passage, in which two men randomly strike up a conversation and a friendship mid-chase, under dangerous circumstances, their dialogue points to parallel experiences of racism. When Archie asks him if he knows why the goons are pursuing him, Orville simply responds: "I'm a Negro," using the period-appropriate qualifier that constitutes the only justification for his mistreatment. Archie's reply, in the same situation, implies both an analogy and a certain amount of ignorance or insensitivity: "So? I'm a Jew. Are you sure you're not being over-sensitive?" Orville, still matter-of-factly, stresses the real peril of his predicament: "You want me to slow down and find out?" (33). This conversation captures the contradictions of the "ally" analogy: although Archie draws a correlation between his own vulnerability to racist violence and Orville's, he fails to properly gauge the limits of this comparison, like many of the liberals whom Feiffer lambasted in his earlier political cartoons. As for Orville's appearance, the character's graceful physique and elegant clothing—reminiscent of Feiffer's drawings of his friend Gregory Hines (Fay 2015, 243)—bear no mark of caricatural exaggeration. A stylish minimalism pervades in this regard: skin color is indicated by a light gray ink wash and curled black hair by thick brush strokes.

A recent graduate from the Columbia School of Journalism, Orville is conducting research on the blacklist. He considers himself an investigative journalist in the mode of I. F. Stone, his hero as well as one of Feiffer's (Feiffer 2010, 99–102), to whom the latter partially dedicated *The Ghost Script*. Impressed with his new friend's outstanding professional competence, Archie hires him to dig into Sox McManus's past (74–75). However, by sending him on this fact-finding mission, Archie underestimates the danger in which he places his assistant. Orville soon finds himself badly beaten and locked in the car trunk of the two HUAC spooks who protect the right-wing union leader. The reporter barely escapes while the two assassins leave their car to dig a grave in the woods (103). Upon finding him wounded by his office door, Archie takes him to the hospital, where Orville informs him of the results of his investigation: by comparing interviews given to newspapers at different times and in different cities, he deduced that McManus is in fact the same man as the labor organizer Billy Doyle, presumed dead (109–110). Paradoxically, Orville's flawless professional ethics and integrity almost caused his death, as he reached out to McManus to corroborate his findings: "That's

FIGURE 3.4 Archie meets the journalist Orville Daniels during a foot chase. From *The Ghost Script: A Graphic Novel* by Jules Feiffer, p. 32. (Copyright © 2018 by B. Mergendeiler Corp. Used by permission of Liveright Publishing Corporation).

what we do in journalism" (110). Archie helps his partner escape to New York and congratulates him for solving the Billy Doyle mystery on his own: "You're a better detective than I am, Orville" (111). He reiterates his assessment of Orville's superiority in the conclusion of the narrative, as he remarks once again that "he's a better investigator than I am, anyhow" (142). In addition to staging the story of a friendship across segregation lines, like in Michael Curtiz's *The Breaking Point*, this ending also implies that Archie's recognition of Orville's talents coincides with a wider context of social progress.

The representation of the second Black character in this graphic novel is perhaps more complex in the ironic devices it employs to question racism. It repeats the same introductory pattern as Archie's encounter with Orville: in one of his multiple chases by the same goons, the endlessly bullied detective hides inside a large building and asks a janitor working on-site not to reveal his presence. As opposed to Orville's professional status as a Columbia graduate, the Black janitor figure recalls the stock domestic figures and dehumanized roles reserved for Black actors throughout the depicted decade. Archie indeed recognizes the man as the actor who played Beanie on a TV show called *Beau and Beanie*, which he used to watch as a child. Despite the chronological confusion of this timeline within the media landscape of the early twentieth century,[17] the reader understands that the *Beau and Beanie* show is a fictional counterpart to 1930s and 1940s sitcoms and radio serials about Black characters anchored in the painfully stereotypical minstrel tradition, such as *Amos 'n' Andy*, initially performed by white actors[18] in grossly fabricated dialect (and in blackface, in the 1930 film *Check and Double-Check*). The mischaracterization of Black language, behavior, and culture, shaped by such preconceived templates, had in return a lasting impact on perceptions and expectations of Blackness in mainstream America (Jackson 2006; Leonard and Robbins 2021).

A similar conflation is at play in Archie's interaction with the janitor (figure 3.5). Upon recognizing him as a former actor, Archie insists that he repeat his catchphrase for his amusement—"You gotta talk to me once like Beanie. 'Y'all shoon't wanna make me maaaaaad, Beau!'"—further commenting that he is his "oldest fan" (54). Such catchphrases were indeed a recurrent comedic device of radio and TV comedies of this type (the phrase "Holy Mackerel!" from *Amos 'n' Andy* entered the American vernacular through similar exposure). By making such a request, which Beanie turns down in no uncertain terms ("Screw you"), Archie seems unaware that the speech act he demands of his interlocutor, even as a theatrical performance, remains a deeply problematic construct with poisonous political and social implications. When

FIGURE 3.5 Beanie's dialogue subverts linguistic stereotypes. From *The Ghost Script: A Graphic Novel* by Jules Feiffer, p. 55. (Copyright © 2018 by B. Mergendeiler Corp. Used by permission of Liveright Publishing Corporation).

the goons enter the building, they speak disrespectfully to the janitor by calling him "boy" (a coded racist expression). He helps Archie by disposing of his pursuers in cringeworthy but calculated dialect: "No, suh, I dun seed hide no' hair o' nobody, 'ceptin' y'all," which convinces the violent mob to turn away. By performing true to stereotype and conforming to the vernacular idiom expected of a working-class Black man through media representations, Beanie turns the signifiers on their heads and transforms the markers of his social alienation into a stratagem to defeat racists. In this instance, Archie understands his ploy: "What a great line! . . . You just come up with that? A brilliant ad lib. And you said it in Beanie's voice" (55). To further indicate that his phrase was an intentional stunt and not a "natural" form of speech, Beanie repeats it several times to himself with different variations, working on his word choice and affected intonation as a professional performer: "Not bad. Needs work. . . . Yeah, I think I'm ready for my comeback" (54). As with other fictional characters in Feiffer's trilogy, one is always tempted to correlate these composite figures with real-life models that may have inspired them. Behind the profile of Beanie, one could perhaps identify actors such as Spencer Williams (1893–1969) who played Andy in the televised adaptation of the *Amos 'n' Andy* show from 1951 to 1953. As an actor, a screenwriter, and a director, Williams was often required to produce and pronounce film dialogue whose phrasing and speech patterns exaggerated the linguistic characteristics associated with Black communities for white consumption (most notably in his collaboration with the producer Al Christie). Williams also branched out into directing his own movies, including low-budget Westerns with all-Black casts targeted for segregated Black audiences (Cripps 1978). After several years of professional difficulties, he returned to Hollywood in the early 1950s, which coincides with the allusion to a "comeback" in Feiffer's episode. Beanie's corpulent physique also seems to match Williams's.

At the conclusion of his interaction with Beanie, Archie still appears unable to distinguish the oppression that Black citizens experience from his own. When the janitor asks him once again to leave, he contends: "Mr. Beanie, c'mon! I'm on your side. I'm a liberal. I'm for civil rights. Are you blacklisted? Is that why you're swabbing floors?" The actor responds: "No, fool. I'm a member of the Negro Party." This statement problematizes the victimization analogy that Archie first conveyed to Orville; indeed, it clearly asserts that the problems faced by Black America in the 1950s are specific and should not be conflated with other forms of oppression. It seems therefore that in staging these two interactions, Feiffer pursued the critical reflection on the liberal ally posture that he began in the 1950s.

Kill My Father: The Return and Demise of Billy Doyle

In *The Ghost Script*, Feiffer returns to the convoluted family dynamics and Oedipal configurations that were omnipresent in *Kill My Mother*, staging a complex web of internal conflicts performed through disguised or mistaken identities. Indeed, the Goldman family also involves an Oedipal triangle of sorts that comprises the son, the mother, and the mother's lover (who may not be Archie's father[19] but who sets up a rivalry for the mother's affection between two men of different generations). Archie comes into contact with his adversary when, sitting in the PI office of "Goldman and Mother: Confidential Investigations," he receives the visit of a potential client who calls himself Sox McManus, a nickname referring to his habit of wearing colorful[20] socks. He presents himself as a teamster, the "Public Affairs Chief at Local 9 Set Construction workers' [union]" (34). Archie replies that he knows McManus's union quite well for its misdeeds—its members often chase him and beat him up, as well as peace demonstrators, and its president is about to go on trial for misappropriation of funds. McManus brushes off Archie's criticism with pretexts: his union president was "framed by a pinko D.A.," and violence against the protesters was justified because they were all "Red" screenwriters. He confirms his anti-communist affiliation by telling the PI that his group is involved with the "Gung Ho America Movement" (a reference to the America First party of the 1940s and 1950s) and seeks to expose "commies and pinko unions and their liberal flunkies." With this objective, he offers to enlist Archie's help in investigating two filmmakers for their "subversive sympathies": the producer Everett Kornblum and the writer-director Annie Hannigan (36–37). Although distinct from the other storylines, McManus's proposal overlaps with other elements of Feiffer's plot, namely the Hollywood blacklist and the film community's response thereto. Like Murchison, who hides his censorship activities under the cloak of philanthropy, and the screenwriters, who conceal their identities behind fronts, the interaction between McManus and Archie is a theatrical game of masks and appearances. The detective, while himself faking ignorance of Annie's identity and political affiliation, has the vague impression of having seen his interlocutor before. Archie asks his client if they have previously met in Bay City, where the action of the two previous volumes took place, but McManus denies it.

The reader, however, may recognize[21] McManus as an older Billy Doyle, using a double point of reference—the character's physiognomy as a younger man in *Cousin Joseph* and an earlier passage from *The Ghost Script* where Billy,

presumed dead, reappears as Cissy Goldman's abusive lover (25–27). In this scene, drunk and violent, Doyle punches Archie's mother when she calls him by his real name: "You should know by now, that name you called me—that guy is dead, rotting away in the Bay City Canal, with his high school buddy Sam Hannigan.... Now I'm a new man with a new face, and a new union that brings in bigger bucks than I ever dreamed of when you and I was Wobblies." Doyle's brutality and opportunism contrast with Cissy's unalterable love for him, and Feiffer's grotesque depiction of their two aging bodies engaged in quarrel and intercourse captures the contradiction between the union leader's deceit and his lover's loyalty. A second paradox that further complicates the Goldmans' family dynamics lies in the fact that Cissy, who remains convinced that Doyle was framed for the murder of Valerie Knox, asked her son—the only person to have discovered Doyle's culpability—to clear his name. Confident in his ability to escape justice, Doyle underestimates Archie, whom he remembers as "a good kid. Not too bright, though" (27).

This web of complex relations continues to produce family innuendos when Archie reports McManus's request to investigate Everett Kornblum and Annie Hannigan to his mother, who heads their PI firm. Although she believes that Kornblum is "too careful, too smart, and too slippery" to be endangered by any probe into his liberal activities (48), she is far more worried about the consequences that Annie may suffer. She warns her son against taking on any assignment from the union leader, whom she professes to know quite well: "Listen to me, my foolish son. Sox McManus has secrets you don't wanna know. The man is dangerous. And you wanna keep him and his hoodlums as far away from Annie as possible. And my God, Elsie! Poor blind Elsie! If Sox finds out Annie's mother is Miss-Know-It-All it could be bad business for all concerned. Including you and me. Leave this alone, Archie!" (49).

While his mother remains evasive about her knowledge of McManus, Archie begins to suspect that the two share a common history. He hires an investigative journalist, Orville Daniels (see earlier in this chapter), to look into the past of this enigmatic individual (74). Upon Orville's discovery that McManus is in fact Billy Doyle, Archie attempts to warn Annie and his mother of their impending danger, but Annie finds Cissy unconscious in her apartment, nearly strangled to death. Deeply shocked by this revelation, the detective punches a Fred Astaire impersonator who interrupts his phone conversation with Annie, then immediately regrets his act of violence in his usual conciliatory fashion (113–114). If this somewhat gratuitous scene serves

no other purpose than to display Archie's perpetual ambivalence and guilt toward violence and self-affirmation, it brings another intertextual reference to Feiffer's numerous drawings of dancers and especially Fred Astaire (Fay 2015, 246–247). In addition, Feiffer folds in another diegetic layer to remind the reader of Archie's complex relationship with his mother: a flashback to Bay City in 1931 (116–117) recalls the episode from *Cousin Joseph* where Cissy Goldman prepares her son for the aftermath of the strike and effectively chooses her political commitment to the union and her loyalty to Doyle over her son.

The conclusion of the rivalry between Archie and Doyle accumulates more loops and twists. As he returns to his office, the PI is ambushed by the union thug and his men. Doyle proceeds to punch him repeatedly to force him to reveal Orville's location. Pinned down by the weight of a larger opponent and receiving blow after blow, Archie fights him back with words. The page layout depicting this fight (118–119) sets up a contrapuntal juxtaposition of physical violence and narrative exposition, whereby the kinetic drawings of Archie's beating, which position him on the receiving end of brute force, also serve as the enunciative source of an accusatory counter-discourse. Archie tells Doyle not only that his mother is still alive and can testify against her aggressor but that he can prove that he abused and murdered Valerie Knox in Bay City back in 1931, thanks to the victim's diary. Clutching his chest and speaking out of breath in fragmented sentences, Doyle interrupts his pummeling of the detective, attempts to negotiate a compromise, then collapses from a heart attack. Archie then gains the upper hand over his attackers. He retrieves a gun from his desk and prevents Doyle's men from calling for medical assistance, forcing them to carry their leader's body on foot to a faraway hospital with little chance of his survival (120).

Having caused the demise of his enemy does not bring Archie full closure, however. In the previous volume, he solved at a very young age the convoluted case of Valerie's murder by discovering the paradox of Doyle's actual culpability in a murder for which he was also framed. Yet, although the sole possessor of the truth, he could not divulge his conclusion for fear of implicating himself in this murky affair. Similarly, at the end of *The Ghost Script*, Archie reflects on the multiple paradoxes of Doyle's defeat. Although he turned the tables on his opponent in extremis, like his comics hero the Spirit, he remains uncertain as to whether he won this fight by chance or competence, leaving him once again with an unresolved question: "Did I win that one?" (121).

Elsie's Revenge: The Return and Demise of Cousin Joseph

To a reader familiar with Feiffer's previous volume, *Cousin Joseph*, Archie's first encounter with Lyman Murchison in his Raymond Chandler–inspired greenhouse offers early clues as to the millionaire's true identity beyond the mystery of the magnate's unknown origins, as he has "appeared out of nowhere, in a puff of smoke" (10). Murchison begins by questioning Archie about his mother, Cecile (Cissy) Goldman, and asks if he shares her communist sympathies. After the PI corrects him by stating that his mother's actual affiliation is not with communists—whom she hates—but with the Socialist Labor Party, and noting that she was involved in Billy Doyle's cannery strike (see chapter 2 of this book), Murchison launches into a reactionary tirade highly reminiscent of Cousin Joseph's in the second tome of the trilogy (50–51, 84) (figure 3.6):

> MURCHISON Please hear me out. This used to be a beautiful country. Then they took it away from us. They called it the New Deal. They said they were going to end the Depression. Instead, they ended America. They shackled us with rules. Thousands of regulations. What a farmer could plant, where or when he could plant it. If he didn't follow the rules, the farmer was fined, or went to jail or lost his farm. We lost our freedom. Instead they gave us unions. In a country that built the railroads, and mined coal and silver, and milled steel and manufactured automobiles—free men, laboring around the clock. Free men who didn't care as long as they got the job done. These men who, through the sweat of their brow, brick by brick, rail by rail, gave us the American Dream. Then the socialists took over, and, *as the night follows the day*, they legislated it all away. They sold us into the slavery of forms and schedules and paperwork. How old are you?
> GOLDMAN Forty-two.
> MURCHISON You have never seen America.
>
> (15, my emphasis)

Such a speech reiterates the main arguments of Cousin Joseph's previous laments to Sam Hannigan two decades before: a longing for a lost America, destroyed by political enemies; a staunch anti-socialist stance, blaming the policies of the New Deal; and a libertarian idealization of work, capitalism, and freedom, void of any concerns about the realities of workers' exploitation. Although this diatribe contains no antisemitic allusion, contrary to Cousin Joseph's earlier discourse, Murchison keeps misnaming Goldman,

FIGURE 3.6 Lyman Murchison expresses his political views to Archie Goldman. From *The Ghost Script: A Graphic Novel* by Jules Feiffer, p. 15. (Copyright © 2018 by B. Mergendeiler Corp. Used by permission of Liveright Publishing Corporation).

whom he calls "Goldberg" and "Goldstein" (15, 18), and his contempt for Archie's ethnicity is so apparent that the latter suggests a more explicit insult when Murchison's anger leaves him at a loss for words: "Is 'Jew' the word you're hunting for?" (19). Murchison denies any antisemitic prejudice, albeit only through economic justification, and professes to uphold the opposite values to those of Cousin Joseph regarding Jewish influence in Hollywood: "I won't have you libel the Jews! I am their best friend in the film business!"

Moreover, Murchison's interaction with Archie contains other possible indications that he is indeed the same man as Cousin Joseph. Although his physical appearance remains somewhat inconclusive, to the double extent that age has transformed his features and that Feiffer's loose graphic style tends to produce unstable signifiers, his use of language offers a less ambiguous clue in the repetition of the idiosyncratic phrase "as the night follows the day," a peculiarity of Cousin Joseph's rhetoric (see chapter 2 of this book). As for the organization that Murchison founded, "Our Forefathers for Freedom," its lofty but generic objectives of "[preserving] the American dream against those who wish to undermine it" (14) and standing in support of "Americanism" (18) are euphemistic façades for anti-communism, much like the real ultraconservative groups that likely inspired this fictional entity, such as the American Legion, the John Birch Society, or the vaguely named American Business Consultants, Inc., whose newsletter compiled an early version of the blacklist. Archie plants a seed of anguish in the millionaire's mind by informing him of the existence of a ghost script that identifies him as the chief conspirator behind the blacklist. When Murchison offers him a large fee to procure a copy of this document, he responds derisively: "I'll see what I can Jew—I mean do" (19–20). The PI then informs Elsie, Patty, and Annie that their target is "hooked."

At this stage of the story, the ghost script remains—at least until a trio of screenwriters decides to give it more concrete existence—a red herring of sorts, a mere ploy devised to unmask the man behind Sam Hannigan's murder in *Cousin Joseph*. Elsie Hannigan's revenge against her husband's killer has indeed become her obsession. Haunted by Sam's "ghost"—a term that adds another meaning to the book's title—she seeks closure on his assassination. She confides to Patty that, while she has made peace with Sam's mistakes and political myopia, her deceased husband remains a dynamic force that calls for her active involvement: "Sam won't let me get used to the fact that his killer goes unpunished. It tears me apart. Sam needs to be laid to rest" (21). She also remarks that her ordinarily silent husband has become very talkative in

ghostly form. Feiffer visualizes Sam's "ghost" as the central figure of a page layout in which his silhouette, drawn in faint ink with spectral contours, is bookended by two columns of panels staging Elsie's rationale for retribution and Sam's request for justice from beyond the grave: "Elsie, it's time to tell my story: who shot Detective Sam Hannigan and dumped his body in the Bay City Canal? He's here! He's close! He's dancing on my grave!" (22). The following page, a full-sized illustration, once again shows Sam's ghost, this time from behind, as he gazes at Patty and Elsie's car receding in the distance—a silent and eerie spectator of his wife's actions (23). Patty promises Elsie that she will find Cousin Joseph and kill him, but Elsie insists that she alone should vindicate her late husband: "Just find him. Killing him is my job."

In this strand of the narrative, Feiffer returns to the main characters of *Kill My Mother* ten years after the events on Tarawa that resulted in Elsie's blindness (see chapter 1 of this book). At this stage, they now work for a radio station, Patty in the support role of announcer, and Elsie as "Miss Know-It-All," the host of a gossip show on Hollywood stars (12). Their new roles remain within the realm of media simulacrum, despite their reluctance: Patty continues to use her reputation and connections as a former actor to collect movie business rumors for her partner's show, and Elsie performs her radio personality of "glamour gal of gossip" with the expected tone of "sassy-girly-talk-chatter" (22). However, despite these conventional positions, Elsie's show also breaks political taboos by conjecturing on air about the effects of the blacklist on movie withdrawals and acting personnel changes. In addition, her investigation into her husband's murder relies on a destitute movie industry insider whose downfall was also the unfortunate consequence of Hollywood's politics: a former producer named Sey Ackerman, in whom multiple strands of the graphic novel's plot, past and present, converge.

Twenty years after Sam's murder, Elsie only has a handful of clues at her disposal to identify Cousin Joseph. Having never seen him, only hearing him on the telephone, and having become blind, she can only rely on auditory signs to recognize the culprit through intonation and speech patterns. However, she found another lead in Sam's papers: the name Sey Ackerman. Annie worries about her mother's obsession with finding Cousin Joseph and asks for Archie's assistance in obtaining information from Ackerman, whom she recognizes as "some kind of cheapo producer out here, before [her] time" (38). Lola Burns corroborates Annie's assessment that Ackerman is a fallen producer who now waits tables at a restaurant: "I used to buy him meals. He was down and out. A big shot once—well, a middle shot. Once upon a time, he lived in a Beverly Hills mansion. When I knew him

he was living in a flop house and drinking himself to death" (61). As a reminder of Ackerman's past glory, the following page repeats *Cousin Joseph*'s chapter where Sam Hannigan delivers a bribe to Ackerman in exchange for calling off a movie script, a scene in which the rich producer already anticipates his employment precarity by telling Sam: "Next month I could be in a tailor shop in Pasadena pressing pants" (62).

Archie finds Ackerman at the diner where he now works. Suspicious that Archie is a cop, he nevertheless asks for money and arranges for a meeting at a bar, adding "your funeral" (63). The chapter in which Ackerman tells his life story to Archie ("Twenty-Nine: Ackerman's Complaint") reads as a lesson in the political paradoxes of American film history. A former B movie producer specializing in Westerns, he recalls the established template for such films: "Westerns were shot under Confederate rules. Southerners were the good guys, Yankees were land grabbers, rustlers, card sharks. Like, as if the South won the Civil War. That's what the market wanted. That's what B-picture producers, like me gave 'em" (64). This assessment coincides with two realities: the B movie industry of the so-called Poverty Row studios did often specialize in the popular genre of Westerns (Morgan 2016, 13–14), and "the genre was the workshop of national mythmaking and a potential vehicle for the Americanization of the Lost Cause, . . . a set of beliefs formed after the Civil War to glorify the antebellum South" (Mayer 2018). However, as a member of the Communist Party, Ackerman was eventually pressured into making "progressive" Westerns reversing those stereotyped portrayals of Northerners and Southerners, as well as presenting a more respectful depiction of American Indians and Black protagonists, against previous clichés.

Here again, Feiffer offers a study of film politics between the Depression and the 1960s. Early signs of the shift from the "Lost Cause" style of Westerns to "revisionist" ones and of the tension between their respective versions of American-ness correspond with the period in which *The Ghost Script* is set. For instance, *High Noon* (Fred Zinnemann, 1952), starring Gary Cooper and written by the former communist screenwriter Carl Foreman—who was called to testify in front of HUAC in 1953—has been seen as one of the first Westerns to challenge the conservative ideology of the genre itself, if not a parable on the blacklist (Newman 1990, 148; Frankel 2017). Some film historians argue that John Wayne, who considered *High Noon* "the most un-American thing [he'd] seen in [his] whole life," purposely teamed up with Howard Hawks in 1959 to make a movie more aligned with traditional values, *Rio Bravo* (Levy 2007).

Ultimately, Ackerman's new movies failed to meet the approval of anyone—they alienated spectators and were denounced as "weak-hearted liberalism" by the party (64). After these financial losses, which considerably diminished his capital, the filmmaker attempted to find a commercial compromise by producing both types of movies: a classic Western with a Confederate subtext, supporting Cousin Joseph's "pro-American" agenda, and a liberal film blessed by the party. Once again, both resulted in failures at the box office: "Audiences bitched that they couldn't tell the good guys from the bad guys" (64). This double collapse brought Ackerman to bankruptcy and expulsion from the party, a perfect illustration of the double jeopardy of such a polarized landscape. Caught between symmetrically opposed demands, he simultaneously lost both Cousin Joseph's funding and his former comrades' backing. When forced to testify in front of HUAC, he refused to name names, but was considered so unimportant a player within Hollywood's landscape that Congress did not even cite him for contempt. With his usual sense of humorous paradox, Feiffer has his character conclude his career summary by the following quip: "So I'm broke and I wait tables. *I had to be an ex-Communist to have my first working-class experience*" (66, my emphasis). He tells Archie that if the latter finds Cousin Joseph, he would like to kill his former patron himself.

Graphically, the double-page sequence featuring Ackerman's life narrative breaks from the norm of the grid layout that Feiffer employs in this volume far more than in the two preceding ones. Instead of framed panels, page 66 juxtaposes multiple iterations of the character, bathed in a gray ink wash strewn with wavy horizontal lines. Ackerman's monologue unfolds over a series of images arranged in a triangular shape that points downward to a central focal point: his interlocutor Archie, shown from behind as the receiver, himself positioned as a substitute to the reader's gaze. The gray palette and the enunciator's rumpled appearance match his tragic narrative with appropriate noir aesthetics. On the right side of this diptych, the page itself forms an oversized single panel containing the two men in conversation, allowing a close-up on Ackerman's ravaged face.

Ackerman's resentment toward the film industry plays an important part in Elsie's ultimate identification of Lyman Murchison as Cousin Joseph. This scene takes place at a "Humanitarian of the Year" ceremony celebrating Murchison as the award recipient, with Elsie and Patty in attendance. Ackerman, also present but as a waiter, seethes with bitterness toward the establishment: "Another bum! When are they getting around to giving me a testimonial dinner?" (97). In a double-page sequence (98–99), through

a deliberate braiding of three figures (Ackerman, Murchison, and Elsie), alternating between framed and unframed panels and displaying simultaneous speech and thoughts, Feiffer sets up the final recognition of Murchison's true identity. This revelatory sequence is orchestrated on the page through the interweaving of three parallel focalizations, each concentrating on different participants in the ceremony. This interpolation of concurrent actions and aspects of a single time frame relies on the "polygraphic" possibilities of the comics medium (Groensteen 2013, 117) and would be impossible to accomplish in most other narrative or visual media, apart from photonovels, insofar as comics allow for the display of multiple foci *in praesentia* on the paginal space. This double-page unit employs braided layouts organized around two different geometric shapes. On the left page, the illustrations alternate among three groups of protagonists, arranged in a "staircase" pattern that divides the page diagonally from top left to bottom right in two triangles. The right side of this panel arrangement, which becomes increasingly narrow, contains the figures of Murchison and the award committee. In a sequence of vertically distributed, unframed panels, an announcer recalls the so-called philanthropist's merits in "the motion picture industry's battle against subversion" and his organization's "ceaseless effort to root out communist and pro-communist sympathies" before introducing Murchison as the recipient of the "Most Valued American of the Year" award. The elderly millionaire remains silent and motionless in this set of images. The left side of this layout, by contrast, displays framed panels that alternate themselves between two groups of characters: Elsie and Patty on one hand, and Ackerman on the other. In this intermingling of images that construct a polyphonic simultaneity, the juxtaposition of the award spectacle and its spectators sets up another disparity—while the announcer praises the awardee, the peripheral onlookers have other thoughts on their minds. Elsie and Patty appear bored and uninterested, having only agreed to attend the ceremony in exchange for the promise of a future interview with Murchison. Far from disengaged however, Ackerman becomes enraged by these accolades, complaining to himself about his mistreatment by the industry: "Who is this bum? I made twenty-five pinko B-westerns in ten years! I never heard of him!"

The right page of this double layout employs a different geometric pattern—that of three parallel columns of three panels each (figure 3.7). The middle vertical section of this layout consists of three unframed panels depicting Murchison's acceptance of his award, surrounded on each side by three framed panels featuring Elsie and Patty (on the left) and Ackerman (on the right),

FIGURE 3.7 Murchison is found out as Cousin Joseph. From *The Ghost Script: A Graphic Novel* by Jules Feiffer, p. 99. (Copyright © 2018 by B. Mergendeiler Corp. Used by permission of Liveright Publishing Corporation).

their double gaze pointing toward the center of the page in anticipation. Read in sequence from left to right, this symmetrical distribution of 3 × 3 images continues to alternate between the speaker and his silent listeners in an enunciative configuration by which the speech balloons emanating from Murchison spread over the panels depicting his receivers, contributing both to the simultaneity effect and to the anticipatory function of this design. Such a focus on reception emphasizes the revelatory elements of Murchison's discourse, which reiterates the same principles that Cousin Joseph once expressed to Sam Hannigan twenty years earlier: "While our enemies within try to divide us, it is our films, our radio and television shows that unite us, that serve to make us, and keep us free. I pledge to you that we will continue our fight to protect the true America of our forefathers! Yes, my fellow patriots, *as the night follows the day*, we shall persevere!" (99, my emphasis).

Murchison is therefore betrayed by his own rhetoric; it is through the discursive clue of his idiosyncratic verbal tic that Ackerman makes the connection with his former avatar as Cousin Joseph: "Where have I heard this phrase before? Holy shit, it's him!" In the bottom right corner of the page, at the same moment, Elsie screams out the name of "Cousin Joseph."

Exacting revenge on Cousin Joseph merges multiple plotlines and involves multiple agents in Feiffer's long-awaited denouement. First, Ackerman drives to Murchison's mansion and demands to see Cousin Joseph at gunpoint, but his much larger bodyguard punches and stabs him to death, then drags his bleeding body inside the house (100–101). Ackerman's elimination leaves Elsie and Patty as the sole enforcers of justice. However, they ultimately benefit from the assistance of an unexpected figure, equally in search of redemption: Addie Perl, the former diner waitress who killed Sam Hannigan at Cousin Joseph's initiative in exchange for the capital to purchase her own establishment. Addie has become the owner of a cabaret, Addie's Atelier, where she employs Lady Veil (Dorothea) as a singer and counts Patty and Elsie—who remain unaware of her betrayal—among her faithful customers. Yet Addie cannot escape her past and must once again face a dilemma that repeats the moral compromise she made by killing Sam. Using the leverage of her ill-acquired nightclub, Murchison's bodyguard (Baxter) pressures her into eliminating Lola Burns before her appearance in front of HUAC, fearing revelations against his boss: "Think of the consequences. You will lose everything you've built up over the last twenty years" (95). Although she considers Lola a friend, like Sam before, Addie resigns herself to accepting the job, but remains deeply conflicted about performing another criminal act for self-preservation (122).

A complicated turn of events leads Addie to joining forces with Elsie instead of fulfilling Murchison's lethal mission. When Dorothea's fingerprints are found on the gun that was used to kill Neil Hammond (see *Kill My Mother*), Patty must turn herself in to the police to exonerate her sister. She thanks Addie for having been kind to Dorothea, who still "doesn't think straight" and "can hardly talk" after her family trauma. She asks Addie to care for Elsie and help her tend to her daily needs, as well as manage her broadcasting career. Addie compares her options and concludes that assisting a blind woman and collecting gossip on Hollywood stars are easier tasks than murder. In return, she explains to Patty that she owes Elsie a debt (without explaining that she killed her husband) and offers to hire a top-notch lawyer to acquit Patty on self-defense. This convoluted set of events creates a new alliance among three women victimized by the same forces. Together, they hatch a plan for revenge: Elsie will kill Murchison/Cousin Joseph, and Addie will eliminate Baxter instead of Lola (124).

This convergence of persecuted victims who confront their villainous oppressor underlines the melodramatic dimension that pervades Feiffer's trilogy, often as a playful counterbalance to its grim historical verisimilitude and its noir codes. Although the emotional tone of these graphic novels cultivates a stark cynicism that mitigates some of the pathos of melodrama— "the indulgence of strong emotionalism; moral polarization; extreme states of being, situations, actions; overt villainy, persecution of the good, clarification of the cosmic moral sense of everyday gestures" (Brooks 1995, 13–14)— the novels' accumulation of plot twists, reversals, and coincidences often mirrors the narrative topoi and conventions of the genre. In addition to the trope of the recognition of the masked villain, antithetical motifs such as guilt and redemption, virtue and debasement, and lapsed loyalties and moral dilemmas also recall melodramatic literature insofar as they establish an "inexorable structure of plotting" that imbues its dispersed diegetic components with a programmatic necessity, much like myth (Brooks 1995, 31). In this regard, although the plot may branch out in multiple directions which may themselves intersect in improbable ways, all narrative strands tend to culminate in a final catharsis that symbolically restores order and redeems the protagonists, at least partially (Brooks 1995, 32).

In this regard, the cathartic resolution of *The Ghost Script* is accomplished through counterviolence, albeit graphically implied rather than explicit. Under the pretext of an interview with Murchison, Elsie and Patty subdue Baxter and enter his mansion. Addie assists the duo by shooting the bodyguard when he questions her determination (130). Inside the house, Elsie

introduces herself to Murchison: "I am Mrs. Sam Hannigan, Cousin Joseph. It's been twenty years since you had Sam murdered.... I am here on my husband's behalf" (132). A desperate Murchison pretends that he is someone else (his own bookkeeper) and proffers more lies and threats, but once again betrays his true identity by repeating his inculpating catchphrase, "as the night follows the day" (133). Patty tells Elsie where to point her gun and when to squeeze the trigger. Like Baxter's, Cousin Joseph's murder remains outside of the representational space, implied but not depicted.

A follow-up to this execution scene shows Archie assisting with the cover-up of Elsie's revenge. In a sequence of three silent pages that contrasts with Archie's permanent monologue (134–136), he arrives at the crime scene, stages Baxter's and Murchison's bodies to create the illusion of a burglary gone wrong, and packs all of Murchison's blackmail files in large bags to dispose of their evidence. This active intervention finally forces Archie to confront his own ambivalence and to redefine himself as the sum of his choices and actions, in existentialist fashion: "I can't go on calling myself wishy-washy. Tough, but I can't be a detective anymore" (137).

Lady Veil's and Sammy Hannigan's Conclusions

Contrasting with melodramatic catharsis, however, film noir usually favors "downbeat" endings that perpetuate the protagonists' state of moral ambiguity, even when they partially redeem themselves. While the victims are irretrievably lost and the guilty generally get their comeuppance—especially in movies made under the Production Code, which stipulated that misdeeds must always be met with appropriate punishment as a deterrent to crime—film noir often negotiated "morally permissible" endings in which "poetic justice" allowed more inconclusive, albeit still dark, outcomes (Conard 2005, 37–38). A distinction must be made in this regard between "sequential" endings (the final segments of individual storylines or diegetic threads) and "narratival" ones (the recapitulation of or commentary on the resolutions of the events depicted in the story, often by the private investigator as first-person narrator) (Conard 2005, 36–37). The chapter in which Archie drives in circles in the desert, searching obsessively for a perfect spot to bury Murchison's blacklist files, like a mid-twentieth-century Don Quixote without a compass, constitutes a hybrid of those two types of endings, to the extent that it is both action based (continuing Archie's journey, albeit in stalled fashion) and enunciative (through Archie's monologue, which wraps up various threads of the

novel). This sequence does not end in closure but in another whimsical plot development (the deus ex machina device of Archie's abduction by aliens).

In addition to Archie's final monologue, *The Ghost Script* formulates two other conclusions, one narratival and the other far more open and implicit. In a final performance (chapter 60, "Swan Song"), Lady Veil recapitulates her family's troubled history in a song suggesting that, despite revenge and partial redemption, closure and catharsis ultimately remain out of reach, at least for the Hughes sisters. Feiffer returns to the blues idiom as an intermedial match for the mournful tone of Lady Veil's despair:

> Have you heard of the Hughes girls,
> And their tabloid strife?
> Sister Mae killed her man, then took her own life,
> Sister Patty's thrown in jail,
> For a crime blamed on me,
> She went and confessed,
> Now nobody's free
> Mae, Patty, and me,
> None of us free,
> Mae, Patty, and Dorothea,
> Not ever again free. (139)

Yet the closing word of this story remains missing or unsaid. The very last chapter belongs to a minor character: Sammy Hannigan, Annie's son and Elsie and Sam's grandson. The tantrum-prone toddler of *Kill My Mother* has become a troubled young man whose misogynistic, antisemitic, and anticommunist politics align with the far right: he is unkind and abusive with his blind grandmother Elsie and her same-sex partner Patty, bullies Jewish classmates, and despises Reds, whom he considers "un-American" (28–29). Sammy therefore embodies the intergenerational reproduction of reactionary thinking across American history, replicating his grandfather's uncritical outlook: "My grandfather, Big Sam—he hated Reds. He'd be proud of me" (102). Annie comments on this cyclical pattern: "So this is what I brought into this world. A son named after my father, a great man who only wanted to do good for his family—and his country. And his namesake, my son, has a swastika framed on his bedroom wall" (73). In a long reactionary rant (chapter 45, "Sammy Waves the Flag"), Sammy complains about the contemporary state of America, notably the omnipresence of Reds in his school's teaching staff (102). As in the Jerome Robbins deposition that Feiffer remembers so

well, he conflates anti-intellectualism with anti-liberalism, noting that "reading is a dead giveaway. Reds don't play sports. They read books. Fat books. You can't understand half the words of what they read." Using the same logic, Sammy concludes that his mother is also a Red: "My mother's pictures are full of too many words. That's a sure sign that a picture is at least pink, if not Red." In his adolescent posturing, only transactional opportunities temper his hatred for his mother—he considers testifying against her unless she buys him a 1951 Chevy convertible. In Sammy's profile, therefore, Feiffer offers an acerbic commentary on the materialistic and conformist tendencies of American mainstream culture of the 1950s and young men of his generation.

The very last page of this bountiful trilogy (148) offers an open, unrepresented ending. At the center of a mostly blank page, the illustration consists of a single panel, yet another intermedial meta-image that matches the shape of a television screen. It shows Sammy Hannigan appearing in front of HUAC, raising his right hand to be sworn in, and stating his name. The actual content of his testimony is left outside the scope of the narrative, alluding to an unseen continuation. As history repeats itself, Feiffer's story loops back to its starting point with the depiction of a child intent on "killing his mother," at least symbolically.

Conclusion

● ● ● ● ● ● ● ● ● ● ● ● ● ●

Homage, Experimentation, and Irony in the Trilogy

After these extensive analyses of each volume, assessing the overall project of the trilogy more broadly requires an ultimate appraisal of three of its main components. First, these three graphic novels are highly referential, not only in their aspiration to historicity and contextual accuracy but also by their intertextual reworking of the themes and iconography of established noir templates. Second, they are characterized by formal innovation, in that they seek original aesthetic solutions to translate their referents in graphic form, often eschewing the conventional spatio-topical designs of comics and approaching each page as a pictorial adventure. Third, their sprawling diegesis and their visual signifiers are permeated by a unique sense of humor, often steeped in irony and other metanarrative devices that counterbalance the usual cynicism of noir with satirical elements aligned with Feiffer's previous works.

Despite the playful nature of its circuitous and unpredictable plot(s), the trilogy re-creates in its panels and pages a world from a different

era—one that Feiffer, contrary to most graphic artists working in the neo-noir genre today, knew from personal experience and did not simply access through other mediatized representations. This verism is evident in depictions of material culture (cars, fashion, urban settings, etc.) and recurrent allusions to popular culture from the 1930s and the 1950s, most notably in the sphere of entertainment: boxing and boxing films, tap dancing, cabaret singing, musicals, Westerns, radio serials, and other forms of escapism prevalent in these decades. Either in explicit citations or in more coded intimations, the trilogy references movies as diverse as *Gold Diggers of 1933* and *Wild Boys of the Road*, singers such as Russ Columbo and Woody Guthrie, radio programs like *The Aldrich Family* and *Amos 'n' Andy*, comedians like Abbott and Costello, and the adventure comics of Milton Caniff and Will Eisner, to name only a few.

In addition, these three works capture the central political issues of this period with equal realism, but also through the subjective lens of the author's progressive worldview. The novels portray a deeply divided America whose struggles remain relevant to today's polarized ideological landscape. They discuss factual events as well as topical subjects, such as immigration, national identity, and the fallacies of nativism in relation to the ideals of the American Dream; unionization and the repressive tactics that a corrupt system of hegemony employed to quash workers' demands; battles for media control, either from political forces seeking to use cinema as reactionary propaganda in the 1930s or from those who questioned progressive representations as fundamentally un-American in the 1950s; and racism, antisemitism, and civil rights. As a longtime political commentator, Feiffer offers his idiosyncratic voice and perspective to recall past debates and moral transgressions, and perhaps, in his own way, to reconsider and repair some of the foundational, traumatic events of his own political coming of age. Cousin Joseph, for instance, represents everything that the author despises in American politics: obfuscation, a manipulative, conspiratorial rhetoric, and a revolting anti-intellectualism.

Of course, the trilogy also references a particular form of storytelling, hard-boiled fiction and film noir. It seeks to replicate a narrative formula and a highly recognizable iconography through imitative devices. The three novels reconstruct in graphic form the characteristic sites of noir: cityscapes, docks, diners, back alleys, boxing venues, industrial zones, and California mansions. They also reproduce the storytelling devices of noir (the private investigator's first-person narration or cinematic voice-over), its distinctive visual elements (its plays on darkness and light, textures and moods, framing and perspective), and its well-known protagonists (the PI, the femme fatale, the

corrupt authorities and notables). They feature violence at their core, in multiple forms (within the family and against women, children, minorities, and the economically dispossessed), and reflect on its moral consequences, in that their conflicted protagonists are confronted with existential ambivalence, engaged in dark transactions, or must undergo a transformative process to be revealed to themselves.

However, despite its faithfulness to established modes of representation, the trilogy is also a site of constant graphic experimentation. Instead of borrowing from the classic neo-noir vocabulary, Feiffer approaches the genre with his own style and imagery, and never ceases to explore unconventional configurations to translate cinematic noir-ness onto the page. He fashions new forms of "iconic solidarity" in large compositions where elements of the décor fuse with the shapes of appended illustrations and panels, widening the scope and equilibrium of the comics page. His continual search for new visual arrangements and plays on symmetry (the calculated recurrence of similar devices forming a semiotic network, for instance in "stanza effects") often demand a more contemplative approach from the reader than the highly legible grid format. These layouts also attempt to duplicate the moving gaze of cinema by creating graphic equivalents of tracking shots and other framing techniques, with a singular result that film itself could often not match. Such hybrid constructs indeed stretch the possibilities of the comics medium through intermediality. Feiffer's nonrealistic, malleable style also formulates creative designs to impart dynamic flow in a static medium and express movement, a fundamental component of the comics language since the seminal works of Rodolphe Töpffer.

Furthermore, Feiffer borrows not only from film but also from literature. Literary allusions abound in these three works, notably the 1930s hard-boiled detective fiction of Dashiell Hammett (*Red Harvest*), Raymond Chandler (*The Big Sleep*), and James M. Cain (*The Postman Always Rings Twice*). His graphic novels employ the chapter organization typical of the novelistic format and orchestrate calculated echoes and contrapuntal effects among the diegetic units (for instance in the parallel chapters of *Kill My Mother* respectively entitled "Right in the Middle of Her Forehead" and "Right in the Middle of His Forehead"). Although whimsical and humorous, his plot management efficiently conjoins sprawling storylines full of surprises and melodramatic twists within the teleological structure of a long revenge arc. These fictions feature realistic dialogues and long theatrical monologues as well as poetic effects, such as in Hammond's slurred rendition of the nursery rhyme "There Was a Little Girl." Furthermore, in their Oedipal dimension, these

stories depicting mothers, fathers, daughters, and sons return to family as the very engine of narrative fiction, confirming Marthe Robert's notion that all storytelling originates in a desire to invent an imaginary family as an outlet for neurosis (Robert 1972). Drawing autobiographical connections with Feiffer's own life, as a child of the Great Depression who projected his escapist desires into comics, was perhaps inevitable in this regard.

Yet historical verisimilitude, political considerations, and the gravity of noir do not preclude a lighter, playful touch from Feiffer who is, after all, a satirist at heart. Among the multiple ironic devices at play in this series of graphic novels, a systematic strategy consists in deconstructing the gender tropes of noir through contemporary critical perspectives. In these books, the hypermasculine private investigator becomes either an incompetent, misogynistic, cross-dressing boozer (Neil Hammond) or an insecure, self-loathing figure dominated by three women (Archie Goldman). The equally hypermasculine Hollywood leading man (Hugh Patton) is revealed to be a woman performing masculinity as a role, and the war hero (Artie) is an emasculated boy who compensates for his disempowerment by a stronger female protagonist (Annie). Conversely, Feiffer revisits the noir archetype of the femme fatale with similar permutations. In dealing with the Hollywood film industry, the three volumes indict the fakeness of entertainment culture and its purported role models, whereby on-screen personas and spectacles are shown to be antithetical to their real counterparts. They reflect on the propaganda use of film and the ideological constructs of the America they promote. The Feifferian imagination clearly revels in staging fortuitous encounters, reversals, and paradoxes, with a tongue-in-cheek reference to the far-fetched predicaments of pulp narratives. Circular schemes form a consistent pattern in the stories: for instance, Faye Bloom presents herself as her own front; Billy Doyle actually committed the murder for which he was framed; Elliot insists that Archie remember him but does not remember Archie when confronted by him two decades later; the entrapped Lola Burns entraps her abuser; and the ghost script about the blacklist, written by blacklistees, is itself blacklisted in the end. Like in melodrama, the plotlines abound in false or masked identities—Patty Hughes as Hugh Patton, Dorothea Hughes as Lady Veil, Billy Doyle as Sox McManus, Cousin Joseph as Lyman Murchison—beyond plausibility. Similarly, Feiffer plays on race representations with ironic, nonliteral dialogues and visual signifiers that reverse expectations and prejudices. Among these ironic devices, reflexivity is perhaps the most striking and the most complex as well. Two metadiegetic passages are remarkable in this regard: the scene in which Kornblum, accused of

un-Americanness, uses the very seduction of film to reshape his accusers' understanding of national identity, and the chapters in *The Ghost Script* in which the screenwriters compose a story about their predicament. In a trilogy of works that systematically reflects on the simulacrum of representation, these meta-stories within the stories not only provide comic relief but are invested with a deeper political message on image-making.

In the end, one could certainly conclude that Feiffer's trilogy is not simply a meta-noir exercise molded in the author's unique stylistics but a wider statement on the politics of representation in America over the course of his own lifetime—a most impressive graphic accomplishment, undoubtedly.

Acknowledgments

I would like to thank Jules Feiffer for his kindness and generosity in discussing his work and life with me during three long phone conversations that took place in March 2021.

My heartfelt gratitude goes to the friends, colleagues, and scholars who encouraged the development of this monograph, including Livio Belloï, Mark McKinney, Martha Kuhlman, Hugo Frey, and Jan Baetens. Thanks to Monica Wright and Jordan Kellman for their institutional support, and to Shelly M. Leroy for her proofreading assistance.

Finally, I would like to express my appreciation to Nicole Solano, Frederick Luis Aldama, and the Rutgers University Press editorial board, manuscript reviewers, and staff for their impeccable work and commitment to comics scholarship. Thank you to W. W. Norton/Liveright Publishing and Robert Shatzkin for authorizing the reproduction of illustrations from the *Kill My Mother* trilogy.

Notes

Introduction

1 Feiffer's hypercritical assessment of his own ability to draw in realistic style should be nuanced. Martha Fay's book reproduces a 1949 strip of four panels entitled *Bronx Boy*, which shows that Feiffer had in truth mastered far more of Eisner's style than he modestly acknowledges (Fay 2015, 54).
2 Notable graphic novels in the neo-noir vein include Brian Michael Bendis, *AKA Goldfish* (1994); Mark Rickett, *Nowheresville* (2002); Warren Ellis, *Fell* (2005); Jaimie S. Rich and Joëlle Jones, *You Have Killed Me* (2009); Simon Oliver and Jason Latour, *Noche Roja* (2011); Joshua Hale Fialkow and Noel Tuazon, *Tumor* (2016); Matt Fraction and Howard Chaykin, *Satellite Sam* (2013); and many others.
3 The OuLiPo, or "Ouvroir de littérature potentielle" (workshop of potential literature), was a French literary movement spearheaded by Raymond Queneau, François Le Lionnais, and Georges Perec in the early 1960s. It drew inspiration from arbitrary constraints and combinatorial mathematics.
4 In addition to Stony Brook, Feiffer has held several teaching positions at American universities, including the Yale School of Drama, Northwestern University, Columbia University, Arizona State University, and Dartmouth College.

Chapter 1 *Kill My Mother*

1 Such interviews include two public lectures at the Politics and Prose bookstore in Washington, D.C., in 2014 and 2018, following the publication of *Kill My Mother* and *The Ghost Script*, respectively. See https://youtu.be/lUeBsJo6vb4 and https://youtu.be/wcJwSB2v5V8 (last consulted May 2, 2024).
2 In the acknowledgments section of *Cousin Joseph*, Feiffer writes:
> This accidental noir trilogy that began with *Kill My Mother* and will end with *The Ghost Script* could never have been conceived or illustrated were I still living out a life of quiet resignation in Manhattan. The fortuitous circumstances that

led to my abandoning the city for the East End of Long Island, where I found a new life, new friends, and a new career as a graphic novelist (no more than the extension of the adventure newspaper-strip cartoonist that I wanted to be as a boy), now brings me as much or more pure joy than at any time in my life.

3 Eventually, delving into the noir universe would bring Feiffer back to politics. Like *Kill My Mother*, *Cousin Joseph* evokes gender politics and the simulacrum of Hollywood, while *The Ghost Script* recalls the blacklisting practices of the House Un-American Activities Committee.

4 The front flap of the book's jacket recounts Feiffer's prestigious cartooning history and its institutional validation: "A legendary career that includes a Pulitzer Prize, an Academy Award, Obie Awards, and Lifetime Achievement Awards from the National Cartoonist Society and the Writers Guild of America."

5 In one of the Politics and Prose interviews (2014), Feiffer stated that he considers his illustrations for the children's book *Henry the Dog with No Tail* (2007), with a script by his daughter Kate Feiffer, drawn in a somewhat more realistic style and in pencil, to be a transitional work toward the style used in *Kill My Mother*.

6 Lippman reaches the right conclusion in this regard ("In Feiffer's hands, yes"), but the format of a book review does not allow her to fully analyze the specificity of Feiffer's graphic constructs in relation to the semiotic possibilities of literature and film. Her review points to the uniqueness of the plot (its Oedipal nature, its deviation from the standard PI figure, its strong female characters) and praises the "poignancy" of Feiffer's drawings, while noting their frequent opaqueness and disorienting lack of clarity.

7 Dubois is particularly interested in the overlap between the roles of investigator and culprit. He notes that the line of separation between justice and culpability is often blurred by the fact that the detective's own guilt can be mirrored in the figure of the culprit, revealing inner imperfections or an inclination to commit the same crimes (Dubois 1992, 213). In his analysis, the "cathartic" function of detective fiction is precisely to deliver the investigator (and the reader) of an overwhelming feeling of guilt by transferring it into a designated culprit at the closure of the novel.

8 Dubois sees an Oedipal substrate (if only partial or tangential, at times) in some of the classic texts of detective fiction, most visibly in Gaston Leroux's *The Perfume of the Lady in Black*, where the young detective Rouletabille is in love with the Lady in Black (his mother) and causes the death of Larsan-Ballmeyer (his father).

9 Family dysfunction is a recurrent theme in Feiffer's works. His 1967 play *Little Murders*, for instance, depicts an ordinary American family (the Newquists) whose apparent normalcy conceals much darker desires and rivalries, as well as contradictory gender roles: Patsy's all-American belief in positive thinking and "go-getterism" hides a manipulative and self-interested savior complex; Carol's middle-class masculinity covers his gender insecurity and fascist propensity, while Kenny's homophobia masks his own homosexuality; and Marjorie competes with her daughter for her family's attention. While the tone of *Little Murders* is far more comical, at times bordering on absurdist, its focus on family dynamics resonates with the *Kill My Mother* trilogy across literary genres and time periods, indicating the author's consistent viewpoint and thematic focus.

10 As he traps a helpless Annie against the back fence of the alley, the security guard exclaims "Perfect! Just the way I like my women," which hints at potential sexual violence (20).

11 "Macdonald's complex plots frequently turn on the search for dead, lost or estranged parents or children. The violent dénouements of such searches are typically revealed by Archer to be the result of long unresolved familial passions" (Porter 2003, 110).

12 Maxime Labrecque cites Robert Altman's *Short Cuts* (1993) as a landmark movie signaling the beginning of a new popularity for choral film in the 1990s, with subsequent staples such as *Magnolia* (1999), *Love Actually* (2003), *Crash* (2004), *Syriana* (2005), *Babel* (2006), *Bobby* (2006), *The Yacoubian Building* (2006), and *Reste avec moi* (2010) (Labrecque 2011, 31).

13 Although some choral films tend to focus on the banality of ordinary life, others can of course be quite eventful—see *Pulp Fiction* or *Babel* as examples.

14 In *Reading Bande Dessinée* (2007), Ann Miller convincingly argues that the narratological concept of "focalization" can be transferred to comics studies: "In the case of heterodiegetic narration, *bande dessinée* allows for zero, internal, and external focalization" (110).

15 Coined by Henri Van Lier (1988), the term "multiframe" refers to the "conglomeration of juxtaposed panels" that compose the page, the double page, and the entire comic or graphic novel (Groensteen 2007, 28).

16 There are few instances of a "waffle-iron" matrix of regular frames in the graphic novel. Page 49 is the most symmetrical of these, with three strips of three panels each, all separated by traditional white gutters and a standard hyperframe, with no encroachments or bleed-through effects. It stands as an exception to the compositional variability of the novel.

17 "Although often separated by the thin blank spaces, panels can be considered as interdependent fragments of a global form, something that is made all the more clear and consistent when the exterior edges of the panels are traditionally aligned. This form generally takes on the aspect of a rectangle, where the dimensions are more or less homothetic to those of the page. The exterior outline of this form, its perimeter, can be given the name hyperframe. . . . The hyperframe is to the page what the frame is to the panel" (Groensteen 2007, 30).

18 Groensteen situates the birth of European "neo-baroque" comics in the 1970s, with the seminal works of Philippe Druillet, who developed "a baroque conception of the comics page, which was characterized by the breaking up of most of the panel frames in favor of the interpenetration of images, the abandonment of the canonical rectangular shape, the creation of an overall 'tabular effect,' the extension of certain compositions across a double page, and a magnification of the décor in relation to the characters, producing an effect of monumentality" (Groensteen 2013, 47). He notes the influence of similar techniques in manga on the Franco-Belgian field and on the American comic book scene of the 1980s (59).

19 Groensteen notes that,
> In the recent works of Will Eisner, it is common that panels are neither framed nor separated by gutters, but interpenetrate each other in an easy fashion. A quick examination shows, however, that most of the pages are organized around a framed panel, where the regular form structures the totality of the surrounding space of the page; the elements of the décor, such as doors and windows, are themselves strongly solicited for their structuring effect, and frequently function as frames; finally, the contrasts between the background blacks, whites, and greys (cross-hatched) reinforces the differentiation of the images. The respect of

the conventions governing the sense of reading (from top to bottom and from left to right) suffices from this point to assure the efficiency of the apparatus. (Groensteen 2007, 44–45)

20 The sign shows a fragment of the word "Hippodrome." The word may refer to several West Coast venues such as the San Francisco Hippodrome. The location of "Bay City" echoes Raymond Chandler's fictional renaming of Santa Monica. "Hippodrome" is also a term used in boxing to refer to "fraudulent, pre-arranged contests" (Streible 2008, 158).

21 Greice Schneider notes that the emphasis on action throughout comics history derived from the influence of the subgenres of pulp adventure literature (pirate stories, detective and crime fiction, war adventures, science fiction, etc.). This association between comics and action also resulted in a long-standing legitimation deficit for comics (Schneider 2017, 49).

22 Mervyn LeRoy's musical film *Gold Diggers of 1933* tells of the economic difficulties that hinder the production of a stage show during the Great Depression. Ginger Rogers's song "We're in the Money," written by Al Dubin and Harry Warren, offers a hopeful view of the imminently ending depression, although the economic recovery was only partial in 1933, and conditions remained dire for most of the 1930s, with another recession in 1937–1938. Rogers's number in the opening scene of the movie includes a chorus of dancing showgirls dressed in outfits, headdresses, and jewelry made of coins, while holding large coins, against a backdrop also featuring giant coins.

23 Feiffer's fascination for dance and dancers dates back to the 1950s. He frequently featured dancers in his *Village Voice* cartoons, beginning with a drawing from March 27, 1957, of a "Dance to Spring" showing nine juxtaposed images of a female dancer in ponytail and black dress taking on various bodily poses (jumping, raising her arms, bending, kneeling, sitting, and making arm and hand gestures) (Feiffer 2010, 187–188). He also famously drew many cartoons of Fred Astaire, including quite recently ("Giving Thanks to Fred Astaire," in *Tablet*, November 18, 2018).

24 In his *Historical Dictionary of Film Noir*, Andrew Spicer remarks that, "like the gangster, the boxer embodies a distorted version of the American success ethic; ambitious to break free from working-class or ethnic poverty, his rise and fall explores the moral and emotional price of success. These thematic and ideological preoccupations meant that the boxing film could be assimilated in the concerns of film noir, particularly to those of the left-wing cycle" (Spicer 2010, 25).

25 On the trope of the femme fatale, see Hanson 2007 and Grossman 2009.

26 In the 2007 reissue of the complete *Terry and the Pirates* by IDW, Feiffer writes: "Before Caniff introduced the Dragon Lady to Pat Ryan, before Burma and Raven Sherman and Normandie Drake fell for our hero, there was not a hint of sex to be found in the American newspaper strip. Caniff changes all that." In his enthusiasm for Caniff's series, he makes a small chronological slip, however, as this episode from *Kill My Mother* is supposed to take place in 1933, while *Terry and the Pirates* debuted in October of 1934, and Normandie Drake was introduced in 1935.

27 Caniff's depiction of strongheaded and glamorous women, often as the love interests or foes of Pat Ryan, implied new "sexual motivations" for the characters and lent a definite "adult appeal" to his strips (Harvey 2007, 227). His portrayal of women often implied an ambivalent nature, to the extent that characters such as Burma or the Dragon Lady were not only sexually provocative but torn between a bad side (their roles as villainesses) and a good side (their secret attraction to Pat), yielding complex representations. Caniff's eroticized artwork also produced the

voluptuous character of Miss Lace in *Male Call* (1943–1946), a publication for U.S. troops during World War II with aesthetics similar to pinup art.

28 On page 11, Feiffer paints a neighborhood scene with a series of closed stores and men selling odd items on the street (clothing, watches, bananas, shoes, dolls, etc.), while other men are sitting idly on the doorsteps of buildings, alluding to the joblessness and desperation of the Great Depression era.

29 Elsie's professional competence and "tough" demeanor point to a gap in the hard-boiled tradition, which embodied an underlying culture that was deeply androcentric: "To be hardboiled and to have retained heroic integrity was to be a man. The culture had generated no precedent for a tough-talking, worldly-wise woman, capable of defending herself in the roughest company, who also possessed the indispensable heroic qualities of physical attractiveness and virtue. A woman in the private eye's role would have been conceivable only as fallen or comic" (Porter 2003, 112).

30 While the hard-boiled tradition tends to feature the detective's "moments of hard-bitten philosophizing about life" (Porter 2003, 105), Hammond's statements often devolve into pure nihilism. In response to Elsie's hopes that her relationship with her daughter will improve, he replies: "When you've been around as long as I have, kiddo, you'll know: No one gets over anything" (6).

31 This one-page section forms the entirety of chapter 21, entitled "There Was a Little Girl," echoing the nursery rhyme of page 47, and correlating to chapter 22 ("Right in the Middle of Her Forehead") and chapter 24 ("Right in the Middle of His Forehead").

32 The presentation of this page is closer to that of illustrated children's books, a genre in which Feiffer excelled before his noir trilogy. Groensteen reminds us that "children's book illustrators' main concern is not layout ([defined] as an arrangement and mutual adjustment of frames) but rather composition (*cum ponere*: to put more than one element together)." The illustrated book is at its most distinctive when "texts and images are not partitioned off into reserved spaces [but] articulated into a global composition" (Groensteen 2013, 53–54).

33 In this instance, Feiffer's retrospective gaze becomes somewhat unrealistic, as it is likely that such a phrase would be considered profanity and prohibited by censorship in the 1930s.

34 Radio comedy shows of the era included family situational comedies such as *Burns and Allen* (which Feiffer references in this novel), *Ethel and Albert*, and *Fibber McGee and Molly*.

35 Chapter 8 (81–83) visualizes the broadcast of *Shut up, Artie!* and highlights the formulaic nature of 1940s popular entertainment, with the announcer presenting the show, the actors reading their lines onstage in front of microphones, the live audience laughing, and the listeners at home gathered around the radio and repeating the show's catchphrases.

36 This confusion between reality and the sound of a radio broadcast is a device employed in the finale of Otto Preminger's film noir *Laura* (1944), when Laura Hunt (Gene Tierney) listens to the journalist Waldo Lydecker's voice on the radio, believing that it is a live performance, and is unaware that he has returned to his apartment to kill her. Later in Feiffer's novel, Artie proposes to use the USO show to draw out the remaining Japanese diehard soldiers hiding in the jungle, once again using entertainment for war purposes (100–101).

37 Page 75 shows Longo acting the part of a "dancing corporal" in a low-budget musical with a war theme. Dressed in military uniform, he performs a two-step tap

dance and sings a song asking girlfriends of soldiers to "stay true" to their men while they are fighting the war overseas.

38 Mae's sacrifices for her husband's career include sexual concessions—she "put out for a bunch of assh-le producers so they'd give [Eddie] a break" and "pays off all of [his] hookers" without complaint (88).

39 This episode recalls some of the rumored practices of Hollywood actors using unethical means and mafia connections to land career-boosting parts in certain movies, for instance Frank Sinatra's alleged maneuvers to be cast in *From Here to Eternity*, parodied by Mario Puzo and Francis Ford Coppola in *The Godfather*.

40 Mae often resorts to verbal and physical abuse to motivate her husband. After his suicide threat, she calls him a "sorry little assh-le" and punches the former boxer without hesitation.

41 The character of Eddie Longo recalls an interesting overlap between boxing and tap dancing in this particular era. Fred Astaire confessed his interest in boxing, while Sugar Ray Robinson tap danced with Gene Kelly on television (Omnibus Show, 1958) and had a semi-successful post-boxing career as an entertainer. James Cagney, the archetype of the on-screen "tough guy," often capable of violence against women, was a combination of both: a tap dancer and vaudeville actor on Broadway and a former amateur boxer (the runner-up for the New York State lightweight title). Cagney danced in movies like *Footlight Parade* (1933). He joined the United Service Organization (USO) during the war and performed morale-boosting vaudeville routines in "camp shows" to entertain the troops.

42 On this subject, see Cohan 2002.

43 The opposition between "lug" and "pansy," as a scale of masculinity, is also used by Gaffney, who bemoans Patton's intervention in similar terms: "A lug like me saved by a pansy, it's humiliating. Makes me look bad" (115).

44 Upon seeing Patton in the flesh for the first time, Mae Longo hints at his resemblance with her sister: "I've never actually met Hugh Patton—so why do I think I know him?" (214).

45 According to Butler:
> When Simone de Beauvoir claims, "one is not born, but, rather, *becomes* a woman," she is appropriating and reinterpreting this doctrine of constituting acts from the phenomenological tradition. In this sense, gender is in no way a stable identity or locus of agency from which various acts proceed; rather, it is an identity tenuously constituted in time—an identity instituted through a *stylized repetition of acts*. Further, gender is instituted through the stylization of the body and, hence, must be understood as the mundane way in which bodily gestures, movements, and enactments of various kinds constitute the illusion of an abiding gendered self. This formulation moves the conception of gender off the ground of a substantial model of identity to one that requires a conception of a constituted *social temporality*. Significantly, if gender is instituted through acts which are internally discontinuous, then the *appearance of substance* is precisely that, a constructed identity, a performative accomplishment which the mundane social audience, including the actors themselves, come to believe and to perform in the mode of belief. If the ground of gender identity is the stylized repetition of acts through time, and not a seemingly seamless identity, then the possibilities of gender transformation are to be found in the arbitrary relation between such acts, in the possibility of a different sort of repeating, in the breaking or

subversive repetition of that style. (Butler 1988, 519–520, emphasis in the original)

Chapter 2 Cousin Joseph

1. Although Elliot's exact status is never clearly defined in the novel, his profile closely resembles that of Pinkerton detectives who provided assistance and protection against union strikes during the Great Depression.
2. Although Annie's contempt for Archie never states its antisemitic nature explicitly, the latter understands its coded message. Annie forbids Artie from playing sports with his Jewish classmate. When Archie asks, "Because I'm a Jew?" her defensive response indicates prejudice and stigmatization: "What makes *you people* so sensitive?" (12, my emphasis).
3. A few pages later, Feiffer may be alluding again to Russ Columbo in a brief sequence where Elise Hannigan gives Sam a good luck charm bracelet, which he jokingly calls a handcuff. He tells her, "I'm your prisoner" (a possible allusion to Columbo's song "Prisoner of Love," released in October of 1931).
4. Hannigan comments, "All it takes is moola," to which Baxter replies, "That's what makes America great, Detective Hannigan." In a graphic novel published in 2016, this retort certainly echoes the Trump presidential campaign and its reactionary slogan.
5. "Once, when an ailing studio chieftain walked into a hospital, he was questioned about his heritage for the institution's records. 'American' he quickly responded, an answer that prompted a startled volunteer to ask, 'But aren't you Jewish?' 'Oh, yes,' he added, 'That too.' 'That too' aptly sums up the attitude of Jews in Hollywood, both on and off the screen, from the inception of movies until the end of the studio system in the late '50s. The attempt at almost total assimilation by the powerful men who ran the studios reflected itself in a de-Semiticizing of the action that took place in front of the lenses" (Desser and Friedman 2003, 1–2).
6. Durgnat's blanket statement oversimplifies the political tensions among 1930s movie moguls. Mark Wheeler (2016) shows internal divisions within Hollywood, which manifested themselves during the 1932 presidential election (between the Republican Herbert Hoover and the Democrat Franklin D. Roosevelt), which was a "battle of the moguls" (with Louis B. Mayer in Hoover's camp and Jack Warner in Roosevelt's) (Wheeler 2016, 30–32). Wheeler notes, however, that the film industry was more united against the socialist Upton Sinclair's 1934 California gubernatorial campaign, fearing corporate taxes and social unrest. On this occasion, MGM produced anti-Sinclair propaganda newsreels that pioneered new media techniques of disinformation (33–37).
7. Ian Scott argues that "the real driving force behind the ideological sensibility and critical social observation at [some of the Hollywood] studios was their most prominent screenwriters, who found something of a collective voice as the 1930s wore on. In promoting the kind of subject material that interested them, these scribes wanted their studios to examine social and political issues far more forcefully and deliberately, even divisively, than is often acknowledged or was thought possible in the era of the production code" (Scott 2016, 52).
8. Among these socially reflective films of the 1930s, Ian Scott lists *The Washington Masquerade* (MGM, 1932), *I Am a Fugitive from a Chain Gang* (Warner Bros., 1932), *Gabriel over the White House* (MGM, 1933), *Wild Boys of the Road* (Warner Bros.,

1933), *Fury* (MGM, 1936), *Mr. Deeds Goes to Town* (Columbia, 1936), *Confessions of a Nazi Spy* (Warner Bros., 1939), and *Mr. Smith Goes to Washington* (Columbia, 1939). Other movies tackled "social dislocation and political crises ... from the perspective of generic melodrama and espionage tropes." Frank Capra is "widely credited with initiating the social-problem film and tackling overt political topics in movies related to the contemporary context of the Great Depression" (Scott 2016, 52).

9 The parallel between Goebbels's first name and Cousin Joseph's is likely intentional.

10 Hollywood's economic and cultural influence on German cinema began in the early days of the Weimar Republic and increased over the course of the 1920s. As Thomas J. Saunders notes:

> Hollywood was essential to German cinema experience in the 1920s because its product, advertising and personalities enjoyed international primacy. Sheer magnitude, its outstanding feature, was not, however, its only component. The German (and European) experience of Hollywood was stamped, as contemporaries gradually realized, by complementarity between the motion picture and American culture. Motion pictures quickly became the most pervasive and persuasive of America's contributions to European culture because cinema epitomized American culture in its mass orientation, tempo, monumentalism, sensationalism and profit urge. In short, Hollywood's dominance signified correspondence between the medium and the American message. Not only did Hollywood bring to more Europeans than ever before "live" impressions of the New World, giving visual contours to the American dream—the moral, social and economic foundations of beauty, success and happiness, it also introduced and recycled interminably a formula for motion picture entertainment rooted in American assumptions which established itself as *the* mode of filmic discourse. This symbiosis of broad cultural and more specific dramatic-filmic conventions lent potency to Hollywood's presence. It made cinema a major pillar of the American imperium in the postwar world. (Saunders 1994, 11–12)

11 Lewis Milestone was born Lev Milstein in Kishinev, the center of pogroms in 1903 and 1905. He immigrated to the United States in 1913 at the age of eighteen.

12 The "fake news" phenomenon of the internet age has recently played a similar role in the resurgence and propagation of antisemitism.

13 In contrast with the text-dominated stillness of this double page, the previous page (49), which depicts Hannigan's side of the phone conversation, uses a more complex system of images. On the left, it displays a full-page drawing of a man atop a telephone pole, seen from a high angle, handing down a line to Hannigan at street level. On the right, four panels are aligned along their right edge but increasingly encroach upon the left illustration, creating a staircase effect that matches its vertical ascension. Each panel provides a closer framing of Hannigan, from a medium shot to an extreme close-up, which creates a depth axis juxtaposed to the vertical top-to-bottom axis of the telephone pole.

14 The notion that Jewish immigrants "invent[ed] the film business" is the only factual element of Cousin Joseph's speech. All the founders of the "Big Five" and the "Little Three" studios had origins in the Eastern European Ashkenazi diaspora (Russia, Germany, Poland, and Hungary): David Sarnoff (RKO); Joseph M. Schenck and William Fox (20th Century Fox); Adolph Zukor and Jesse Lasky (Paramount Pictures); Harry, Albert, Sam, and Jack Warner (Warner Bros.); Marcus Loew, Louis B. Mayer, and Samuel Goldwyn (Metro-Goldwyn-Mayer); Carl Laemmle

(Universal Pictures); Harry and Jack Cohn and Joe Brandt (Columbia Pictures); and Douglas Fairbanks (United Artists).

15 This paradox is further highlighted by Hannigan's reverse admiration for Hardy Knox's entrepreneurialism and financial ascension from modest origins, which he calls "coming up the hard way" (40–41).

16 Conflating Jewishness and leftist radicalism is also a tendency of American far-right ideology that pervaded the investigations of the House Un-American Activities Committee into Hollywood film personnel, beginning in 1940 at the initiative of Representative Martin Dies, who boldly claimed that forty-two prominent members of the film community were either communists or "fellow travelers" responsible for propaganda with the simple explanation that "most of the producers are Jews" (Wheeler 2016, 44). These HUAC attacks intensified in the late 1940s and early 1950s and had a profound impact on Feiffer's political upbringing.

17 The full list of Hollywood personnel targeted by a Nazi assassination plot included "Jack Benny, Herbert Biberman, Eddie Cantor, Charles Chaplin, Emmanuel Cohen, Sam Goldwyn, Henry Herzbrun, Al Jolson, Leon Lewis, Fredric March, Louis B. Mayer, Paul Muni, Joseph Schenck, B. P. Schulberg, Mendel Silberberg, Franchon Simon, Donald Ogden Stewart, Gloria Stuart, Sylvia Sydney, Ernst Toller, Walter Winchell, Marco Wolff, and William Wyler" (Ross 2017, 205). The plan called for slaughtering all of them on the same night with pipe bombs stuffed with dynamite, and killing all Jews attempting to flee Los Angeles by boat with dynamite as well.

18 Feiffer names the character "Jerry Margulies" when he introduces him on p. 73. On the following page (cited in figure 2.4), he changes the spelling to "Marguiles." This is likely a typo. "Margulies" is the standard spelling of a common Ashkenazi surname (other variants include "Margules").

19 This name change draws a parallel between Jewish, Irish, and Italian minorities. The name "Defoe" not only transposes the phonemes of the original "Di Franco" but contains a pun on the character's boxing past (as Jerry's foe) and current romantic status (as Jerry's rival for Sally's heart).

20 The pulp novelist Max Brand (a pen name for Frederick Schiller Faust) created the character of Dr. Kildare for stories in *Cosmopolitan* magazine in 1936. Paramount Pictures released *Internes Can't Take Money* in 1937, then MGM produced a series of nine films featuring the actor Lew Ayres from 1938 to 1942, starting with *Young Dr. Kildare*. Other transmedial adaptations followed: the titular character was also the subject of a radio series in the 1950s, a television series in the 1960s, and a comics series (1962–1983).

21 Episode 1 of Ken Burns, Lynn Novick, and Sarah Botstein's documentary *The U.S. and the Holocaust* (2022), entitled "The Golden Door (Beginnings—1938)," recounts the history of American antisemitism and its ties with Germany in the 1930s.

22 In *Backing into Forward*, Feiffer offers an extensive account of his early interest in labor issues. As a self-educated young man, he borrowed library books on "the Industrial Revolution, the robber barons, the rise of organized labor, strikes, the suppression of dissent, the Palmer raids" (Feiffer 2010, 98).

23 During the Great Depression, the Pinkerton Detective Agency was often hired by industrialists as a private provider of law enforcement for the specific goal of "union busting," infiltrating workers' circles, intimidating strikers, or sending strikebreakers and so-called goon squads to crush rallies.

24 Countless other acts of violence were committed to undermine strikes and assault strikers well before the 1930s, for instance the 1914 "Machine Gun Massacre" in Ludlow, Colorado, in which the National Guard launched a raid against striking miners, killing twenty people, mostly among the strikers' innocent family members.
25 Feiffer's singer also recalls the union organizer and writer of labor songs Joe Hill, the "troubadour of discontent."
26 Feiffer recently published caricatures of Donald Trump in the *Tablet* online magazine.
27 In *Backing into Forward*, Feiffer remarks that his mother had little interest in men or children, yet "she certainly tended to us. She did her job. One of my mother's great stores of pride was that she did her job. As men did not do theirs. Men fell down on the job. Men drank. Men were weak. Men could not be trusted" (80). He quotes a conversation with his mother in which she explains the complexity of her situation quite candidly: "Because you see, Sonny Boy, it was the Depression and I had to work, because your father's business failed and he couldn't keep a job, and I had to be away from home a lot, and maybe when you were little, you resented me for that" (Feiffer 2010, 32). When he takes the bait and answers that he did indeed have feelings of resentment, she replies, in typical passive-aggressive fashion: "Is that the thanks I get?" (33). Feiffer connects this episode with his long habit of drawing stereotypical Jewish mothers (the first one appearing in the *Village Voice* in December 1958).
28 Despite the ambivalence of her portrayal as a conflicted maternal figure, Cissy Goldman recalls the important role of women labor activists, social reformers, and advocates for women's rights such as the famed Mother Jones (Mary J. Harris Jones), Esther Peterson, Lucy Randolph Mason, Frances Perkins, Lucy Parsons, Jane Addams, etc., and the numerous Jewish women who contributed to the labor movement from the 1910s to the 1930s, including Clara Lemlich Shavelson, Pauline Newman, Rose Schneiderman, Bessie Abramovitz Hillman, and especially Sophie Melvin Gerson, an important figure of the Gastonia textile workers' strike.
29 The notion that political opponents still belong to the same community and have ties through school, family, or friendship adds complexity to Feiffer's depiction of social dynamics. Billy Doyle, Cissy Goldman, and Sam Hannigan were all friends in high school and maintained mutual respect.
30 Many Irish songs from the nineteenth and early twentieth centuries are named after women characters who often personify Ireland itself ("Molly Malone," The Girl from Donegal," Mary from Dungloe," etc.). Those songs accompanied the Irish diaspora to the main hubs of Irish immigration such as Boston, New York, and Philadelphia, establishing a presence in American folklore as well.
31 Sharon Knolle provides a thematic overview of this recurrent topic, which lists H. Bruce Humberstone's *I Wake Up Screaming* (1941), John Huston's *The Asphalt Jungle* (1950), Otto Preminger's *Where the Sidewalk Ends* (1950), Nicholas Ray's *On Dangerous Ground* (1951), Joseph Losey's *The Prowler* (1951), Richard Quine's *Pushover* (1954), Don Siegel's *Private Hell 36* (1954), and Orson Welles's *Touch of Evil* (1958) (Knolle 2020).
32 An earlier passage in the graphic novel (29–30) shows Hannigan and Hammond having drinks at Addie's. As they discuss Hammond's past as an alcoholic, Hannigan reminds him that he had a propensity for beating up female suspects, one of whom nearly died. "You were a dangerous drunk," remarks Hannigan, a presage of Hammond's intoxicated assault on Addie in the conclusion of *The Ghost Script*.

33 Artie's meekness and unassertiveness recall the "nebbish" characters of Bernard Mergendeiler in his earlier cartoons and Sandy, played by Art(ie) Garfunkel in *Carnal Knowledge* (Mike Nichols, 1971).
34 Feiffer and Rosenblatt have been friends for many years. When Feiffer was dismissed from his regular post at *The Village Voice* in 1998, Rosenblatt invited him to teach in Stony Brook University's writing program. Feiffer, who suffers from macular degeneration, contributed illustrations to Rosenblatt's *Cataract Blues* (2023).

Chapter 3 The Ghost Script

1 Lola's real name is Mitzi Kaslowski, from Wheaton, Illinois (78). It can be assumed that she anglicized her Polish name, like many actors of her generation.
2 Joan Crawford transitioned from dramas and comedies to film noir in the 1940s and 1950s, although she continued to act in a variety of film genres (musicals, romantic comedies, melodramas, Westerns, etc.). Her noir filmography includes *Mildred Pierce* (Michael Curtiz, 1945), *Flamingo Road* (Michael Curtiz, 1949), *The Damned Don't Cry* (Vincent Sherman, 1950), *This Woman Is Dangerous* (Felix E. Feist, 1952), and *Sudden Fear* (David Miller, 1953).
3 On Elsie's Miss Know-It-All radio show, Kornblum feigns to be unaware of the existence of the blacklist: "What blacklist? Except for all that talk in the press, I don't know of any blacklist" (12).
4 Whether the studios were always aware of the real identities of the screenwriters who hid under fronts remains more ambiguous than Feiffer suggests. Larry Ceplair and Steven Englund (1983) note that "some producers obviously knew the real identity of their writers. For example, the King Brothers were aware that Dalton Trumbo ('Robert Rich') was scripting 'The Brave One,' and Hannah Weinstein had enlisted Ring Lardner and Ian McLellan Hunter to write the popular series 'The Adventures of Robin Hood.' Most assignments, however, required that . . . a writer's identity be hidden from the producer as well as from the viewer" to protect the studios (405). Ceplair and Englund also remark that dividing income between the "real" authors and their fronts could sometimes turn problematic when fronts became enamored with their reputation.
5 The French word *quiproquo* refers to a theatrical device of mistaken identity, often used in comedies. Molière's *Tartuffe* (1664) and *Le Médecin malgré lui* (1666) are classic examples of this type of reversal. William Shakespeare's *The Comedy of Errors* (1594) and *Twelfth Night* (1601) already made use of similar comedic devices.
6 Ronald Reagan testified in front of the HUAC in 1947 as president of the Screen Actors Guild. When the chief investigator Robert E. Stripling asked him: "What steps should be taken to rid the motion picture industry of any communist influences?" Reagan answered in ambivalent terms, expressing his personal dislike for communism and his belief in government intervention, but also his concerns about democracy: "In opposing those people, the best thing to do is make democracy work. . . . As a citizen, I would hesitate to see any political party outlawed on the basis of its political ideology. However, if it is proven that an organization is an agent of foreign power, or in any way not a legitimate political party—and I think the government is capable of proving that—then that is another matter. . . . Sir, I detest, I abhor their philosophy, but I detest more than that their tactics, which are those of the fifth column, and are dishonest, but at the

same time I never as a citizen want to see our country become urged, by either fear or resentment of this group, that we ever compromise with any of our democratic principles through that fear or resentment. I still think that democracy can do it." The full Reagan testimony is available at https://www.reaganfoundation.org/media/51313/red-scare.pdf?srsltid=AfmBOopLodbY4G6sfiTJCoTEyQSkOg7eHz08Kb2q17q3FrLkx-lxbokY.

7. The analogy with superhero comics is worth noting for its intertextual reference, especially from Feiffer, who wrote *The Great Comic Book Heroes* in 1965 as a tribute to the readings of his youth. Created in 1941 by Jack Kirby and Joe Simon for Marvel Comics, Captain America was conceived with a patriotic intent from the onset, in the context of America's conflict with Germany and Japan. However, he was reinvented by Atlas Comics as an anti-communist fighter in the 1950s.

8. This hypothetical resemblance with Bromberg extends to Archie's face (dark curly hair, dark round eyes, wide and flat nose).

9. Feiffer viewed *Little Murders* as an absurdist metaphor on "disturbance and disenchantment in the 1960s," which he likened to a "colossal national nervous breakdown" (Feiffer 2010, 328). He wrote the novel version of the story the same year as JFK's assassination, and posited that the second run of the play in 1969 was more successful than the initial 1967 staging because his point resonated more clearly with current events, including the 1968 Democratic Convention riots, Robert Kennedy's and Martin Luther King Jr.'s assassinations, the attempt on George Wallace's life, the escalation of the Vietnam War, the Kent State murders, and protests in the streets and on college campuses (384). Although these topical elements do not match the earlier historical context of the noir trilogy, strong thematic and narrative parallels are nevertheless discernible between the two works, fifty years apart.

10. In his autobiography, Feiffer credits psychoanalysis for allowing him to reflect on "[his] guilt, [his] rage, [his] self-loathing, [his] self-pity, [his] alienation" (Feiffer 2010, 271).

11. He cites Mort Sahl, Lenny Bruce, and the duo of Mike Nichols and Elaine May as Jewish comedians from his generation who introduced a new neurotic tone in American humor (Feiffer 2010, 217).

12. The desert location of this scene alludes to the 1947 "Roswell Incident." The tropes of Cold War paranoia in movies made around the time of Feiffer's story (1953) are evident in movies such as *The Flying Saucer* (Mikel Conrad, 1950), *The Day the Earth Stood Still* (Robert Wise, 1951), *The Thing from Another World* (Christian Nyby, 1951), *The Man from Planet X* (Edgar G. Ulmer, 1951), *The War of the Worlds* (Byron Haskin, 1953), *Invaders from Mars* (William Cameron Menzies, 1953), *Phantom from Space* (W. Lee Wilder, 1953), etc. In *Backing into Forward*, Feiffer recalls that 1950s alien invasion movies were metaphorical expressions of the nation's fear of communism (Feiffer 2010, 170).

13. Race is of course ubiquitous in American hard-boiled fiction as well, for instance in Jim Thompson's *Pop 1280* (1964) and in the Harlem-set novels of Chester Himes.

14. *The Set-Up* could be viewed as the oppositive of a "progressive" noir about race, considering that its script rewrote Joseph Moncure March's 1928 poem about discrimination but replaced its Black boxer with a white protagonist and relegated James Edwards to a minor supporting role (Flory 2013, 397–398).

15. Feiffer also became a friend of James Baldwin, whom he met through Rustin. He also credits Baldwin for having "rewritten" his "sensibility in terms of race" (Fay 2015, 115).

16 On this subject, see Johnson 2003, Gateward and Jennings 2015, and Al-Saji 2019. Examining the Franco-Belgian comics corpus, Mark McKinney has convincingly argued that French-language comics constitute a "colonialist cultural formation" (McKinney 2011).
17 Archie claiming that he "watched" the "*Beau and Beanie* show" every Saturday since the age of five creates some chronological confusion. If Archie is forty-two years old in 1953, he was five in 1916, which is before the invention of television in 1928 and the first full broadcasts of the early 1930s, which were interrupted by the Great Depression. This timeline seems to coincide better with Feiffer's own birth date in 1929.
18 The original *Amos 'n' Andy* radio serial (1928–1940) was voiced by the white actors Freeman Gosden (Amos Jones) and Charles Correll (Andy Brown), both steeped in the minstrel tradition. The show was highly popular throughout the 1930s, despite protests from the Black community for its blatant mischaracterization of Black behavior and speech. It was followed by a TV adaptation (fifty-two episodes on CBS in 1951–1953) with the Black actors Alvin Childress (Amos) and Spencer Williams (Andy). There were similar issues with other radio and television sitcoms of the era portraying Black characters, such as *Beulah* (1949–1954), featuring Hattie McDaniel as a Black housekeeper working for a white family.
19 Archie's actual father remains unknown throughout the three volumes. The story hints that he may also be Sam Hannigan's son when Cissy Goldman tells Archie that she dated Sam in high school.
20 Feiffer uses vivid colors more often in this third volume than in the two preceding ones. McManus's socks bring bright yellow and red touches into the dark gray palette of the graphic novel, creating a rare, whimsical emphasis on the page. Other instances of (non-black-and-white) bright colors include Lola Burns's magenta dress (5) and red dominatrix outfit (30–31), Elsie and Patty's orange car (21–23, 50–51), and Murchison's brown robe (132–133).
21 The evidence of this recognition of McManus as Doyle is somewhat mitigated by several factors. Although the reader has earlier points of visual reference for Billy Doyle, Feiffer's sketchy style sometimes complicates character identification, often deliberately, as in the case of the Hughes sisters in *Kill My Mother*. Doyle's younger self in *Cousin Joseph* presents an entirely different appearance than in the third volume, and the bedroom encounter with Cissy takes place at night, which blurs the characters' bodies and faces.

References

Primary Sources

Feiffer, Jules. 1965. *The Great Comic Book Heroes*. New York: Bonanza Books.
———. 1966. *Feiffer on Civil Rights*. New York: Anti-Defamation League of B'nai B'rith.
———. 1968. *Little Murders*. New York: Random House.
———. 1977. *Ackroyd: A Mystery of Identity*. New York: Avon Books.
———. 1979. *Tantrum*. New York: Alfred A. Knopf.
———. 1989. "Munro." In *Feiffer: The Collected Works*, vol. 2, 19–70. Seattle: Fantagraphics.
———. 2010. *Backing into Forward: A Memoir*. New York: Nan A. Talese/Doubleday.
———. 2014. *Kill My Mother: A Graphic Novel*. New York: Liveright.
———. 2016. *Cousin Joseph: A Graphic Novel*. New York: Liveright.
———. 2018. *The Ghost Script: A Graphic Novel*. New York: Liveright.

Secondary Sources

Adams, James Truslow. 2001. *The Epic of America*. Safety Harbor, FL: Simon Publications.
Al-Saji, Alia. 2019. "Glued to the Image: A Critical Phenomenology of Racialization through Works of Art." *The Journal of Aesthetics and Art Criticism* 77 (4): 475–488.
Arnesen, Eric, ed. 2007. *Encyclopedia of U.S. Labor and Working-Class History*. New York: Routledge.
Baetens, Jan. 1989. *Hergé écrivain*. Brussels: Labor.
———. 2019. *The Film Photonovel: A Cultural History of Forgotten Adaptations*. Austin: University of Texas Press.
Baetens, Jan, and Pascal Lefèvre. 1993. *Pour une lecture moderne de la bande dessinée*. Brussels: CBBD.

Baetens, Jan, Hugo Frey, and Fabrice Leroy, eds. 2022. *Intermediality in French-Language Comics and Graphic Novels*. Lafayette: University of Louisiana at Lafayette Press.

Baker, Robert A., and Michael T. Nietzel. 1985. *Private Eyes: 101 Knights: A Survey of American Detective Fiction 1922–1984*. Bowling Green, OH: Bowling Green State University Popular Press.

Bal, Mieke. 1997. *Narratology: Introduction to the Theory of Narrative*. Toronto: University of Toronto Press.

Barthes, Roland. 1970. *S/Z*. Paris: Éditions du Seuil.

Beckett, Samuel. 2006. "Play." In *The Complete Dramatic Works of Samuel Beckett*. London: Faber & Faber.

Belloï, Livio. 2022. "Still Pictures, Moving Frame: Comics on the Edge of Cinema." In *Intermediality in French-Language Comics and Graphic Novels*, edited by Jan Baetens, Hugo Frey, and Fabrice Leroy, 1–13. Lafayette: University of Louisiana at Lafayette Press.

———. 2023. "The 'First' Graphic Novel in America: Revisiting *He Done Her Wrong* and *It Rhymes with Lust*." In *The Cambridge Companion to the American Graphic Novel*, edited by Jan Baetens, Hugo Frey, and Fabrice Leroy, 19–37. New York: Cambridge University Press.

Bellour, Raymond. 2000. *The Analysis of Film*. Edited by Constance Penley. Bloomington: Indiana University Press.

Bendersky, Joseph W. 2007. *A Concise History of Nazi Germany*. Lanham, MD: Rowman and Littlefield Publishers.

Bendis, Brian Michael. 1994. *A.K.A. Goldfish*. Portland: Image Comics.

Biesen, Sheri Chinen. 2005. *Blackout: World War II and the Origins of Film Noir*. Baltimore: Johns Hopkins University Press.

———. 2014. *Music in the Shadows: Noir Musical Films*. Baltimore: Johns Hopkins University Press.

Brooks, Peter. 1995. *The Melodramatic Imagination: Balzac, Henry James, Melodrama, and the Mode of Excess*. New Haven, CT: Yale University Press.

Brubaker, Ed, and Sean Phillips. 2018. *Fade Out: The Complete Collection*. Portland: Image Comics.

Buhle, Paul, and David Wagner. 2005. *Hide in Plain Sight: The Hollywood Blacklistees in Film and Television*. New York: St. Martin's Griffin.

Butler, Judith. 1988. "Performative Acts and Gender Constitution: An Essay in Phenomenology and Feminist Theory." *Theatre Journal* 40 (4): 519–531.

Caniff, Milton. 2007. *The Complete Terry and the Pirates*. Vol. 1, *1934–1936*. San Diego: IDW Publishing.

———. 2012. *Steve Canyon*. Vol. 1, *1947–1948*. San Diego: IDW Publishing.

Carlson, Peter. 1983. *Roughneck: The Life and Times of Big Bill Haywood*. New York: W. W. Norton.

Ceplair, Larry, and Steven Englund. 1983. *The Inquisition in Hollywood: Politics in the Film Community, 1930–1960*. Berkeley: University of California Press.

Chabon, Michael. 2000. *The Amazing Adventures of Kavalier & Clay*. New York: Random House.

Chandler, Raymond. 2000. *The Big Sleep and Other Novels*. London: Penguin Classics.

Charyn, Jerome. 1975. *Blue Eyes*. New York: Simon & Schuster.

Cohan, Steven. 2002. "'Feminizing' the Song-and-Dance Man: Fred Astaire and the Spectacle of Masculinity in the Hollywood Musical." In *Hollywood Musicals, the Film Reader*, edited by Steven Cohan, 87–101. London: Routledge.

Conard, Mark T., ed. 2005. *The Philosophy of Film Noir*. Lexington: University Press of Kentucky.
Cripps, Thomas. 1978. "The Films of Spencer Williams." *Black American Literature Forum* 12 (4): 128–134.
Daniel, Cletus E. 1982. *Bitter Harvest: A History of California Farmworkers 1870–1941*. Berkeley: University of California Press.
Davis-McElligatt, Joanna. 2023. "Black Looking and Looking Black: African American Cartoon Aesthetics." In *The Cambridge Companion to the American Graphic Novel*, edited by Jan Baetens, Hugo Frey, and Fabrice Leroy, 193–209. New York: Cambridge University Press.
Desser, David, and Lester D. Friedman. 2003. *American Jewish Filmmakers*. Champaign: University of Illinois Press.
Devinatz, Victor G. 2007. "Cannery and Agricultural Workers Industrial Union." In *Encyclopedia of U.S. Labor and Working-Class History*, edited by Eric Arnesen, 206–207. New York: Routledge.
Deyo, Nathaniel. 2020. *Film Noir and the Possibilities of Hollywood*. London: Palgrave Macmillan.
Dickos, Andrew. 2002. *Street with No Name: A History of the Classic American Film Noir*. Lexington: University Press of Kentucky.
Diffrient, David Scott. 2018. "Contemporary Comic Books and Hollywood Noir: Remediating Cinematic Style and Cultural Memory in *The Fade Out*." *Journal of Graphic Novels and Comics* 10 (3): 1–26.
Dos Passos, John. 2024. *U.S.A.: The Complete Trilogy*. Boston: Mariner Books Classics.
Dove, George N. 1997. *The Reader and the Detective Story*. Bowling Green, OH: Bowling Green State University Popular Press.
Dubois, Jacques. 1992. *Le Roman policier ou la modernité*. Paris: Nathan.
Durgnat, Raymond. 1996. "Paint It Black: The Family Tree of Film Noir." In *Film Noir Reader*, edited by Alain Silver and James Ursini, 37–52. New York: Limelight Editions.
Eisner, Will. 2000–2008. *The Spirit Archives*. Vols. 1–26. New York: DC Comics.
———. 2005. *Comics and Sequential Art: Principles and Practice of the World's Most Popular Art Form*. Tamarac, FL: Poorhouse Press.
Ellis, Warren, and Ben Templesmith. 2005. *Fell*. Portland: Image Comics.
Évrard, Franck. 1996. *Lire le roman policier*. Paris: Dunod.
Faison, Stephen E. 2008. *Existentialism, Film Noir, and Hard-Boiled Fiction*. Amherst, NY: Cambria Press.
Fay, Martha. 2015. *Out of Line: The Art of Jules Feiffer*. New York: Abrams.
Feiffer, Kate. 2007. *Henry the Dog with No Tail*. New York: Simon & Schuster/Paula Wiseman Books.
Fialkow, Joshua Hale, and Noel Tuazon. 2016. *Tumor*. Portland: Oni Press.
Flory, Dan. 2013. "Ethnicity and Race in American Film Noir." In *A Companion to Film Noir*, edited by Andrew Spicer and Helen Hanson, 387–404. Hoboken, NJ: Blackwell Publishing.
Fraction, Matt, and Howard Chaykin. 2013. *Satellite Sam*. Portland: Image Comics.
Frankel, Glenn. 2017. *High Noon: The Hollywood Blacklist and the Making of an American Classic*. New York: Bloomsbury Publishing.
Gabler, Neal. 1988. *An Empire of Their Own: How the Jews Invented Hollywood*. New York: Doubleday.
Gateward, Frances, and John Jennings. 2015. Introduction to *The Blacker the Ink: Constructions of Black Identity in Comics and Sequential Art*, edited by Frances

Gateward and John Jennings, 1–18. New Brunswick, NJ: Rutgers University Press.
Genette, Gérard. 1988. *Narrative Discourse Revisited*. Ithaca, NY: Cornell University Press.
Greimas, Algirdas-Julien. 1983. *Structural Semantics: An Attempt at a Method*. Translated by Daniele McDowell, Ronald Schleifer, and Alan Velie. Lincoln: University of Nebraska Press.
Groensteen, Thierry. 2007. *The System of Comics*. Translated by Bart Beaty and Nick Nguyen. Jackson: University Press of Mississippi.
———. 2013. *Comics and Narration*. Translated by Ann Miller. Jackson: University Press of Mississippi.
———. 2014. *M. Töpffer invente la bande dessinée*. Paris: Les Impressions Nouvelles.
———. 2017. *The Expanding Art of Comics: Ten Modern Masterpieces*. Translated by Ann Miller. Jackson: University Press of Mississippi.
———. 2020. "Hors-champ." In *Le Bouquin de la bande dessinée*, edited by Thierry Groensteen, 377–380. Paris: Laffont.
Grossman, Julie. 2009. *Rethinking the Femme Fatale in Film Noir: Ready for Her Close-Up*. London: Palgrave-Macmillan.
Hammett, Dashiell. (1929) 1992. *Red Harvest*. New York: Random House.
Hanson, Helen. 2007. *Hollywood Heroines: Women in Film Noir and the Female Gothic Film*. London: I. B. Tauris.
Hapke, Laura. 1995. *Daughters of the Great Depression: Women, Work, and Fiction in the American 1930s*. Athens: University of Georgia Press.
Hart, Christopher. 2006. *Drawing Crime Noir: For Comics and Graphic Novels*. New York: Watson-Guptill.
Harvey, Robert C. 2007. *Meanwhile . . . A Biography of Milton Caniff, Creator of Terry and the Pirates and Steve Canyon*. Seattle: Fantagraphics.
Harvey, Sylvia. 1998. "Woman's Place: The Absent Family of Film Noir." In *Women in Film Noir*, edited by E. Ann Kaplan, 35–46. London: BFI.
Hatfield, Charles. 2005. *Alternative Comics: An Emerging Literature*. Jackson: University Press of Mississippi.
Jackson, Ronald. L., II. 2006. *Scripting the Black Masculine Body: Identity, Discourse, and Racial Politics in Popular Media*. Albany: State University of New York Press.
Johnson, Charles. 2003. Foreword to *Black Images in the Comics: A Visual History*, edited by Fredrik Strömberg, 6–19. Seattle: Fantagraphics.
Kalinak, Kathryn. 1992. *Settling the Score: Music and the Classical Hollywood Film*. Madison: University of Wisconsin Press.
Kellogg, Carolyn. 2014. "Jules Feiffer Dances with Noir in His Graphic Novel *Kill My Mother*." *Los Angeles Times*, August 21, 2014.
Kitchen, Denis, and Paul Buhle. 2009. *The Art of Harvey Kurtzman: The Mad Genius of Comics*. New York: Abrams ComicArts.
Knolle, Sharon. 2020. "The Stained Shield: Corrupt Cops of Noir." *Noir City* (30): 13–20. https://www.filmnoirfoundation.org/noircitymag/The-Stained-Shield.pdf.
Kracauer, Siegfried. 2004. *From Caligari to Hitler: A Psychological History of the German Film*. Princeton, NJ: Princeton University Press.
Kunka, Andrew J. 2018. "Crime Genre Fiction in the Graphic Novel." In *The Cambridge History of the Graphic Novel*, edited by Jan Baetens, Hugo Frey, and Stephen E. Tabachnick, 457–475. Cambridge: Cambridge University Press.

Labrecque, Maxim. 2011. "Le film choral: l'art des destins entrecroisés." *Séquences* (275): 31–35.
Latham, Bethany. 2014. "Kill My Mother." *Historical Novel Society* 69 (August): https://historicalnovelsociety.org/reviews/kill-my-mother.
Lefèvre, Pascal. 2011. "Some Medium-Specific Qualities of Graphic Sequences." *SubStance* 40 (1): 14–33.
Lehman, David. 2001. *The Perfect Murder: A Study in Detection*. Ann Arbor: University of Michigan Press.
Leonard, David J., and Stephanie Troutman Robbins. 2021. *Race in American Television: Voices and Visions That Shaped a Nation*. Westport, CT: Greenwood Books.
Leroux, Gaston. 2022. *The Perfume of the Lady in Black*. Berkeley, CA: Mint Editions.
Leroy, Fabrice. 2014. "Une tragédie de details: L'architecture de l'infra-ordinaire dans les *Building Stories* de Chris Ware." In *La Mécanique du détail*, edited by Livio Belloï and Maud Hagelstein, 227–244. Lyon: ENS Éditions.
———. 2023. "The Mad-Men Generation: Kurtzman and Feiffer." In *The Cambridge Companion to the American Graphic Novel*, edited by Jan Baetens, Hugo Frey, and Fabrice Leroy, 38–56. New York: Cambridge University Press.
Levy, Emanuel. 2007. "High Noon: John Wayne Hated Cooper's Film." *Cinema 24/7*, June 12, 2007, https://emanuellevy.com/review/high-noon-why-john-wayne-hated-the-film-9/.
Lippman, Laura. 2014. "Them Dames." Review of *Kill My Mother* by Jules Feiffer. *New York Times*, August 14, 2014, https://www.nytimes.com/2014/08/17/books/review/jules-feiffers-kill-my-mother.html.
Lott, Eric. 1997. "The Whiteness of Film Noir." *American Literary History* 9 (3): 542–566.
Macdonald, Ross. (1959) 1996. *The Galton Case*. New York: Vintage Crime/Black Lizard.
Martinbrough, Shawn. 2007. *How to Draw Noir Comics: Art and Technique of Visual Storytelling*. New York: Watson-Guptill.
Mayer, Hervé. 2018. "The South between Two Frontiers: Confederate Cowboys and Savage Rednecks." *Revue LISA/LISA e-journal* 16 (1): https://doi.org/10.4000/lisa.9409.
McCloud, Scott. 1994. *Understanding Comics: The Invisible Art*. New York: Harper Perennial.
McGilligan, Patrick, and Paul Buhle. 1999. *Tender Comrades*. New York: St. Martin's Griffin.
McKinney, Mark. 2011. *The Colonial Heritage of French Comics*. Liverpool: Liverpool University Press.
Mikkonen, Kai. 2017. *The Narratology of Comic Art*. New York: Routledge.
Miller, Ann. 2007. *Reading Bande Dessinée: Critical Approaches to French-Language Comic Strip*. Bristol: Intellect Books.
Miller, Frank. 1986. *Batman: The Dark Knight Returns*. New York: DC Comics.
———. 2005. *Frank Miller's Complete Sin City Library*. Milwaukie, OR: Dark Horse Books.
Morgan, Iwan. 2016. Introduction to *Hollywood and the Great Depression: American Film, Politics and Society in the 1930s*, edited by Iwan Morgan and Philip John Davies, 1–26. Edinburgh: Edinburgh University Press.

Morgan, Iwan, and Philip John Davies. 2016. *Hollywood and the Great Depression: American Film, Politics and Society in the 1930s*. Edinburgh: Edinburgh University Press.

Mouly, Françoise, and Mina Kaneko. 2014. "Jules Feiffer's *Kill My Mother*." *The New Yorker*, January 31, 2014, https://www.newyorker.com/books/page-turner/jules-feiffers-kill-my-mother.

Ness, Richard R. 2008. "A Lotta Night Music: The Sound of Film Noir." *Cinema Journal* 47 (2): 52–73.

Newman, Kim. 1990. *Wild West Movies*. London: Bloomsbury Publishing Ltd.

Oliver, Simon, and Jason Latour. 2011. *Noche Roja*. New York: Vertigo.

Peeters, Benoît. 2002. *Lire la bande dessinée*. Paris: Flammarion.

Peretz, Eyal. 2017. *The Off-Screen: An Investigation of the Cinematic Frame*. Redwood City, CA: Stanford University Press.

Porpiro, Robert G. 2006. "No Way Out: Existential Motifs in the Film Noir." In *Film Noir Reader*, edited by Alain Silver and James Ursini, 77–93. New York: Limelight.

Porter, Dennis. 2003. "The Private Eye." In *The Cambridge Companion to Crime Fiction*, edited by Martin Priestman, 75–111. Cambridge: Cambridge University Press.

Potsch, Elizabeth, and Robert F. Williams. 2012. "Image Schemas and Conceptual Metaphor in Action Comics." In *Linguistics and the Study of Comics*, edited by Frank Bramlett, 13–36. London: Palgrave McMillan.

Rich, Jamie S., and Joëlle Jones. 2009. *You Have Killed Me*. Portland: Oni Press.

Rickett, Mark. 2002. *Nowheresville*. Portland: Image Comics.

Robert, Marthe. 1972. *Roman des origines et origines du roman*. Paris: Gallimard.

Rosenblatt, Roger. 2013. *The Boy Detective: A New York Childhood*. New York: Harper Collins.

———. 2023. *Cataract Blues: Running the Keyboard*. San Diego: San Diego State University Press.

Ross, Steven J. 2017. *Hitler in Los Angeles: How Jews Foiled Nazi Plots against Hollywood and America*. New York: Bloomsbury.

Sabin, Roger. 1996. *Comics, Comix & Graphic Novels: A History of Comic Art*. London: Phaidon Press.

Saunders, Thomas J. 1994. *Hollywood in Berlin: American Cinema and Weimar Germany*. Berkeley: University of California Press.

Schneider, Greice. 2017. *What Happens When Nothing Happens: Boredom and Everyday Life in Contemporary Comics*. Leuven: Leuven University Press.

Schrader, Paul. 2006. "Notes on Film Noir." In *Film Noir Reader*, edited by Alain Silver and James Ursini, 53–64. New York: Limelight Editions.

Schwartz, Nancy Lynn. 2001. *The Hollywood Writers' Wars*. Lincoln, NE: Authors Guild Backinprint.

Scott, Ian. 2016. "Columbia Pictures and the Great Depression: A Case Study of Political Writers in Hollywood." In *Hollywood and the Great Depression: American Film, Politics and Society in the 1930s*, edited by Iwan Morgan and Philip John Davies, 49–65. Edinburgh: Edinburgh University Press.

Shaw, Beth Kobliner, Jacob Shaw, and Jules Feiffer. 2013. *Jacob's Eye Patch*. New York: Simon and Schuster.

Silver, Alain, and James Ursini. 2006. *Film Noir Reader*. New York: Limelight Editions.

Smolderen, Thierry. 2009. *Naissances de la bande dessinée: De William Hogarth à Winsor McCay*. Paris: Les Impressions Nouvelles.

Spicer, Andrew. 2010. *Historical Dictionary of Film Noir*. Plymouth, UK: Scarecrow Press.

Stargardt, Ute. 1998. "'Rassenpolitik' in National Socialist Cinema." *Shofar* 16 (3): 1–27.
Steinbeck, John. 2006. *The Grapes of Wrath*. London: Penguin Classics.
Streible, Dan. 2008. *Fight Pictures: A History of Boxing and Early Cinema*. Berkeley: University of California Press.
Thompson, Jim. 2014. *Pop 1280*. New York: Mulholland Books.
Todd, Ellen Wiley. 1993. *The "New Woman" Revised: Painting and Gender Politics on Fourteenth Street*. Berkeley: University of California Press.
Traub, Hans. 1933. *Der Film als politisches Machtmittel* [The film as a political means of power]. Munich: Münchner Druck Und Verlagshaus.
Valis Hill, Constance. 2014. *Tap Dancing America: A Cultural History*. Oxford: Oxford University Press.
Van Dover, J. K. 2022. *The Truman Gumshoes: The Postwar Detective Fiction of Mickey Spillane, Ross Macdonald, Wade Miller and Bart Spicer*. Jefferson, NC: McFarland.
Van Lier, Henri. 1988. "La bande dessinée, une cosmogonie dure." In *Bande dessinée, récit et modernité*, edited by Thierry Groensteen, 5–24. Paris: Futuropolis.
Wandtke, Terrence R. 2015. *The Dark Knight Returns: The Contemporary Resurgence of Crime Comics*. Rochester: RIT Press.
Wheeler, Mark. 2016. "The Political History of Classical Hollywood: Moguls, Liberals, and Radicals in the 1930s." In *Hollywood and the Great Depression: American Film, Politics and Society in the 1930s*, edited by Iwan Morgan and Philip John Davies, 29–48. Edinburgh: Edinburgh University Press.

Filmography

Altman, Robert, dir. 1980. *Popeye*. Los Angeles: Paramount Pictures.
Arkin, Alan, dir. 1971. *Little Murders*. Los Angeles: Twentieth Century Fox.
Bacon, Lloyd, dir. 1933. *Footlight Parade*. Burbank, CA: Warner Bros.
Biberman, Herbert J., dir. 1954. *Salt of the Earth*. New York: Independent Productions.
Borzage, Frank, dir. 1932. *A Farewell to Arms*. Los Angeles: Paramount Pictures.
———. 1933. *Man's Castle*. Los Angeles: Columbia Pictures.
Brabin, Charles, dir. 1932. *The Washington Masquerade*. Beverly Hills, CA: Metro-Goldwyn-Mayer.
Brown, Melville W., dir. 1930. *Check and Double Check*. New York: RKO Pictures.
Browning, Tod, dir. 1931. *Dracula*. Universal City, CA: Universal Pictures.
Bucquet, Harold S., dir. 1938. *Young Dr. Kildare*. Beverly Hills, CA: Metro-Goldwyn-Mayer.
Burns, Ken, Lynn Novick, and Sarah Botstein, dirs. 2022. *The U.S. and the Holocaust*. PBS.
Capra, Frank, dir. 1934. *It Happened One Night*. Los Angeles: Columbia Pictures.
———. 1936. *Mr. Deeds Goes to Town*. Los Angeles: Columbia Pictures.
———. 1939. *Mr. Smith Goes to Washington*. Los Angeles: Columbia Pictures.
Conrad, Mikel, dir. 1950. *The Flying Saucer*. Los Angeles: Film Classics.
Cooper, Merian C., and Ernest B. Schoedsack, dirs. 1933. *King Kong*. New York: RKO Pictures.
Coppola, Francis F., dir. 1972. *The Godfather*. Los Angeles: Paramount Pictures.
Curtiz, Michael, dir. 1945. *Mildred Pierce*. Burbank, CA: Warner Bros.
———. 1949. *Flamingo Road*. Burbank, CA: Warner Bros.
———. 1950. *The Breaking Point*. Burbank, CA: Warner Bros.
Daves, Delmer, dir. 1950. *Broken Arrow*. Los Angeles: Twentieth Century Fox.

Del Ruth, Roy, dir. 1932. *Winner Take All*. Burbank, CA: Warner Bros.
Ford, John, dir. 1940. *The Grapes of Wrath*. Los Angeles: Twentieth Century Fox.
Garnett, Tay, dir. 1945. *The Valley of Decision*. Beverly Hills, CA: Metro-Goldwyn-Mayer.
———. 1946. *The Postman Always Rings Twice*. Beverly Hills, CA: Metro-Goldwyn-Mayer.
Goulding, Edmund, dir. 1938. *The Dawn Patrol*. Burbank, CA: Warner Bros.
Green, Alfred E., dir. 1931. *Smart Money*. Burbank, CA: Warner Bros.
Haskin, Byron, dir. 1953. *The War of the Worlds*. Los Angeles: Paramount Pictures.
Hawks, Howard, dir. 1932. *Scarface*. Los Angeles: United Artists.
———. 1933. *Today We Live*. Beverly Hills, CA: Metro-Goldwyn-Mayer.
———. 1944. *To Have and Have Not*. Burbank, CA: Warner Bros.
———. 1946. *The Big Sleep*. Burbank, CA: Warner Bros.
———. 1959. *Rio Bravo*. Burbank, CA: Warner Bros.
Humberstone, H. Bruce, dir. 1941. *I Wake Up Screaming*. Los Angeles: Twentieth Century Fox.
Huston, John, dir. 1941. *The Maltese Falcon*. Burbank, CA: Warner Bros.
———. 1950. *The Asphalt Jungle*. Beverly Hills, CA: Metro-Goldwyn-Mayer.
———. 1972. *Fat City*. Los Angeles: Columbia Pictures.
Keighley, William, dir. 1935. *G Men*. Burbank, CA: Warner Bros.
———. 1936. *Bullets or Ballots*. Burbank, CA: Warner Bros.
Kubrick, Stanley, dir. 1955. *Killer's Kiss*. Los Angeles: United Artists.
La Cava, Gregory, dir. 1933. *Gabriel over the White House*. Beverly Hills, CA: Metro-Goldwyn-Mayer.
Lang, Fritz, dir. 1936. *Fury*. Beverly Hills, CA: Metro-Goldwyn-Mayer.
———. 1953. *The Big Heat*. Los Angeles: Columbia Pictures.
LeRoy, Mervyn, dir. 1931. *Little Caesar*. Burbank, CA: Warner Bros.
———. 1932. *I Am a Fugitive from a Chain Gang*. Burbank, CA: Warner Bros.
———. 1933. *Gold Diggers of 1933*. Burbank, CA: Warner Bros.
Litvak, Anatole, dir. 1939. *Confessions of a Nazi Spy*. Burbank, CA: Warner Bros.
Losey, Joseph, dir. 1951. *The Prowler*. Los Angeles: United Artists.
Mankiewicz, Joseph L., dir. 1950. *No Way Out*. Los Angeles: Twentieth Century Fox.
Marshall, George, dir. 1938. *The Goldwyn Follies*. Los Angeles: United Artists.
Menzies, William Cameron, dir. 1953. *Invaders from Mars*. Los Angeles: Twentieth Century Fox.
Milestone, Lewis, dir. 1930. *All Quiet on the Western Front*. Universal City, CA: Universal Pictures.
———. 1939. *Of Mice and Men*. Los Angeles: United Artists.
———. 1946. *The Strange Love of Martha Ivers*. Los Angeles: Paramount Pictures.
Nichols, Mike, dir. 1971. *Carnal Knowledge*. Los Angeles: Embassy Pictures.
Nyby, Christian, dir. 1951. *The Thing from Another World*. New York: RKO Pictures.
Ophüls, Max, dir. 1949. *The Reckless Moment*. Los Angeles: Columbia Pictures.
Preminger, Otto, dir. 1944. *Laura*. Los Angeles: Twentieth Century Fox.
———. 1950. *Where the Sidewalk Ends*. Los Angeles: Twentieth Century Fox.
Quine, Richard, dir. 1954. *Pushover*. Los Angeles: Columbia Pictures.
Rapper, Irving, dir. 1956. *The Brave One*. New York: RKO Pictures.
Ray, Nicholas, dir. 1951. *On Dangerous Ground*. New York: RKO Pictures.
Ritt, Martin, dir. 1976. *The Front*. Los Angeles: Columbia Pictures.
Robson, Mark, dir. 1956. *The Harder They Fall*. Los Angeles: Columbia Pictures.

Rossen, Robert, dir. 1947. *Body and Soul*. Los Angeles: United Artists.
Santell, Alfred, dir. 1937. *Internes Can't Take Money*. Los Angeles: Paramount Pictures.
Schertzinger, Victor, dir. 1937. *Something to Sing About*. Los Angeles: Grand National Pictures.
Seitz, George B., dir. 1937. *A Family Affair*. Beverly Hills, CA: Metro-Goldwyn-Mayer.
Selwyn, Edgar, dir. 1930. *War Nurse*. Beverly Hills, CA: Metro-Goldwyn-Mayer.
Siegel, Don, dir. 1954. *Private Hell 36*. Hollywood, CA: Filmmakers Releasing Organization, Inc.
Ulmer, Edgar G., dir. 1951. *The Man from Planet X*. Los Angeles: United Artists.
Van Dyke, W. S., dir. 1934. *Manhattan Melodrama*. Beverly Hills, CA: Metro-Goldwyn-Mayer.
———. 1934. *The Thin Man*. Beverly Hills, CA: Metro-Goldwyn-Mayer.
Vidor, Charles, dir. 1946. *Gilda*. Los Angeles: Columbia Pictures.
Vidor, King, dir. 1934. *Our Daily Bread*. Los Angeles: United Artists.
Walsh, Raoul, dir. 1942. *Gentleman Jim*. Burbank, CA: Warner Bros.
———. 1947. *The Man I Love*. Burbank, CA: Warner Bros.
Welles, Orson, dir. 1947. *The Lady from Shanghai*. Los Angeles: Columbia Pictures.
———. 1958. *Touch of Evil*. Universal City, CA: Universal Pictures.
Wellman, William A., dir. 1931. *The Public Enemy*. Burbank, CA: Warner Bros.
———. 1933. *Wild Boys of the Road*. Burbank, CA: Warner Bros.
Whale, James, dir. 1931. *Frankenstein*. Universal City, CA: Universal Pictures.
Wilder, W. Lee, dir. 1953. *Phantom from Space*. Los Angeles: United Artists.
Wise, Robert, dir. 1949. *The Set-Up*. New York: RKO Pictures.
———. 1951. *The Day the Earth Stood Still*. Los Angeles: Twentieth Century Fox.
———. 1956. *Somebody Up There Likes Me*. Beverly Hills, CA: Metro-Goldwyn-Mayer.
———. 1959. *Odds against Tomorrow*. Los Angeles: United Artists.
Wyler, William, dir. 1953. *Roman Holiday*. Los Angeles: Paramount Pictures.
Zinnemann, Fred, dir. 1952. *High Noon*. Los Angeles: United Artists.

Index

Italicized page numbers indicate illustrations.

20th Century Fox, 75, 190n14

Abbott and Costello, 58, 130, 176
abstract representation, 4, 36, 102
Ackroyd, A Mystery of Identity, 146
actants, 20, 26
Adams, James Truslow, 84
Addams, Chas, 11
adventure comics, 2, 14, 42, 176
Adventures of Sam Spade, The, 7
aesthetics: of Feiffer's trilogy, 5–6, 15, 21, 28, 36–37, 51, 80, 86, 89, 101, 110, 113, 126, 129, 175; of film noir, 24, 70, 90, 112, 167; of noir comics, 3, 4, 187n27
AKA Goldfish, 183n2
alcoholism, 39, 49–50, 53, 71, 115–116, 144, 192n32
Aldrich Family, The, 55, 176
alienation, 63, 111, 113, 147, 158, 167, 194n10
allegory, 92, 96, 133. *See also* metaphor
Allen, Woody, 139
All Quiet on the Western Front, 78
alternance, 12, 20, 36, 43–44, 78, 110, 124. *See also* framing; page layout
Altgeld, John Peter, 95
Altman, Robert, 133, 185n12

Amazing Adventures of Kavalier & Clay, The, 11
American Dream, 81, 84–85, 106, 116, 148, 162–164, 176, 190n10. *See also* immigration
Amos 'n' Andy, 156, 158, 176, 195n18
analepsis, 65, 123
anatomy, 43–44, 59
Andy Hardy, 77
anti-intellectualism, 81, 126, 174, 176. *See also* reactionism
antisemitism: against Hollywood, 66, 74–83, 88, 94; in Nazi ideology, 77, 81, 162–164, 191n21; in school, 73, 117, 173, 189n2; opposition to, 10, 12, 76, 93, 176
archetype, 9–10, 18, 92, 131, 178, 188n41
architecture, 21, 33
Arkin, Alan, 85, 146
army: in American culture, 93; in Feiffer's life, 127; in Feiffer's works, 8, 31, 54, 133, 187n37; in union busting, 96. *See also* militarism
Arnesen, Eric, 97
Arno, Peter, 11
Asphalt Jungle, The, 192n31
Astaire, Fred, 57, 76, 160–161, 186n23, 188n41

207

Astérix, 130
Atlas Comics, 194n7
authority, 8, 10, 77, 130, 135, 146. *See also* policemen
autobiography. See *Backing into Forward*

Babel, 185nn12–13
Bacall, Lauren, 62
Backing into Forward: Feiffer's art, 2–3, 5, 7, 133, 142, 146–147, 186n23, 194n9; Feiffer's politics, 95, 106, 109, 126–128, 152, 154, 191n22, 194n12; Feiffer's upbringing, 9, 103, 115, 119, 178, 192n27, 194nn10–11
Bad Friend, A, 121, 128
Baetens, Jan, 6, 24, 90, 130
Baker, Robert A., 48
Baldwin, James, 194n15
Barthes, Roland, 54
Barzman, Norma and Ben, 139
Batman, The Dark Knight Returns, 4
Bay City, 19, 55, 62, 97, 114, 159–161, 165, 186n20
Beauvoir, Simone de, 188n45
Beckett, Samuel, 31
Belafonte, Harry, 152
Belloï, Livio, 6, 53
Bellour, Raymond, 20
Bendersky, Joseph W., 81
Bendis, Brian Michael, 4, 183n2
Benny, Jack, 191n17
Berlin, Irving, 88
Bernard and Huey, 9
Bernstein, Walter, 139
betrayal, 11, 112–113, 115, 125, 128, 170. *See also* revenge
Beulah, 195n18
Beverly Hills, 74, 79–81, 134, 165
Biberman, Herbert J., 96, 191n17
Biesen, Sheri Chinen, 3, 53, 62
Big Heat, The, 53
Big Sleep, The, 2, 63, 118, 124, 143, 177
Black characters, 150–154, 156, 158, 166, 194n14, 195n18
blacklist: in the trilogy, 11, 66, 124–129, 132–140, 144, 148, 154, 158–159, 164–165, 172, 178, 184n3, 193n3; real-life victims of, 10, 96, 127–128, 134, 139, 152. *See also* blacklist; censorship; House Un-American Activities Committee

blackmail, 56, 119, 128, 172. *See also* revenge
Blue Eyes, 20
blues, 14, 62–63, 116, 173. *See also* music; singing
b-movie, 76, 166. *See also* cinema
Bobby, 185n12
Bogart, Humphrey, 45
Borzage, Frank, 77, 93
Botstein, Sarah, 191n21
Boudin, Leonard, 10, 106
boxing: as Great Depression entertainment, 14, 93, 176; boxing noir, 45, 92, 152, 186n24, 194n14; in earlier Feiffer works, 8; in the trilogy, 18, 34–35, 45, 56, 79, 90, 119, 186n20, 188nn40–41, 191n19
Boy Commandos, 3
Boy Detective, The, 120
Brand, Max, 191n20
Brandt, Joe, 191n14
Bransten, Richard, 139
Brave One, The, 134, 193n4
Breaking Point, The, 152, 156
Broadway, 86, 125, 127, 132, 138–140, 188n41
Broken Arrow, 134
Bromberg, J. Edward, 10, 127–128, 139, 143, 194n8
Bronx, 3, 9, 14, 66, 183n1
Brooks, Peter, 12, 171
Brubaker, Ed, 55
Bruce, Lenny, 194n11
Buck Rogers in the 25th Century, 11
Buhle, Paul, 130, 134
Building Stories, 69
Bullets or Ballots, 77
Burns, Ken, 191n21
Burns and Allen, 187n34
Busch, Wilhelm, 130
Bush, George H. W., 101
Butler, Hugo, 139
Butler, Judith, 59–61, 188n45

Caesar, Irving, 88
Cagney, James, 53, 57, 92, 188n41
Cain, James M., 5, 14, 112, 177
Calculus Affair, The, 130
California, 66, 83, 97, 176, 189n6
camp shows, 14, 31, 56–57, 187n36, 188n41. *See also* comedy

Caniff, Milton, 2, 5, 11–12, 14, 49, 66, 176, 186nn26–27
cannery, 11, 66, 73, 97–99, 103, 118, 162. *See also* unions
Cantor, Eddie, 76, 191n17
capitalism, 67, 100, 129, 162
Capra, Frank, 76, 190n8
Captain America, 3, 143, 194n7
caricature, 86, 100, 153, 192n26. *See also* satire
Carlson, Peter, 109
Carnal Knowledge, 9, 129, 193n33
cars: in film noir, 36; in the trilogy, 30–33, 36–40, 68–74, 89, 145–150, 165, 176, 195n20
Cataract Blues, 193n34
catchphrase, 55, 71, 156, 172, 187n35. *See also* radio
catharsis, 17–18, 171–173. *See also* revenge
censorship, 4, 24, 75, 125, 138, 140, 159. *See also* blacklist; McCarthyism
Ceplair, Larry, 134, 193n4
Chabon, Michael, 11
Chandler, Raymond: as literary model, 2, 5, 14, 19, 48, 51, 97, 126, 141, 146, 186n20; *The Big Sleep*, 118, 124, 143, 162, 177
Chaplin, Charlie, 83, 191n17
Charyn, Jerome, 20
Chaykin, Howard, 183n2
Check and Double-Check, 156
children: characters in the trilogy, 16, 24, 33, 54, 67, 71, 103–104, 109, 117–120, 144–145, 174, 177, 185n11; during the Great Depression, 9, 75, 103, 119; Feiffer's childhood, 9, 11, 13, 103, 119, 178, 192n27; Feiffer's children's stories, 7–9, 13–14, 67, 184n5, 187n32
Childress, Alvin, 195n18
choreography, 43, 45, 79, 86, 127, 139. *See also* dance; music
Christie, Al, 158
chronophotography, 41, 68
cinema: alien invasion movies, 150, 173, 194n12; choral film, 12, 20–21, 185nn12–13; cine-mimetic devices in comics, 5–6, 8, 20, 36–37, 68, 73, 89–92, 111–115, 131–132, 176–177; escapism during the Depression, 11, 14, 75–77, 83, 176, 178; gangster movies, 14, 53, 77; German cinema, 78, 190n10;

Hollywood studios, 19, 56, 58, 74, 125, 135, 139, 189n5; horror movies, 76; ideology, 6, 11, 77–83, 88, 132, 152, 176–177; lost cause Westerns, 166; medical drama, 92, 191n20; medium, 4, 6, 15, 19, 24, 30–31, 39, 41–42, 58, 70, 92–93, 96, 126, 130, 132, 177, 184n6, 185nn12–13; musicals, 7, 62–63, 74, 88, 186n22, 187n37; slapstick, 130; social problem movies, 76; spectator, 24, 68, 83, 165, 167–168; stock figures, 150, 156; war movies, 10, 31, 53, 58, 132. *See also* film noir; screenwriter
cityscape, 3, 50, 68–69, 176
civil rights, 10, 109, 133, 152–153, 158, 176. *See also* race
Civil War, 152, 166
Clarke, Mae, 53
class: difference, 48–49, 94, 106, 118, 167; middle class, 184n9; struggle, 76; working class, 67, 81, 97, 109, 158, 186n24
Clifford, 7–8
Cobean, Sam, 11
Cohan, Steven, 188n42
Cohen, Emmanuel, 191n17
Cohn, Harry, 75, 191n14
Cole, Jack, 2
Cole, Lester, 134
color: black-and-white, 3–5, 129, 195n20; bright colors, 129, 159, 195n20; ink wash, 21, 37, 79, 102, 113, 154, 167; lighting contrast in noir, 4–6, 21, 37, 113, 115, 176; sepia, 89–90
Columbia Pictures, 75, 190n8, 191n14
Columbia University, 154, 156, 183n4
Columbo, Russ, 74, 176, 189n3
comedy, 58, 93, 130, 135, 138, 146. *See also* camp shows; caricature; satire
Comedy of Errors, The, 193n5
communism: anti-, 142–143, 159, 162, 164, 173, 194n7, 194n12; in Hollywood, 125, 128–129, 131, 134, 136, 138, 140, 166–168, 191n16, 193n6; in the labor movement, 100, 106. *See also* politics; Soviet Union
Conard, Mark T., 172
Confessions of a Nazi Spy, 190n8
Congress, 125, 131, 167. *See also* House Un-American Activities Committee; McCarthyism
Conrad, Mikel, 194n12

conspiracy, 81, 94, 109, 144, 146
continuity: narrative, 6–8, 36, 73, 102, 116; visual, 36, 39, 68–69, 73–74, 89, 113
contrapuntal representation, 44, 107, 139, 141, 161, 177. *See also* irony
Cooke, Darwyn, 4
Cooper, Gary, 166
Coppola, Francis Ford, 188n39
cops. *See* policemen
Correll, Charles, 195n18
Cosmopolitan, 191n20
Crash, 185n12
Crawford, Joan, 131–132, 193n2
Cripps, Thomas, 158
Crum, Bartley, 139
cultural assimilation in the US, 11, 75, 119, 145, 150, 189n5. *See also* immigration
Curtiz, Michael, 118, 132, 152, 156, 193n2

Damned Don't Cry, The, 193n2
dance: in 1930s cinema, 76, 132, 176, 186n22, 188n41; in earlier Feiffer works, 8, 161, 186n23; in the trilogy, 14, 43–*46*, 56–58, 63, 119, 133, 139, 187n37. *See also* choreography; music
Daniel, Cletus E., 97
Darrow, Clarence, 95
Darrow, Whitney, 11
Dassin, Jules, 134
Daves, Delmer, 134
Davis-McElligatt, Joanna, 153
Dawn Patrol, The, 19
Day the Earth Stood Still, The, 194n12
Dean, Abner, 11
Debs, Eugene, 95, 106
décor, 30, 36–37, 45, 177, 185nn18–19
Del Ruth, Roy, 92
denouement, 53, 111–112, 170
Desser, David, 75–76, 189n5
detective story, 15, 20, 47, 184n7, 186n21. *See also* private investigator
Devinatz, Victor G., 97
Deyo, Nathaniel, 23
dialogue: in comics, 42; in hard-boiled literature, 5; in radio plays, 7; in *The Feiffer Strips*, 8; in *The Spirit*, 7; in the trilogy, 5, 12, 30–*32*, 34, 36, 43–44, 48, 58, 69–71, 73–74, 89, 94, 111, 115–116, 129, 131, 133, 135, 154, *157*–158, 167, 177–178, 190n13. *See also* speech
Dickos, Andrew, 36
Dies, Martin, 191n16
Diffrient, Scott, 10, 48–49, 56
Dineur, Fernand, 130
diptych, 24, 101, 167
Dirks, Rudolph, 130
disenchantment, 67, 84, 150, 194n9
disguise, 19, 28, 59, 135, 139, 159. *See also* mask; reversal
Dmytryk, Edward, 128
Donat, Robert, 59
Dopple, 7
Dos Passos, John, 95–96
Double Indemnity, 2
Dove, George N., 54
Dracula, 76
Dragon Lady, 49, 186nn26–27
Drake, Normandie, 12, 49, 186n26
Dreiser, Theodore, 95
Dr. Kildare, 92, 191n20
Druillet, Philippe, 185n18
Dubois, Jacques, 15, 19, 55, 184nn7–8
Duchamp, Marcel, 41
Dunn, Alan, 11
Durgnat, Raymond, 76, 189n6

Edwards, James, 152, 194n14
Eisenhower, Dwight David, 101, 152
Eisner, Will: collaboration, 2–3, 7, 14, 95, 183n1; comics theory, 8, 41–42, 59; influence, 5, 11–12, 66, 124, 147, 176, 185n19
Ellis, Warren, 183n2
empathy, 10, 44, 90, 92, 112–113
Englund, Steven, 134, 193n4
Erdman, Ernie, 88
eroticism, 36, 62, 186n27. *See also* sexuality
Escher, M. C., 68
espionage, 8, 10, 109, 190n8
Ethel and Albert, 187n34
ethics: amorality, 112, 170; corruption, 16, 48, 55, 67, 110–111, 132, 141, 176–177; film noir, 172, 186n24; Great Depression, 112, 116, 177; Hollywood, 45, 56, 79, 125, 133; journalism, 154; melodrama, 171; morality, 45, 49–51, 56, 115–116, 128, 131, 140, 145, 148, 170–172, 176–177, 186n24,

190n10; opportunism, 50, 53, 116, 125, 140, 160; PI character, 18, 29, 48–51, 53, 112, 115–116, 140–141, 145, 148; pragmatism, 29, 45, 50, 79, 103, 112, 115, 127, 133, 135; witch hunt, 127–128, 131, 140
Evans, Robert, 133
Évrard, Franck, 48
existentialism, 116, 146, 172, 177
experimentation in the trilogy, 2, 6, 8, 73, 177
expressionism, 3, 4, 43, 101–102, 119

Fairbanks, Douglas, 191n14
Faison, Stephen E., 116
family: dynamics, 9, 16–19, 61–63, 159–160, 171, 173, 178, 184n9, 187n34; dysfunction during the Depression, 67, 75, 77, 103, 117–118, 133
Fancy Free, 127
Farewell to Arms, A, 92
Faulkner, William, 93
Fay, Martha, 8, 10–12, 100, 152–154, 161, 183n1, 194n15
Feiffer, Kate, 184n5
Feiffer, Rhoda, 9, 103, 119
Feiffer on Civil Rights, 153
Feiffer Strips, The, 7, 9–10, 14, 131, 152
Feist, Felix E., 193n2
Fell, 183n1
fellow travelers, 129, 191n16
femme fatale, 9–10, 18, 47–49, 53, 131, 176, 178, 186n25
Fialkow, Joshua Hale, 183n2
Fibber McGee and Molly, 187n34
Fields, W. C., 76
film. *See* cinema
film actor: characters in the trilogy, 6, 18–19, 54–58, 124–125, 131–132, 148, 156–158, 165, 187n35, 193n1; non-fictitious, 10, 31, 74–75, 77–78, 93, 127, 139–140, 144, 188n39, 188n41, 191n20, 193n6, 195n18
film noir: aesthetics and iconography, 3–6, 14, 21, 23–24, 36–37, 113, 115, 167; archetypes, 9, 20, 26, 143, 150, 178; codes, 2, 5, 14, 47, 49–51, 126, 171; family in, 67, 103, 118; injustice in, 111–112; inspiration for the trilogy, 1–2, 14–15, 66, 92, 126, 175–178, 183n2; moral ambivalence in, 49, 116; music in, 62–63; narrative devices, 4, 12, 20, 52, 141, 171–172, 176; politics in, 96; race in, 150, 152, 194n14; social justice in, 150; violence in, 53
Flamingo Road, 132, 193n2
Flory, Dan, 150, 152, 194n14
flying saucer, 12, 150–151, 194n12
Flying Saucer, The, 194n12
Flynn, Errol, 19, 59
folk singers, 7, 73, 98, 104, 107, 192n30. *See also* music; singing
Footlight Parade, 76, 188n41
Ford, John, 77
foreigners, 75, 77–78, 81, 193n6. *See also* immigration
Foreman, Carl, 166
Foster, Hal, 11
Fox, William, 75, 190n14
Fraction, Matt, 183n2
framing: close-up, 5, 33, 86, 95, 102, 110, 119, 167, 190n13; counter-shot, 21, 24, 34, 113; focalization, 23, 100, 168, 185n14; *hors-champ*, 21, 23–24, 44, 110, 112, 142; panorama, 39, 102; perspective, 4, 6, 21, 24, 29–30, 34, 36, 39, 44, 59, 68–69, 71, 89, 92, 101, 113, 115, 119, 176, 184n9; proportion, 24, 34, 37, 39, 53, 59, 110; scale of illustrations, 33, 69, 113; tracking shot, 68, 70, 73, 177; unframed images, 7, 45, 59, 95, 109, 167–168; zoom, 69–70
Franco-Belgian comics, 130, 185n18, 195n16
François, André, 11
Frankel, Glen, 125, 166
Frankenstein, 76
Friedman, Lester D., 75–76, 189n5
From Here to Eternity, 188n39
Front, The, 139
Fury, 190n8

Gable, Clark, 19, 59
Gabler, Neal, 76
Gabriel over the White House, 189n8
Galton Case, The, 19
Garfunkel, Art, 9, 193n33
Garland, Judy, 77
Garnett, Tay, 96
Gateward, Frances, 195n16
gaze: as point of view, 6, 70, 73; in cinema, 68, 177; of characters, 23–24, 53, 63, 90, 129; of readers, 36, 63, 113, 142, 165, 167, 169–170

gender: archetypes and roles, 9, 20, 49–50, 52, 109, 150, 178, 184n9; femininity, 47–49, 55, 59, 61, 102; inequality, 16; insecurity, 47, 51–54, 57; masculinity, 9–10, 19, 31, 47–49, 53–54, 56–57, 59, 61, 93, 135, 141, 145, 178, 184n9, 188n43; performance, 10, 18–19, 28, 31, 54–61, 135, 184n3, 184n45
generations, 17, 85–86, 115, 133, 159, 173–174, 194n11
Genette, Gérard, 23, 138
Germany, 66, 78, 83, 190n14, 191n21, 194n7
Gershwin, George, 88
Gerson, Sophie Melvin, 192n28
gesture: characters, 39, 47, 86, 102, 133; comics vocabulary, 42, 59, 68; Feiffer's style, 14, 186n23. *See also* motion
Gilda, 62
G-Men, 77
Godfather, The, 188n39
Goebbels, Joseph, 78–79, 190n9
Gold Diggers of 1933, 43, 76, 176, 186n22
Goldfish, Samuel, 75
Goldman, Judith, 12
Goldwyn, Samuel, 55, 83, 190n14, 191n17
Goldwyn Follies, The, 55
Gordon, Ruth, 139
Goscinny, René, 130
Gosden, Freeman, 195n18
Grahame, Gloria, 53
Grant, Lee, 139
Grapes of Wrath, The, 77, 96
Great Comic Book Heroes, The, 11, 194n7
Great Depression: cinema of, 76–77, 92, 166, 186n22, 190n8; historical context, 6, 9–10, 48, 83, 96–97, 102–103, 119, 141, 178, 189n1, 189n23; imagery in Eisner, 3; theme in the trilogy, 14, 16, 43, 50, 66–67, 74–75, 79, 83, 85, 94, 109, 112, 115, 162, 187n28
Greimas, Algirdas Julien, 26
Groensteen, Thierry: comic art possibilities, 1, 9, 168; comics history, 42, 86; spatio-topical system, 6, 21, 23–24, 28, 30, 36, 39, 73, 175, 185n15, 185nn17–19, 187n32
Grossman, Julie, 186n25
Guthrie, Woody, 95, 97–98, 102, 176

Hammett, Dashiell, 2, 14, 19, 48, 95, 146, 177
Hanson, Helen, 186n25

Hapke, Laura, 103
hard-boiled literature: inspiration for the trilogy, 14, 67, 96, 176–177, 187n29; tropes and devices, 26, 47, 52, 54, 111, 116, 141, 143, 145, 187n30, 194n13
Hart, Christopher, 4
Harvey, Robert C., 49, 186n27
Harvey, Sylvia, 102–103, 118
Haskin, Byron, 194n12
Hatfield, Charles, 42
Hawks, Howard, 62, 93, 118, 143, 166
Haywood, Bill, 95, 106, 109
Hayworth, Rita, 62
Hellman, Lillian, 139
Hemingway, Ernest, 93
Henry the Dog with No Tail, 184n5
Hergé, 130
hermeneutic code, 15, 20, 26, 54, 63
heroism, 31, 49, 54, 58, 93. *See also* simulacrum
Herzbrun, Henry, 191n17
Hey Look!, 130
High Noon, 166
Hill, Joe, 192n25
Hillman, Bessie Abramovitz, 192n28
Himes, Chester, 194n13
Hines, Gregory, 154
Hitler, Adolf, 78–79
Hoffa, Jimmy, 10
Hogarth, Burne, 11
Hokinson, Helen, 11
Holiday, Billie, 62
Hollywood Ten, 125, 134
Holmes, Sherlock, 120
homage, the trilogy as, 11, 14–15, 36, 66, 70
homophobia, 145, 184n9
Hoover, Herbert, 189n6
House Un-American Activities Committee (HUAC): hearings, 10, 125–128, 139, 166, 191n16, 193n6; in the trilogy, 124, 129, 131, 135, 140, 148, 167, 170, 174, 184n3. *See also* blacklist; McCarthyism
Humberstone, H. Bruce, 192n31
Huston, John, 14, 45, 192n31

I Am a Fugitive from a Chain Gang, 77, 189n8
iconic solidarity, 6–7, 177. *See also* page layout

illustrations in children's literature, 7, 14
I Love a Mystery, 7
immigration: Irish, 85–88, 104, 192n30; Italian, 90, 92–93, 150, 191n19; Jewish, 9–10, 80–81, 88, 90, 93, 103, 146. *See also* American Dream; foreigners
implicit representation, 4, 62, 73, 76, 173
intermediality, 1–6, 68–73, 89–92, 104, 173–174, 177
Internes Can't Take Money, 191n20
intertextuality, 10, 15, 97, 124, 143, 147, 161, 175, 194n7
Invaders from Mars, 194n12
investigative journalism, 10, 96, 125, 154–156, 160
irony: from the author, 10, 47, 57, 86, 107, 109, 129, 148, 156, 175, 178; from the characters, 53, 96, 118, 135, 140, 143
It Happened One Night, 76
I Wake Up Screaming, 192n31

Jackson, Ronald. L., 156
Jacobi, Lou, 85
Jacob's Eye Patch, 14
jazz, 14, 62, 88
Jennings, John, 195n16
Jewishness: creators, 11, 88; guilt in Jewish culture, 9, 103, 126, 147–148; humor, 147, 194n11; in Hollywood, 66, 75, 78, 81, 83, 93–94, 164, 189n5, 190n14, 191n16; mothers, 9, 104, 192n27; New Yorkers, 9, 76, 79, 119–120, 126; reflection on, 12, 94, 104, 118–119, 126, 147; unionists, 67, 192n28; victimization, 67, 71, 119, 173, 189n2. *See also* antisemitism
John Birch Society, 164
Johnson, Charles, 195n16
Jolson, Al, 88, 191n17
Jones, Joëlle, 183n2
Jones, Mary J. Harris (Mother Jones), 192n28

Kalinak, Kathryn, 62
Kaneko, Mina, 2
Kanin, Garson, 139
Katzenjammer Kids, The, 130
Kazan, Elia, 128
Kellogg, Carolyn, 2, 4, 8
Kempton, Murray, 10, 106

Kennedy, John Fitzgerald (JFK), 146, 194n9
Kennedy, Robert, 194n9
Kent State, 194n9
Kermit, 7–8
Khan, Gus, 88
King, Martin Luther, Jr., 194n9
King Brothers, 193n4
King Kong, 76
Kirby, Jack, 3, 194n7
Kitchen, Denis, 130
Knapp, Evalyn, 53
Knolle, Sharon, 111, 192n31
Kracauer, Siegfried, 78
Kubrick, Stanley, 45
Kunka, Andrew J., 4
Kurtzman, Harvey, 130

Labrecque, Maxime, 20, 185n12
Ladd, Alan, 57
Lady from Shanghai, The, 62
Laemmle, Carl, 75, 78, 190n14
Lang, Fritz, 53
Lardner, Ring, Jr., 134, 193n4
Lasky, Jesse, 75, 190n14
Latham, Bethany, 5
Latour, Jason, 183n2
Laura, 187n36
Laurel and Hardy, 130
Lawson, John Howard, 134
layout. *See* page layout
Lefèvre, Pascal, 6, 24
Lehman, David, 19
Le Lionnais, François, 183n3
Le Médecin malgré lui, 193n5
Leonard, David J., 156
Leroux, Gaston, 184n8
Leroy, Fabrice, 6–7, 12, 69
LeRoy, Mervyn, 186n22
Levy, Emanuel, 166
Lew Archer, 19
Lewis, Jerry, 130
Lewis, Leon, 191n17
Lippman, Laura, 15, 59, 184n6
Little Caesar, 77
Little Murders, 85, 146, 184n9, 194n9
Loeb, Philip, 139
Loew, Marcus, 75, 190n14
London, Jack, 95
Longfellow, Henry Wadsworth, 39

Losey, Joseph, 192n31
Lott, Eric, 152
Love Actually, 185n12
Lum and Abner, 58
Lupino, Ida, 62

Macdonald, Ross, 19, 185n11
Magnolia, 185n12
Male Call, 187n27
Maltese Falcon, The, 2, 47
Maltz, Albert, 134
Man from Planet X, The, 194n12
manga, 44, 185n18
Manhattan Melodrama, 19
Man I Love, The, 62
Man in the Ceiling, The, 7
Mankiewicz, Joseph L., 152
Man's Castle, 77
March, Fredric, 191n17
Marey, Etienne-Jules, 41
Marlowe, Philip, 120, 143–144
Martin, Dean, 130
Martinbrough, Shawn, 4
Marvin, Lee, 53
Marx Brothers, 76
mask, 129, 147, 159, 171, 178, 184n9. *See also* disguise; reversal
Mason, Lucy Randolph, 192n28
Max und Moritz, 130
May, Elaine, 194n11
Mayer, Hervé, 166
Mayer, Louis B., 75–76, 83, 131, 189n6, 190n14, 191n17
McCarthyism, 10, 100, 124, 139. *See also* censorship; House Un-American Activities Committee
McCloud, Scott, 8, 41
McDaniel, Hattie, 195n18
McGilligan, Patrick, 134
McKenney, Ruth, 139
McKinney, Mark, 195n16
McLellan Hunter, Ian, 134, 193n4
McParland, James, 109
Meanwhile, 8
Meet Corliss Archer, 55
melodrama, 12, 49, 86, 92, 123, 138, 171–172, 177–178, 190n8. *See also* pathos; plausibility
Menzies, William Cameron, 194n12

Mergendeiler, Bernard, 193n33
metalepsis, 138
meta-noir, 147, 179
metaphor, 31, 63, 76, 92, 104, 132, 148, 194n9, 194n12. *See also* allegory
metonymy, 4, 24, 63, 68, 73
MGM, 55, 77, 92, 189n6, 191n20
Mikkonen, Kai, 41
Mildred Pierce, 2, 118, 193n2
Milestone, Lewis, 77, 118, 190n11
militarism, 54, 93. *See also* army
Miller, Ann, 23, 185n14
Miller, David, 193n2
Miller, Frank, 4
minimalism, 14, 130, 154
minorities, 81, 150, 177, 191n19. *See also* immigration; race
minstrel tradition, 156, 195n18. *See also* race
misogyny, 10, 41, 53, 109, 115, 173, 178. *See also* women
Miss Marple, 120
Modell, Frank, 11
mogul, 66, 75, 83, 143, 189n6
Molière, 135, 193n5
Moncure, Joseph, 194n14
monologue: in film noir, 12; in *The Feiffer Strips*, 8, 147; in *Little Murders*, 85, 146; in the trilogy, 40–41, 47, 51–52, 74, 80, 95, 130, 141–143, 145–146, 167, 172–173, 177
monstration, 23–24, 33
Morgan, Iwan, 75–77, 166
Mostel, Zero, 139
motion, representation of, 8, 24, 33, 37, 41–45, 68, 89, 113. *See also* page layout
Mouly, Françoise, 2
Mr. Deeds Goes to Town, 190n8
Mr. Smith Goes to Washington, 190n8
Muni, Paul, 191n17
Munro, 7–8, 10, 54, 133
music, 7, 64, 74, 79–80, 88. *See also* singing
mystery, 16, 20–21, 26, 116, 143, 156, 162
mythology, 85, 93, 104

narrative: closure, 24, 54, 112, 123, 148, 161, 164, 173, 184n7; convergence, 9, 19–20, 31, 71, 171; fragmentation, 16, 18–20, 58, 68, 70–71, 73–74; juxtaposition, 20, 70, 124;

loop effects, 26, 71, 124, 131, 135–136, 140, 150, 161, 174; structure, 6, 11–12, 68, 70–71, 73, 123–124, 132, 136, 140, 161, 171–172, 175, 177; subplots, 7, 11–12, 16, 18, 20, 62, 67–68, 71–73, 97, 102, 123, 136, 159, 171–172, 177; teleological, 12, 20, 85, 177; transitions, 4, 31, 41
nationalism, 66, 83, 88, 93, 106, 176. *See also* patriotism
Nazi Germany, 77–78, 81, 83–84, 191n17
nebbishness, 9, 141, 193n33
neo-baroque, 30, 185n18
neo-noir, 3–5, 176–177, 183n2
Ness, Richard R., 62
New Deal, The, 76, 162
Newman, Kim, 166
Newman, Pauline, 192n28
newspapers, 7, 49, 90, 96, 146, 154
New Yorker Magazine, 2, 11
New York Times, 13, 15
Nichols, Mike, 193n33, 194n11
Nicholson, Jack, 9
Nietzel, Michael T., 48
nihilism, 9, 85, 116, 187n30
Nixon, Richard, 101
Noche Roja, 183n2
noir comics, 3–4, 6. *See also* neo-noir
nostalgia, 2, 86, 104
Novick, Irv, 3
Novick, Lynn, 191n21
No Way Out, 152
Nowheresville, 183n2
Nyby, Christian, 194n12

Odds Against Tomorrow, 152
Odets, Clifford, 127–128, 139
Oedipus, 9, 13, 15–20, 117, 159, 177, 184n6, 184n8
Oedipus Rex, 15
Of Mice and Men, 77
Oliver, Simon, 183n2
On Dangerous Ground, 192n31
On the Town, 127
ontology, 26, 41
Ophüls, Max, 150
Orchard, Harry, 109
Oscars, 56–57
OuLiPo, 183n3
Our Daily Bread, 77

page layout: backgrounds, 3, 24, 34, 44, 70, 73, 120, 129, 185n19; braided, 6, 16, 21, 28, 31, 57, 68, 70, 73, 168; comics grid, 6–7, 28, 30, 33–34, 37, 89, 102, 120, 126, 167, 177, 185n16; contrapuntal, 161, 165; double-page, 21, 28, 30, 73, 80, 84, 89, 101–102, 109, 167–168, 185n15, 185n18, 190n13; hyperframe, 30, 39, 45, 51, 53, 59, 185nn16–17; iconic repetition, 8, 69, 110, 142; movement-based, 68–73; multi-frame, 6–7, 28–30, 33, 37, 45, 51, 185n15; object-based, 6, 21–23, 30, 33–34, 36–39, 68–71; rhetorical, 28–30, 33, 37, 81; stanza, 36–39, 177; stratification, 6, 36, 98; strip, 2, 10, 13–14, 28, 42, 49, 66, 131, 147, 152–153, 183nn1–2, 185n16, 186nn26–27; symmetrical configurations, 24, 33, 43, 110, 113, 170, 177; tableau, 24, 36, 39, 68–69, 73, 89, 101–102; visual juxtaposition, 21, 23, 29, 33, 41, 45, 68, 71, 73, 79, 86, 89, 101, 110, 112–113, 148, 153, 161, 168, 186n23, 190n13
panel: encroachment, 6, 28–29, 43, 52, 70, 185n16, 185nn18–19, 190n13; gutters and dividers, 29, 33–34, 37, 68, 79, 110, 120, 185n16, 185n19. *See also* framing
paradox, 88, 115–116, 135, 140, 145, 160–161, 167, 191n15
Paramount Pictures, 75, 92, 190n14, 191n20
paranoia, 24, 138, 146, 194n12
paratext, 15
Parsons, Lucy, 192n28
pathos, 15, 92, 171. *See also* melodrama
patriotism, 62, 66, 77, 84, 90, 98, 129. *See also* nationalism
Peeters, Benoît, 28
Pegg, Simon and Frost, Nick, 130
Perec, Georges, 183n3
Peretz, Eyal, 24
performativity, 10, 54, 59, 61, 129, 140, 188n45. *See also* gender; simulacrum
Perkins, Frances, 192n28
Peterson, Esther, 192n28
Phantom from Space, 194n12
Phillips, Sean, 4
photogram, 41
photography, 24, 41
photorealism, 3, 14, 90
Pierce, Veda, 118

Pinkerton Detective Agency, 109, 189n1, 191n23
Plastic Man, 2
plausibility, 19, 178. See also melodrama
playwriting, 13, 66, 146
Poirot, Hercule, 120
Poitier, Sidney, 152
policemen: authority, 66–67, 88, 97, 104, 109, 120, 142, 171; characters in the trilogy, 16, 50, 65, 71, 93, 95, 98, 101, 110–112, 115–116, 142, 166; in film noir, 3, 10, 48, 111
politics: conservative, 75–77, 85, 164, 166; far right, 81, 83, 121, 173, 191n16; idealism, 109, 116, 127–128; ideology of characters, 77, 93, 103, 107, 134, 138; left-wing, 7, 10, 66, 95, 127–129, 133, 138, 186n24; liberal Hollywood, 11, 125, 130, 132–138, 160, 167, 174; Republican, 76, 189n6; right-wing, 10–11, 67, 83, 136, 142, 154; socialism, 142, 162, 189n6. See also communism; nationalism; reactionism
Polonsky, Abraham, 152
polyphony, 6, 31, 33, 69, 168. See also speech
polysemy, 58, 73, 135
Pop 1280, 194n13
Popeye, 11, 133
Porpiro, Robert G., 116
Porter, Dennis, 19, 48, 51, 54, 96, 140–141, 185n11, 187nn29–30
Postman Always Rings Twice, The, 112, 177
Potsch, Elizabeth, 41–42
poverty, 77, 85, 90, 186n24. See also Great Depression; immigration
Poverty Row studios, 76, 166
Powell, William, 19, 59
prejudice, 73, 76, 93, 117, 152, 164, 178, 189n2. See also antisemitism; immigration; race; women
Preminger, Otto, 187n36, 192n31
Price, George, 11
Private Hell 36, 192n31
private investigator: in noir, 2, 9, 12, 47–48, 96, 141, 176, 187n29; in the trilogy, 16–18, 29, 49–53, 67, 126, 138, 140–148, 159–162, 172, 178, 184n6
propaganda, 11, 66, 78–83, 132, 176, 178, 189n6, 191n16
prostitution, 128, 130

Prowler, The, 192n31
psychoanalysis, 194n10
Public Enemy, The, 53, 77
pulp, 14, 93, 96, 178, 186n21, 191n20
Pulp Fiction, 185n13
Pushover, 192n31
Puzo, Mario, 188n39

queer, 31, 57, 93. See also gender
Queneau, Raymond, 183n3
Quine, Richard, 192n31
quiproquo, 135, 193n5

race, representations of, 10, 118, 150, 152–158, 178, 194nn13–15
radio: influence on Feiffer, 4, 6–7, 11, 14, 124, 156, 176, 187n34, 187n36, 191n20, 195n18; in the trilogy, 31, 42–43, 54–55, 58, 74, 84, 131, 165, 170, 187n35, 193n3
Rapper, Irving, 134
Ray, Nicholas, 192n31
Raymond, Alex, 11
reactionism: forces, 66, 133, 176; ideology, 73, 83, 88, 93, 162, 173, 189n4; social attitudes, 48, 106, 146. See also politics
Reagan, Ronald, 136, 193n6
realism, 96, 107, 176. See also verisimilitude
Reckless Moment, The, 150
Red Harvest, 96, 141, 177
red herring, 139–140, 164
Reds, 79, 100, 106, 143, 173–174. See also communism; House Un-American Activities Committee; McCarthyism
Red Scare, 6, 10, 66, 97, 100, 106. See also communism
Red Squad, 67, 88. See also unions
reflexivity: aesthetic, 4, 15, 26; metanarrative, 12, 54, 57, 64, 70, 73, 123–124, 132, 135–136, 138–140, 178; thematic, 11, 15, 40, 45, 51, 58, 148
religion, 80–81, 84, 92, 94
Remarque, Erich Maria, 78
repression, 40, 67, 88, 96, 100, 102, 125, 138
Reste avec moi, 185n12
revenge, 18, 51–52, 57, 109–110, 123–125, 128–132, 162–164, 170–173
reversal: identity, 19, 54, 129, 134; plot, 10, 16, 41, 53–54, 58, 93, 100, 107, 121

rhyme, 39–41, 177, 187n31
rhythm, 37, 142, 146
Rich, Jaimie S., 183n2
Rickett, Mark, 183n2
Rio Bravo, 166
Risso, Eduardo, 4
Ritt, Martin, 139
RKO, 76, 190n14
Robbins, Frank, 2
Robbins, Jerome, 127, 173
Robbins, Stephanie Troutman, 156
Robert, Marthe, 178
Roberts, Marguerite, 139
Robinson, Eddie, 57
Robinson, Sugar Ray, 188n41
Robson, Mark, 45
Rogers, Ginger, 43, 76, 186n22
romance, 74, 90, 92–93
Roman Holiday, 134
Rooney, Mickey, 77
Roosevelt, Franklin D., 76, 189n6
Rosenblatt, Roger, 120, 193n34
Ross, Steven J., 78, 83, 191n17
Rossen, Robert, 45
Roswell Incident, 194n12
Rouverol, Jean, 139
Russia, 86, 94, 106, 142, 190n14. *See also* Soviet Union
Rustin, Bayard, 152–153, 194n15
Ryan, Pat, 49, 186nn26–27

Sabin, Roger, 9
Sahl, Mort, 194n11
Saint-Ogan, Alain, 130
Saji, Alia al-, 195n16
Salt of the Earth, 96
Sanford, John, 139
San Francisco, 96, 186n20
Santa Monica, 97, 186n20
Sarnoff, David, 190n14
Satellite Sam, 183n2
satire, 7, 9, 12–14, 54–55, 104, 175, 178. *See also* caricature; irony
Saunders, Thomas J., 190n10
scapegoat, 81, 110, 119. *See also* violence
Scarface, 77
scenery, 33, 68, 70–71, 113. *See also* page layout
Schary, Dore, 75

Schenck, Joseph and Nicholas, 75, 190n14, 191n17
Schneider, Greice, 42, 186n21
Schneiderman, Rose, 192n28
Schrader, Paul, 115
Schulberg, B. P., 191n17
Schwartz, Nancy Lynn, 76
science fiction, 133, 186n21. *See also* flying saucer
Scorchy Smith, 2
Scott, Adrian, 134
Scott, Ian, 76, 189nn7–8
Screen Actors Guild, 193n6
screenwriter: characters in the trilogy, 124–125, 132–139, 144, 159, 164, 178–179; Feiffer as, 1, 12–13, 131, 133; non-fictitious, 11, 75–76, 125, 127–128, 152, 158, 166. *See also* Hollywood Ten
seduction, 9, 36, 47, 83, 133, 179
segregation, 141, 152, 156, 158. *See also* antisemitism; race
self-deprecation, 56, 104, 116, 118, 126, 145, 178, 194n10. *See also* Jewishness
Selwyn, Edgar, 92
sequentiality, 6–8, 31–34, 39, 44, 68, 89, 126, 172. *See also* narrative
seriality, 36, 39
Set-Up, The, 45, 150, 194n14
sexuality: in *The Feiffer Strips*, 9; in the trilogy, 16, 47–51, 56, 61, 69, 110, 117–118, 120, 129, 144, 184n10, 188n38; in Milton Caniff, 49, 186nn26–27. *See also* eroticism
Shakespeare, William, 94, 135, 193n5
Shavelson, Clara Lemlich, 192n28
Shaw, Beth Kobliner and Jacob, 14
Sherman, Vincent, 193n2
Shield, The, 3
Short Cuts, 185n12
Shuster, Joe, 11
Siegel, Don, 192n31
Siegel, Jerry, 11
Silberberg, Mendel, 191n17
Simon, Franchon, 191n17
Simon, Joe, 3, 194n7
simulacrum: in film, 6, 13, 31, 45, 57, 165, 179, 184n3; in gender performance, 54, 135; in politics, 100, 111, 140
Sinatra, Frank, 188n39

Sin City, 4
Sinclair, Upton, 189n6
singing: cabaret, 7, 14, 18, 170, 176; Cissy Goldman, 104; Eddie Longo, 187n37; film noir, 62; Great Depression, 43, 74, 76, 97–98, 102, 176, 186n22, 189n3; Hootie Pines, 73, 98, 107, 192n25; Lady Veil, 18, 61–64, 170, 173; Sam Hannigan, 104, 192n30; Sam Hannigan's father, 84–88. *See also* music
sitcoms, 156, 195n18
Smart Money, 53
Smith, Bessie, 62
Smolderen, Thierry, 42
socioeconomic context, 66, 76–77, 111
soldier, 14, 31, 53–55, 57–58, 75, 92, 187nn36–37
Something to Sing About, 56
Sophocles, 15
sound effects, 3, 7, 23
South Pacific, 31, 54, 56
Soviet Union, 94, 109. *See also* communism; Russia
Spade, Sam, 7, 47, 120
speech: characters as enunciators, 8, 29–31, 39, 51–52, 58, 73–74, 89–90, 109, 141, 145, 148, 161, 167, 170, 172; use of speech balloons, 23, 69, 71, 81, 95, 101, 103, 133
Spicer, Andrew, 45, 186n24
Spirit, The, 2–3, 7, 12, 14–15, 124, 147, 149, 161
Stalin, Joseph, 10, 79, 129, 131
Stargardt, Ute, 78
Steig, William, 11
Steinbeck, John, 77, 95–96
Steinberg, Saul, 11
Stern, Jerome, 85, 146
Sternwood, Carmen, 118
Steunenberg, Frank, 109
Steve Canyon, 15
Stewart, Donald Ogden, 191n17
Stoll, George E., 55
Stone, Isidor Feinstein, 10, 106, 125, 154
Stoopnagle and Budd, 58
Strange Love of Martha Ivers, The, 118
Streible, Dan, 186n20
Stripling, Robert E., 193n6
Stuart, Gloria, 191n17
Sudden Fear, 193n2
suicide, 56, 75, 139, 188n40

Superman, 11
Suspense, 7
Sutherland, Donald, 146
Sydney, Sylvia, 191n17
synthesis, 16, 21, 28–29, 39, 68, 111. *See also* narrative
Syriana, 185n12

Tantrum, 7–8
Tarawa, 31, 54, 59, 165
Tartuffe, 193n5
Tarzan of the Apes, 11
television, 3–4, 6, 134, 139, 158, 170, 174, 188n41, 191n20
Temple, Shirley, 76
temporality, 24, 28–29, 34, 123, 188n45
Terminal Triumph, 56–57
Terry and the Pirates, 2, 49, 186n26
Thalberg, Irving, 75
There Was a Little Girl, 39, 177, 187n31
Thing from Another World, The, 194n12
Thin Man, The, 19
This Woman Is Dangerous, 132, 193n2
Thompson, Jim, 194n13
Tierney, Gene, 187n36
Tif et Tondu, 130
Today We Live, 93
Todd, Ellen Wiley, 102
To Have and Have Not, 62
Toller, Ernst, 191n17
Töpffer, Rodolphe, 42, 177
Touch of Evil, 192n31
transmediality: adaptation between media, 4, 77–78, 93, 112, 158, 191n20, 195n18; as a device, 6, 70, 131, 191n20. *See also* intermediality; intertextuality
Traub, Hans, 78
trauma: family, 9, 13, 16–19, 26, 62–64, 103, 171; historical, 10, 176. *See also* violence
Trotsky, Leon, 131, 138
Trumbo, Dalton, 134, 193n4
Trump, Donald, 189n4, 192n26
Tuazon, Noel, 183n2
Tumor, 183n2
Twelfth Night, 193n5
twins, 17–18, 62, 130

Uderzo, Albert, 130
Ulmer, Edgar G., 194n12

un-American, 80, 94, 166, 173, 176
unemployment, 16, 50, 67, 125, 127, 131
Union Maid, 97–98, 102
unions: labor unionization, 10, 84–85, 88, 95, 97–98, 100–111, 136, 138, 159–162, 176; organizers, 98, 192n25; strikes, 11, 67, 88, 95–98, 100–102, 105, 110–111, 141, 161–162, 189n1, 191n22, 192n24, 192n28; strikebreakers, 50, 67, 88–89, 96–98, 101–103, 142, 144, 153–154, 156, 158, 191n23
United Artists, 191n14
Universal Pictures, 75, 191n14
USA: The Complete Trilogy, 96
U.S. and the Holocaust, The, 191n21

Valis Hill, Constance, 57
Valley of Decision, The, 96
Van Dover, J. K., 19
Van Lier, Henri, 185n15
vaudeville, 55, 76, 88, 130, 188n41
verisimilitude, 12, 43, 98, 136, 153, 171, 178. *See also* realism
Vidor, Charles, 62
Vidor, King, 77
Vietnam War, 10, 194n9
Village Voice, 13, 100, 142, 147, 152–153, 186n23, 192n27, 193n34
violence: fight scenes, 21–23, 29–30, 79, 106–107, 119–120, 147, 160–161; film noir, 53, 62, 152; noir comics, 3–4; riots, 95, 101–103, 141–142, 152, 194n9; toward women, 53, 62, 69, 177, 184n10, 188n41; war scenes, 57–58. *See also* trauma
voice-over, 6, 12, 52, 141, 176
vulnerability, 50, 142, 154

Wagner, David, 134
Waiting for Lefty, 127
Wallace, George, 194n9
Walsh, Raoul, 45, 62
Wandtke, Terrence R., 4
Ware, Chris, 21, 69
Warner Bros., 75, 189n8, 190n8, 190n14
War Nurse, 92

War of the Worlds, The, 194n12
Washington Masquerade, The, 189n8
WASP, 147, 150
Wayne, John, 166
Weinstein, Hannah, 193n4
Welles, Orson, 62, 192n31
Wellman, William, 77
Westerns, 74, 76, 158, 166–168, 176, 193n2
West Side Story, 127
Wheeler, Mark, 76, 189n6, 191n16
Where the Sidewalk Ends, 192n31
Wild Boys of the Road, 77, 176, 189n8
Wilder, Billy, 14
Wilder, W. Lee, 194n12
Williams, Frances E., 150
Williams, Gluyas, 11
Williams, Robert F., 41–42
Williams, Spencer, 10, 158, 195n18
Winchell, Walter, 191n17
Winner Take All, 92
Wise, Robert, 45, 152, 194n12
witch hunt, 131, 134–136, 138, 140. *See also* blacklist; House Un-American Activities Committee; McCarthyism
Wobblies (Industrial Workers of the World), 95–96, 160
Wolff, Marco, 191n17
Wolheim, Louis, 78
women: characters in the trilogy, 16, 63, 144, 171, 178; role in society, 48, 50–51, 75, 97, 103–104, 192n28. *See also* family; femme fatale; gender; misogyny; violence
World War I, 83, 90, 92, 94
World War II, 6, 10, 14, 16, 48, 94, 143, 187n27
Wyler, William, 134, 191n17

Yacoubian Building, The, 185n12
Yiddish, 104
You have killed me, 183n2

Zig et Puce, 130
Zinnemann, Fred, 166
Zukor, Adolph, 75, 190n14

About the Author

FABRICE LEROY is a professor of Francophone Studies at the University of Louisiana at Lafayette. His monographs on comics include *Sfar So Far: Identity, History, Fantasy and Mimesis in Joann Sfar's Graphic Novels* and *Pierre La Police: Une esthétique de la malfaçon* (with Livio Belloï). With Jan Baetens and Hugo Frey, he co-edited *Intermediality in French-Language Comics and Graphic Novels* and *The Cambridge Companion to the American Graphic Novel*.